YALE UNIVERSITY PRESS
PELICAN HISTORY OF ART

FOUNDING EDITOR: NIKOLAUS PEVSNER

RUDOLF WITTKOWER

ART AND ARCHITECTURE IN ITALY
1600–1750

REVISED BY JOSEPH CONNORS AND JENNIFER MONTAGU

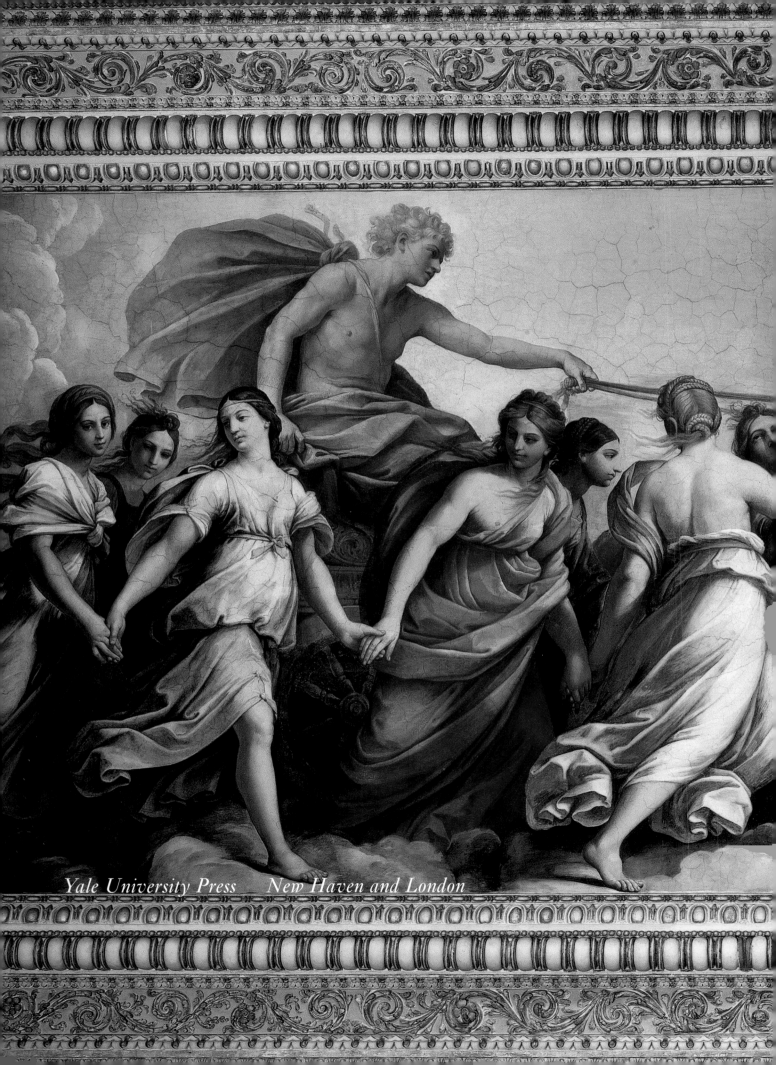

Yale University Press New Haven and London

Rudolf Wittkower

Revised by Joseph Connors and Jennifer Montagu

Art and Architecture in Italy 1600–1750

VOLUME ONE

The Early Baroque 1600–1625

To
My Wife

First published 1958 by Penguin Books Ltd
Sixth edition, revised by Joseph Connors and Jennifer Montagu,
first published 1999 by Yale University Press
10 9 8 7 6 5 4 3 2 1

Set in Monophoto Ehrhardt by Best-set Typesetter
Printed in Singapore
Designed by Sally Salvesen

TITLE PAGE: Giudo Reni, *Aurora*, Rome, Palazzo Pallavicini.

Library of Congress Cataloging-in-Publication Data

Wittkower, Rudolf.
 Painting in Italy, 1600–1750 / Rudof Wittkower, revised by
Joseph Connors and Jennifer Montagu
 p. cm.
 Updated ed. of: Art and architecture in Italy, 1600 to 1750.
 Contents: [1] Early Baroque – [2] High Baroque – [3] Late
Baroque.
 Includes bibliographical references and index.
 ISBN 0-300-0789-0 (cloth 3 vols. : alk. paper), ISBN 0-300-
07889-7 (paper 3 vols. : alk. paper), – ISBN 0-300-07939-7 (paper:
v. 1 : alk. paper) – ISBN 0-300-07940-0 (paper : v. 2 : alk. paper) –
ISBN 0-300-0741-9 (paper : v. 3 : alk. paper)
 1. Art, Italian–History. 2. Art, Modern– 17th–18th cen-
turies–Italy. I. Connors, Joseph, II. Montagu, Jennifer. III.
Wittkower, Rudolf. Art and architecture in Italy, 1600–1750. IV.
Title.
N6926.W5 1999
759.5–dc21
98-49066
 CIP

Contents

Forewords

THE FIRST EDITION

In all fairness, I feel the reader should be warned of what he will not find in this book. Such a first sentence may be psychologically unwise, but it is morally sound. I am concerned with the Italian Baroque period in the widest sense, but not with the European phenomenon of Neo-classicism. Thus Winckelmann and his circle as well as the Italian artists who followed his precepts fall outside the scope of my work. Nor will the struggle between the supporters of Greece and those of Rome be reported, a battle that was joined in the 1750s from Scotland to Rome and in which Piranesi took such an active part. In addition, little or next to nothing will be said about the festive life of the period: the Baroque stage and theatre, and the sumptuous decorations in easily perishable materials put up on special occasions often by first-rate artists. Finally, the development of the garden, of town-planning, and of interior decoration could hardly be touched upon, though I am only too well aware that all this is particularly relevant for a comprehensive picture of the Baroque age. My aim is narrower, but perhaps even more ambitious. Instead of saying little about many things, I attempted to say something about a few things, and so concerned myself only with the history of painting, sculpture, and architecture.

Even so, the subject and the space at my disposal dictated severe limitations with which the reader may want to be acquainted before turning to the pages of this book. It was necessary to prune the garden of history not only of dead but, alas, also of much living wood. In doing this, I availed myself of the historian's right and duty to submit to his readers his own vision of the past. I tried to give a bird's-eye view, and no more, of the whole panorama and reserved a detailed discussion for those works of art and architecture which, owing to their intrinsic merit and historical importance, appear to be in a special class. Intrinsic merit and historical importance – these notions may be regarded as dangerous measuring rods, and not every reader may subscribe to my opinions: yet history degenerates into chronicle if the author shuns the dangers of implicit and explicit judgements of quality and value.

At this point I make bold to express a view which may be unpopular with some students of the Italian Baroque. Excepting the beginning and the end of the period under review, i.e. Caravaggio, the Carracci, and Tiepolo, the history of painting would seem less important than that of the other arts and often indeed has no more than strictly limited interest – an ideal hunting-ground for specialists and 'attributionists'. This fact has been somewhat obscured by the great mass of valuable research made during the last forty years in the field of Italian Baroque painting at the expense of studies in the history of architecture and sculpture. Roughly from the second quarter of the seventeenth century on, the most signal developments in easel-painting lay outside Italy, and Italian painters became the recipients rather than the instigators of new ideas. It is, however, in conjunction with, and as an integral part of, architecture, sculpture, and decoration that Italian painters of the Baroque made a vital and internationally significant contribution with their large fresco cycles. The works without peer are Bernini's statuary, Cortona's architecture and decoration, and Borromini's buildings as well as those by Guarini, Juvarra, and Vittone. But it was Bernini, the greatest artist of the period, who with his poetical and visionary masterpieces created perhaps the most sublime realization of the longings of his age.

Based on such considerations, I have placed the accents in the story that follows. Approximately one-fourth of the text is devoted to Bernini, Cortona, and Borromini; the chapter on Bernini alone takes up over ten per cent of the book. Another ten per cent is concerned with Caravaggio, the Carracci, and Tiepolo, while roughly the same space is given to Sacchi, Algardi, Duquesnoy, and the great Piedmontese architects. This accounts for more than two-fifths of the text. Since hundreds of artists, many of them of considerable stature, share between them as much text as I have given to a mere dozen of the greatest, my narrative may be criticized as lopsided. But I am prepared to accept the challenge. New and pregnant ideas have always been few and far between. It is the origin, unfolding, and expansion of these ideas with which I am here concerned. Their echo and transformation in the work of minor artists can be sketched with a large brush.

My story begins with the anti-Mannerist tendencies which arose towards the end of the sixteenth century in various Italian centres, and the curtain falls over the Baroque scene at different places in different decades. If one postulates the year 1750 roughly as the watershed between the Late Baroque and Neoclassicism, it appears that the three main sections of this book comprise spans of approximately thirty, sixty, and again sixty years. Two-fifths of the text have been devoted to the two generations limited by the beginning and the end of Bernini's career, since I consider the Roman High Baroque of Bernini, Borromini, and Pietro da Cortona the most exciting years of the century and a half under review and one of the most creative periods of the whole history of Italian art; the remaining three-fifths are equally divided between the first and third parts. Some readers may regret that this disposition has resulted in an all too brief discussion of eighteenth-century painting, particularly of the Venetian School, but a fairly full treatment would in any case have gone far beyond the space at my disposal; also I believe that the structure I wanted to give the book justified and even demanded this brevity.

For the main divisions of the whole period I have used the terms, by now well established, of Early, High, and Late Baroque. Only recently have we been reminded[1] that such terminological barricades contain fallacies apt to mislead the author as well as his public. Yet no historical narrative is possible without some form of organization, and though the traditional terminology may have – and indeed has – serious

shortcomings, it conveniently and sensibly suggests chronological caesuras during one hundred and fifty years of history. If we accept 'Baroque' – like 'Gothic' and 'Renaissance' – as a generic term and take it to cover the most diverse tendencies between roughly 1600 and 1750, it will yet be seen in the text of the book that the subdivisions 'Early', 'High', and 'Late' indicate real historical caesuras; but it became necessary to expand the 'primary' terminology by such terms as 'transitional style', 'High' and 'Late Baroque classicism', 'archaizing classicism', 'crypto-romanticism', 'Italian Rococo', and 'classicist Rococo', all of which will be explained in their proper place.

I dictated a rough draft of large parts of the manuscript in the summer of 1950. Most of my spare time in the following seven years was given to elaborating, revising, and completing the work. The manuscript reached the editor in batches from the beginning of 1956 on; by the summer of 1957 almost the entire text had been dispatched. I mention these facts because they explain why recent research is not so fully incorporated as I should have liked. Since new and often important results appear in an uninterrupted stream, it was virtually impossible to keep the older chapters of the manuscript permanently up to date. I have attempted, however, to incorporate in the Notes all the major publications until the autumn of 1957.

It is not possible to mention all the names of friends and colleagues who answered my inquiries. I am particularly indebted to Peggy Martin, Sheila Somers, and St John Gore, through whose assistance the manuscript made progress at a difficult period. Paolo Portoghesi and G. E. Kidder Smith allowed me to use some beautiful photographs. Howard Hibbard helped with the search for, and supply of, illustrations. In addition, I am greatly indebted to him for many corrections of facts and for allowing me to use some of the results of his researches in the Borghese archive. Philip Pouncey and Henry Millon emended some errors at proof stage. My gratitude goes above all to Ilaria Toesca and Italo Faldi, who year after year put their time and resources unflinchingly at my disposal. I am deeply grateful for what they have done for me by correspondence and during my regular visits to Rome. Milton J. Lewine took upon himself the self-denying task of reading one set of proofs. Ever watchful and scrupulously conscientious, he covered the galleys with comment; his many constructive suggestions as to content and style considerably improved my final text.

The book was prepared and written mainly with the resources of the Warburg Institute and the Witt Library (Courtauld Institute), London; the Bibliotheca Hertziana, Rome; the German Art Historical Institute, Florence; and the Avery Library, Columbia University, New York. I wish to put on record that without the loyal support of the directors and staffs of these excellent institutions the work could never have been finished in its present form.

Finally, I have to thank the editor, Nikolaus Pevsner, not only for constant advice and encouragement, but also for his infinite patience. Whenever my own spirit began to flag, the thought sustained me of how much easier it was to be an author than an editor.

New York, December 1957

FOREWORD TO THE SECOND EDITION

In the five and a half years since the appearance of the first edition of this book Italian Baroque studies have taken immense strides forward. Many key figures had then lacked modern monographs but this deficiency has now been partly overcome. Arisi's *Panini*, Bologna's *Solimena*, Briganti's *Cortona*, Constable's *Canaletto*, D'Orsi's *Giaquinto*, Enggass's *Baciccio*, and Morassi's *Tiepolo* indicate the breadth and importance of the research concluded in the intervening period. Moreover, minor masters such as Carneo, Carpioni, Cecco Bravo, and Petrini have recently found biographers. Exhibitions from the Venetian and Bolognese Seicento to the splendid Baroque Exhibition in Turin have brought together, sifted, and submitted to scholarly discussion an enormous mass of new material. One-man shows, often accompanied by bulky and monographic catalogues, have helped to clarify the *œuvre* and development of Cerano, Cigoli, Morazzone, Pellegrini, Pianca, Marco Ricci, Tanzio, and others. Scores of papers, many of them written by a rising generation of intensely active, perspicacious, and devoted scholars – among whom I gratefully name Borea, A. M. Clark, Ewald, Griseri, Hibbard, Honour, Noehles, Posner, and Vitzthum – have helped to correct old misconceptions and to expand the confines of our knowledge. In a word, much of the groundwork for the book which I rashly undertook to write years ago has only in the last half decade been laid by the concerted endeavour of many scholars.

Confronted with this situation, I felt tempted to recast some of the old chapters. In the end, I decided against such a course, because I had regarded it as my primary task to submit a coherent historical vision of the entire period and, despite all the valuable work done in recent years, dismissed the need for a change or disruption of the original structure of the book. Nevertheless, a great many errors have been amended in the text, and facts, ideas, and judgements have been brought in line with new results wherever and whenever I found them convincing.

The bulk of the new research has been incorporated in the Notes, to which I have added about 15,000 words. In addition, the Bibliography has been brought up-to-date (until summer, 1964); in some cases I have listed weak and unsatisfactory writings for the sole purpose of saving time to students who might otherwise be misled by a promising title.

The reception of the first edition has been favourable beyond expectation. If the test of an author's success lies in the extent to which his ideas percolate and become, acknowledged as well as unacknowledged, common property, I have no reason to be dissatisfied. I hope that the considerably increased critical apparatus will make the book even more useful. But, as before, the text is meant to stand on its own and be perused by those who want to *read* a coherent narrative rather than *use* a textbook, without the constant and irritating turning of pages to the back of the book.

It only remains to thank the many friends who helped me with comments and corrections. Among them Julius Held and Howard Hibbard should be specially mentioned; their vigilant eye caught a number of blatant errors.

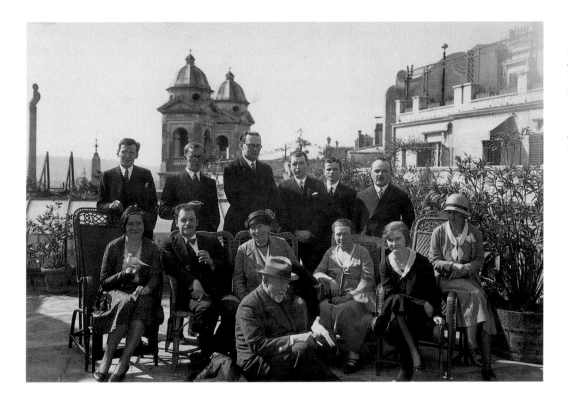

Art historians on the terrace of the Bibliotheca Hertziana, Palazzo Zuccari, Rome, 1 May 1931: *Standing*: Dr Gross, Dr Baumgart, Dr Wittkower, Dr Keller, Dr Koerte, Dr Schudt; *seated*: Frl. Urbig; Professor Hetzer, Frau Eisler, Frau Professor Hetzer, Frl. Schmidbauer, Baroness Weiss; *seated in front*: Professor Ernst Steinmann

Judy Nairn watched over the new edition as she did over the old. Her whole-hearted co-operation spurred me to action. She also took upon herself the unenviable task of compiling a new and fuller index.

Florence, August 1964

FOREWORD TO THE THIRD EDITION

In some fields of the history of art and especially in the field of Baroque studies research has made and is making such giant steps forward that a book first vaguely envisaged more than a generation ago and written in the 1950s can only survive if the process of bringing it up to date never ceases. Once again, however, I had to abandon the temptation of recasting whole chapters of the text of the book and had to restrict myself to a few extensive and a vast number of minor corrections. The bulk of the new critical material, covering mainly the period between the spring of 1964 and the spring of 1971, has been incorporated in the Notes and the Bibliography. Both Notes and Bibliography have grown very considerably and have reached a size that, in my view, should not be transgressed. Even so, it was impossible (nor was it my intention) to aim at anything approaching completeness. The selection of the material newly incorporated in this edition was dictated not only by the importance of

contributions, but also by my own interests and reading capacity. Moreover, I have to admit frankly that some fine studies may never have come to my knowledge. Thus I have to emphasize strongly that omission only rarely implies refutation.

Once again, I have to point out that the notes and the bibliography supplement each other: a great deal of bibliographical material only appears in the notes, while a good many works are only mentioned in the bibliography, where I have often given fuller comments than in the previous editions. And once again I have to thank many friends who have helped me in one way or another, given me the benefit of their criticism and corrected mistakes. Among them I mention gratefully the names of Diane David, Howard Hibbard, C. Douglas Lewis Jr, Carla Lord, Tod Marder, Jennifer Montagu, and Werner Oechslin.

*Podere La Vescina,
Lucignano,
June 1971*

For notes and revisions for the reissue of this volume in 1980 the editors are most grateful to Professor Alice Binion, Miss Laura Gilbert, Professor Howard Hibbard, Professor Henry Millon, and Mrs Margot Wittkower.

Introduction to the New Edition

by Jennifer Montagu and Joseph Connors

RUDOLF WITTKOWER (1901–1971)

Rudolf Wittkower was born in Berlin. He finished his Arbitur in 1918, still too young to be drafted before the armistice of November. In this year he found his future wife and co-author, Margot Holzmann, but it took several years of searching before he arrived at art history. He studied architecture for a year in Berlin, but bored with incessant repetition of the Greek orders he decided to change to psychology. Too late to register for the programme he wanted in Heidelberg, he studied archeology for a semester and only then turned to art history. He went to Munich to study with Wölfflin but was disappointed with the grand man, who lectured to packed halls but had little contact with students, even those in his seminar, which was run by an assistant. After a year he returned to Berlin and did his thesis under Adolf Goldschmidt on the *quattrocento* Veronese painter Domenico Morone. In January 1923 he moved to Rome to take up a position as an assistant to Ernst Steinmann, director the Bibliotheca Hertziana, and on the last day of that year he broke with tradition by marrying, at the age of twenty-two.

In Rome Wittkower's first task was to assist Steinmann in completing his *Michelangelo-Bibliographie, 1510–1926*, to which his energy and organising intelligence contributed so much that he appeared as joint author of the publication (1927). It was Wittkower who began the compilation of those bibliographical indices under artists and places on which all later users of the Hertziana's splendid library have come to rely. Wittkower began to interest himself in the undervalued fields of baroque architecture and sculpture. He attempted to win Steinmann's interest by showing him photographs of S. Ivo and S. Andrea al Quirinale. From Rome he contributed a number of entries on Roman seventeenth- and early eighteenth-century sculptors to Thieme-Becker's *Künstler-Lexikon*. At this time there was little sympathy for the baroque, and the literature was sparse. Fabbrini's biography of Cortona (1896) and Fraschetti's of Bernini (1900) made valuable archival contributions, but the first book that can be described as a modern monograph was Eberhard Hempel's sensitive and well-researched *Francesco Borromini* of 1924. Oskar Pollak had tried to lay a firm foundation for the field by collecting a huge mass of documents for the patronage of the baroque popes, but the project had been cut short by his death in the First World War. The parts of his material relating to St Peter's and Urban VIII were published only in 1928-31. Finally a younger Roman nobleman, the Marchese Giovanni Incisa della Rocchetta, was steadily investigating the archives of his own family, the Chigi, and introduced Wittkower to their riches.

In 1927 Wittkower moved his family back to Berlin but he continued to visit Rome and to work on Bernini, an inter-est that was to occupy so much of his life, culminating in 1955 in the publication of *Gianlorenzo Bernini, The Sculptor of the Roman Baroque*. In order to lay secure foundations for a study of the artist he undertook the catalogue of the drawings, collaborating with Heinrich Brauer, who had written his doctoral thesis on the Bernini drawings in Leipzig. The resulting monumental and still unsurpassed volume was published under the auspices of the Hertziana, despite Steinmann's original doubts as to whether Bernini could be worthy of such support. Wittkower recalled a momentary setback when Bernard Berenson visited Steinmann and was taken to meet the two young scholars. The connoisseur from I Tatti sat at the other end of the table and looked over their photographs one by one, not bothering to turn them right side up. At the end he said, 'When I look at these, I feel physically sick.' Afterwards Wittkower was furious, and vowed that if he ever taught he would never do anything like that, but would always try to find the value and the importance of what a student was doing.

The year 1931, which saw the publication of *Die Zeichnungen des Gianlorenzo Bernini*, was also the time Wittkower opened an attack on a theoretical and ideological current in German art history. Hans Sedlmayr, the rising star of Vienna art history and author of a highly theoretical book of 1930 on Borromini, reviewed the monograph Coudenhove-Erthal brought out that same year on Carlo Fontana. Passing over the book with a few faint words of praise, Sedlmayr took the opportunity of the review to proclaim the existence of two art histories, one a positivist search for facts, the other (and higher) kind a theoretically driven search for abstract principles of form. Coudenhove-Erthal had found all the facts on Fontana one might ever need to know, Sedlmayr wrote, and was a good example of the 'first art history'. But to arrive at the 'second art history' one had to understand the inner *Gestaltungsprinzipien* as only Sedlmayr himself did.

Wittkower wrote a review of the review, excoriating both authors. Coudenhove-Erthal had missed the twenty-seven volumes of Fontana drawings at Windsor. Sedlmayr, he wrote, imposed abstract Platonic structures that did not fit the architecture and drained all individuality from the artist. Sedlmayr's counterattack was massive, but his young challenger stood firm. Wittkower was constitutionally averse to the imposition of authoritarian constructs on history, which he felt barred rather than facilitated access to the individual work. Sedlmayr's rapid rise in Germanic art history, and Wittkower's realization as early as the Munich *putsch* that Hitler would win and that he could never live in Germany, added fire to the exchange, but it was based on deeply contrasting views of what made for valid art history.

In 1932 Wittkower took up a temporary position as lecturer at the University of Cologne, but the following year he and his family left Nazi Germany for London; his father had been born in England, and this fortunate chance gave him British nationality, which facilitated not only his entry into England, but his employment at the Warburg Institute. There began another shift in his interests: as joint-editor of the *Journal of the Warburg and Courtauld Institutes*, from its first issue in 1937–8 he contributed a succession of articles and notes, many on broadly iconographic themes, and, particularly, on the influence of motifs brought from the East on Western art. It was in order to establish the Warburg Institute in England, as well as to provide the British public with some access to art at a time of war, when most of the collections of originals had been removed for security, that the Director, Fritz Saxl, created a series of photographic exhibitions. Wittkower (who was then in charge of the Institute's extensive photographic collection) produced *British Art and the Mediterranean*, in collaboration with Saxl, which was subsequently made into a book (1948, reprint 1969). Italian art, and particularly architecture, remained an abiding interest, even when he no longer had access to the originals. The Warburg library, however, contained a wealth of contemporary theoretical writings, and encouraged an interdisciplinary approach, which led to what was to be his most influential book, *Architectural Principles in the Age of Humanism* (1949, revised ed. 1962).

The inability to revisit the country which had for so long been the focus of his studies never diminished his insatiable scholarly curiosity: he became increasingly interested in British architecture, and, as was already apparent in *British Art and the Mediterranean*, the Italian influences that lay behind its development; in particular, this meant Andrea Palladio. Nor had his involvement with drawings diminished: he collaborated with Tancred Borenius in cataloguing Sir Robert Mond's collection of drawings, over half of which were Italian (though one might doubt how far his insights prevailed over the views of the owner), and collaborated with Anthony Blunt in the organisation and publication of the first two volumes of Walter Friedlaender's *The Drawings of Nicolas Poussin* (1938, 1949). On Blunt's initiative, he undertook the catalogue of the Carracci drawings at Windsor Castle (1952), which was notable for its achievement in sorting out the hands and personalities of the three artists.

Although Wittkower taught while in England, this consisted mainly of lecturing to artists at the Slade School of Art as Durning Lawrence Professor (1949–56), and in supervising PhD students. It was only with his appointment as Chairman of the Department of Art History and Archaeology at Columbia University in New York in 1956 that his full potential as a teacher could be realised. There also he had full scope to exercise his organising abilities in the expansion and enhancement of the department (and, in view of those interests developed in his years at the Warburg, it can hardly be coincidental that one of his first acts was to appoint a lecturer in Near Eastern Art), to make it one of the leading centres for the study of art history in the United States. The considerable load of wide teaching and administrative duties did not diminish his scholarly output:

not only was this book completed in New York, but he wrote, in collaboration with his wife, what was to be his most popularly acclaimed book, *Born under Saturn: The Character and Conduct of Artists – A Documentary History from Antiquity to the French Revolution* (1963), and, again in close association with his wife, continued his uncompleted work on the architectural interests of Lord Burlington.

This very brief outline of Wittkower's career is intended neither to provide a full account of his work, nor to present that generous and endearing personality remembered with such affection by so many. But a summary of the experiences which formed him, and an indication of the main areas of his interests, may help to explain how he could write a book like this. They exemplify that indefatigable capacity for work and abundant energy, stressed in the two long obituary notices by his former students, Howard Hibbard and David Rosand, and also his extreme professionalism. Whatever the task in hand (and it should be noted that not all were the tasks he would necessarily have chosen), he turned to it with enthusiasm, determination, exacting scholarship, and immense organisational powers; moreover, for each task he adapted his method and approach to that most suited to the material, or the audience. Confident in the breadth of his own knowledge, he saw no need to remind the reader of it. Inevitably, a book on the Italian baroque will contain many references back to Michelangelo and Palladio, where Wittkower's mastery of these subjects will be apparent, but he did not dwell on his own fundamental contributions to the study of their work or to the definition of mannerist architecture. Interested though he was in the concept of genius, and the destructive influence of Saturn on not a few of the artists who form the subject of this book, he resisted any impulse to expand on it in a context where such a discussion would have been inappropriate. The reader of this book will certainly be aware of the depth of Wittkower's learning, but hardly of its range.

WITTKOWER'S TEXT

Art and Architecture in Italy 1600–1750 was the largest volume in the Pelican History of Art series. This is hardly surprising, for, despite its title, it covers almost two hundred years of architecture, sculpture and painting in a country that, for most of the first hundred, was the leading centre of European art, and where a new style was created and developed, the baroque, that was to dominate the rest of the continent (and much of South America). Moreover, contemporaries were well aware of the merits of the artists of their day, and wrote extensively of their lives and work in biographies, guide-books and theoretical treatises.

But still, the period fell largely out of fashion during the nineteenth century. Younger readers may also need reminding that even in the mid-twentieth-century the general public, as against the specialist art historians, was uncomfortable with the baroque, and particularly in Protestant countries. There was a still wide-spread belief that all rhetorical art (of which the Italian baroque was the supreme example) was necessarily insincere, and lacking in genuine spirituality, while, had it been sincere, its close dependence on a religion which many held suspect would have rendered it no less

incapable of conveying a true and genuine faith – which somehow the equally Catholic middle ages had achieved. As well as conveying the historical facts, a book on the Italian baroque had also to indicate the falsity of such prejudices.

The book was, therefore, a formidable undertaking, and one completed with outstanding success. That Wittkower was able to reduce this vast mass of material to a coherent and readable history is due not only to his own capacity to read and master the vast literature, but to his decision 'to prune the garden of history', as he put it in his Foreword to the first edition. This Foreword admirably describes the method that he adopted, and there is no need to repeat it here. It is sufficient to say that it worked splendidly, and his book has remained unsurpassed as a guide through the labyrinth of interacting and competing schools, of vital centres and often fascinating peripheries, both for university students, and for art lovers interested in understanding more about this crucial period. The high respect, even veneration, in which his book has been held ever since it first appeared must put the wisdom of that decision beyond any question.

The polemic with Sedlmayr sheds some light on the present volume. It is organised according to a grand conceptual structure in which Italian art was divided into Early, Middle and Late Baroque, with each period encompassing classical and baroque trends. These categories now seem somewhat rigid. Still, however artificial Wittkower's periodization seems today, it is helpful to remember that he was intent on reappropriating categories from the philosophical art history of Wölfflin and Sedlmayr. They were not to be discarded entirely but reinvigorated though the lived encounter with the individual work of art. Furthermore Wittkower was intent on playing down the theatrical interpretation of the High Baroque. If theatre were to enter the picture it was not in the Roman High Baroque but in Longhena's Venice and in the Roman Late Baroque, which derived from north Italian sources. In Wittkower's treatment of Piazza S. Pietro there is an unforgettable contrast between Bernini's dynamic conception of the space and Carlo Fontana's attempts to redesign the approach so that the ends of Bernini's colonnade would be seen from a great distance, like the wings of a stage backdrop. Late Baroque sceonography superseded High Baroque dynamism.

In any consideration of Wittkower, with all his many and varied interests, one figure stands out: Gianlorenzo Bernini. This is singularly appropriate, for Wittkower clearly felt some personal affinity with this baroque giant, and, indeed, he and Bernini were alike in their energy, their devotion to work, their capacity to organise, and their ability to carry on a diversity of projects at the same time. The profound study that Wittkower had devoted to the artist over the years enabled him to convey the range of his talents within the limited pages of this book, while it is the great baroque artist's enduring genius which, like a thread running through it, serves to hold the book together. The long chapter on Bernini, which takes up ten per cent of the book, is an essay in close analysis. Wittkower does not list Bernini's production in chronological order but sweeps back and forth over the whole oeuvre, posing different questions: the problem of the one vs. the many views of a work of sculpture (a

chance once again to lay Wölfflinian generalisations to rest), the use of light and colour, the *concetto*, and the sculptor's working procedure. This chapter is still the best place to go for a short synthetic introduction to Bernini's architecture and especially to that most complex statement of Bernini's psychological approach, Piazza S. Pietro.

Another hallmark of Wittkower's interpretation of the baroque is his insistence on the emotionally involved spectator. He steers clear of the nineteenth-century term *Gesamtkunstwerk*, which was associated with Wagnerian theatricality. Instead he revives a term used by Bernini's biographer Baldinucci, 'the beautiful whole', to describe a style where, '[with] all barriers down, life and art, real existence and appearance melt into one.' He drew attention to the great complexes of painting, sculpture and architecture, both Bernini's and those of his predecessors and competitors.

He saw the same qualities – spectator participation and intense emotional involvement with complexes involving many media – operative in both high art and in more popular manifestations of piety, such as the *sacri monti* of Lombardy and Piedmont, which he treated in terms of the Tridentine reforms and the spirituality promoted by the Borromeos. This brought down on his head criticism from recent scholars who want to trace the origins of the *sacro monte* to the Franciscan spirituality of the late quattrocento. But aside from the fact that this earlier period does not come within the scope of an already large book, it should be emphasised that Wittkower was the only art historian of his time to treat the phenomenon of the *sacro monte* with interest and respect. The flood of studies that has followed seemed to us to merit inclusion as a separate category in the bibliography.

Unlike most survey books, which maintain an even pace of narration, Wittkower deliberately alternated between fast-forward chapters, which cover dozens or hundreds of artists, and chapters which focus closely, almost luxuriantly, on a single figure. The first chapter on the Counter-Reformation covers so many artists active in so many large complexes that it has always seemed one of the most difficult in the book, daunting even to specialists. In addition this was not an art that Wittkower responded to with sympathy. He tried to focus on what was common to all the reform movements, namely the goal of setting the soul of the spectator on fire with a truely emotional art. But he was apt to dismiss the sheer acreage of fresco in the Vatican and Lateran Palaces and in S. Maria Maggiore as propaganda conceived to gratify patrons who sorely lacked discernment. The pontificates of Sixtus V, Clement VIII and Paul V were for him the valley that came between the twin peaks of the Renaissance and the High Baroque.

But there are other chapters where Wittkower offers a close look at a single master. After the bombardment of names and dates that fills up chapter one, the second chapter focuses exclusively on Caravaggio. It is beautifully written and intensely personal, the ideal place for the general reader to begin. Borromini, like Caravaggio, exerted on Wittkower the fascination of the heretic. He drew (perhaps overdrew) a contrast between the expansive and brilliant Bernini, an artist-architect in the humanist tradition, and

the neurotic and reclusive Borromini, the specialist technician who came to architecture out of the building trades. He saw links between Borromini's use of geometry and the secrets of the medieval mason. Not every interpretation Wittkower advanced was equally convincing. Possibly Borromini's gothic qualities are too much stressed by Wittkower; and it now seems that the star-hexagon is not after all the basis of the plan of S. Ivo. But there are fundamental truths that Wittkower was sometimes able to put in a nutshell. He comes very close to the heart of Borromini's achievement when he says that 'geometric succinctness and inexhaustible imagination, technical skill and religous symbolism have rarely found such a reconciliation.'

Above all Wittkower was anxious to refute Sedlmayr's view, based on Kretschmer's psychology, which diagnosed Borromini as an aberrant personality and saw his architecture as the fruit of neurosis. Borromini was at times a difficult man and may have had tailspins, but for Wittkower his creativity came from periods of normalcy, indeed of intense lucidity, not from neurosis. He had the opportunity to expand on these ideas in the lecture 'Francesco Borromini: Personality and Destiny' inaugurating the Borromini congress in 1967, a piece that remains a brilliant psychological study of a baroque artist.

It might be thought at first glance that Wittkower's Pelican is unduly Rome-centric. Indeed each major section begins with developments in Rome and provincial centres always come second. However, appearances here are somewhat misleading. Wittkower knew Rome intimately but was also fascinated by devlopments in Milan, Venice, Bologna, Naples and dozens of smaller centers. Early on he saw the importance of the Barnabite and Jesuit connections, and the way in which ideas speeded from Lombardy and Emilia to Rome and back again in the pouches and letters of priests who were also architects. He had the opportunity in 1972 to take these themes further in a classic article on the historiography of Jesuit architecture, a topic that seemed to us to have grown so rapidly that it merited a separate section in the bibliography.

In Wittkower's view Rome was first but by no means always foremost, especially in the early and latter periods. Although he had great respect for the seriousness and substance of Carlo Maderno, he felt that Milan, not Rome, was the vital center of early baroque architecture, and he thought that in the end not Maderno but his Milanese contemporary, Francesco Ricchini, would emerge as the truely imaginative architect of the period. Venice is treated as a major center and architects like Longhena and Massari given their due. Wittkower also shared Anthony Blunt's fascination with Naples. In Cosimo Fanzago he found a great if puzzling universal artist, a Bernini of the south, and in Vanvitelli a scenographic genius on a par with anyone in north Italy. He was totally taken by the staircases and churches of Fernando Sanfelice, which he found 'spirited, light-hearted, unorthodox, infinitely imaginative'. He made space in the book for the Neapolitan Christmas crib and for the exuberant Baroque of Lecce.

However, it can be fairly said that Wittkower missed his chance with Sicily, for all his devotion to the stuccoes of Giacomo Serpotta. The efflorescence of architecture in the forty cities in southeastern Sicily that were rebuilt after the earthquake of 1693 merits only a passing mention. Work on Noto, Ragusa, Catania and the 'ideal plans' of Avola and Grammichele has enriched our knowledge of Sicilian baroque enormously over the past two decades. The convent complexes of south Italian cities are also becoming a focus of research, and indeed those of Rome as well. Through the study of female patrons of convents and benefactresses of religious orders a feminist viewpoint has begun to shape new research in the field. The much expanded Sicilian bibliography shows the richness of this new field.

There is one area on the periphery of Italy that Wittkower cannot be accused of neglecting: Piedmont. He was fascinated by the rich blossoming of architectural creativity in Turin and the countryside. As early as 1946, as soon as wartime restrictions were relaxed, he and his wife visited Turin and travelled around the Piedmontese countryside by bus, asking the driver to stop at tiny country chapels by the then unknown Vittone. These early explorations were recapitulated in a travelling seminar he gave in Piedmont in the summer of 1958, for which a detailed diary survives.

When Blunt asked Wittkower to lecture at the Courtauld Insitute in 1946 and Wittkower proposed as his topic the architecture of Vittone, Blunt thought he was surely joking and had made the name up. Aside from the sensitive pages in Brinckmann's books of the 1930s, Piedmontese baroque was uncharted territory. Wittkower saw it as the flower at the end of a long stem. He had a view of what we might call today 'the long Renaissance', a continuity of forms and theories that had not lost its creativity over 350 years. With Vittone the principles of the central churches of the early Renaissance, which Wittkower explored in his celebrated *Architectural Principles in the Age of Humanism* of 1949, had come full circle. It seemed entirely natural to Witkower that this breathtakingly imaginative architect should write cerebral treatises and dedicate them to God and the Virgin. He wondered if his lost writings on domes would ever turn up. Wittkower saw Vittone as the counterpart in architecture to Francesco Guardi, the genius in the backwater, the man who kept the ideals of Alberti and Leonardo alive almost on the eve of the French Revolution.

Looking back from forty years on, three questions immediately present themselves: how could one man write such a book? How has our approach to the subject changed in the intervening period? And how well does this text stand up from a modern point of view?

The first of these questions is one which may be less obvious to ordinary readers than to those who have attempted to up-date the bibliography. It is no secret that, even for this relatively mechanical task, the Yale University Press found it impossible to recruit a single person, eventually agreeing to divide it between two. Even so, they could not have completed it had not kind friends generously undertaken to sort out the literature on some of the artists (Caravaggio, the Carracci, and Tiepolo) on whom the bibliography has proliferated to an extent where only those with a long-standing familiarity with the subjects could be relied upon to reduce it to even the many column inches included here, while others pointed out mistakes that should be corrected in areas of their own specialised knowledge. Although

Wittkower must undoubtedly have consulted and discussed his work with colleagues, the book is manifestly the work of one hand, and in this lies it great virtue.

If the ability to read and master so much bibliographical and visual material, and the clarity of mind to organise it into a coherent and systematic whole, were apparent in many of his other publications, even from the Michelangelo bibliography of the 1920s, it would still be appropriate to say something about the language of this book – and English, it should be remembered, was not his mother-tongue. Like his lecturing style, it is not brilliant, nor even captivating; but it is clear, precise, and concise. While it is easy to read, it should none the less be read with care, for behind a brief remark often lies an indication of more profound thought and judgement, which the less observant reader may miss, but which, if attended to, may open fuller vistas which the author could not explore within the limited space at his disposal. Perhaps, even here, one could see the effect of his training in the 1920s, writing those brief Thieme-Becker entries.

Mountain-stream limpidity was the goal, and the strategy was to stimulate and suggest ideas rather than overwhelm the reader with the voice of authority. Sometimes, especially in the fast-forward chapters, there is so much information packed into the text that it begins to resemble a prized carpet holding its complex patterns in hundreds of knots per square inch. But then unexpectedly the text will light up with a matchless phrase. Students who have grown up with the book will not easily forget the sentences that describe, for example, Caravaggio's 'unapproachable magic light'; or the curvature of Cortona's SS. Martina e Luca façade, which 'appears to be the result of a permanently active squeeze'; or the spaces of Longhena's S. Maria della Salute, where 'the eye is not given a chance to wander off and make conquests of its own'; or Borromini's Propaganda Fide façade, where 'the impression of mass and weight has grown immensely; the windows now seem to dig themselves into the depth of the wall'. It was not only the erudition of the book, but its humanity and its sense of drama, that raised it to the rank of classic and keep it there.

STUDIES IN THE BAROQUE SINCE 1958

Wittkower realized that he would have to set strict limits if he were to encompass a vast field in a single volume. So he systematically excluded everything but the three sister arts; the prominence he gave to architecture in addition to painting and sculture was already exceptional for a book of this kind. However, in the forty years since the book was written the boundaries of the field have been enlarged in many directions. The architecture of baroque churches has been illuminated through studies of liturgy, music and especially paraliturgical devotions such as the Forty Hours. The field of ephemeral architecture has blossomed with studies of festivals, fireworks, temporary palace façades, catafalques, canonization apparati, and the Chinea. The baroque landscape has finally begun to receive attention, from the villas of Lombardy and the Brenta to the great villa-parks outside of Rome. The bibliography has been enlarged to reflect this literature in these new subfields.

Recent research, abundant and confident, treats the art of the Counter Reformation popes with far more sympathy. It generally discards Wittkower's stylistic categories and concentrates on questions of iconography, liturgy, and theology. Propaganda has seemed a positive quality to a generation that enjoys explicating complex ideologies. Other issues now inform research on this period: the controversy over iconoclasm, Cardinal Baronius and the revival of early Christian art, the rediscovery of the catacombs and the cult of the martyrs, the veneration accorded to icons and relics with milennial histories, the reshaping of *Roma sancta* into a city of pilgrimage – all of these themes have been illuminated by recent work in the field, which we have listed under the patronage of individual popes.

The study of patronage and collecting was brought to the forefront of attention by Francis Haskell's innovative study of 1963. Wittkower thought of Haskell's book as the ideal companion to his Pelican. Patronage has dominated recent research on all aspects of the field, and has fitted well with the almost fanatic search for archival documents that characterizes the work of many younger scholars. On the level of the popes, though the relevant volumes of Pastor will always remain a fund of information, the apologetic tone has been replaced in recent work by an emphasis on career patterns and the strategic rise of new families into the clerical elite. The new emphasis is perhaps most visible in the study of the baroque palace. In the original book palaces were primarily regarded as embodiments of style. Now they and the fresco cycles in them are more likely to be seen in terms of the cultural production of a society that raised nepotism to an art form. The glimmers of a new dawn of palace studies were to be found as far back as Elling's innovative book of 1956. The new palaceology, an active field with close links to the study of palaces in England, Spain and France, stresses the function of spaces and the rituals of aristocratic life.

Haskell opened up the study of a figure who only appears in passing in Wittkower's Pelican, Cassiano dal Pozzo, antiquarian, ornithologist, collector, patron of Poussin, and founder of a famous 'paper museum' that was meant to encompass an enormous range of antique objects and natural specimens. The literature on Cassiano and his world has burgeoned with the publication of the acts of several conferences, the catalogues of two exhibitions, and an ongoing project to publish the remnants of the *museo cartaceo* now preserved at Windsor and elsewhere. The study of other 'gabinetti di curiosità' and in particular of collections of natural wonders has blossomed in the past decade and has allowed us to add a section on 'Museum Culture' to the bibliography.

There are some perceptive remarks in Wittkower on the organization of sculptors' workshops, but in general his cannot be said to be a very sociological book. But it has been possible to add to the bibliography recent works in what Jennifer Montagu calls the 'industry of art', not least Wittkower's own Slade Lectures on the techniques of sculpture (*Sculpture: Processes and Principles*, London, 1977). The study of the career patterns for artists, of artists' houses and collections, and of knighthood for artists has just begun. This represents a shift away from the dominant trends of the time this book was written, which were weighted heavily in the direction of psychology.

The most striking development since 1958 has been in the almost terrifying multiplication of the material, though that is not a change, for it was already a problem in 1958, which had become worse by the time of the second edition six years later, and had become almost overwhelming by 1971; only a few additions were made to the edition of 1980, and it is hardly necessary to say that in the past years the flow of new material has not abated. Not only have new names been discovered and presented, but minor figures have been the subjects of extensive articles, monographs, and exhibitions. Local periodicals have sprung up, resurrecting long-forgotten artists from the remoter regions. In recent years it seems that scarcely a village in Italy has not put on an exhibition of its local hero, most often of the seventeenth or early eighteenth century, and often complemented by the published acts of a conference; some artists so honoured do not even figure in Wittkower's notes. At the same time, archival researches have greatly increased our knowledge over the whole range of talent, providing everything from secure dating to changes in attribution which, in a few cases, have led to the revelation of new aspects of an artistic personality.

One characteristic of recent bibliography on the Italian baroque has been this proliferation of exhibitions on single artists. Obviously, there are political and economic reasons for this, but it is also regrettable that often the most recent and reliable study of an artist should be a catalogue: inevitably, this will concentrate on the works available for loan, often making it hard to find information about equally, or more significant works not included in the exhibition. At the same time, while the fashion for numerous introductory essays makes the catalogue useless for visitors to the exhibition itself, they form an unsatisfactory picture of the artist, sometimes overlapping, and inevitably leaving gaps in the subject, and failing to deal with aspects of the artist and his work that would be provided in a traditional monograph. Similarly, conferences produce a series of articles, dealing with individual problems, and do not make up the full study that many artists still require.

Another type of publication which has multiplied in recent years is the repertory. This can be extremely useful in providing a range of illustrations of artists' works, though it has to be said that all too often this is vitiated by an over-reliance of works in private collections or on the market, sometimes of dubious authenticity, and incapable of being checked, when a collection of securely authenticated works would have presented a more reliable and useful guide to the artist's style and personality. Even the best of these, however, being ordered in alphabetical sequence according to the artists' names, can serve only as a convenient substitute for the Witt or Conway Libraries, placing an ever-expanding range of reproductions within easy reach of the student; but they are not a substitute for a chronological history.

WITTKOWER'S TEXT TODAY

How well has Wittkower's volume stood up to this vast increase in our knowledge of the period during the past forty years? It has, undeniably, remained a standard book for the teaching of art history, if (it might be crudely said) for no better reason than that there is no other work which covers this ground.

We have put this question to several colleagues, and the most frequent criticism is that it is unbalanced, that is to say that it provides too little coverage of whatever is the particular interest of the respondent. Possibly those making such a criticism (and, to be fair, this was usually in the context of its use as a tool in teaching a more narrowly focused course) have not read the excellent Foreword that Wittkower wrote to the first edition. In any case, bearing in mind that it was already the largest book in the series, one has to ask what should go out to make room for this expansion, and here no answer is forthcoming. Even forgetting Wittkower's clearly expressed reasons for this selectivity, reading the book from cover to cover (as, of course, we have had to do several times), and not just dipping into it to find what it has to say on a particular artist, or school, the most striking quality is precisely its balance. Coming to Wittkower's book after having seen a splendid exhibition, or reading an exciting article on some hitherto obscure artist, it is salutary to be reminded that, when all is said and done, one has to agree with Wittkower that Annibale Carracci, Bernini, Borromini, Pietro da Cortona (as an architect and decorator) and Tiepolo are still the major figures, in the true etymological sense of the word.

Another criticism was that it overlooks the contribution of foreign artists working in Italy. Obviously, the conception of the Pelican series meant that these would be dealt with in other volumes; even Poussin, who spent almost the whole of his working life in Rome, is, inevitably, the hero of the volume on France. Nonetheless, looking at the index, it is rather astonishing to see the number of references to Poussin, Rubens, Van Dyck, Puget and Vouet; even Charles Mellin gets two mentions. If the influence of these foreign painters, particularly on the Roman school, would have been clarified by a fuller discussion, and if sculpture in late seicento Genoa would have been easier to understand had Puget's work been illustrated, either would have been outside the scope of the volume, but the careful reader of both text and notes is made aware of their importance. One might add that the engravings made of Vouet's later work in France had an enormous influence, and were copied not only in the decorative arts but also in paintings; yet to deal fully with this, and other outside influences would have enlarged the book beyond any reasonable bounds.

It is, however, undeniable that the eighteenth century becomes a rather desperate scramble through a welter of names, and here one is aware that recent scholarship (which for the seventeenth century has expanded and refined, but not substantially changed our vision) has begun to clarify and radically alter the way we see and write about the eighteenth century, even if there is still much to be done. One senses that Wittkower is relatively unfamiliar with the material, particularly the painting and sculpture, and is therefore unable to form it into such a clearly structured and coherent pattern as he did for the previous century. In part this was due to the focus of his own interests, but it was also due to the poverty of information available at the time. Today's reader of the third part of this work may be surprised to read that 'the names of Filippo Raguzzini, Gabriele Valvassori,

Ferdinando Sanfelice, and Bernardo Vittone...convey little even to the student of Italian architecture', forgetting how much our present knowledge of such architects owes to Wittkower's own researches, or the studies he encouraged others to undertake. Yet even now, when many more articles have appeared, and books on many of the artists, it is still not easy to get a grasp on the whole panorama of eighteenth-century Italy.

It is in this part of the book, too, that one becomes acutely aware of what now seems a very old-fashioned and over-simplified way of placing each artist on the scale from Baroque to Classic. However, it is equally evident that this over-schematic approach enables the author to impose some order on this mass of material, so much of which will be unfamiliar to all but the most specialised reader. Again, in his discussion of eighteenth-century sculpture, one is aware of how often he refers to the enduring example of Bernini, an influence so ubiquitous that it hardly requires to be reiterated, while more acknowledgment might have been made of other influences from the previous century (Algardi, Duquesnoy, and Cortona/Ferri); however, if this leads on occasions to underestimating the individual contributions and personal characteristics of the later sculptors, this reference back to more familiar material undoubtedly helps the reader to keep his bearings.

THE NEW EDITION

It is remarkable that, while we might frequently have wanted to argue with his judgements on individual artists, or at times whole schools – whether from our own individual prejudices, or because new studies have led to a generally accepted revaluation – we have found only one case of a genuine and substantial mistake, where he bases his analysis of Cortona's late style on a painting now known to have been painted some twenty-four years earlier. Of course, this is not to say that there are not innumerable cases of what are now known to be wrong dates, or, on a few occasions, changed, or at least disputed attributions. Undoubtedly, had Wittkower survived to produce this new edition, he would have corrected such changes in dates, something to which we have drawn attention only where they led him to unsustainable conclusions (and, it should be said, where, with our less extensive knowledge, we are aware of them), and new names would be added, at least to the notes. Possibly he might have included some reference in the notes to areas of interest that have expanded since the original edition, and to new discoveries made.

We are very conscious that we have been entrusted with another man's book, and one that has justly acquired a canonical status, in great part precisely because of the lasting validity of the general 'bird's-eye view...of the whole panorama' which he gave, and that balance which he so brilliantly, and self-denyingly, struck, reserving 'a detailed discussion for those works of art and architecture which, owing to their intrinsic merit and historical importance, appear to be in a special class'. It is not our right to tamper with these achievements, nor would we have wished to do so. We have taken account of one new area of interest by including in the bibliography a section on Patronage, and included a little

more on the ephemeral art of festivals (in the General sections), but not, specifically, theatre, and, following his example, we have not expanded into the area of garden studies, nor that of the decorative arts. We have recognised the growth of interest in previously neglected regions of Italy, at least to the extent of including a section on Umbria and the Marches. The exclusion from the Artists section of some names of those on whom little significant work has been done in recent years, and the inclusion of others, will give some idea of shifts of scholarly interest; however, we have not included there any artist not mentioned in the text. This had led to some painful exclusions of excellent books on minor figures, or important new discoveries, for it was not our task to produce a bibliography of Italian baroque art, and in most such cases an attentive reading of the more recent general books on the area concerned will lead the student of the subject to the material we have omitted.

Constant re-reading of the text, and the encouragement of those who have expressed enthusiasm for a new edition, have intensified our own admiration for what is indeed not just a text-book, but a remarkable work of scholarship. It formed our own vision of the subject, as it did that of subsequent generations. It is from a profound belief that this vision still remains essentially valid, and that this wisely conceived and well-written text will continue to inform and inspire new generations, that we have attempted to produce an up-dated bibliography, one that we hope remains true to the spirit of the original, while introducing the new scholarship that will enable the user to carry his or her research further. In doing so, we have had to call on the assistance of a number of generous friends, and should like here to record our thanks to those without whose kind help the task would have been impossible: Andrea Bacchi, Miles Chappell, Donald Garstang, John Gash, Steven Ostrow, Giovanna Perini, Catherine Puglisi, Louise Rice, Mary Newcome Schleier, John T. Spike, Catherine Whistler, and John Pinto for myriad suggestions in architecture.

SOURCES

Sedlmayr, Hans. 'Geschichte und Kunstgeschichte', *Mitteilungen des Oesterreichischen Instituts für Geschichtsforschung*, L (1936), 185–99.

Schapiro, Meyer. 'The New Viennese School' (review of Otto Pächt, ed. *Kunstwissenschaftliche Forschungen*, II, Berlin, 1933), *Art Bulletin*, 36 (1936), 258–66.

Hibbard, Howard. Obituary, *Burlington Magazine*, CXIV (1972), 173–7; republished in *The Writings of Rudolf Wittkower: A Bibliography*, ed. Donald M. Reynolds, Rome, 1989.

Newhouse, Victoria. 'Margot Wittkower: Design Education and Practice, Berlin–London, 1919-1939', *Journal of Design History*, III (1990), 83–101.

Partnership and Discovery: Margot and Rudolf Wittkower, Margot Wittkower interviewed by Teresa Barnett, Art History Oral Documentation Project, complied under the auspices of the Getty Center for the History of Art and the Humanities, 1994.

Rosand, David. Obituary, *Proceedings of the British Academy*, XC, 1996, 556–70.

Romano, Giovanni. *Storie dell'arte: Toesca, Longhi, Wittkower, Previtali*, Rome, 1998, 62–92.

Principles Followed in the New Edition

TEXT: Unchanged, except for some dates of artists for which new secure documents have emerged; these have been incorporated where we are aware of them, but no serious attempt has been made to check those given in the previous edition. These changes have not been noted, except where they invalidate a statement in the text, in which case a starred note is provided. Dates of works of art have not been similarly changed; however, where newly-found documentation (concerning dates, or other facts) makes the text seriously misleading, this has been indicated with a starred note. Such notes have been kept to the minimum. Cross-references to other volumes are cited in the form (II: Chapter 4, Note 27).

NOTES: Unchanged, except for artists' dates (as for the text); a few starred notes correct the more misleading errors. Some references, now omitted from the Bibliography, have been expanded. The bibliography in the Notes is now badly out of date: for artists given individual bibliographies these should be consulted; more recent information on most of the others can be found through the general books listed either under the relevant art, or the relevant region. The same applies to the works.

BIBLIOGRAPHY: The bibliography for all three parts starts on p. 123 of volume III. Wittkower felt that his bibliography was already long enough; we have therefore tried to limit the inevitable extension by eliminating many works cited in earlier editions, even though these may be important for historiography. This applies particularly to articles dealing with a limited aspect of an artist, or a few works, where these have been adequately covered by a later monograph. This decision was the more easily taken in the realisation that almost everything that has been deleted from the bibliography is still cited in the Notes; it is the more easy to justify where there is a good modern work with a full bibliography, but it has been somewhat relaxed where more recent literature may be hard to find. Frequent references are made to reviews; almost invariably, these are critical, because these are the ones that add significant new material, or point out short-comings that the reader should be warned about; in many cases this is unfair, and the same book may have been well received by some, or even most other reviewers. However, some books do deserve harsh judgement, while meriting inclusion in the bibliography for their illustrations, or simply because they are the only studies available. It should be noted that, perhaps inadvisably, we have omitted theses published from microfilm. (1) Arts: Wittkower's text very rarely mentions prints or drawings; we have added nothing on prints, and even on drawings (where there have been innumerable publications) we have tried to select the more important and reliable, such as the major museum catalogues covering this period, and the most important exhibition catalogues. The same principle has been applied to

the Regions. Museum catalogues of paintings have not been included – with one exception. (2) Artists: The principles upon which Wittkower distinguished between those artists for whom summary bibliographies were provided only in the Notes, and those listed in the Bibliography, are not clear. In the case of artists of some importance, on whom a good monograph now exists, we have decided to add them. On the other hand, a number of relatively minor figures formerly included in the Bibliography (and some not so minor) can best be studied either through the general books, or from the *Dizionario biografico degli italiani* or the *Dictionary of Art* (published by Macmillan), and they have been omitted. Artists mentioned by Wittkower only in the notes, or omitted altogether, have not been included, even where there is a good modern monograph (with one exception). Because of the abundance of new publications, it has not been possible to list articles with the generosity of previous editions. Where there is a recent monograph, articles are listed only if they add substantial new information (not, for example, those that only publish one or two new works), or if they provide important factual information on works dealt with at some length in the text; however, sometimes a recent article is cited, where it points to earlier bibliography. Where there is no good monograph, a selection of the more important articles is given. As Wittkower said very little about drawings, books or exhibitions of drawings by artists whose drawings are not discussed in the text have only very seldom been included. However, for some artists catalogues of their drawings constitute virtual monographs, and these have been cited. For many Genoese and Neapolitan artists, while there are numerous articles dealing with individual aspects or a few works, more useful references can be found through the general works on those cities. For other centres some general books, e.g. *I pittori bergamaschi*, contain what are in effect brief monographs, and references have been given also under the individual artists.

ILLUSTRATIONS: One hundred illustrations have been added to this edition. The first priority was to illustrate those works which Wittkower describes, or specifically comments upon, so that the reader can better follow the text, The second priority was to give a better indication of the work of some of the major artists who had been rather inadequately represented, and, finally, an attempt has been made to flesh out the personalities of some of those artists dismissed in a brief sentence or two in the text. In the captions to these new illustrations account has been taken of new locations, which occasionally differ from those given in the text, and also changes in the dating confirmed by newly published documents, or authorised by more recent studies; captions to the original illustrations have not been changed. References to illustrations in other volumes are given in the form [II: 23] to indicate plate 23 of volume II.

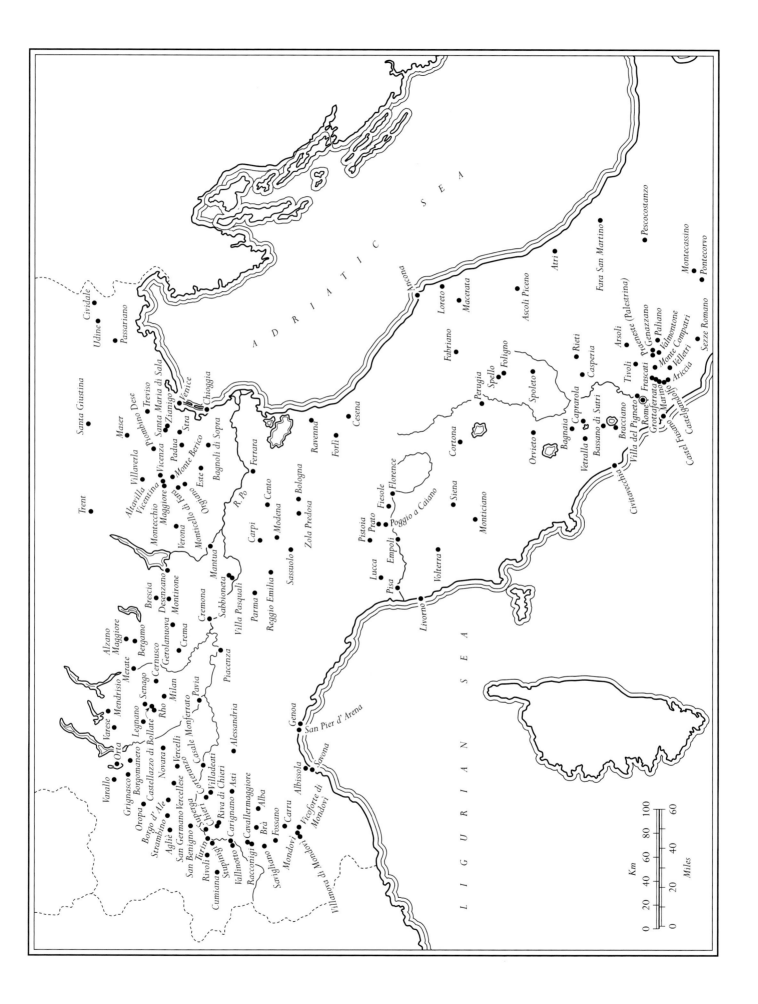

ADRIATIC SEA

LIGURIAN SEA

Cividale
Udine
Passariano
Santa Giustina
Trent
Maser
Villaverla
Altavilla Vicentina
Montecchio
Maggiore
Piombino Dese
Treviso
Santa Maria di Sala
Zianigo
Stra
Venice
Chioggia
Padua
Vicenza
Monte Berico
Verona di Pra
Monticello di
Ognano Este
Bagnoli di Sopra
Ferrara
R. Po
Cento
Modena
Bologna
Zola Predosa
Carpi
Mantua
Sabbioneta
Villa Pasquali
Parma
Reggio Emilia
Sassuolo
Cremona
Brescia
Desenzano
Montirone
Gerolanuova
Crema
Piacenza
Alzano
Maggiore
Bergamo
Cernusco
Mendrisio
Merate
Senago
Legnano
Rho
Milan
Pavia
Casale Monferrato
Alessandria
Varese
Orta
Varallo
Oropa
Grignasco
Borgomanero
Castellazzo di Bollate
Novara
Vercelli
San Germano Vercellese
Cortereale
Monferrato
Willadeati
Strambino
Agliè
Superga
Turin
Chieri
Carignano
Asti
Riva di Chieri
Cavallermaggiore
Alba
Brà
Fossano
Carru
Savigliano
Racconigi
Vallinotto
Stupinigi
Cumiana
Rivoli
San Benigno
Borgo d'Ale
Villanova di Mondovì
Vicoforte di
Mondovì
Mondovì
Albisola
Savona
San Pier d'Arena
Genoa

Ancona
Loreto
Macerata
Ascoli Piceno
Atri
Fara San Martino
Pescocostanzo
Montecassino
Pontecorvo
Sezze Romano
Arsoli
Praeneste (Palestrina)
Genazzano
Paliano
Valmontone
Monte Compatri
Velletri
Ariccia
Castelgandolfo
Casal Fusano
Tivoli
Villa del Pigneto
Frascati
Grottaferrata
Marino
Rome
Rieti
Casperia
Bagnaia
Caparola
Vetralla
Bassano di Sutri
Bracciano
Civitavecchia
Fabriano
Foligno
Spello
Spoleto
Orvieto
Perugia
Cortona
Siena
Monticiano
Volterra
Livorno
Pisa
Lucca
Empoli
Pistoia
Prato
Fiesole
Florence
Poggio a Caiano
Ravenna
Forlì
Cesena

Km
0 20 40 60 80 100
Miles
0 20 40 60

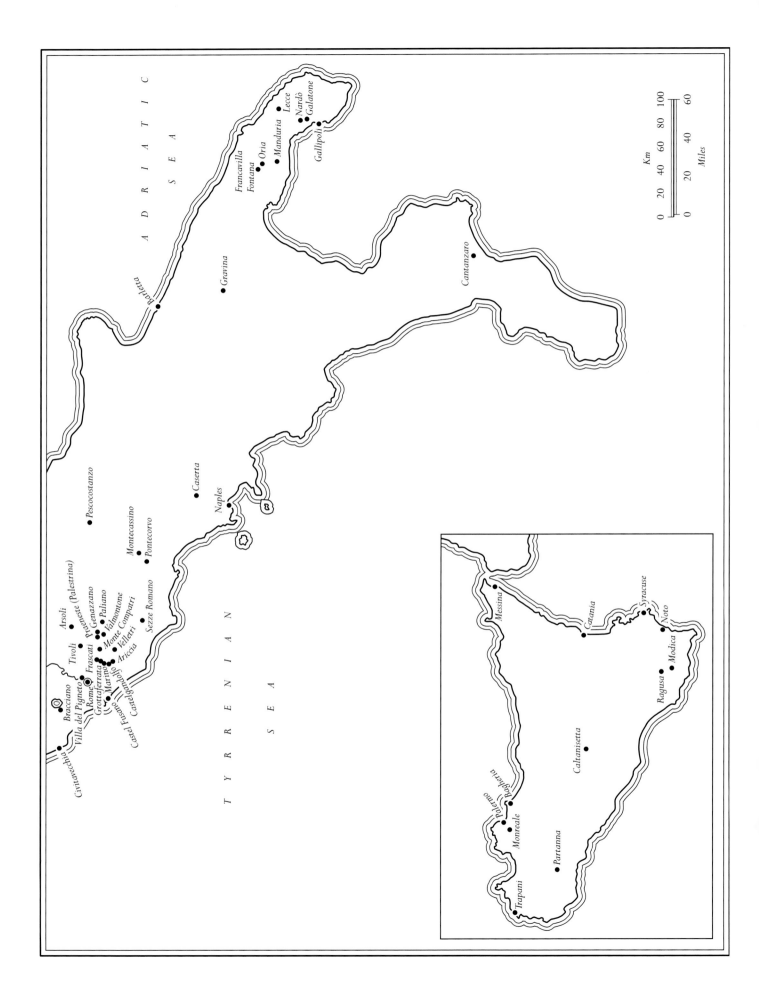

Rome: Sixtus V to Paul V (1585–1621)

With the Sack of Rome in 1527 an optimistic, intellectually immensely alert epoch came to an end. For the next two generations the climate in Rome was austere, anti-humanist, anti-worldly, and even anti-artistic. The work of reform of the Church, begun at the Lateran Council in 1512 on Julius II's initiative, was seriously taken in hand and carried out with grim determination. During Pius IV's pontificate (1559–65) the Venetian envoy reported from Rome: 'Life at Court is mean, partly through poverty, but also owing to the good example of Cardinal Borromeo. . . . They [the clergy] have altogether withdrawn from every sort of pleasures. . . . This state of things has been the ruin of artisans and merchants. . . .' But the practice of art was far from being extinct: it was turned into an important weapon to further Catholic orthodoxy.

The Council of Trent and the Arts

At its last session in December 1563 the Council of Trent, which had accomplished the work of reform over a period of almost twenty years, pertinently defined the role assigned to the arts in the reformed community. Religious imagery was admitted and welcomed as a support to religious teaching. One passage of the decree demands that 'by means of the stories of the mysteries of our Redemption portrayed by paintings or other representations, the people be instructed and confirmed in the habit of remembering, and continually revolving in mind the articles of faith'. Consequently strictest discipline and correctness in the rendering of the holy stories were required, and the clergy was made responsible for the surveillance of the artists. The terse deliberations of the Council were soon enlarged upon by a veritable flood of literature, produced by churchmen and reformers rather than by practising artists.

Leaving all details aside, the recommendations of such writers as St Charles Borromeo, Cardinal Gabriele Paleotti, the Fleming Molanus, Gilio da Fabriano, Raffaello Borghini, Romano Alberti, Gregorio Comanini, and Possevino may be summarized under three headings: (i) clarity, simplicity, and intelligibility, (ii) realistic interpretation, and (iii) emotional stimulus to piety. The first of these points is self-explanatory. The second has a dual aspect. Many stories of Christ and the saints deal with martyrdom, brutality, and horror and, in contrast to Renaissance idealization, an unveiled display of truth was now deemed essential; even Christ must be shown 'afflicted, bleeding, spat upon, with his skin torn, wounded, deformed, pale and unsightly',[1] if the subject requires it. Truth, moreover, called for accuracy down to the minutest detail. On this level, the new realism almost becomes synonymous with the old Renaissance concept of decorum, which requires appropriateness of age, sex, type, expression, gesture, and dress to the character of the figure represented. The relevant literature abounds in precise directives. It is these 'correct' images that are meant to appeal to the emotions of the faithful and support or even transcend the spoken word.

And yet, in the decrees of the Council and in the expositions by its severe partisans, there is almost an iconoclastic streak. In no uncertain terms did the Council proscribe the worship of images: in the words of the decree 'the honour shown to them refers to the prototypes which those images represent'.[2] But it is easier to postulate the difference between idol and image than to control the reaction of the masses. We therefore find men like St Philip Neri warning his penitents not to fix their eyes too intently on images, and St John of the Cross advocating that the devout man needs few images and that churches, where the senses are least likely to be entertained, are most suitable for intense prayer.

It has long been a matter of discussion among art historians to what extent the art of the later sixteenth century expressed the exigencies of the reformed Catholic Church.[3] In one respect the answer is not difficult to give; artists of religious imagery had to comply with some of the obvious demands of counter-reformatory decorum, such as the avoidance of nude figures. In another respect the answer is more baffling. The Church was vociferous in laying down the rules, but how to sublimate them into an artistic language of expressive power – that secret could be solved only by the artists. This granted, are we at all capable to judge whether, where, and when the artists caught up with the spirit of the Council? Since apodictic statements in an area pertaining to individual sensibility are doomed to failure, our conclusions have relative rather than absolute value. After this proviso, it may be said that, with the exception of the Venetians and a few great individualists like the aged Michelangelo, most of the artists working roughly between 1550 and 1590 practised a formalistic, anti-classical, and anti-naturalistic style, a style of stereotyped formulas, for which the Italians coined the word *maniera*[4] and which we now call 'Mannerism' without attaching a derogatory meaning to the term. Virtuosity of execution and highly decorative surface qualities go with compositional decentralization and spatial and colouristic complexities; in addition, it is not uncommon that deliberate physical and psychic ambiguities puzzle the beholder. Finally, the intricacies of handling are often matched by the intricacies of content. Many pictures and fresco cycles of the period are obscure and esoteric, possibly not in spite of but because of the close collaboration between painter and priest. One is inclined to believe that this art, which not rarely reveals a hardly veiled licentiousness under the guise of prudery, was suited to please the refined Italian society, then following the dictates of Spanish

etiquette, but it had hardly the power to stir religious emotions in the mass of the faithful. To be sure, Mannerism as it was practised during the later sixteenth century was not an answer to the artistic requirements of the counter-reformatory Church: it lacked clarity, realism, and emotional intensity.

It is only from about 1580 onwards, or roughly twenty years after the promulgation of the Council decrees, that we begin to discern a counter-reformatory art on a broad basis. So much may be said at present: the new art has not a clear-cut unified physiognomy. Either the realistic or the emotional component may be stressed; as a rule, clarity supersedes complexity and often, though by no means always, deliberate formal austerity provides the answer to the severe 'iconoclastic' tendencies which we have mentioned. Meanwhile, however, the Counter-Reformation moved towards a new phase. Before discussing in some detail the pattern of artistic trends in Rome, certain aspects of the historical setting must be sketched.

The Church and the Reformers

The period from Sixtus V (1585–90) to Paul V (1605–21) has a number of features in common which single it out from the periods before and after. Spanish influence, which Italy had nurtured in all spheres of life during the sixteenth century, began to decline. Paul IV's war against Spain (1556–7), though a disastrous failure, was a first pointer to things to come. Sixtus V renewed the resistance against Spanish predominance. Clement VIII (1592–1605) reconciled Henry IV of France to the Holy See, and from then on dates the ascendancy of France at the expense of Spain. This change is symptomatic. The rigours of the reform movement were over. Never again was there a pope so austere, so ascetic and uncompromising as Paul IV (1555–9), so humble and saintly as Pius V (1566–72). From the 1570s and 80s on Protestantism was on the defensive; Catholic stabilization and restoration began and in the following decades all of Poland, Austria, southern Germany, France, and parts of Switzerland consolidated their Catholic position or even returned to the old Faith. The deep sense of danger which pervaded the Church during the critical years had passed, and with this returned an easier deportment and a determination to enjoy life such as had not existed in Rome since the days of the Renaissance. Moreover, progressive religious movements, born in the days of the Council of Trent but not always looked upon with approval by the reactionary faction of the reformers, were now firmly established. Protected and encouraged by papal authority, they developed into the most effective agencies of the Catholic Restoration.

The most important movements, St Philip Neri's Oratory and St Ignatius of Loyola's Society of Jesus, two seemingly opposed off-shoots of neo-Catholicism, have yet much in common. Philip's Oratory grew out of informal meetings of laymen who preached and discoursed spontaneously, following only their inner voices. A cheerful but deeply devotional spirit prevailed among Philip's disciples, a spirit that reminded the learned Cardinal Baronius of early Christianity. It is clear that such an unorthodox approach to religion aroused awe and suspicion. But in 1575 Gregory XIII

formally recognized the Oratory and in the same year its seat was transferred to the church of S. Maria in Vallicella. After that the Oratory soon became fashionable, and a pope like Clement VIII was very close to it. Although the rules were written in 1583 and a definite constitution, solemnly approved by Paul V, was drawn up in 1612, the democratic spirit of the original foundation was preserved. Philip's apostolate, as Ludwig von Pastor says, extended down from the pope to the smallest urchin in the streets. The Congregation remained a group of secular priests tied together by voluntary obedience and charity. Philip died in May 1595. It is characteristic of the universal reverence in which he was held that the process of canonization began as early as two months after his death.[5]

By contrast to the Oratory, the Society of Jesus was monarchical and aristocratic in its constitution, pervaded by a spirit of military discipline, bound by strict vows, and militant in its missionary zeal. But, like the Oratory, the Society was designed to serve the common people; like the Oratorians, the Jesuits were freed from the bonds of monastic observance and replaced the traditional withdrawal behind the walls of the monastery by an active participation in the affairs of the world. Notwithstanding their determined opposition to the new scientific age that was dawning, their intellectualism, casuistry, and interest in education were as typical of the new spirit as their approach to the doctrine of Grace and the guide to devotion laid down by Ignatius himself in the *Spiritual Exercises*. The Dominicans were upholders of Thomism, which had seen such a powerful revival in the days of the Council of Trent, and championed the Pauline-Augustinian-Thomistic position, that Grace descended on man irrespective of human participation. The Jesuits, by contrast, taught that human collaboration was essential to render Grace efficacious. This point of view was advocated with great learning by the Spanish Jesuit Luis de Molina in his *Concord of Free Will with the Gifts of Grace*, published in 1588, and resulted in a long-drawn-out struggle with the Dominicans which ended only in 1607, by order of Paul V himself. Although the Holy See reserved judgement and sided neither with Thomism nor Molinism, the suspense alone was like a battle won by the Jesuits: the more positive and optimistic Jesuit teaching, that man has an influence on the shaping of his destiny, was admitted and broke the power of medieval determinism.

Although inspired by the ascetic writings of the past, St Ignatius's *Spiritual Exercises* were equally new and progressive. Their novelty was twofold. First, the method of guiding the exercitant through a four-weeks' course is eminently practical and adaptable to each individual case. During this time the periods of contemplation are relatively brief and hardly interfere with normal duties. The cleansing of the soul does not prepare for, or take place in, cloistered seclusion; it prepares, on the contrary, for the active work as a soldier of the Church Militant. And secondly, all a man's faculties are employed to make the Exercises an extremely vivid personal experience. The senses are brought into play with almost scientific precision and help to achieve an eminently realistic awareness of the subjects suggested for meditation. The first week of the exercises is devoted to the contemplation of Sin, and St Ignatius requires the

exercitant to see the flames of Hell, to smell the sulphur and stench, to hear the shrieks of sufferers, to taste the bitterness of their tears and feel their remorse. During the last two weeks the soul lives with equal intensity through the Passion, Resurrection, and Ascension of Christ. The *Spiritual Exercises* were written early in St Ignatius's career and, after many revisions, were approved by Paul III in 1548. Although large numbers of the clergy practised the Exercises at an early date, they became most effective in the course of the seventeenth century, after the publication in final form in 1599 of the Directory *(Directorium in Exercitia)*, drawn up by Ignatius as a guide to the Exercises.

The list of distinguished seventeenth-century artists who were Jesuits is longer than is generally realized.[6] Even among the others there were probably not a few who felt drawn towards Jesuit teaching. Bernini's close relations with the Jesuits are well known, and it has been noticed that there is a connexion between the directness of Loyola's spiritual recommendations, their tangibility and realism, and the art of Bernini and his generation.[7] At an earlier date the same observation can be made with regard to Caravaggio's art.[8] But there is no common ground between the spirit of the Exercises and the broad current of Late Mannerism. Nor is it possible to talk of a 'Jesuit style',[9] as has often been done, or to construe a direct influence of the Jesuits on stylistic developments at any time during the seventeenth century.

Ignatius's practical and psychological approach to the mysteries of faith, so different from the abstract theological speculations of the Council discussions, was shared not only by men like St Philip Neri and St Charles Borromeo, but even by such true sixteenth-century mystics as St Teresa and St John of the Cross. Unlike the mystics of the Middle Ages, they controlled, ever watchful, the stages leading to ecstasy and supplied in their writings detailed analyses of the soul's ascent to God. It characterizes these counter-reformatory mystics that they knew how to blend the *vita activa* and *contemplativa*. No more practical wisdom and down-to-earth energy can be imagined than that shown by Teresa and John of the Cross in reforming the Carmelite Order.

Similarly, determination, firmness, and tenacity in translating into action the decrees of the Council guided St Charles Borromeo, the youthful Archbishop of Milan who was Pius IV's nephew. At the time of his death in 1584 (aged forty-six), he had, one is tempted to say, streamlined his large diocese, had modernized clerical education by founding his famous seminaries, and had prepared manuals for pupils, teachers, and artists. Charles Borromeo was a staunch supporter of both the Oratory and the Society of Jesus. He practised the *Spiritual Exercises* and leant heavily on Jesuit support in carrying through his reforms at Milan. It was he who formed the most important link between the papal court and the new popular movements, and who promoted the ascendancy of Jesuits and Oratorians. Both Philip and Ignatius had to struggle for recognition. In spite of the latter's fabulous success, external vicissitudes under the Theatine Pope Paul IV, the Dominican Pope Pius V, and the Franciscan Pope Sixtus V ended only when Gregory XIV confirmed St Ignatius's original constitutions in 1591; but the internal difficulties were not resolved until Paul V's reign (1606).

Ignatius died as early as 1556; Francis Xavier, the great Jesuit missionary, the 'Apostle of the Indies', had died four years before; Teresa passed away in 1582, Charles Borromeo in 1584, and Philip Neri in 1595. The processes leading to their beatification and canonization were conducted during the first two decades of the new century. The inquiry into St Charles's life began in 1604, and he was canonized in 1610. Ignatius was beatified in 1609 after a long process begun under Clement VIII. Teresa's process of beatification was concluded after ten years in 1614, Philip Neri's in 1615, and Francis Xavier's in 1619. After protracted discussions initiated under Paul V, the four great reformers, Ignatius, Teresa, Philip Neri, and Francis Xavier, were canonized during Gregory XV's brief pontificate, all on 22 May 1622.

This date, if any, is of symbolic significance. It marks the end of the 'period of transition' here under review. When these reformers joined the empyrean of saints, the struggles were past. It was a kind of authoritative acknowledgement that the regenerative forces inside Catholicism had saved the Church. This date may also be regarded as a watershed in matters of art. The period from Sixtus V to Paul V has none or little of the enthusiastic and extrovert qualities of the exuberant Baroque which came into its own in the 1620s and prevailed in Rome for about fifty years. Moreover, during the earlier period the old and the new often exist indiscriminately side by side. This is one of the important characteristics of these forty-odd years, and it must be said at once that the official art policy of the popes tended to support reactionary rather than progressive artists. The reverse is true from Urban VIII's reign onwards.

The 'Style Sixtus V' and its Transformation

Compared with the second and third quarters of the sixteenth century, its last decades saw an immense extension of artistic activity. The change came about during the brief pontificate of the energetic Sixtus V (1585–90). It is well known that he transformed Rome more radically than any single pope before him. The urban development which resulted from his initiative and drive reveals him as a man with a great vision. It has rightly been claimed that the creation of long straight avenues (e.g. 'Strada Felice', linking Piazza del Popolo with the Lateran), of star-shaped squares (Piazzas S. Maria Maggiore and del Popolo, before Valadier), and the erection of fountains and obelisks as focusing points for long vistas anticipate seventeenth-century town-planning ideas. In the historic perspective it appears of decisive importance that after more than half a century a pope regarded it as his sacred duty – for the whole enterprise was undertaken 'in majorem Dei et Ecclesiae gloriam' – to turn Rome into the most modern, most attractive, and most beautiful city of Christianity. To be sure, this was a new spirit; it was the spirit of the Catholic Restoration. But the artists at his disposal were often less than mediocre, and few of the works produced in those years can lay claim to distinction. After the Sack of Rome a proper Roman school had ceased to exist, and most of the artists working for Sixtus were either foreigners or took their cue from developments outside Rome. In spite of all these handicaps some-

thing like a 'style Sixtus V' developed, remaining in vogue throughout the pontificate of Clement VIII and even to a certain extent during that of Paul V.

This style may be characterized as an academic *ultima maniera*, a manner which is not anti-Mannerist and revolutionary in the sense of the new art of Caravaggio and the Carracci, but tends towards dissolving Mannerist complexities without abandoning Mannerist formalism. It is often blunt and pedestrian, on occasions even gaudy and vulgar, though not infrequently relieved by a note of refined classicism. This characterization applies equally to the three arts. It is patently obvious in architecture. Sixtus gave the rebuilding of Rome into the hands of his second-rate court architect, Domenico Fontana (1543–1607), although the much more dynamic Giacomo della Porta was available to him. Fontana's largest papal building, the Lateran Palace, is no more than a dry and monotonous recapitulation of the Palazzo Farnese, sapped of all strength. A similar academic petrifaction is evident in a façade like that of S. Girolamo degli Schiavoni (1588–9), which Sixtus commissioned from Martino Longhi the Elder. Without altogether excluding Mannerist superimpositions of motifs, this architecture is flat, thin, and timid. It is against such a background that Carlo Maderno's revolutionary achievement in the façade of S. Susanna (1603) [51] must be assessed. It is true that Clement VIII favoured Giacomo della Porta and that after the latter's death in 1602 Carlo Maderno stepped into his position as architect of St Peter's. But it is also true that the architect after Paul V's own heart was Flaminio Ponzio (1559/60–1613),[10] who perpetuated until his death a noble version of the academic Mannerism of the 1580s and 90s. And it is equally true that the Cavaliere d'Arpino, whose feeble classicism is the exact counterpart in painting of Longhi's and Ponzio's buildings, was in almost unchallenged command during the 1590s[11] and maintained a position of authority throughout Paul V's pontificate.

The frescoes of the Vatican Library (which Domenico Fontana had built), the papal chapel erected by Fontana in S. Maria Maggiore, and the frescoes in the transept of S. Giovanni in Laterano exemplify well the prosaic nature and vulgarity of official taste under Sixtus V and Clement VIII. Although varying somewhat in style and quality, the painters engaged on such and other official tasks – Antonio Viviani, Andrea Lilli, Ventura Salimbeni, Paris Nogari, Giovan Battista Ricci, Giovanni Guerra, Arrigo Fiamingo (Hendrick van den Broeck), and Cesare Nebbia – fulfilled at least one requirement of the Council decrees, namely that of clarity. At the same time, mainly two Flemings, Egidio della Riviera (Gillis van den Vliete) and Nicolò Pippi of Arras (Mostaert), and the Lombard Valsoldo (Giovan Antonio Paracca), were responsible for the flabby statues and narrative reliefs in Sixtus V's multicoloured chapel. The two former died in the early years of the seventeenth century, while Valsoldo lived long enough to work again on the decoration of Paul V's chapel, the counterpart to that of Sixtus V. This 'pragmatic' style fulfilled its purpose and gratified the patrons, even when it sank down to the level of pure propaganda. The example that comes to mind is the many frightful scenes of martyrdoms in S. Stefano Rotondo, which invariably have a nauseating effect on the modern beholder.

But Nicolò Circignani (called Pomarancio, 1516–96), who painted them, was the artist favoured by the Jesuits;[12] the church belonged to the German novices of the Order. It was just the unrelieved horror of these representations that was to inflame missionary zeal. In the words of Cardinal Paleotti: 'The Church wants, in this way, both to glorify the courage of the martyrs and to set on fire the souls of her sons.'[13] Nor can it be denied that such paintings hardly evoke aesthetic satisfaction.

If a bird's-eye view of the whole period from Sixtus V to the end of Paul V's reign shows some intrinsic common qualities, a closer inquiry reveals the existence of a variety of trends. In addition, there is a slow but continuous shift even of official art policy away from Sixtus V's philistine counter-reformatory art towards a fuller, more vigorous, more poetical, and also more emotional manner.

Before the end of the century four principal tendencies may be differentiated in Rome itself, each having its roots far back and each having much wider, all-Italian implications. There was first the facile, decorative manner of the arch-Mannerist Federico Zuccari (1542/3–1609), who combined in his art elements from the latest Raphael and from Tuscan and Flemish Mannerism with impressions which had come to him from Veronese and the Venetians. He was the truly international artist of the *fin de siècle*, constantly travelling from court to court, Olympian in demeanour, prone to esoteric intellectual speculations, superficial and quick in his production. Although he had no official commissions in Rome after 1589 and was indeed absent from the city most of the time after that year, his influence was yet great on the painters working for Sixtus V and Clement VIII.

A second trend was that of the Florentines, who had a considerable share in mid-sixteenth-century fresco-painting in Rome. Their complex Mannerism, tied to the old Florentine emphasis on rhythmic design, followed the general development and gave way towards the end of the century to a more simplified and solid academic manner, which is mainly represented by Bernardino Poccetti. Artists such as Passignano and Ciampelli transplanted this Florentine manner to Rome, not without blending it with Venetian colourism and Zuccari's *maniera facile*. For the third trend, there was Girolamo Muziano, who came into prominence under Sixtus V's predecessor, Gregory XIII. Coming from Brescia and steeped in the traditions of Venetian painting, he never fell wholly for the *maniera* then in vogue. It was really he who introduced into Rome a sense for Venetian colour and a taste for rich landscape settings. This was taken up and developed by Flemings, mainly Paul Brill (1554–1626), whose 'picturesque' northern *vedute* were admitted even in churches and on the walls of the Vatican Palace in the reign of Paul V.[14] A good deal of Muziano's chromatic approach to painting was assimilated in Rome. Artists like his pupil Cesare Nebbia (*c.* 1536–1614), one of the busiest and most slapdash practitioners of the period, showed how to reconcile it with Federico Zuccari's academic Mannerism. Finally, Federico Barocci's Correggiesque emotionalism must be mentioned, although he was working in Urbino. His pictures reached Rome at an early date, but his influence spread even more through the many artists who came under his spell.

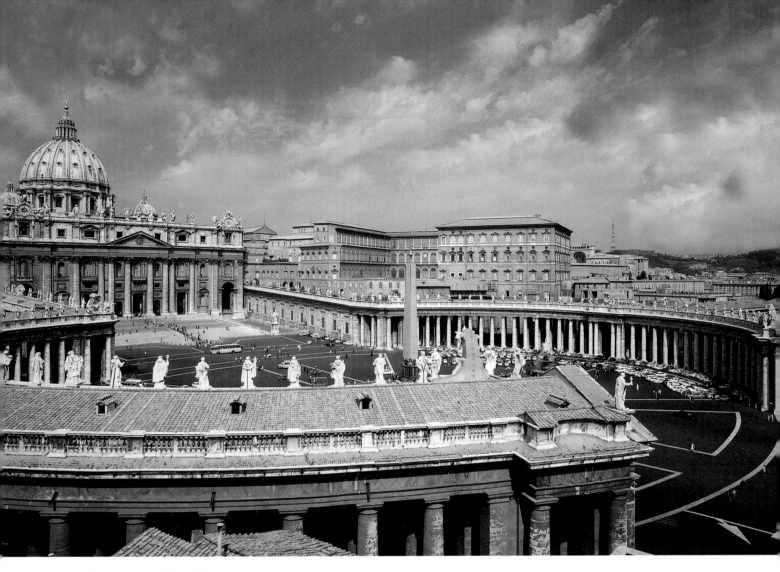

1. Rome, piazza and façade of St Peter's

Taken all in all, during the first decades of the new century the tendency of the older painters of all shades was to supplant Zuccaresque and late Tuscan Mannerism by a softer and warmer palette and a more sensitive characterization of figures. Caravaggio's and Annibale Carracci's revolts broke into this setting at the end of the nineties. But it must be emphasized that there was no immediate repercussion on papal art policy. Nor did the art of these masters appreciably influence the development of the older artists, although a painter like Cristoforo Roncalli (1552–1626) used a Carraccesque 'cloak' for his pictures at the end of his career[15] and Giovanni Baglione turned Caravaggesque for brief moments. Moreover while Annibale's Bolognese followers entrenched themselves firmly in Rome during the first two decades of the seventeenth century and public taste shifted decisively in their favour away from the older Mannerists, Caravaggism remained almost entirely an affair for eccentrics, connoisseurs, and artists and had run its course – as far as Rome was concerned – by the time Paul V died.

Paul V and Cardinal Scipione Borghese as Patrons

A brief survey of patronage during Paul V's reign will help the reader to assess the complexities which beset the historian who tries to define the art of the first quarter of the seventeenth century. Official patronage in Rome was concerned with three major tasks, St Peter's, the Cappella Paolina in S. Maria Maggiore, and the Quirinal Palace. By far the greatest problem facing Paul V was the completion of St Peter's. Once he had taken the decision to abandon Michelangelo's centralized plan, the pope proceeded with great determination. Carlo Maderno began the façade in 1607 and the nave in 1609 and finished them both in 1612 (with the exception of the farthest bay at each end) [1]. Shortly after (1615–16) he built the Confessio, which opens in the form of a horse-shoe before the high altar under the dome. Although the pope himself supported Maderno's appointment in spite of strong competition from less progressive architects, the decoration of the new building went into the hands of steadfast Mannerists.

2. Flaminio Ponzio: Rome, S. Maria Maggiore, Cappella Paolina, 1605–11

3 (*opposite*). Rome, S. Maria Maggiore, Cappella Paolina, Tomb of Paul V, 1608–15

Paul V, it is true, was not responsible for the decoration of the dome, consisting of trite representations in mosaic of Christ and the Apostles, half-figures of popes and saints, and angels with the Instruments of the Passion. This commission, for obvious reasons unrivalled in importance and by far the largest available at the turn of the century, was handed over by Clement VIII to his favourite Cesari d' Arpino in 1603. Owing to its magnitude, it was not finished until 1612.[16] Clement VIII also chose most of the artists for the huge altarpieces, later transferred into mosaic. Roncalli, Vanni, Passignano, Nebbia, Castello, Baglione, and Cigoli were here given splendid opportunities, while neither Caravaggio nor Annibale had a chance of being considered.

Paul V's principal sculptor in St Peter's was the Milanese Ambrogio Bonvicino (*c.* 1552–1622),[17] the friend of Federico Zuccari and Cristoforo Roncalli. His is the classicizing relief of *Christ handing the Keys to St Peter* over the central entrance to the church. Giovan Battista Ricci from Novara (1545– 1620), one of the least solid *maniera* painters under Sixtus V, was given the honourable task of painting frescoes in the Confessio, and he also designed the stucco decorations of the portico. Since elegant and rich stucco decora-

tions were the only field in which Roman Mannerists under Gregory XIII and Sixtus V had shown real inventiveness and originality, Ricci here drew upon a vigorous, living tradition and created a work the excellence of which has always been acclaimed. Finally, it should be mentioned that Ferrabosco's famous clock-tower of 1616–17,[18] which had to be pulled down when Bernini built his colonnades, was not an impressive example of architectural grandeur. During the time it was standing, it must have clashed strangely with the early Baroque vigour of Maderno's façade.

The Cappella Paolina in S. Maria Maggiore [2], which the pope resolved to build as early as June 1605, supplies a more coherent idea of official taste than the vast complex of St Peter's. Almost the size of a church, the Greek-cross chapel with its high dome rose to the design of Flaminio Ponzio, who had to follow closely the model of the Chapel of Sixtus V. These two chapels, forming a kind of transept to the Early Christian basilica, are testimonies of the beginning and the end of an epoch. Ponzio's structure was completed in 1611, but the decoration was not finished until the end of 1616. Coloured marbles, gilding, and precious stones combine to give an impression of dazzling splendour which sur-

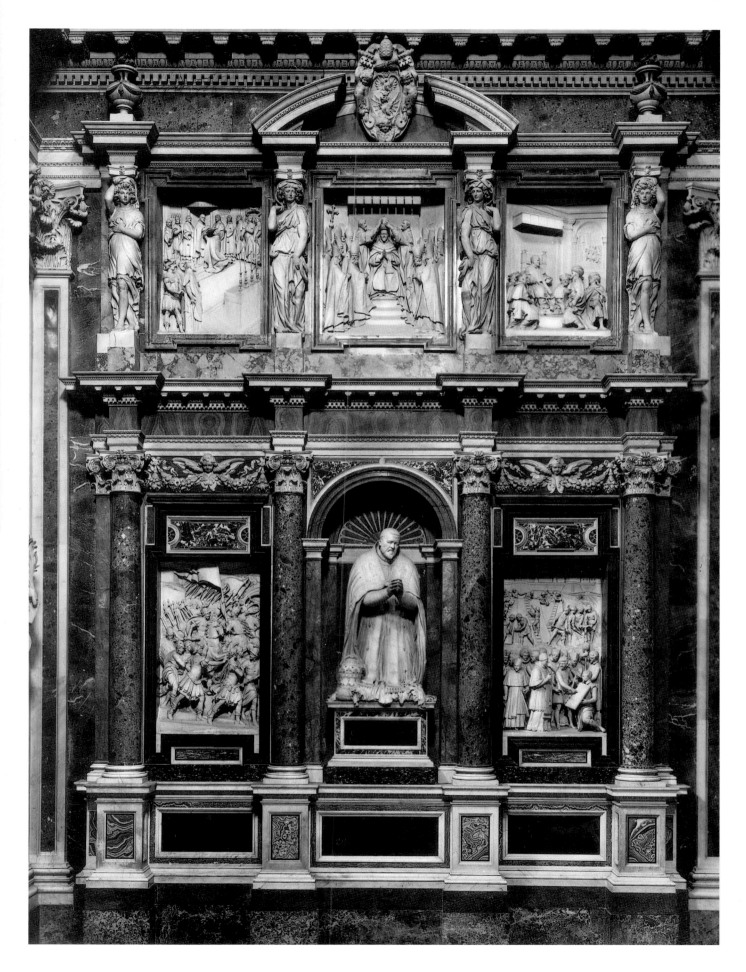

passes the harsher colour effects of Sixtus's Chapel. It was Sixtus V who with his multicoloured chapel began a fashion which remained in vogue far into the eighteenth century. One should be careful not to explain this custom simply as the 'baroque' love for swagger and magnificence. Much of the coloured marble was taken from ancient buildings. This was an important part of Sixtus V's counter-reformatory programme of systematically transforming pagan into Christian Rome. Moreover, by placing this sumptuous spectacle before the eyes of the faithful, Sixtus fulfilled the neo-medieval demand, voiced by men like Molanus, that the Church, the image of heaven on earth, ought to be decorated with the most precious treasures in existence. Along the side walls of the Paolina rise the enormous tombs of Clement VIII and Paul V with the statues of the popes surrounded by painterly narrative reliefs – all set in a triumphal-arch architecture which is so massive and rich that it dwarfs the relatively small-scale sculptural decoration [3]. Compared with their models in the Chapel of Sixtus V, these tombs show a further accretion of decorative detail, to the detriment of the effectiveness of the sculpture. The artists responsible for the statues and reliefs belonged mainly to the older generation born about 1560: Silla da Viggiù, Bonvicino, Valsoldo, Cristoforo Stati, Nicolò Cordier, Ippolito Buzio, Camillo Mariani, and Pietro Bernini, Gianlorenzo's father. In addition, two younger artists, Stefano Maderno and Francesco Mochi, were employed.[19] In other words, practically every sculptor then working in Rome made some contribution. It is indicative of the change taking place that Italians should supersede the Flemings who were so prominent in Sixtus's Chapel. The Lombard element now prevailed. In spite of the uniformity of the sculptural decoration, style and quality differ; and it is probably not by chance that the most reactionary and timid among the sculptors, Silla da Viggiù, received the lion's share: to him fell the statues of Clement VIII and Paul V.

Sculpture at this moment lagged behind the revolutionary events in painting brought about by Caravaggio and Annibale Carracci. It is not astonishing that the schism between the old guard and progressive masters like Mariani and Mochi – obvious *post festum* to art-historically trained eyes – was hardly noticed in the pope's circle. But the situation in painting was vastly different, and here the compromise character of Paul V's policy cannot be overlooked. Characteristically, he gave the direction of the whole enterprise into the hands of the Cavaliere d'Arpino. The Cavaliere himself painted the pendentives of the dome [4] and the lunette above the altar; the Florentine Ludovico Cigoli decorated the dome, and Guido Reni, possibly on the initiative of the Cavaliere, executed ten smaller frescoes in all, among them the unsatisfactorily shaped lunettes flanking the windows (1610–12). In addition, the Florentine Passignano (frescoes in the sacristy),[20] and the Mannerists Giovanni Baglione and Baldassare Croce (1553–1628) were given a share, while Lanfranco joined them later.[21] It is typical of one facet of official patronage during the second decade that all these artists, Mannerists, 'transitionalists', and 'modernists', worked side by side, and that the academic eclecticist d'Arpino topped the list.

A study of the third great papal undertaking, the Quirinal

Palace, allows one to revise to a certain extent the impression carried away from the Paolina. Late in 1605 the pope entrusted his court architect, Flaminio Ponzio, with the enlargement of the existing building, which Carlo Maderno was ordered to continue after the former's death in 1613.[22] A number of splendid new rooms were ready for decoration from 1610 onwards, two of which deserve special attention: the 'Sala Regia' (now 'Sala de' Corazzieri') and the pope's private chapel (Cappella dell'Annunciata). The decorative framework of the painted frieze along the walls of the Sala de' Corazzieri (1616–17)[23] was apparently designed by Agostino Tassi (c. 1580–1644). Its crowded organization on the short walls reveals Tassi's late Mannerist Florentine training, while the perspective openings into imaginary rooms on the long walls show him influenced by the North Italian illusionism that had had a home in Rome since the days of Gregory XIII. Lanfranco and Carlo Saraceni were the principal executants of the figures and scenes.[24] The division of hands between the artists participating is not easily established,[25] but the phenomenon is interesting enough: we are faced with an *entente cordiale* of a Carracci pupil and a Caravaggio follower under the direction of a Roman who had studied in Florence. It may be added that it was rare for a *Caravaggista* to be considered for public fresco commissions of this kind.[26] Tassi himself consolidated here his reputation as a specialist in illusionist architecture *(quadratura)*; in this capacity he collaborated with Domenichino and later, above all, with Guercino.

The main glory of the place is the Cappella dell'Annunciata, which was decorated between 1609 and 1613[27] by Guido Reni assisted by Lanfranco, Francesco Albani, Antonio Carracci, and the less distinguished Tommaso Campana. Here at last is a fully fledged co-ordinated enterprise by the young Bolognese masters. It found enthusiastic approval at the papal court; one can, however, hardly doubt that the pope's preference for Reni in the Quirinal as well as in S. Maria Maggiore and the Vatican[28] was due to Cardinal Scipione Borghese's good offices.

The cardinal nephew, Paul V's favourite, was perhaps the most brilliant representative of the Pauline era. Jovial, vivacious, worldly in his outlook, famed for his sumptuous banquets, he invested much of his immense wealth in his buildings, collections, and the patronage of living artists. He was a true enthusiast and, contrary to the admonitions of the Trent Council, loved art for art's sake. His rapacity was matched by a catholicity of taste which also seems to have been a hallmark of other aristocratic patrons of these years. Not only a vast number of ancient works, but also many of the finest jewels of the present Borghese Gallery, paintings by Titian, Raphael, Veronese, Dossi, and others, adorned his collection; but it is more interesting in this context that he bought with equal zest pictures by the Cavaliere d'Arpino, by Passignano, Cigoli, Barocci, Caravaggio, Domenichino, and Lanfranco.[29] In fact, he was one of the

4. Rome, S. Maria Maggiore, Cappella Paolina. One of the pendentives and arches with frescoes by the Cavaliere d'Arpino and Guido Reni, 1610–12

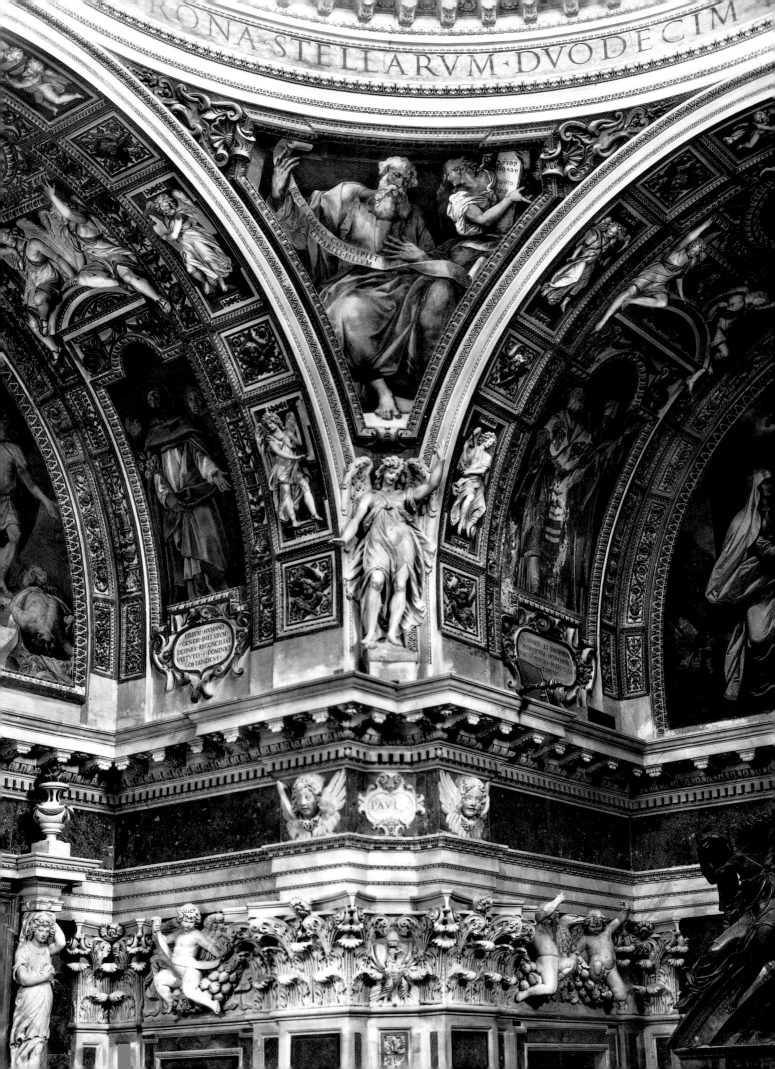

RONA · STELLARVM · DVODECIM

ECCE · VIRGO · CONCIPIET · ET · PARIET · FILIVM

FILIVM · HVMANO ·
GENERI · INFENSVM ·
DEIPARA · RECONCILIAT
VIRTVTES · S · DOMINICI ·
OSTENDENS

IGNATII · ET · THEOPHILI ·
PATRI · MICHAEL · ANTIOCHENI ·
MARIANI · CONTRA · HAERETICOS ·
LINEANT

PAVL

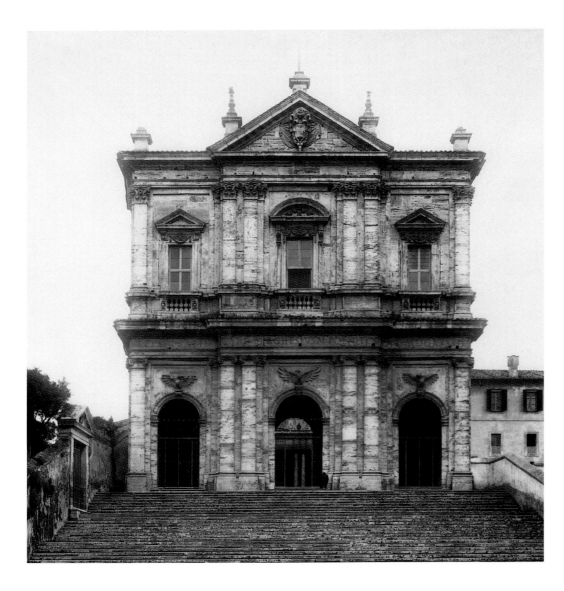

5. Giovan Battista Soria: Rome,
S. Gregorio Magno, 1629–33

earliest admirers of Caravaggio, just as he discovered at a remarkably early period the genius of Bernini. In his munificent commissions of works in fresco, both for private and public buildings, he showed partiality to the Bolognese, particularly to Guido Reni, who belonged to his household from 1608 onwards, and later to Lanfranco. But he did not hesitate to employ even feeble Mannerists, men like Nicolò Pomarancio (St Andrew Chapel, S. Gregorio Magno) or the latter's pupil, Gaspare Celio (Caffarelli Chapel, S. Maria sopra Minerva).

After Ponzio's death, the architect Scipione Borghese favoured for ecclesiastical buildings sponsored and paid by him was Giovan Battista Soria (1581–1651), who continued an academic manner far into the seventeenth century. His façade of S. Maria della Vittoria (1625–7); his masterpiece, the façade and forecourt of S. Gregorio Magno (begun 1629) [5]; and the nave of the cathedral at Monte Compatri near Rome (1630), were all executed for Scipione Borghese. Though not without dignity, they testify to the latter's conservative views as far as church architecture is concerned. Soria's architecture is somewhat more forceful than Ponzio's, who, on the cardinal's initiative, had executed the delicate classicist renovation of S. Sebastiano fuori le mura

(1609–13, completed by Vasanzio)[30] [6,7]. During his lifetime Ponzio remained the family architect and in this capacity continued the palace at which the elder Martino Longhi had worked for Cardinal Deza and which Paul V had purchased shortly before he was raised to the pontificate (February 1605). Irregular in shape, the western façade, the longest palace front in Rome, is largely the work of Ponzio. It follows the sombre tradition of the Palazzo Farnese, while the festive double-column courtyard (a novelty in Rome) points to the import of north Italian, probably Genoese, ideas.[31] The Palazzo Borghese was reserved by Paul V for the use of his brothers. In addition, Cardinal Scipione built for himself the present Palazzo Rospigliosi-Pallavicini in Piazza Montecavallo, begun in 1613. As in S. Sebastiano, the Dutchman Vasanzio (Jan van Santen), trained as a cabinet-maker and later Ponzio's collaborator and successor as papal architect, took over after his master's death.[32] It was Vasanzio who built the attractive Casino (1612–13), which Antonio Tempesta, Paul Brill, Cherubino Alberti, Passignano, Giovanni Baglione,[33] and, above all, Guido Reni decorated with frescoes. Agostino Tassi and Orazio Gentileschi painted the ceiling of the nearby 'Casino of the Muses' (1611–12) and Ludovico Cigoli a cycle of frescoes in

6 and 7. Flaminio Ponzio and
Giovanni Vasanzio: Rome,
S. Sebastiano, 1609–13

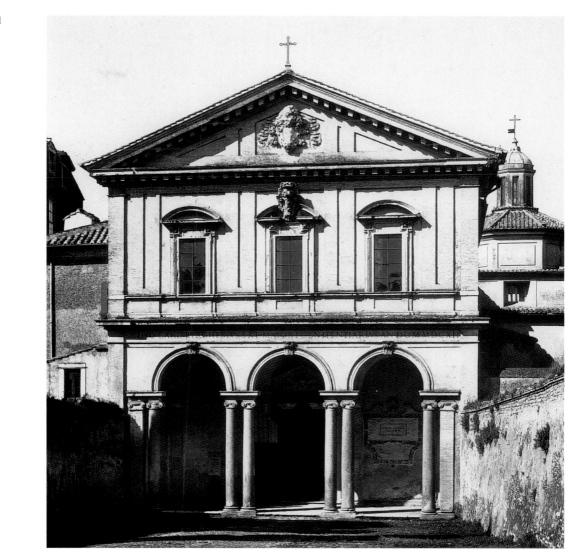

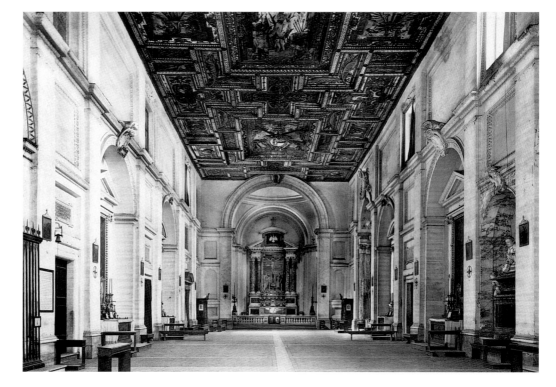

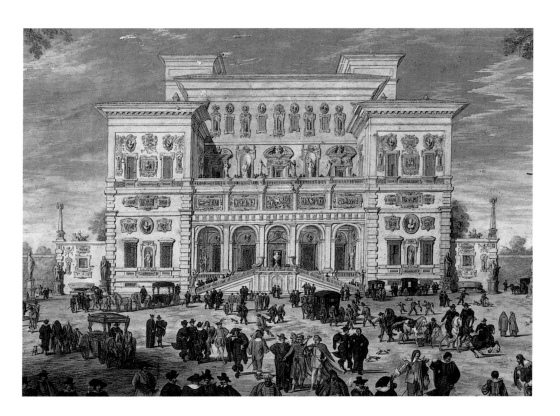

8. Giovanni Vasanzio: Rome, Villa Borghese, 1613–15. Detail from a painting

9. Frascati, Villa Mondragone. Garden front. Begun by M. Longhi, 1573, continued by Vasanzio, 1614–21

10. Flaminio Ponzio: Rome, Acqua Paola, 1610–14

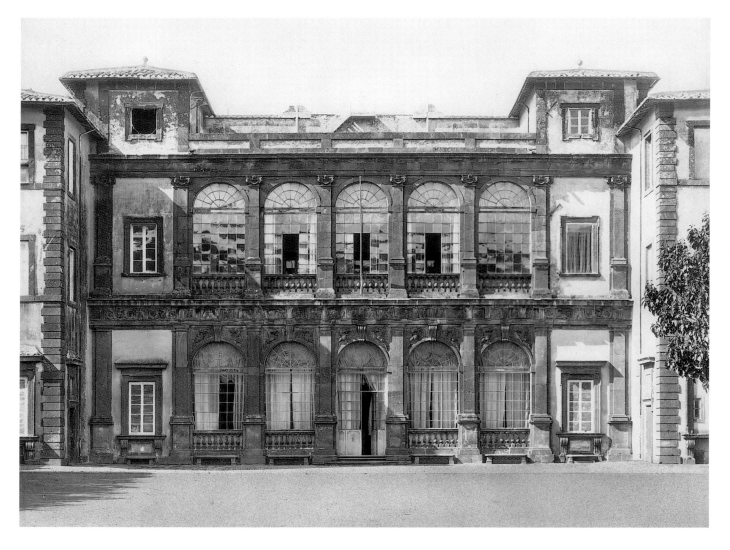

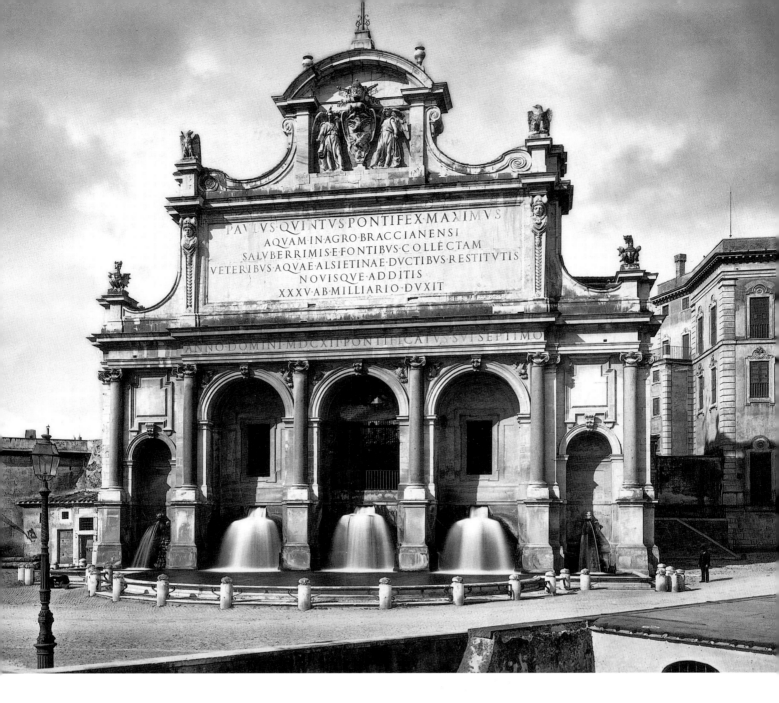

yet another casino.[34] Thus this *ensemble*, created for Scipione Borghese, supplies once again a fascinating cross-section through the variety of tendencies existing side by side at the beginning of the second decade.

The cardinal's enthusiasm was concentrated on the erection of his villa on the Pincio (the present Galleria Borghese), which he wanted to be built by Ponzio.[35] But once again death interfered, and Vasanzio served as architect of the structure which rose between 1613 and 1615. If any building, it was this villa in its original condition that represented the quintessence of its patron's taste. The type follows that of the Roman *villa suburbana*, established a hundred years before in Peruzzi's Farnesina. But where Peruzzi used a classical severity, Vasanzio covered the whole U-shaped front with niches, recesses, classical statuary, and reliefs [8] (much of the decoration was stripped at the beginning of the nineteenth century) – a late example of that Mannerist *horror vacui* which had found its 'classical' expression in Pirro Ligorio's Casino of Pius IV and

Annibale de' Lippi's Villa Medici on the Pincio. Vasanzio also enlarged Martino Longhi's Villa Mondragone at Frascati (1614–21)[36] for Scipione Borghese, and it is here, in the fountains and the beautiful loggia [9], so often erroneously attributed to Vignola, that his picturesque approach to architecture found a new, unexpected outlet.

Although far from exhaustive, our list of works executed for Paul V and his illustrious nephew is remarkable enough. But the impression of their lasting achievement as patrons of the arts would be incomplete without mentioning the many fountains with which they embellished Rome. Fountains rose in the squares of S. Maria Maggiore and the Lateran, in Piazza Scossa Cavalli and Piazza di Castello (destroyed). None of them can compete with the stateliness and elegance of Maderno's mushroom-shaped fountain in the Square of St Peter's or the monumentality of Ponzio's triumphal-arch front of the Acqua Paola (on the Janiculum) with its cascades of gushing water (1610–14) [10].[37] Ever since Sixtus V's days fountains had played an important part in Rome's

urban development, but in contrast to the tradition of Florentine fountains with their predominantly sculptural decoration, Roman fountains were either unadorned, consisting of a shaft which supported a combination of basins, or, if placed against a wall, were architectural and monumental. It is again a sign of the essential unity of the period from Sixtus V to Paul V that the approach to this problem remained basically unchanged. Ponzio's Acqua Paola was merely an improved version of Domenico and Giovanni Fontana's Acqua Felice (1587). As in so many other respects, the change came only during Urban VIII's pontificate when Bernini broke irrevocably with this Roman tradition [II: 23].

Caravaggio's and Annibale Carracci's Supporters

The most distinguished patron in Rome after Scipione Borghese was surely the Marchese Vincenzo Giustiniani (1564–1637). As a young man he gave Caravaggio his unstinted support, and his courageous purchase of the *St Matthew*, refused by the priests of S. Luigi de' Francesi, probably prevented the shipwreck of Caravaggio's career as a painter of monumental religious pictures. But the Marchese collected with equal relish works of the Bolognese[38] and, moreover, reserved a special place in his household for the Mannerist Cristoforo Roncalli (called Pomarancio, 1552–1626), who began as a pupil of the older Nicolò Pomarancio and developed into a highly esteemed 'transitionalist'. It was this painter who served as Giustiniani's counsellor in artistic matters and who accompanied him in 1606 on his travels through Italy and Europe.[39] Later in Giustiniani's life the German Sandrart published for him his collection of ancient marbles (*Galleria Giustiniani*, 1631) to which Frenchmen, Duquesnoy and other Flemings as well as Lanfranco and Domenichino's pupil Giovan Battista Ruggieri contributed the designs and engravings.

If Caravaggio found devoted patrons among the nobility and higher clergy, it would yet be incorrect to talk of a distinct faction in his favour. The men who sided with him seem to have been enterprising, enthusiastic, and liberal in their outlook. This is certainly true not only of Scipione Borghese and Vincenzo Giustiniani, but also of Cardinal Francesco Maria del Monte, Caravaggio's earliest patron, who has been described as 'a kind of ecclesiastical minister of the arts in Rome';[40] it is true of the brothers Asdrubale and Ciriaco Mattei, who had 'fallen victim to the fashion for Caravaggio' (Baglione), but at the same time patronized artists like Cristoforo Roncalli and Gaspare Celio. These last artists were also favoured by the Crescenzi brothers, who were responsible for Caravaggio's getting the commission for the Contarelli Chapel; and this list might easily be continued.

Quite different were the fortunes of Annibale Carracci and his Bolognese friends and followers. Indeed, it is permissible in their case to talk of a faction, or rather two factions, determined to promote the Bolognese cause. There were the Farnese, in particular the powerful Cardinal Odoardo, under whose aegis Annibale painted the Farnese Gallery; he remained unfailingly loyal to his Bolognese *protégés*, employed Domenichino and Lanfranco in the palace,

and must be credited with having collected most of the sixty-odd works attributed in the Farnese inventory of 1662 to the Carracci and their school. The second faction was associated with the circle of Cardinal Pietro Aldobrandini, Clement VIII's nephew and secretary of state, for a time the most influential man in Rome, and the political antagonist of Odoardo Farnese. The cardinal himself cherished the art of the Cavaliere d'Arpino. But his secretary, Monsignor Giovanni Battista Agucchi (1570–1632), born at Bologna, was Annibale's devoted admirer and Domenichino's close friend; to the same circle belonged Monsignor Giovanni Antonio Massani and Francesco Angeloni, Cardinal Ippolito Aldobrandini's secretary.[41] Both Massani and Angeloni concentrated on collecting the Bolognese masters, and we happen to know that Angeloni possessed at least 600 Annibale drawings for the Farnese Gallery. It is at once evident that the men of this coterie, unlike Caravaggio's unbiased patrons, were guided by principles. Their single-minded partisanship was to become of ever greater importance in the early seventeenth century.

Agucchi himself tried his hand at a theoretical treatise, his *Trattato della Pittura*,[42] in which, among other ideas, he formulated anew the central principle of the classical doctrine, that nature is imperfect and that the artist has to improve upon her by selecting only her most beautiful parts. This empirical, Aristotelian theory was harnessed for an attack on two fronts: belief in it justified stricture of the *maniera* painters as much as of the *Caravaggisti*. From this point of view neither the Platonic concept of an *a priori* idea of beauty in the artist's mind (Zuccari's *disegno interno*) nor the exact imitation of imperfect nature (Caravaggio) was a defensible position. It is interesting that this new affirmation of the classical doctrine was written between 1607 and 1615, just after Zuccari's *Idea* had appeared (1607), which in a happy phrase has been called 'the swan song of the subjective mysticism of Mannerist theory'.[43] Agucchi and his circle found the realization of their theoretical approach – namely nature embellished and idealized – in the art of Annibale Carracci and Domenichino. They despised the older Mannerists and created the legend of Caravaggio's unbridled naturalism.

More than one distinguished scholar has pointed out that the period around 1600 was averse to theoretical speculations.[44] The essential truth of this cannot be contested. The artists themselves became tongue-tied. Federico Zuccari's elaborate programme of lectures to be delivered before the newly founded Academy of St Luke was an anachronism even before it ingloriously petered out as a result of the artists' resistance. Both Caravaggio and Annibale Carracci derided the clever chattering about art of which the Mannerists were so fond. The liberal-minded patrons seem to have been interested in experiment and quality rather than in principles. Moreover, no important treatise extolling the new ideas was published during the first half of the seventeenth century. And yet the flame kindled in Agucchi's circle was never again extinguished. On the contrary, the classical-idealist theory, which guaranteed the dignity of painting on a level with Zuccari's academic eminence, was soon more or less vociferously championed, strengthened, and streamlined by amateurs and artists alike. It may be

recalled that Domenichino sided, as one would expect, with the extreme classical point of view by exalting *disegno* (line) at the expense of *colore* (colour), and that later Francesco Albani planned a treatise the orthodoxy of which, judging from Malvasia's report, would have gone far beyond Agucchi's rather broad-minded expositions.[45] In any case, the *cognoscenti* of the early seventeenth century sided more and more determinedly with the opinions of the Agucchi circle and helped to bring about the climate in which the ascendancy of Bolognese classicism over Mannerism and Caravaggism was secured.

This ascendancy may be gauged by a glance at the list (p. 46) of important fresco cycles in palaces and churches executed by the Bolognese from 1608 onwards. Especially as regards the decoration of palaces, they enjoyed almost a monopoly during the second decade.

The new Churches and the new Iconography

No appreciation of the vast changes that came about in the artistic life of Rome from Sixtus V's days onwards is possible without due consideration of the hectic activity in the ecclesiastical field. Few churches had been built in Rome during the first half of the sixteenth century. But as the century advanced the new intensity of devotion in the masses required energetic measures, and, above all, the new Orders needed churches to accommodate their large congregations. The beginning was made with the Gesù, the mother church of the Jesuit Order, rising from 1568 and consecrated in 1584. With its broad single nave, short transept, and impressive dome this church was ideally suited for preaching from the pulpit to great numbers of people. It established the type of the large congregational church that was followed a hundred times during the seventeenth century with only minor variations. During the next decades Rome saw three more large churches of this type rising, each surpassing the previous one in size. In 1575 the Chiesa Nuova (S. Maria in Vallicella) [II: 73] was begun for St Philip Neri's Oratorians by Matteo di Città di Castello and continued by the elder Martino Longhi.[46] The building was consecrated in 1599, but Fausto Rughesi's traditional façade was not yet finished in 1605. S. Andrea della Valle, a stone's throw from the Chiesa Nuova, was designed by Giacomo della Porta (not by Pietro Paolo Olivieri) for the Theatines, whose Order had been founded during the early years of the religious strife (1524).[47] Begun in 1591, the building was taken over by Carlo Maderno in 1608 and completed in 1623 except for the façade. Finally, a second vast Jesuit church, S. Ignazio, was planned after the founder's canonization and begun in 1626. The canonization of St Charles Borromeo in 1610 was immediately followed by the dedication to him of no less than three churches in Rome: the very large S. Carlo al Corso, S. Carlo ai Catinari, built for the Barnabites, a congregation founded at Milan in 1533, and the small S. Carlo alle Quattro Fontane, which the Discalced Trinitarians later replaced by Borromini's structure.

In addition to these new buildings, owed to the counter-reformatory Orders and the new saints, more medium-sized and small churches were erected during the three decades of Clement VIII's and Paul V's pontificates than in the preceding 150 years. One need only call to mind S. Maria della Scala (in Trastevere, 1592), S. Nicolò da Tolentino (1599–1614), S. Giuseppe a Capo le Case (1598, rebuilt 1628), S. Bernardo alle Terme (1598–1600), and S. Susanna (façade, begun 1597), all built during Clement VIII's reign, or S. Maria della Vittoria (1606), S. Andrea delle Fratte (1612), SS. Trinità de' Pellegrini (1614), S. Maria del Suffragio (1616), and S. Maria Liberatrice (1617), all rebuilt or newly raised under Paul V. To this list may be added such important restorations as Cardinal Baronius's of SS. Nereo and Achilleo,[48] Cardinal Pietro Aldobrandini's of S. Niccolò in Carcere, and Cardinal Sfondrate's of S. Cecilia in the days of Clement VIII as well as those of S. Francesca Romana, S. Crisogono, S. Sebastiano fuori le Mura, SS. Quattro Coronati, and S. Maria in Trastevere during Paul's pontificate. Finally, large and richly decorated chapels like that of Cardinal Caetani in S. Pudenziana (1595), of the Aldobrandini in S. Maria sopra Minerva (1600–5), of Cardinal Santori in the Lateran (begun before 1602), and of the Barberini in S. Andrea della Valle (1604–16) show that the first families of Rome competed in adding lustre to old and new churches.

In spite of solid and worthy achievement, the masters of the period here under review on the whole lack initiative, inventiveness, and a spirit of adventure. It seems to have been *bon ton* in those years not seriously to infringe established patterns. Thus a cloud of anonymity, if not of dullness, hangs over much ecclesiastical work of the time. One wonders how a Bernini, a Cortona, or a Borromini would have solved the problem of the large congregational church if such an opportunity had been offered them. In any case, the great masters of the post-Pauline era found stirring, imaginative, and highly personal solutions for traditional ecclesiastical tasks. The change effected during Urban VIII's pontificate is no less revolutionary in this than in other respects.

All the immense work of construction going on in the last decades of the old century and the first of the new required decoration by painters, sculptors, stucco workers, and craftsmen. As a rule, the direction remained in the hands of the architect. In the case of the Aldobrandini Chapel in S. Maria sopra Minerva (begun 1600, consecrated 1611), Giacomo della Porta and, after his death, Carlo Maderno filled this post. But they were no more than the *primi inter pares* in co-ordinating the works of the painters Barocci (*Last Supper*, altar) and Cherubino Alberti (vault) and of the sculptors Camillo Mariani, Nicolò Cordier, Ippolito Buzio, Valsoldo, and Stefano Maderno. Collective enterprises became the rule from Sixtus V to the end of Paul V's pontificate, even though the artists engaged on the same task often held very different views. This trend was reversed under Urban VIII. Chapels such as those of the Raimondi and Cornaro families show throughout the imprint of Bernini's master-mind: co-workers were assistants rather than artists in their own right.

The new churches confronted painters in particular with a prodigious task. They had not only to cover enormous wall-spaces with frescoes but had, above all, to create a new iconographical tradition. Saints like St Charles Borromeo, St Ignatius, St Francis Xavier, and St Teresa had to be hon-

oured; their lives, miracles, and wordly and spiritual missions had to be solemnized. In addition, in the face of the Protestant challenge, the dogmas of the Catholic Church had to be reasserted in paintings which would strengthen the belief of the faithful and grip their emotions. Finally, as regards many scenes from the Old and New Testaments and from the lives of the saints, a shift was needed away from tradition towards an emphasis on heroic exemplars (David and Goliath, Judith and Holofernes), on models of repentance (St Peter, the Prodigal Son), on the glory of martyrdom[49] and saintly visions and ecstasies, or on hitherto unexplored intimate events from the childhood of Christ. These remarks indicate that one can truly talk about a counter-reformatory iconography.[50]

The rise of the new iconography may be observed from the last two or three decades of the sixteenth century onwards, but it must be stressed that in Rome the vast majority of the great cycles of frescoes, in the Gesù, S. Andrea della Valle, S. Carlo al Corso, the Chiesa Nuova, S. Ignazio, S. Carlo ai Catinari, and elsewhere were painted after the first quarter of the seventeenth century. In other words, the decoration of these churches belongs to a stylistic phase later than the buildings themselves. The reason lies, partly in any case, in the time-lag between the early activities of the new Orders and the canonization of their founders. But this is not the whole story. It was, for instance, in keeping with the early austere 'iconoclastic' tendencies that St Philip Neri wanted the walls of the Chiesa Nuova whitewashed,[51] the same walls which half a century later were covered with Pietro da Cortona's exuberant decorations. Moreover, although it is true that one can hardly expect representations of the apotheoses of saints before they are canonized, the climate under Clement VIII and Paul V was not favourable to the 'deification' in pictures of the great men of the Counter-Reformation. As we have mentioned, the popes themselves ordered the most meticulous inquiries into the cases of the prospective saints and the processes dragged on over many years. It is also important to notice that, as a rule, there is a considerable difference in the representation of the saints between the earlier phase and the later. In pictures of the second decade, such as those by Orazio Borgianni (S. Carlo alle Quattro Fontane, Rome) [36], Orazio Gentileschi (S. Benedetti, Fabriano), or Carlo Saraceni (S. Lorenzo in Lucina, Rome), the saints may be shown in a state of devotion and ecstasy, and in this exalted frame of mind they may see visions to which the beholder becomes a party. But rarely do they appear soaring up to heaven or resting on clouds in the company of angels, presupposing, as it were, that the entire image is the beholder's visionary experience [II: 177].

Such scenes belong to the High Baroque, and for size and grandeur alone they establish a new artistic convention. When this happened, the great reformers had been dead for at least two generations, and it is evident even without any further comment that nothing could be more averse to the spirit in which they had worked.

No doubt is possible, then, that the Counter-Reformation made necessary a specific counter-reformatory iconography; nor that the iconographical pattern of the early seventeenth century changed to a certain extent during the post-Pauline period. But can one also talk of a specific counter-reformatory style? Summarizing what has been indicated in the foregoing pages, we may conclude that, of course, the Church made use of various artistic manifestations and stylistic trends which in turn were not independent of the religious temper of the age. In the coexistence of 'classical' reticence and 'vulgar' pomp one may be able to discern two different facets of counter-reformatory art. But above and beyond all this, it seems possible to associate a distinct style with the spirit of the reformers: a style which reveals something of their urgency and enthusiasm, of their directness of appeal and mystic depth of conviction. Since this is a matter concerning all Italy, a more explicit verdict must be postponed until the development of painting in the provinces has been surveyed (p. 74).

The Evolution of the 'Genres'

It is often said that a significant step in the slow and persistent shift from the primarily religious art of the Middle Ages to the primarily secular art of modern times was accomplished during the seventeenth century. There is truth as well as fallacy in this statement. It is fallacious to believe that an equation exists between the degree of naturalism and realism – in themselves highly problematical notions – and the profane character of works of art. Verisimilitude is no synonym for irreverence. Although the logic of this statement is unassailable, whether or not the beholder will regard the art of the seventeenth century as a truly religious art depends on his own, partly subconscious, tems of reference. But it cannot be denied that the largest part of artistic production during the period under review is of a religious nature. By comparison the profane sector remains relatively insignificant. This is correct, even though after Annibale Carracci's Farnese ceiling classical mythology and history become increasingly important in the decoration of palaces. In this respect Paul V's reign reveals an undeniable affinity with the Roman High Renaissance.

These observations may now be given more substance. It was in the years around 1600 that a long prepared, clear-cut separation between ecclesiastical and secular art became an established fact. Events in Rome hastened this division for the whole of Italy. Still life, genre scenes, and self-contained landscapes begin to evolve as species in their own right at this historical moment. None of these remarkable developments takes place without the active participation of northern, mainly Flemish, artists.[52] Rome, of course, was not the only Italian city where northern influence made itself felt. It may suffice to recall Florence, Bologna, and Genoa. Yet many northern artists were magically drawn to Rome, and Rome became the international meeting place where new ideas were avidly exchanged and given their characteristically Italian imprint.

The new species aroused such interest that even a man of Cardinal Federico Borromeo's stern principles was much attracted by such 'trifles' as landscapes and still lifes. We are choosing him as an example because his case illustrates that around 1600 a collector had to turn to Rome for specimens of the new genres. It is well known that the cardinal owned

Caravaggio's *Basket of Fruit* (now Ambrosiana, Milan); he admired, moreover, the art of Paul Brill and Jan Bruegel, both of whom he befriended and whose works figured prominently in his collection at Milan. Whenever he stayed in Rome he visited Brill's studio,[53] and on one occasion at least, in 1611, Giovan Battista Crescenzi acted as intermediary between artist and patron. The correspondence reveals that Crescenzi, the supervisor of Paul V's official artistic enterprises and thus a great power in matters of taste, had an eye for the qualities of Brill's seascapes.

Paul Brill, the younger brother of the less important Mattheus, held a key position in the process of assimilating Flemish landscape painting in Italy.[54] His early Flemish manner changed considerably, first under Muziano's and later under Annibale Carracci's influence. Thus monumentalized and italianized, his landscapes and seascapes became part of the broad stream of the Italian development. They lead on to Agostino Tassi's seascapes[55] and finally to those of Claude.

It is true that landscape painting had emerged as a specialized branch during the second half of the sixteenth century. Italians of the sixteenth and seventeenth centuries admitted the 'genre' as legitimate, probably not uninfluenced by the prominence Pliny gave to the work of the Roman landscape painter Studius.[56] But from Alberti's days on the noble art of history painting had pride of place in the hierarchy of values, and Italians, for the time being at any rate, regarded landscape painting as a pleasant recreation from the more serious business of 'high art'. This was pre-cisely how an artist like Annibale Carracci felt. Exclusive specialization in the lower genres was therefore left to the foreigners. These remarks, of course, apply also to still life and the popular genre.

In spite of their theoretical approach, the contribution of Italians to the development of the genres in the early years of the seventeenth century was not negligible. The popular genre had a home in Bologna and was cultivated by the Carracci rather than by Caravaggio. Although working with essentially Mannerist formulas, the pupil of the Fleming Stradanus, Antonio Tempesta (1555–1630), who spent most of his working life in Rome, became instrumental in creating the realistic battle-piece and hunting-scene. In Caravaggio's circle the detailed realism of the Flemish fruit and flower still life was to a certain extent stylized and replaced by a hitherto unknown fullness of vision.[57] But during the period with which we are at present concerned all this was still in its beginnings.[58]

Only after the first quarter of the seventeenth century do we find that Italians are devoting themselves wholly to the practice of the specialized genres, that the market for these adjuncts to high art grows by leaps and bounds and that each speciality is further subdivided into distinct categories. Foreigners again had a vital share in this process. The most patent case is that of landscape painting: the names of Poussin and Claude are forever associated with the full flowering of the heroic and pastoral landscape. But it was left to the Italian Salvator Rosa to establish the landscape type which the eighteenth century called 'sublime'.

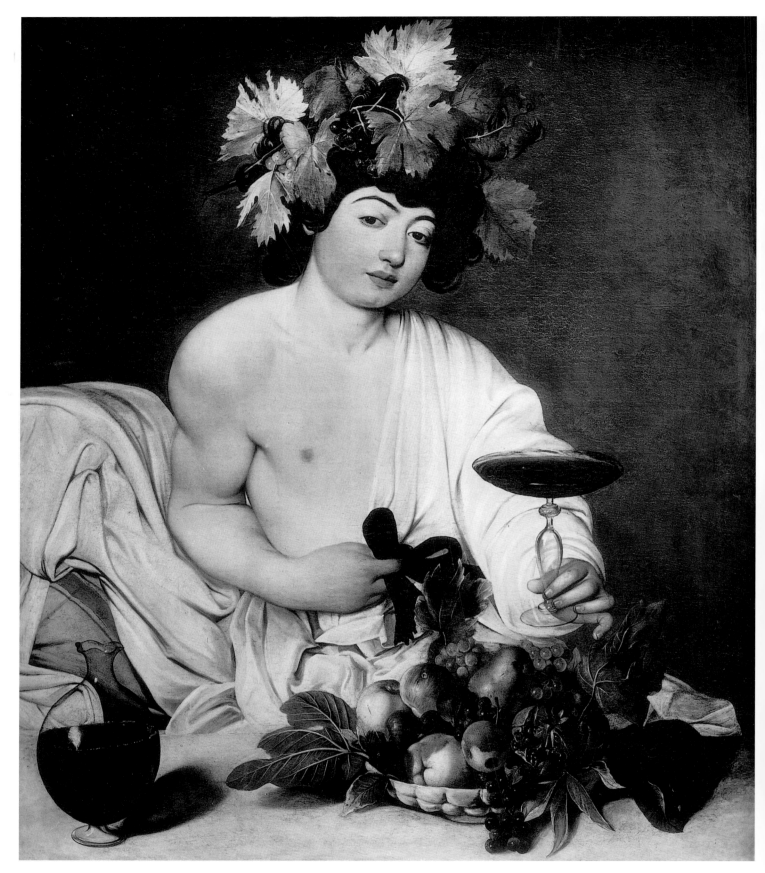

11. Caravaggio: *Bacchus*, *c.* 1595. Florence, Uffizi

Caravaggio

Caravaggio, in contrast to Annibale Carracci, is usually considered a great revolutionary. From the mid seventeenth century onwards it has indeed become customary to look upon these two masters as being in opposite camps: the one a restorer of time-honoured tradition, the other its destroyer and boldest antagonist. There is certainly some truth in these characterizations, but we know now that they are much too sweeping. Caravaggio was less of an anti-traditionalist and Annibale Carracci more of a revolutionary than was believed for almost 300 years.[1]

Michelangelo Merisi, called Caravaggio, was born late in 1571, probably in Milan. Before the age of thirteen he was apprenticed in Milan to the mediocre painter Simone Peterzano and stayed with him for about four years. Peterzano called himself a pupil of Titian, a relationship not easily revealed by the evidence of his Late Mannerist work.[2] One has no reason to doubt that in this studio Caravaggio received the 'correct' training of a Mannerist painter. Equipped with the current knowledge of his profession, he reached Rome about 1590 and certainly not later than 1592.[3] His life there was far from uneventful. Perhaps the first consistent bohemian, he was in permanent revolt against authority, and his wild and anarchic character brought him into more than one conflict with the police.[4] In 1606 he had to flee from Rome because of a charge of manslaughter. During the next four restless years he spent some time at Naples, Malta, Syracuse, and Messina. On his way back to Rome he died of malaria in July 1610, not yet thirty-nine years old.

When he first reached Rome, he had had to earn his living in a variety of ways. But hackwork for other painters, among whom was perhaps the slightly older Antiveduto Gramatica (1571–1626),[5] left a youth of his temperament and genius thoroughly dissatisfied. For a short time he also worked for Giuseppe Cesari (later the Cavaliere d'Arpino) as a studio hand,[6] but soon started on his own. At first unsuccessful, his fortunes began to change when Cardinal Francesco del Monte bought some of his pictures.[7] It seems that through the agency of this same prince of the Church he was given, in 1599, his first commission for a monumental work, the paintings in the Contarelli Chapel of S. Luigi de' Francesi [16]. This event appears in retrospect as the most important caesura in Caravaggio's career. From then on he produced almost exclusively religious paintings in the grand manner. With these data at hand, the brief span of Caravaggio's activity may conveniently be divided into four different phases: first, the Milanese period; even though paintings of this period will probably never be discovered, it is of great consequence not only because of the conventional training with Peterzano, but also because of the lasting impressions made on him by older North Italian masters

such as Savoldo, Moretto, Lotto, and the brothers Giulio and Antonio Campi; secondly, the first Roman years, about 1592–9, during which Caravaggio painted his *juvenilia*, for the most part fairly small pictures consisting, as a rule, of one or two half-figures [11]; thirdly, the period of monumental commissions for Roman churches, beginning in 1599 and ending with his flight from Rome in 1606;[8] and finally, the work of the last four years, again mainly for churches and done in a fury of creative activity, while he moved from place to place.

A comparison between an early Roman and a post-Roman work [11 and 15] gives the measure of Caravaggio's surprising development. His uninhibited genius advanced with terrific strides into uncharted territory. If we had only his earliest and his latest pictures, it would be almost absurd to maintain that they are by the same hand. To a certain extent, of course, this is true of the work of every great master; but in Caravaggio's case the entire development was telescoped into about eighteen years. In fact, between the paintings shown in illustrations 11 and 15 there may not be more than thirteen years.

Not unexpectedly, the biographical caesuras coincide with the vital changes in his style, but these changes have too many ramifications to be described by a purely formal analysis. Much more may be learned about them by inquiring into his approach to mythological, genre, and religious subjects and by focusing on the character and meaning of his realism and his *tenebroso*, the two pillars on which his fame rests. Contrary to what is often believed, genre scenes play a very subordinate part in Caravaggio's production. They seem even more marginal than mythological and allegorical[9] themes and, may it be noted, almost all the non-religious pictures belong in the first Roman years. In contrast to genre painting, mythologies and allegories clearly indicate an artist's acceptance of a learned tradition; and it cannot be sufficiently emphasized that we find the young Caravaggio working within this tradition, of his own accord. It is fair to assume that in the Uffizi *Bacchus* [11] he represented himself in mythological disguise.[10]

Mythological or allegorical portraiture has, of course, a pedigree leading back to Roman times. Nor is the attitude of the sitter here new in the history of portraiture. On the contrary, examples are legion showing the sitter addressing the beholder, as it were, from behind a table or parapet. What, then, is remarkable about this picture? Wine and wreath apart, there is little that is reminiscent of the god of antiquity. His gaze is drowsy, his mouth soft and fleshy; white, overfed, and languid, he holds the fragile glass with a dainty gesture. This well-groomed, pampered, lazy androgyne, static like the superb still life on the table, will never move or ever disarrange its elaborate coiffure and its

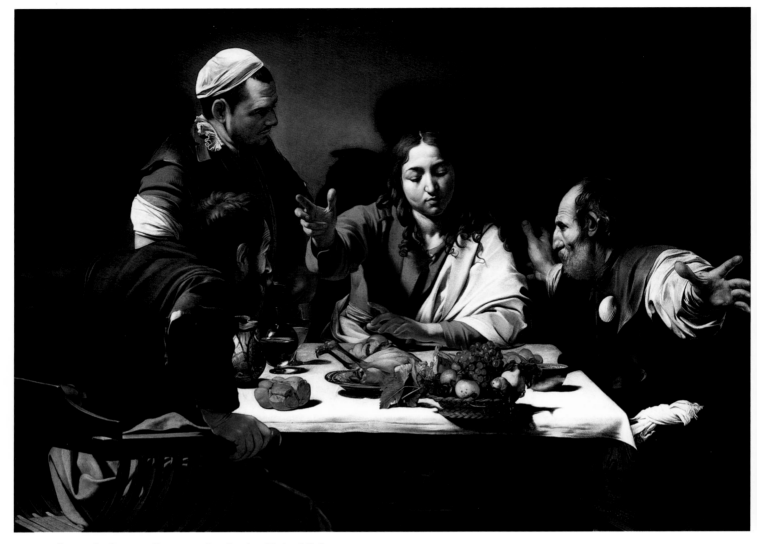

12. Caravaggio: *Supper at Emmaus*, *c.* 1600. London, National Gallery

precious pose. Contemporaries may have looked upon this interpretation as mythological heresy,[11] which was not Caravaggio's invention either. It originated in the era of Mannerism when artists began to play so lightly with mythological themes that the ancient gods could even become objects of derision.[12] But the Bacchic paraphernalia of Caravaggio's picture should not be regarded as mere supercilious masquerade: he chose the emblems of Bacchus to express his own sybaritic mood. When Bronzino represented Andrea Doria as Neptune, he conveyed metaphorically something about the admiral's mastery of the sea. Caravaggio's disguise, by contrast, makes sense only as a support to an emotional self-revelation. The shift from the statement of an objective message to the indication of a subjective mood adumbrates a new departure the importance of which hardly needs stressing.[13]

The sitter's dissipated mood is also clearly expressed by the key in which the picture is painted: bright and transparent local colours with hardly any shadows are set off against the shining white of the mass of drapery. The colouristic brilliance is combined with an extraordinary precision and clarity of design and a scrupulous rendering of detail, particularly in the vine leaves of the wreath and the still life of fruit on the table.[14] No atmosphere surrounds the figure; colour and light do not create space and depth as they do in Venetian painting. Depth, in so far as it can be visualized, is suggested by foreshortenings such as those of the arm and hand holding the wine-glass. Other early pictures by Caravaggio may be similarly described, but in none of them are the tones so glassy, the whites so penetrating, and the pink of the flesh so obscene. Colours and tone values clearly sustain the precious mood of the picture. At this period Caravaggio's method of stressing individual forms with local colour is as far removed from the practice of Venetian colourism as it is indeed from the elegant and insipid generalizations of the Mannerists. On the other hand, a marked Mannerist residue is perceptible in the Bacchus, not only in such details as the folds and the flaccid bare arm, but, above all, in the pervading quality of stylization, which proves that the old catchword of Caravaggio's realism should be used with caution, particularly in front of the early Roman works. Soon after the Bacchus, Caravaggio again represented himself in a mythological disguise, but this time appropriately expressing his own frenzy through

the horrifying face of *Medusa* (Florence, Uffizi). The simple fact that he painted the picture on a round wooden shield proves his awareness of traditional literary associations, and those who quote this work as an extreme example of his realism unpermissibly divorce the content from the form. Nor is the formal treatment really close to nature, as anyone who tries to imitate the pose will easily discover. This image of terror has the power to 'petrify' the beholder just because it is unrealistic and reverts to the old expressive formula of classical masks of tragedy.[15]

Similarly, Caravaggio's few genre pieces can hardly be called realistic. Like other Italian artists of the period, he was indebted to Northerners who had long practised this branch of art and had begun to invade the Italian market in the later sixteenth century. But if their genre painting, true to the meaning of the word, shows anonymous people following their everyday occupations, it must be said that neither Caravaggio's *Card Sharpers* nor his *Fortune Teller* reflect fresh observations of popular contemporary life. Such slick and overdressed people were not to be found walking about; and the spaceless settings convey a feeling of the *tableau vivant* rather than of 'snapshots' of actual life.[16] One looks at these pictures as one reads a romantic narrative the special attraction of which consists in its air of unreality.

It has been mentioned before that from 1599 onwards by far the greater part of Caravaggio's activity was devoted to religious painting, and henceforth very considerable changes in his approach to his art are noticeable. These changes may here be observed in a cabinet picture, the National Gallery *Supper at Emmaus* (c. 1600) [12].[17] Only the rich still life on the table links the picture to his early Roman period. But, as if his youthful escapades were forgotten and eradicated, suddenly and unexpectedly Caravaggio reveals himself as a great painter of religious imagery. The change is marked not only by a revision of his palette, which now turns dark, but also by a regression to Renaissance exemplars. Compositionally the work derives from such representations of the subject as Titian's *Supper at Emmaus* in the Louvre, painted about 1545. In contrast, however, to the solemn stillness in Titian's work, the scene is here enacted by means of violent gestures – intense physical reactions to a spiritual event. Christ is deeply absorbed and communicates the mystery through the slight bending of His head and His downcast eyes, both accompanied by the powerful language of the blessing hands. The sacramental gesture of these hands takes on an added emotional significance through their juxtaposition to the lifeless legs of the chicken on the table. The incomprehension of the innkeeper is contrasted with the reaction of the disciples who recognize Christ and express their participation in the sacred action by rugged, almost compulsive movements. In keeping with the tradition stemming from Alberti and Leonardo, Caravaggio, at this stage of his development, regarded striking gestures as necessary to express the actions of the mind.

With Caravaggio the great gesture had another distinct meaning; it was a psychological device, not unknown in the history of art,[18] to draw the beholder into the orbit of the picture and to increase the emotional and dramatic impact of the event represented: for Christ's extremely foreshortened arm

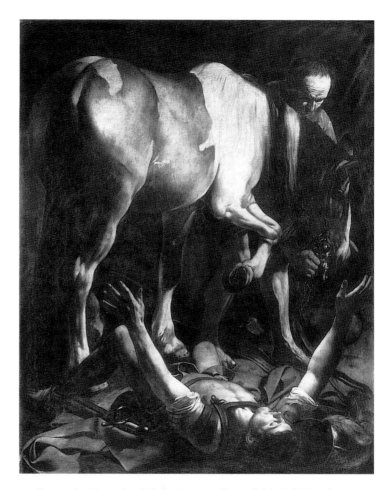

13. Caravaggio: *Conversion of St Paul*, 1600–1. Rome, S. Maria del Popolo, Cerasi Chapel

as well as the outflung arm of the older disciple seem to break through the picture plane and to reach into the space in which we stand. The same purpose is served by the precarious position of the fruit-basket which may at any moment land at our feet. In his middle period Caravaggio often used similar methods in order to increase the participation of the worshipper in the mystery rendered in the picture. Special reference may be made to the first version of the *St Matthew and the Angel* painted for the Contarelli Chapel, where the saint's leg appears to jut right out of the picture, or to the second version with one leg of the stool dangling over the ledge into the beholder's space; and also to the extremely foreshortened body of the saint in the *Conversion of St Paul* in S. Maria del Popolo [13] and the jutting corner of the Stone of Unction in the Vatican *Deposition*, which is echoed by Joseph of Arimathea's elbow.[19]

Towards the end of his Roman period Caravaggio painted a second *Supper at Emmaus* (Milan, Brera). Here he dispensed with the still life acessories on the table and, even more significantly, with the great gestures. The picture is rendered in a much less dramatic key and the silence which pervades it foreshadows a trend in his post-Roman work.

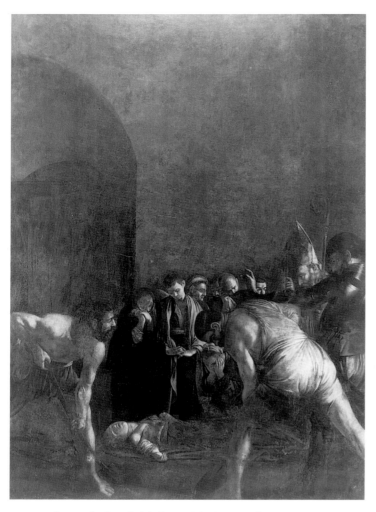

14. Caravaggio: *Burial of St Lucy*, 1608 . Syracuse, S. Lucia

15. Caravaggio: *Raising of Lazarus*, 1609. Messina, Museo Regionale

In the works of the middle period Caravaggio takes great pains to emphasize the volume and corporeal solidity of the figures, and sometimes, packs them so tightly within the limits imposed by the canvas that they seem almost to burst the frame [13]. In other paintings of this period, however, a tendency is stressed that was already noticeable in a few of the early pictures, namely the creation of a large spaceless area above the figures, an emptiness which Caravaggio exploited with tremendous psychological effect. Not only is the physical presence of the figures more vigorously felt by contrast with the unrelieved continuum, but the latter may even assume symbolic significance as in the *Calling of St Matthew*, where darkness lies menacingly over the table around which St Matthew and his companions sit. In the majority of the post-Roman pictures the relation of figures to space changes in one direction, the most telling examples being the Syracuse *Burial of St Lucy* [14] and the Messina *Raising of Lazarus* [15].[20] Here the deeply disturbing and oppressive quality of the void is rendered more acute by the devaluation of the individual figures. Following Italian tradition, during the middle period each single figure was sharply individualized; in the late pictures, by contrast, figures tend at first glance to merge into an almost amorphous mass. As one would expect, traditional gestures are

abandoned and emotions are expressed by a simple folding of the hands, by a head held pressed between the palms or bowed in silence and sorrow. When ample gestures are used, as in the *Raising of Lazarus*, they are not borrowed from the stock of traditional rhetoric, as were the upraised hands of the Mary in the *Deposition* or the extended arms of St Paul in the *Conversion* [13]. The spread-out arms of Lazarus at the moment of awakening have no parallel in Italian painting.

In his early pictures, Caravaggio often created an atmosphere of peculiar still life permanency. During the middle period he preferred a transitory moment, stressing the dramatic climax of an event, as in the first *Supper at Emmaus*, the *Judith killing Holofernes* (Rome, Galleria Nazionale, Palazzo Barberini), and the *Conversion of St Paul*. In the late period, the drama is often transposed into a sphere of ghost-like unreality. Although in a picture like the Naples *Flagellation of Christ* no real action is shown and the hangmen do not strike, as was the rule in the iconographical tradition, the scene is more cruel and infinitely more gripping and Christ's suffering even more poignant than in any previous rendering of the subject in Italy.

Many of Caravaggio's pictures of the middle period are tied to tradition not only in their language of expressive ges-

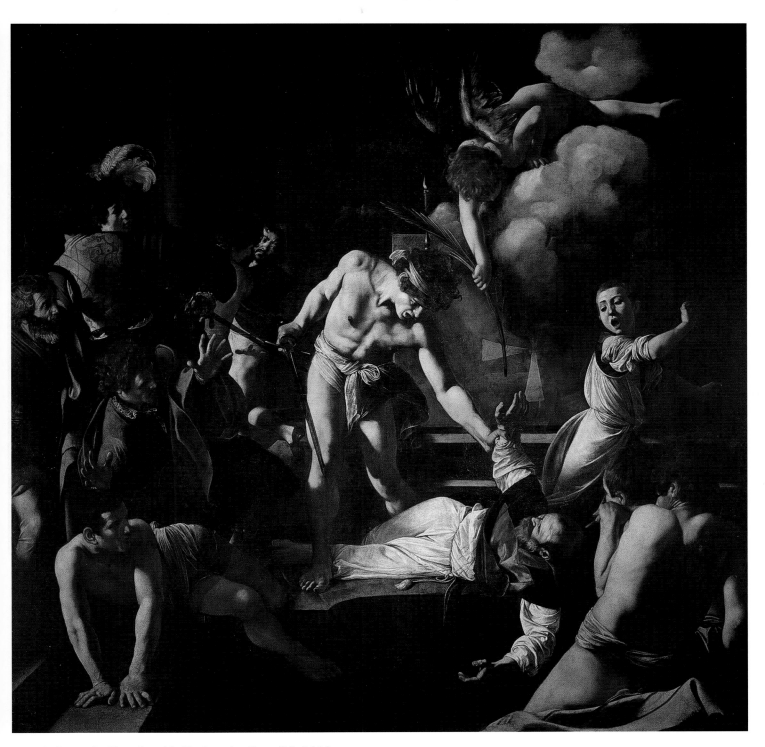

16. Caravaggio: *Martyrdom of St Matthew*, 1600. Rome, S. Luigi de' Francesi, Contarelli Chapel

ture and in their iconography,[21] but even in their compositional arrangement. In this respect, perhaps none of his monumental works is more indebted to the past than the *Martyrdom of St Matthew* [16]. In this work he used to a considerable extent the Mannerist repertory of repoussoir figures together with compositional devices and refinements which were becoming rare at this moment in Rome.[22] The type of composition with the figures revolving, as it were, round a central pivot is dependent on works like Tintoretto's *St Mark rescuing a Slave*, while the group of the executioner, saint, and frightened acolyte is borrowed from Titian's *Death of St Peter Martyr* (destroyed). It is not

unlikely that the present composition, painted over an entirely different earlier one, was a concession forced upon Caravaggio by the difficulties which he encountered during the work in the Contarelli Chapel. This explanation is also suggested by the unique occurrence in his *œuvre* of an angel appearing from heaven upon clouds. Clouds were the traditional emblem to be used for the representation of visions and miracles: Caravaggio never admitted them, with this one exception. Whenever he had to show angels, he robbed them of those soft props which by no stretch of the imagination can support a figure of flesh and blood in the air.

Most of the later Roman works are much more severely

constructed than the *Martyrdom of St Matthew*, witness the *Deposition of Christ* or the *Death of the Virgin*. But the post-Roman paintings are by comparison even more austere, and their compositions are reduced to a seemingly artless simplicity. Reference may be made to the solid triangle of figures in the Messina *Adoration of the Shepherds*, the closely packed group of figures in the *Lazarus*, or the hieratic symmetry of the coactors in the *Decapitation of St John*.

Looking at his early work in particular, one may be inclined, as generations have been, to regard Caravaggio as an artist who renders what he sees with meticulous care, capturing all the idiosyncrasies of his models. Caravaggio himself seems to have spread this legend, but we have already seen how little it corresponds to the facts. Moreover, apart from his recognizably autograph style, he developed what can only be called his own repertory of idiomatic formulas for attitudes and poses, the recurrent use of which was surely independent of any life model.[23] In addition, he sacrificed by degrees the interest in a logical disposition and rational co-ordination of the figures in favour of the emotional impact he wished to convey. This tendency is already noticeable in the early *Musical Party*, and is much more in evidence in the works after 1600. In one of the most striking pictures of this period, the *Conversion of St Paul*, it is impossible to say where the saint's lower right leg would be or how the attendant's legs can possibly be joined to his body. Later, in the post-Roman works, he was on occasions quite reckless, and nowhere more so than in the *Seven Works of Mercy*, one of his most moving and powerful pictures. The meaning of this procedure becomes patently clear in the *Burial of St Lucy* [14]. By enormously exaggerating the size of the grave-diggers, sinister and obnoxious creatures placed painfully close to the beholder, and by representing them out of all proportion to the scale of the mourners only a few steps further back, the brutality and senselessness of the crime are more convincingly exposed than could ever have been done by a 'correct' distribution of figures in space.

All these observations lead one to conclude that Caravaggio progressively abandoned working from life models and that his post-Roman pictures, above all, were to a large extent painted from memory. This is also supported by the fact that no drawings by Caravaggio survive. He must, of course, have drawn a good deal in Peterzano's studio, but he seems to have reversed Mannerist procedure once he was on his own. Compared with the Renaissance masters, late Mannerists neglected studies from nature; they used stock poses for their preparatory designs and cartoons. It may be surmised that Caravaggio, by contrast, made many incidental sketches from nature, which one would not expect to survive, but dispensed with any form of cumbersome preparation for his paintings. In fact it is well known that he worked *alla prima*, straight on to the canvas, and this is the reason why his pictures abound in *pentimenti*, which can often be discovered with the naked eye. This procedure, admirably suited to his mercurial temperament, makes for directness and immediacy of contact between the beholder and the picture, whereas distance and reserve are the obvious concomitants of the 'classical' method[24] of arriving at the finished work by slow stages.

Caravaggio's *ad hoc* technique stemmed from a Venetian tradition, but in Venice, where preparatory drawings were never entirely excluded, this 'impressionist' approach to the canvas had two consequences which seem natural: it led to a painterly softening of form and to an emphasis on the individual brush-stroke. In Caravaggio's work, however, the forms always remain solid, his paint is thin, and consequently the brush-stroke is hardly perceptible. In his middle period it begins to be more noticeable, particularly in the highlights, while in his post-Roman pictures two new conflicting tendencies are apparent. On the one hand, forms harden and stiffen, and bodies and heads may be painted with little detail and few transitions between light and dark – resulting in near-abstractions. Certain passages in the *Seven Works of Mercy* illustrate this trend very fully. Side by side with this development can be found what is, by comparison, an extremely loose technique: the face of Lazarus, for example, is rendered by a few bold brush-strokes only. Instead of the careful definition of form still prevalent during the middle period, or the daring simplification and petrifaction of form in certain post-Roman works, one is faced in the *Raising of Lazarus* with shorthand patterns symbolizing heads, arms, and hands.

Little has so far been said about the most conspicuous and at the same time the most revolutionary element of Caravaggio's art, his *tenebroso*. With his first monumental commissions he changed from the light and clear early Roman style to a new manner[25] which seemed particularly suitable to religious imagery, the main concern during the rest of his life. Figures are now cast in semi-darkness, but strong light falls on them, models them, and gives them a robust three-dimensional quality. At first one may be inclined to agree with the traditional view that his lighting is powerfully realistic; it seems to come from a definable source, and it has even been suggested that he experimented with a *camera obscura*. Further analysis, however, shows that his light is in fact less realistic than Titian's or Tintoretto's. In Titian's as later in Rembrandt's pictures light and darkness are of the same substance; darkness only needs light to become tangible; light can penetrate darkness and make twilight space a vivid experience. The Impressionists discovered that light creates atmosphere, but theirs is a light without darkness and therefore without magic. With Caravaggio light isolates; it creates neither space nor atmosphere. Darkness in his pictures is something negative; darkness is where light is not, and it is for this reason that light strikes upon his figures and objects as upon solid, impenetrable forms and does not dissolve them, as happens in the work of Titian, Tintoretto, or Rembrandt.

The setting of Caravaggio's pictures is usually outside the realm of daily life. His figures occupy a narrow foreground close to the beholder. Their attitudes and movements, their sudden foreshortenings into an undefined void, heighten the beholder's suspense by giving a tense sensation of impenetrable space. But despite, or because of, its irrationality, his light has power to reveal and to conceal. It creates significant patterns. The study of a picture like the Doria *St John the Baptist* [17] of about 1600,[26] which derives from the nudes of the Sistine ceiling, will clarify this point. The pattern created by light and darkness almost gainsays the natural artic-

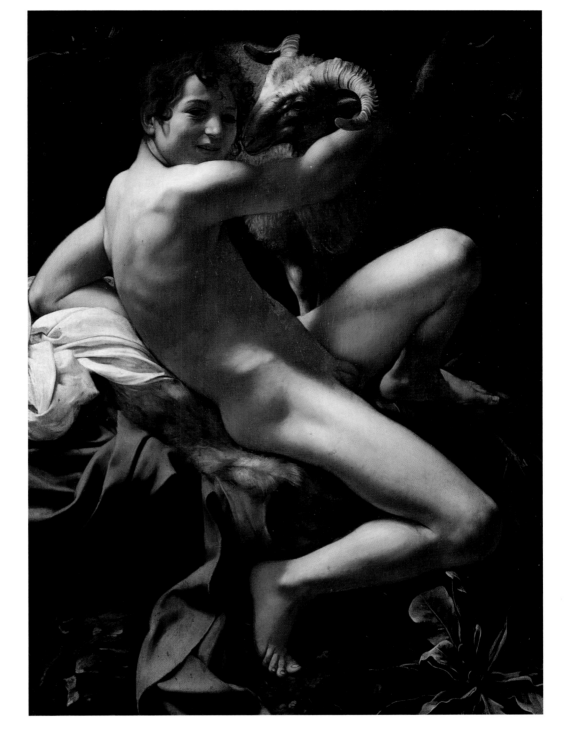

17. Caravaggio: *St John the Baptist*, c. 1600. Rome, Capitoline Museum

ulation of the body. Light passages radiate from a darker centre like the spokes of a wheel. Thus by superimposing a stylized play of light and shade over the natural forms, an extraneous concept is introduced which contradicts Michelangelo's organic interpretation of the human body. Caravaggio used wheel-patterns of light in some of the multi-figured compositions of his later Roman years, for instance the *Martyrdom of St Matthew*, the *Crucifixion of St Peter*, and the *Death of the Virgin*. A glance at the illustration of the *Martyrdom* [16] suffices to see that the abstract pattern of light is given precedence in the organization of the canvas. It is the radiating light that firmly 'anchors' the

composition in the picture plane and, at the same time, singles out the principal parts of dramatic import. In pictures of the middle period the areas of light are relatively large and coherent and coincide with the centre of interest. In the late pictures darkness engulfs the figures; flashes and flickers of light play over the surface, heightening the mysterious quality of the event depicted. This is nowhere more striking than in the *Raising of Lazarus*, where heads, pieces of drapery, and extremities break through the surrounding darkness – a real-unreal scene over which broods an ineffable sense of mystery.

From the very beginning of Christian imagery light has

been charged with symbolism. God's presence in the Old Testament or Christ's in the New is associated with light, and so is Divine Revelation throughout the Middle Ages, whether one turns to Dante, Abbot Suger, or St Bonaventura. Although from the fifteenth century onwards light is rendered naturalistically and even atmospherically, particularly in Venice, it never loses its supernatural connotation, and the Baroque age did not break with this tradition. Nevertheless, painters of religious imagery were always faced with the seemingly insoluble problem of translating visions into pictorial language. Describing St Francis's stigmatization, St Bonaventura says 'when the vision had disappeared, it left a wonderful glow in his [St Francis's] heart'. Giotto was quite incapable of translating the essence of these words into pictorial language. He and many after him had to express the human experience of mystical union with God by a descriptive, narrative method. Language was far in advance of the visual arts. Seventeenth-century painters caught up with it. A painter like Cigoli was well able to render St Francis's psycho-physical reactions [65]. But although he made true in his painting the sensation described by Bonaventura, he was still tied to the traditional descriptive method: for the vision itself is shown bathed in heavenly light breaking through the clouds. It must be remembered that the ecstasy of vision is a state of mind to which no outsider is admitted; it is perception and revelation inside one man's soul. This was the way Caravaggio interpreted visions from the very beginning. In his *Ecstasy of St Francis* of about 1595[27] he showed the saint in a carefully observed state of trance; one eye is closed; the other, half open, stares into nothingness and the body, uncomfortably bent backward, seems tense and stiff. Mystery is suggested by the glimmer of light breaking through the dark evening sky. The invisible is not made visible, but we are allowed to wonder and to share; a wide scope is left for the imagination. It is the light alone that reveals the mystery, not light streaming down from the sky or radiating from the figure of Christ. The mature Caravaggio drew the last consequences. In his *Conversion of St Paul* he rendered vision solely on the level of inner illumination. Light, without heavenly assistance, has the power to strike Saul down and transform him into Paul, in accordance with the words of the Bible: 'Then suddenly there shone round about him a light from Heaven and he fell to the earth and heard a voice say unto him: Saul, Saul, why persecutest thou me?' Paul, eyes closed, mouth open, lies completely absorbed in the event, the importance of which is mirrored in the moving expression of the enormous horse.

By excluding a heavenly source, Caravaggio sanctified light and gave it a new symbolic connotation. One may return to the study of his symbolic use of light in the *Calling of St Matthew*, where Christ stands in semi-darkness and the wall above him shines bright, while a beam of light falls on those who, still under the large shadow of darkness, are about to be converted. It is precisely the antithesis between the extreme palpability of his figures, their closeness to the beholder, their uncomeliness and even vulgarity – in a word, between the 'realistic' figures and the unapproachable magic light that creates the strange tension which will not be found in the work of Caravaggio's followers.

It has been shown in the first chapter that Caravaggio had devoted patrons among the liberally minded Roman aristocracy. And yet, his large religious pictures were criticized or refused with almost clockwork regularity.[28] The case of the *Death of the Virgin* throws an interesting light on the controversy which his works aroused and the fervour of the partisanship. It was rejected by the monks of S. Maria della Scala, the church of the Discalced Carmelites; but Rubens, at that time in Rome, enthusiastically advised his patron the Duke of Mantua to acquire the painting for his collection. Before it left Rome, however, the artist arranged a public exhibition and great crowds flocked to see the work. Caravaggio's opponents, it seems, were mainly recruited from the lower clergy and the mass of the people. They were disturbed by theological improprieties and offended by what appeared an irreverent treatment of the holy stories and a lack of decorum. They were shocked to find their attention pinpointed by such realistic and prominent details as the dirty feet in the *St Matthew* and the *Madonna di Loreto* or the swollen body of Mary in the *Death of the Virgin*. Only the *cognoscenti* were able to see these pictures as works of art.

It is a paradox that Caravaggio's religious imagery, an art of the people for the people, was heartily distrusted by the people; for it can scarcely be denied that his art was close in spirit to that popular trend in Counter-Reformation religion which was so marked in the activity of St Charles Borromeo in Milan and St Philip Neri in Rome as well as in St Ignatius's *Spiritual Exercises*.[29] Like these reformers, Caravaggio pleaded through his pictures for man's direct gnosis of the Divine. Like them he regarded illumination by God as a tangible experience on a purely human level. It needed his genius to express this aspect of reformed religion. His humanized approach to religious imagery opened up a vast new territory; for his work is a milestone on the way to the representation of those internalized 'private' visions which his own period was still unable and unwilling to render.

The aversion of the people to his truly popular art is not the only paradox in Caravaggio's life. In fact the very character of his art is paradoxical, and the resulting feeling of awe and uneasiness may have contributed to the neglect and misunderstanding which darkened his fame. There is in his work a contrast between the tangibility of figures and objects and the irrational devices of light and space; between meticulous study from the model and disregard for representational logic and coherence; there is a contrast between his *ad hoc* technique and his insistence on solid form; between sensitivity and brutality. His sudden changes from a delicacy and tenderness of feeling to unspeakable horror seem to reflect his unbalanced personality, oscillating between narcissism and sadism. He is capable of dramatic clamour as well as of utter silence. He violently rejects tradition but is tied to it in a hundred ways. He abhors the trimmings of orthodoxy and is adamant in disclaiming the notion that supernatural powers overtly direct human affairs, but brings the beholder face to face with the experience of the supernatural. But when all is said and done, his types chosen from the common people, his magic realism and light reveal his passionate belief that it was the simple in spirit, the humble and the poor who held the mysteries of faith fast within their souls.

The Carracci

At the beginning of the last chapter it was noted that it is still customary to see Caravaggio and Annibale Carracci as the great antagonists in Rome at the dawn of the seventeenth century. The differences between them are usually summed up in pairs of contrasting notions such as naturalism–eclecticism, realism–classicism, revolt–traditional. This erroneous historical conception has grown over the centuries, but before the obvious divergencies to be found in their art hardened into such antithetical patterns, contemporaries believed that the two masters had much in common. Thus the open-minded collector and patron Marchese Vincenzo Giustiniani, who has often been mentioned in these pages, explained in a famous letter[1] that, in his view, Caravaggio, the Carracci, and a few others were at the top of a sliding scale of values, because it was they who knew how to combine in their art *maniera* and the study from the model: *maniera* being, as he says, that which the artist 'has in his imagination, without any model'. Vincenzo Giustiniani clearly recognized the *maniera* in Caravaggio and also implied by his wording that the mixture of *maniera* and realism (i.e. work done directly from the model) was different in Caravaggio and the Carracci. Even though our terminology has changed, we are inclined nowadays to agree with the opinions of the shrewd Marchese.

Nevertheless it was, of course, Annibale Carracci and not Caravaggio who revived the time-honoured values in Italian art and revitalized the great tradition manifest in the development of painting from Giotto to Masaccio and on to Raphael. Caravaggio never worked in fresco. But it was monumental fresco-painting that educated Italians of the seventeenth and eighteenth centuries still regarded as the finest flower of art and the supreme test of a painter's competence. This approach, which was deeply rooted in their theoretical premises and historical background, was detrimental to the fortunes of the easel-painter Caravaggio. It helped, on the other hand, to raise Annibale Carracci to his exalted position, for, next to Raphael's Stanze and Michelangelo's Sistine Ceiling, his frescoes in the Farnese Gallery were regarded until the end of the eighteenth century as the most important landmark in the history of painting. And now that we are beginning to see rule rather than freedom in Caravaggio's work, we are also able once again to appreciate and assess more positively than writers of the last 150 years[2] the quality of Annibale's art and his historical mission. Once again we can savour those virtues in Annibale's bold and forthright 'classicism' which were inaccessible to the individualist and 'realist' Caravaggio.

One must study Annibale's artistic origins and see him in relation to the other painters in his family in order to understand the special circumstances which led up to the climax of his career in the frescoes of the Farnese Gallery. Among the various attempts at reform during the last decades of the sixteenth century Bologna soon assumed a leading position, and this was due entirely to the exertions of the three Carracci. Agostino (1557–1602) and Annibale (1560–1609) were brothers; their cousin Lodovico (1555–1619) was their senior by a few years. It was Lodovico without any shadow of doubt who first pointed the way to a supersession of the complexity, sophistication, and artificiality of Late Mannerism. In the beginning the three artists had a common studio, and during the early period of their collaboration it is not always easy to distinguish between their works.[3] After 1582 they opened a private 'academy', which had, however, a quite informal character. This active school, in which special emphasis was laid on life drawing, soon became the rallying point of all progressive tendencies at Bologna.[4] At the same period, in the early 1580s, the personalities of the three Carracci become more clearly defined, and from about 1585 onwards a well-documented series of large altarpieces permits us to follow the separate developments of Annibale and Lodovico. Agostino, a man of considerable intellectual accomplishments, was primarily an engraver and also, so it seems, a devoted teacher with a real knack of communicating the elements of his craft.[5] As a painter he attached himself to Annibale rather than Lodovico. It is, therefore, justifiable to concentrate on the two latter artists and begin with a study of some of their fully developed Bolognese works as a springboard to a correct assessment of the pre-Roman position.

Annibale's *Virgin with St John and St Catherine* of 1593 (Bologna, Pinacoteca) [18][6] immediately calls to mind works of the Central Italian High Renaissance of 1510–15. Three powerfully built figures are joined by the compositional device of the triangle, well known from High Renaissance paintings, and are placed in front of a simple and massive classical architecture. Moreover the *contrapposto* is extended from governing the unit of each figure to determining the greater unit of the whole, for the two saints, left and right of the central axis, form balanced contrasts. This is the compositional method first practised by Leonardo and followed by Raphael, Fra Bartolommeo, and other High Renaissance masters. Also the firm stance and the clear, unequivocal gestures and expressions of Annibale's figures are reminiscent of early sixteenth-century Florentine art. But Annibale's deep, warm, and glowing colours, replacing the pale, often *changeant* hues of Mannerism, give his work a distinctly down-to-earth quality; by comparison, Central Italian High Renaissance paintings appear cold and remote. Annibale's rich and mellow palette derives from Correggio and the Venetians. These masters rather than Raphael were from the beginning of his career his consciously elected guides in the revolt against contemporary Mannerism. The

Virgin with St John and St Catherine is, in fact, the first picture in which Annibale's turn to a Central Italian type of composition is evident.

Individual motives prove that even at this important moment Annibale was more indebted to North than to Central Italian models: the figure of St Catherine is borrowed from Veronese, the medallion on the throne from Correggio's throne in the *Virgin with St Francis* (Dresden), and the Child resting one foot on His Mother's foot from Raphael's *Madonna del Cardellino* (Louvre). These models were used almost undisguised, for everyone to see. At this juncture it may be asked whether such a picture is a sterile imitation, an 'eclectic' mosaic selected from acknowledged masterpieces. The reader hardly needs to be reminded that until fairly recently the term 'eclectic' was liberally employed to support the condemnation of post-Renaissance art in general and that of the Carracci in particular; nor has this designation disappeared from highly competent specialized studies.[7] If the term 'eclecticism' implies the following of not only one but more than one and even many masters, Annibale, like so many artists before and after him, availed himself of a traditional Renaissance method; a method advocated, for instance, by Leonardo as the proper road to a distinguished style. This procedure came into disrepute only with the adulation of the *naïveté* of genius in the Romantic era.[8] If 'eclecticism' is used, however, as a term to expose a lack of co-ordination and transformation of models – and in this sense it may justifiably be used – then it does not fit the case under review; for, like every great artist, Annibale did create something entirely new from his models: he wedded Correggiesque *sfumato* and warm Venetian tone values to the severe compositional and figure conceptions of the Central Italian High Renaissance, while at the same time he gave his figures a sculptural quality and palpability which will be sought in vain during the High Renaissance, but which conform to the seventeenth-century feeling for mass and texture.

Some of the steps by which Annibale arrived at this important phase of his development may be retraced. The *Crucifixion* of 1583 (Bologna, S. Niccolò) illustrates his Mannerist beginnings. Two years later, in the *Baptism of Christ* (Bologna, S. Gregorio) [19], the Correggiesque quality cannot be overlooked, although formally and colouristically Annibale is here still struggling against the older conventions. After that date he surrenders increasingly to Correggio's colour and emotional figure conceptions. This development may be followed from the Parma and Bridgewater House *Lamentations over the Body of Christ* (the latter destroyed) to the Dresden *Assumption of the Virgin* of 1587 [20]. From then on, Titian and Veronese begin to replace Correggio, with important consequences: Titian's dramatic colour contrasts replace the lighter Parmese tonality, and Venetian composure and gravity Correggio's impetuous sensibility. To assess this change, one need only compare the *Assumption* of 1592 (Bologna, Pinacoteca) with the earlier versions of the same subject. But already the Dresden *Virgin with St John, St Francis, and St Matthew* of 1588 [21] was essentially Venetian, as the asymmetrical, Veronese-like composition immediately reveals. None the less Correggio's grace and charm pervade the picture, and it must be said at once that in spite of his reduced influence,

19. Annibale Carracci: *The Baptism of Christ*, 1585. Bologna, S. Gregorio

18. (*opposite*) Annibale Carracci: *The Virgin with St John and St Catherine*, 1593. Bologna, Pinacoteca

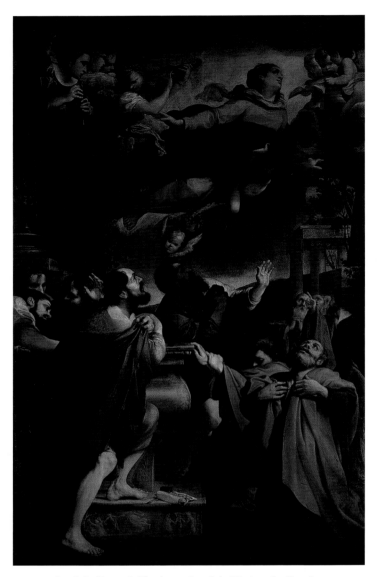

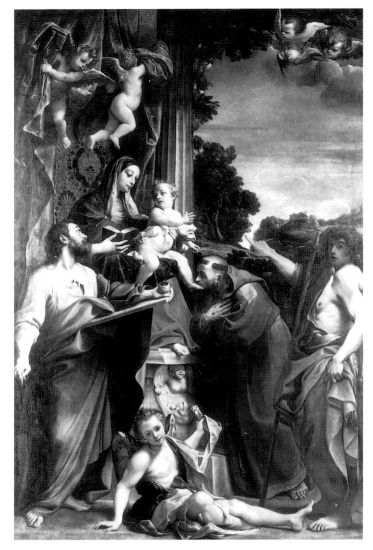

20. Annibale Carracci: *The Assumption of the Virgin*, 1587. Dresden, Gemäldegalerie

21. Annibale Carracci: *The Virgin with St John, St Francis and St Matthew*, 1588. Dresden, Gemäldegalerie

22. (*opposite*) Lodovico Carracci: *The Holy Family with St Francis*, 1591. Cento, Museo Civico

the Correggiesque component remained noticeable even in Annibale's Roman years. The trend of his development is clear: the character of his late Bolognese works continued to be pre-eminently Venetian right to his departure from Bologna; he moved away from Correggio towards solidity and clear definition of attitudes and expressions and towards an impressive structural firmness of the whole canvas.

His cousin Lodovico turned in a different direction. A study of his *Holy Family with St Francis* of 1591 (Cento, Museo Civico) [22] makes this abundantly evident. The basic conception of such a picture has little in common with Titian, as a comparison with the latter's *Pesaro Madonna* may show. The principal group recurs in both pictures: the Virgin on a high throne with St Joseph beneath and St Francis who recommends with a pleading gesture the donors in the right-hand corner. Yet how different is the interpretation! The mere bulk and weight of Lodovico's figures make his work different in essence from any

Renaissance painting. Moreover, St Joseph and St Francis have exchanged places, with the result that, in contrast to Titian's work, the relation between the donors, St Francis, and the Virgin runs zigzag across the picture. Lodovico's figures are deeply engaged and their mute language of gestures and glances is profoundly felt – very different from Titian's reserve as well as from the cold correctness of the Mannerists. It is precisely this emphasis on gesture and glance that strikes a new note: St Francis's eyes meet those of the Virgin and emotions quiver; the mystery of Divine Grace has been humanized, and this is also implied in the spontaneity of the Child's reaction. All the registers are pulled to draw the beholder into the picture. He faces the Virgin, as does St Francis – indeed, he can imagine himself kneeling directly behind the saint; the close viewpoint helps to break down the barrier between real and painted space and, at the same time, the strong *sotto in sùß* ensures that the Virgin and Child, in spite of their nearness, remain in a

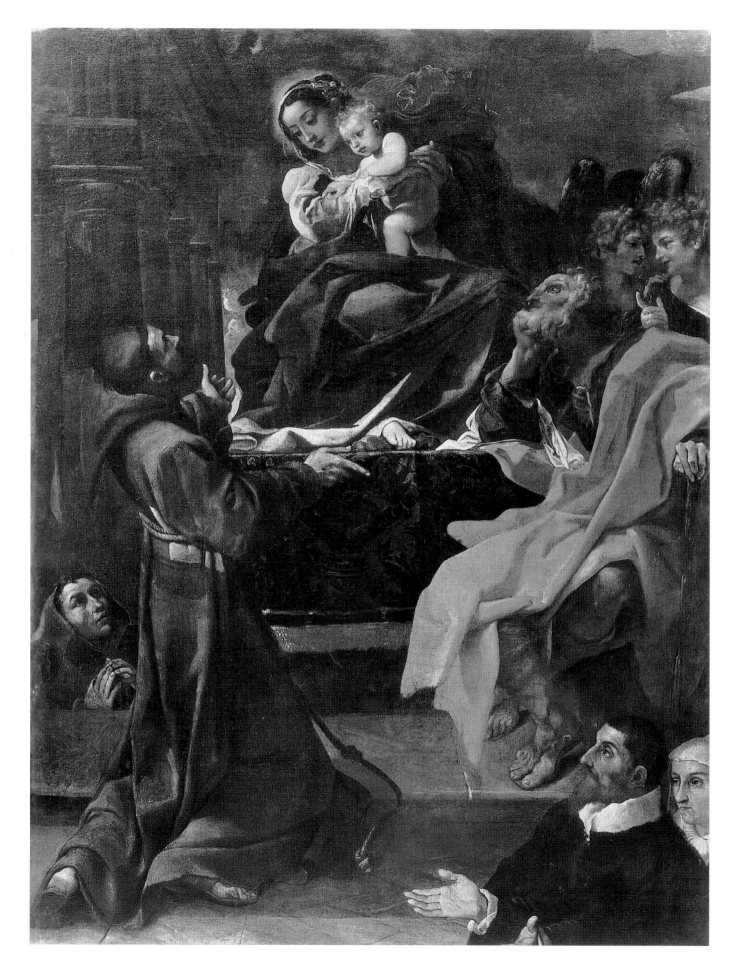

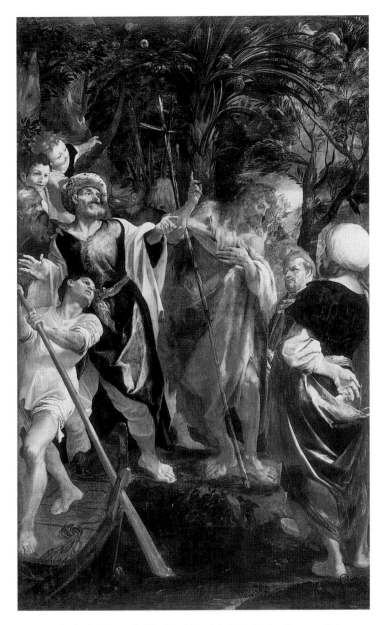

23. Lodovico Carracci: *The Preaching of St John the Baptist*, 1592. Bologna, Pinacoteca

world removed from that of the beholder. Titian, by contrast, has done everything to guarantee the inviolability of the picture plane and, compared with Lodovico's, his figures show the restraint and aloofness of a cult image.

Although for the sheer volume of the figures and the immediacy of their presence the two cousins form here in the early nineties what might be called a 'united Seicento front', the spirit informing Annibale's art is closer to that of the Renaissance masters than to Lodovico's, for Annibale lacks Lodovico's intense emotionalism. It is only to be expected that their approach to colour would also be fundamentally different. Annibale, conforming to the Renaissance tradition, used light and shade, even in his most painterly Bolognese works, primarily to stress form and structure. Lodovico, on the other hand, created patterns of light and dark often independent of the underly-

ing organic form; and he even sacrificed clarity to this colouristic principle. One need only compare the right knee and leg of the Virgin in illustrations 18 and 22 to see how decisively Annibale's and Lodovico's ways part. It is evident that Lodovico owed much more than Annibale to the study of Tintoretto, in whose pictures one finds those brilliant and sudden highlights, that irrational flicker which conveys emotion and a sense of mystery. The basic quality of classic art, namely clear definition of space and form, meant very little to an artist steeped in this painterly tradition. It is characteristic of this approach that foreground stage and background scenery are often unrelated in Lodovico's pictures; in the Cento altarpiece [22] the colonnade looks like an added piece of stage property, and the acolyte behind St Francis emerges from an undefined cavity. Such procedure frequently makes the 'readability' of Lodovico's settings elusive.

For the sake of clarity, we may now define the difference between Annibale and Lodovico as that between the Classical and the Baroque, never forgetting of course that there is in their work that close affinity which we have noticed, and that I am, therefore, stretching the terms beyond their permissible limits. But with this proviso it may be said that Lodovico at the beginning of the nineties had evolved a painterly Baroque manner in contradistinction to Annibale's temperate classicism. Although pictures of such importance as the *Madonna dei Bargellini* of 1588 and the *Preaching of St John* of 1592 [23] (both Pinacoteca, Bologna) are essentially Venetian with Correggiesque overtones – in the *St John* he followed Veronese for the composition and Tintoretto for the light – Lodovico's whole trend in these years is towards the colossal, the passionate, dramatic, and heroic, towards rich movement and surprising and capricious light effects; in a word, away from Venice and towards the style of Correggio's fresco in the dome of Parma Cathedral. The principal document of this tendency is the *Transfiguration* of 1593 (Bologna, Pinacoteca); pictures like the dramatic *Conversion of St Paul* of 1587–9, the *Flagellation* and *Crowning with Thorns* of 1594–5 (all three Bologna, Pinacoteca), even the ecstatic *St Hyacinth* of 1594 (Louvre), illustrate this Baroque taste. To a certain extent, therefore, Lodovico and Annibale after their common Mannerist beginnings developed in different directions.

With advancing age, however, and after the departure of his cousins from Bologna, Lodovico's work became by degrees retrogressive, and some of his late pictures show a return to patently Mannerist principles.[9] With some signal exceptions, there was at the same time a notable decline in the quality of his art. The better pictures of this period, like the *Meeting of St Angelus with St Dominic and St Francis*, the *Martyrdom of St Angelus*, and *St Raymond walking over the Sea* [24] (all three 1608–10,[10] Bologna, Pinacoteca and S. Domenico), appeal by the depth of mystical surrender and by their linear and decorative grace; his failures show a studied, superficial classicism, mask-like expressions, tired gestures, and a veneer of elegant sweetness.[11] Lodovico's sense for decorative patterns, his emotionalism, and above all his painterly Baroque approach to colour and light contained potentialities which were eagerly seized on by masters of the next generation, particularly by Lanfranco and Guercino;

taken all in all his influence on the formation of the style of the younger Bolognese masters cannot be overestimated. But it was mainly his earlier manner up to about 1600 which attracted them, while his less satisfactory later manner had often an irresistible appeal to minor masters who were directly or indirectly dependent on him, such as Francesco Brizio (1574–1643), Lorenzo Garbieri (1580–1654), and even Reni's pupil Francesco Gessi (1588–1649). It is then evident that Lodovico was not the man to lead painting back to classical poise and monumentality. Such qualities were, however, manifest in Annibale's work of the 1590s and were even implicit in his pictures of the 1580s. It was therefore more than mere chance that he, rather than Lodovico, accepted Cardinal Odoardo Farnese's invitation to come to Rome to paint monumental frescoes in his palace.

With Annibale's departure in 1595 the common studio broke up. Two years later Agostino followed him, leaving Lodovico alone in Bologna. During his ten active years in Rome, between 1595 and 1605, Annibale fulfilled the promise of his late Bolognese work: he became the creator of a grand manner, a dramatic style buttressed by a close study of nature, antiquity, Raphael, and Michelangelo. It was this style, equally admired by such antipodes as Poussin and Bernini, on which the future of 'official' painting depended for the next 150 years.

Annibale's first work in the Farnese Palace was the decoration with frescoes of a comparatively small room, the so-called Camerino Farnese, executed between 1595 and 1597, before Agostino's arrival. On the ceiling and in the lunettes he painted scenes from the stories of Hercules and Ulysses, which have, in accordance with contemporary taste, not only a mythological but also an allegorical meaning: they illustrate the victory of virtue and effort over danger and temptation.[12] The decorative framework in which the stories are set is still dependent on North Italian models, in particular on the monochrome decorations in the nave of Parma Cathedral; but in the structure of the mythological scenes and in the treatment of individual figures the impact of Rome begins to be noticeable. It was fully developed in the Gallery of the same palace, the decoration of which began in 1597 and may not have been completely finished until 1608.[13]

The hall of about 60 by 20 feet has, above the projecting cornice, a coved vault which Annibale was asked to decorate with mythological love scenes chosen from Ovid's *Metamorphoses* [25]. It has been made probable that Cardinal Farnese's librarian, Fulvio Orsini, wrote the programme for the ceiling[14] and that in the final stages Annibale's learned friend, Monsignor Giovan Battista Agucchi, may have acted as adviser.[15] The theme is the power of all-conquering love, to which even the gods of antiquity succumb. In contrast to the emblematic character of most Mannerist cycles of frescoes the programme of this ceiling is centred on mythology, and Annibale painted the stories with such vigour and directness that the beholder is absorbed by the narrative and entertaining spectacle before his eyes rather than distracted by the less obvious symbolical and moralizing implications.[16] In this joyful and buoyant approach to classical antiquity a return will be noticed to the spirit of Raphael's *Cupid and Psyche* frescoes in the Farnesina.

It was precisely at the moment when Caravaggio began

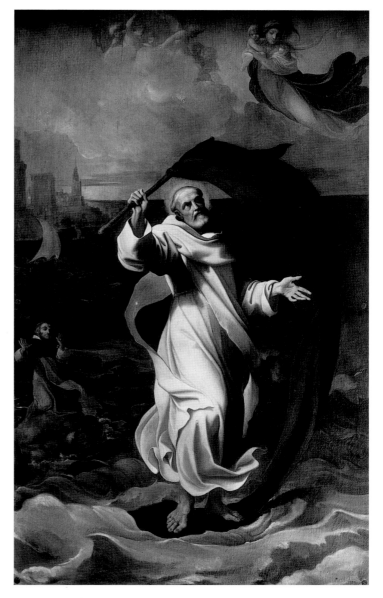

24. Lodovico Carracci: *St Raymond walking over the Sea*, 1608–10. Bologna, S. Domenico

his career as a painter of monumental religious pictures that Annibale turned to monumental mythologies on an unprecedented scale. And just as Caravaggio found a popular idiom for religious imagery, Annibale perfected his highly civilized manner to cater for the refined taste of an exclusive upper class. The very fact that his patron, a prince of the Church and one, moreover, who bore that family name, surrounded himself with frescoes of this nature is indicative of a considerable relaxation of counter-reformatory morality. The frescoes convey the impression of a tremendous *joie de vivre*, a new blossoming of vitality and of an energy long repressed.

For the organization of the whole work Annibale experimented with a number of possibilities. He rejected simple friezes, suitable only for rooms with flat ceilings, a type of decoration used by him and his collaborators in the Palazzi

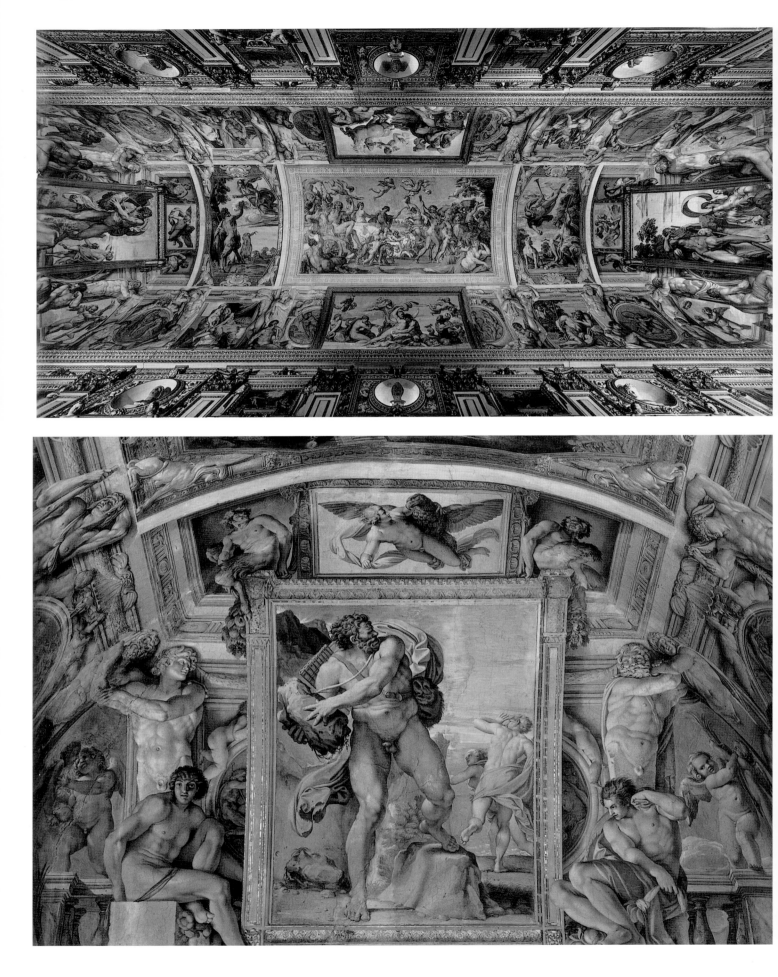

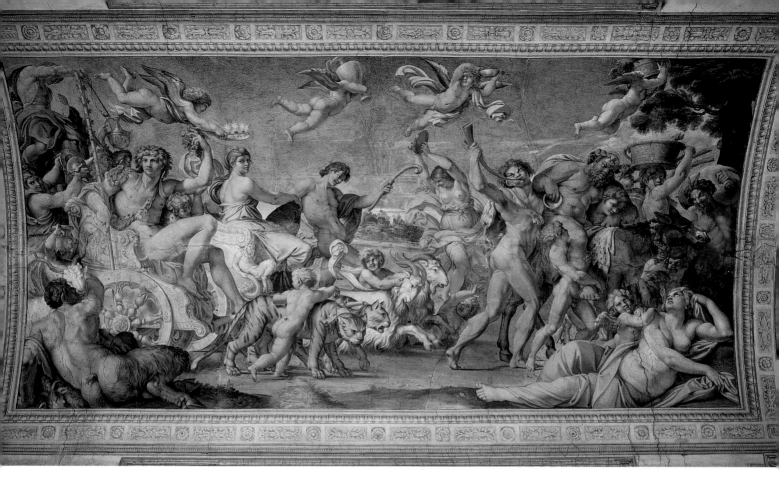

25. (*opposite, above*) Annibale Carracci: The Farnese Gallery, begun 1597. Frescoes. Rome, Palazzo Farnese

26. (*opposite, below*) Annibale Carracci: *Polyphemus*. Farnese Gallery [cf. 25]

27. (*above*) Annibale Carracci: *The Triumph of Bacchus and Ariadne*. Farnese Gallery [cf. 25]

Fava and Magnani-Salem at Bologna. Other Bolognese reminiscences,[17] however, were to have a more lasting influence, namely the Ulysses cycle in the Palazzo Poggi (now the University), where Pellegrino Tibaldi had combined pictures painted like easel-paintings with figures in the corners of the ceiling perspectively foreshortened for the view from below. This is a combination first found in Raphael's Logge in the Vatican,[18] which were, of course, well known to Annibale. Illusionist architectural painting *(quadratura)*, aimed at extending real architecture into an imaginary space, had existed ever since Peruzzi had 'opened up' the Sala delle Colonne in the Villa Farnesina about 1516, but it was not until the second half of the sixteenth century that *quadratura* on ceilings really came into its own. Bologna, *di scienze maestra* (Bellori), was the centre of this practice, which required an intimate knowledge of the theory of perspective. When the Bolognese Pope Gregory XIII (1572–85) summoned Tommaso Laureti and Ottaviano Mascherino from Bologna to paint in the Vatican Palace, *quadratura* gained a firm foothold in Rome. It had its most resounding triumph in Giovanni and Cherubino Alberti's decoration of the Sala Clementina in the Vatican, executed between 1596 and 1598, that is exactly when Annibale began his Farnese ceiling.[19] *Quadratura* was then the last word in wall- and ceiling-painting, sanctioned, moreover, by the highest papal authority. Annibale, however, decided not to use pure *quadratura* but to follow the Palazzo Poggi type of 'mixed' decoration. Like Tibaldi, he painted the mythological scenes as *quadri riportati*, that is, as if they were framed easel pictures transferred to the ceiling, and incorporated them in a *quadratura* framework. His decision to use *quadri riportati* for the principal scenes was almost certainly influenced by Michelangelo's Sistine ceiling, but he was doubtless also

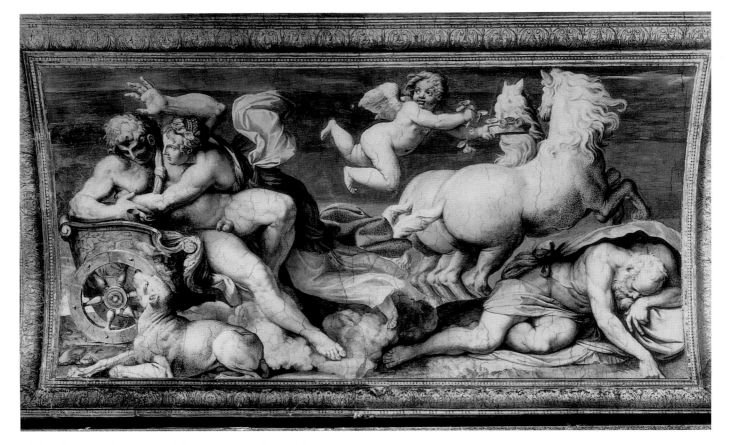

28. Agostino Carracci: *Cephalus and Aurora*, 1597–1600. Rome, Palazzo Farnese

convinced that the mythological representation, as belonging to the highest class of painting,[20] should be rendered objectively and in isolating frames. Thus, although Annibale's ceiling is much more complex than Raphael's Logge or Tibaldi's Ulysses cycle, it remains in the same tradition of compromise solutions.

Annibale devised a *quadratura* framework consisting of a large cornice fully visible only in the four corners and supported all round the room by a carefully-thought-out system of herms and atlantes [26]. It is this whole framework, together with the sitting youths handling garlands, that is foreshortened for the viewpoint of the spectator. Since all this decoration is contrived as if it were real – the seated youths of flesh-and-blood colour, the herms and atlantes of simulated stucco, and the roundels of simulated bronze – the contrast to the painted pictures in their gilt frames is emphasized, and the break in consistency therefore strengthens rather than disrupts the unity of the entire ceiling. The crowding within a relatively small space of such great variety of illusionist painting, the overlapping and superimposition of many elements of the over-all plan, logical and crystal-clear and nowhere ambiguous as it would surely be in a similar Mannerist decoration, the subtle build-up from the corners towards the centre – all this gives this work a dynamic quality quite different from the steady rhythm and comparative simplicity of Michelangelo's Sistine ceiling, to which Annibale evidently owed so many of his constituent ideas. There is here, moreover, for the first

time a noticeable continuity leading on from the real architecture of the walls to the painted decorative figures of the ceiling, and this contributes perceptibly to the dynamic unity of the entire Gallery.

The centre of the ceiling is dominated by the largest and most elaborate composition in the scheme, the *Triumph of Bacchus and Ariadne* [27]. Surviving drawings show how closely Annibale had studied Bacchanalian sarcophagi; in fact, the train of revellers in the fresco has retained something of the classical relief character, while individual figures can be closely paralleled by classical types. On the other hand, the fresco has a flowing and floating movement, a richness and exuberance which one would seek in vain either in antiquity or in the High Renaissance. The composition strikes a balance between firm classical structure and imaginative freedom; it consists of two crowded groups which rise gently from the centre of the two sides, and the caesura between them is bridged by a maenad and a satyr following the beat of the tambourine with an impetuous dance. The Bacchic retinue is compositionally enlivened and at the same time held together by the undulating rhythm of the flying cupids and by the telling *contrapposto* of the satyr and nymph below, reclining figures which have a framing as well as a space-creating function. This richness of compositional devices heralds a new age. Each single figure retains a statuesque solidity unthinkable without a thorough study and understanding of classical sculpture, and Annibale imparted something of this sculptural quality to his many

preparatory chalk drawings. Nevertheless these magnificent drawings remain at the same time close to nature, since, true to the traditions of the Carracci 'academy', every single figure was intensely studied from life. It is this new alliance between naturalism and classical models – so often in the past a life-giving formula in Italian art, but with what different results! – that accounts for the boisterous vitality of Annibale's Roman manner. His classical style, full-blooded and imaginative and buttressed by a loving study of nature, keeps the beholder at a certain distance, however, and he always remains conscious of a noble reserve. Clearly, Annibale's was a classical revival that contained many potentialities. From it a way led to Poussin's pronounced classicism as well as to the freedom of Rubens and the High Baroque. On the other hand, Annibale's combination of *quadratura* and the *quadro riportato* had only a limited following. The broad current of the Italian development turned towards a complete illusionist spatial unification.

During the execution of the Gallery, Annibale had the help of his rather pedantic brother Agostino for three years (1597–1600).[21] Contemporary sources attribute to him the two large frescoes of *Cephalus and Aurora* [28] and the so-called *Galatea*,[22] and this is borne out by the cool detachment of these paintings, which lack the *brio* and energy of Annibale's manner. In 1600 Agostino fell out with his brother, left Rome, and went to Parma, where he decorated with mythological scenes a ceiling in the Palazzo del Giardino for the Duke Ranuccio Farnese.[23] Agostino's earlier manner may best be studied in his carefully constructed, strongly Venetian masterpiece, the *Communion of St Jerome*, dating from the early 1590s (Bologna, Pinacoteca). His complete conversion to Annibale's Roman manner is evident in the Parma frescoes, which display a somewhat metallic and frozen classicism. His premature death in 1602 prevented the completion of this work.[24]

One other aspect of the Farnese ceiling should here be stressed. In his preparatory work Annibale re-established, after the Mannerist interlude, the method of Raphael and Michelangelo. Many hundreds of preparatory drawings must have existed, of which a fair number survive, and in these every single part of the ceiling was studied with the greatest care. Annibale handed down to his school this Renaissance method of slow and systematic preparation, and it is probably not too much to say that it was mainly through his agency that the method remained in vogue for the following 200 years. It broke down only in the Romantic era, when it was felt that such a tedious process of work hampered inspiration.

Annibale's development in Rome was rapid, and the few years left to him at the beginning of the new century were crowded with important works. Again, the fate and careers of Caravaggio and Annibale run strangely parallel. At about the time Caravaggio fled from Rome, never to return, Annibale retired from life stricken by a deep melancholia, and during his last years hardly touched a brush.[25] In his later canvases we can follow a progressive accretion of mass and sculptural qualities coupled with a growing economy in the compositions.[26] The *Assumption of the Virgin* of 1601 for the Cerasi Chapel in S. Maria del Popolo is a characteristic work of his fully developed Roman manner [29]. Here for

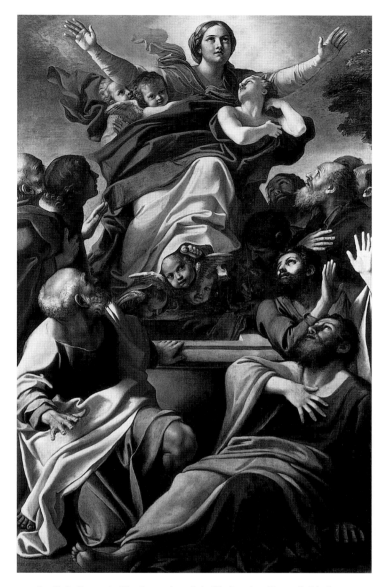

29. Annibale Carracci: *The Assumption of the Virgin*, 1601. Rome, S. Maria del Popolo, Cerasi Chapel

the first and only time Annibale and Caravaggio worked on the same commission, and the visitor to the chapel naturally lets his eye wander from one master to the other. In such a comparison Annibale's *Assumption* may appear tame and even laboured, but it is worth observing that, just as in Caravaggio's *Conversion of St Paul* [13] and his *Crucifixion of St Peter*, it is the overpowering bulk of Annibale's figures that dominates the canvas. In spite of this triumph of the massive sculptural figure, Annibale's *Assumption* shows that he never forgot the lesson learnt from Titian and Correggio. By fusing Venetian colour with Roman design, a painterly approach with classical severity of form, Annibale demonstrated in practice – as was correctly seen in his own day[27] – that these old contrasts, about which so much ink had been spilt in theoretical discussions of the sixteenth century, were no longer irreconcilable.

In their measured and heroic expressions many of

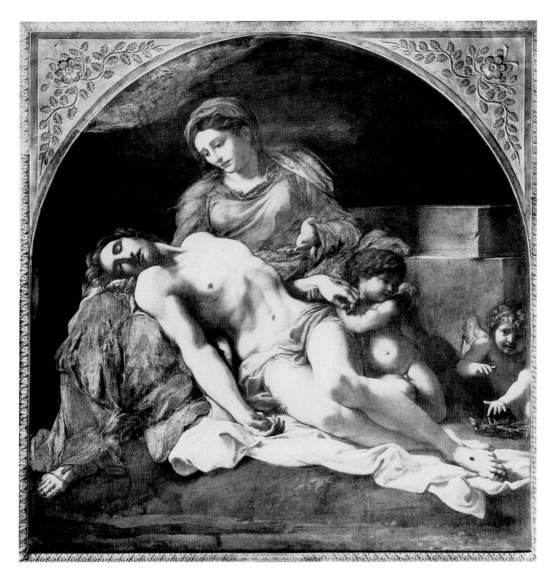

30. Annibale Carracci: *Pietà*.
Naples, Museo Nazionale

Annibale's late pictures, such as the London *Domine Quo Vadis*, the Naples *Pietà* [30], or the Paris *Lamentation*, are reminiscent of classical tragedy. Contemporaries realized that Annibale was deeply concerned with the Aristotelian problem (*Poetics*, 17) which, since Alberti's days, had taken up a central position in any consideration of the highest class of painting, namely how to represent in an appropriate and forceful visual form the *affetti*, the emotions of the human soul. Annibale had neither the theoretical mind of an Alberti nor the experimental passion of a Leonardo; he was, in fact, opposed to theorizing and a man of few words. But he sensed, as it were intuitively, the temper of the age, and in his concern for the telling use of gestures and expressions one has no difficulty in recognizing a new rationalist spirit of analysis. To base the rendering of the *affetti* on rational and generally valid findings became an important preoccupation of seventeenth-century artists. Poussin learned his lesson from Annibale, and the same problems were later submitted to philosophical analysis by Descartes in his *Passions de l'Âme* of 1649.

A new sensibility characterizes the seventeenth century, and this manifests itself not only in what may appear to us nowadays as the conventional language of rhetoric, but also in highly charged subjective expressions of feeling, grief and melancholy. The rational medium of design gives conventional gestures an objective quality, while the irrational medium of colour adds to conveying those intangible marks which are not readily translatable into descriptive language. The early Roman *Bacchus playing the Lute to Silenus* (London, National Gallery) exemplifies very well this important element in Annibale's *œuvre*. There is an atmosphere of melancholy pervading this little picture, and this is due to the wonderfully rich Titianesque evening sky casting a sombre mood over the wide deserted landscape behind the figures. Characteristically, this mood is transmitted through the landscape, and, as in Venice, landscape always plays an important part in Annibale's canvases as a foil against which to set off and underline a picture's prevailing spirit.[28] Considering this Venetian evaluation of the landscape element, it is not strange to find pure landscapes early in Annibale's career.

His first loosely constructed landscapes, peopled with

31. Annibale Carracci: *The Flight into Egypt*, c. 1604. Rome, Galleria Doria-Pamphili

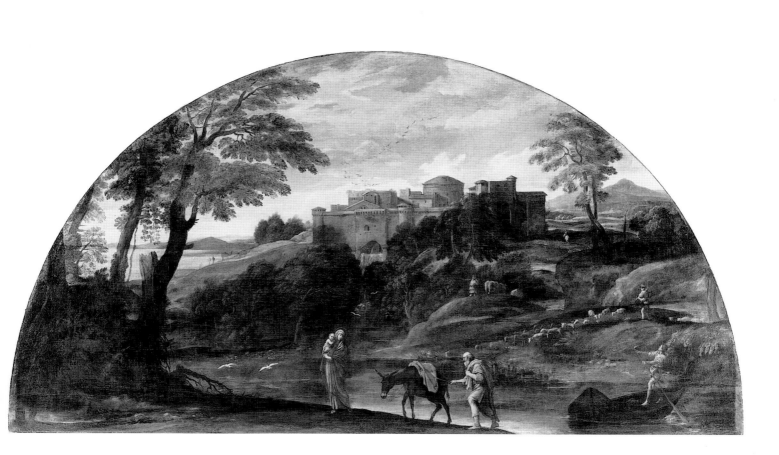

huntsmen and fishermen (Louvre), are essentially Venetian. But in accordance with the general trend to his development and under the impression, it would seem, of the severe forms of the Campagna, Annibale in Rome replaced the freedom and rusticity of his early landscapes by carefully constructed landscape panoramas. The most celebrated example of this new landscape style is the lunette with a *Flight into Egypt* (Rome, Galleria Doria-Pamphili) [31], dating from about 1604.[29] An integral part of these panoramas is always the work of man – castles and houses, turrets and bridges, severely composed of horizontals and verticals and placed at conspicuous points in the landscape. The architectural motif in the centre of the Doria *Flight into Egypt* is framed by a cluster of large trees in the left foreground – such trees become *de rigueur* in this type of landscape – and by the trees to the right in the middle distance; nor is the position of the Holy Family fortuitous: the group moves forward protected, as it were, by the firm lines of the castle above it and, in addition, it is placed at the meeting points of two spatial diagonals formed by the sheep and the river; thus figures and buildings are intimately blended with the carefully arranged pattern of the landscape. This is neither Nature untouched and wild where the role of man shrinks into insignificance – as in the landscapes of some contemporary northern artists working in Rome, above all Paul Brill and Jan Bruegel – nor is it on the other hand the fairly-lands which Elsheimer created in his Roman years; instead it is a heroic and aristocratic conception of Nature tamed and ennobled by the presence of man. It was Annibale's paintings of ideal landscapes that prepared the way for the landscapes of Domenichino and Albani, of Claude and Poussin.

Annibale's grand manner of the Roman years may rightly be regarded as his most important achievement, but the formal side of his art had an interesting counterpart of informality. Both Annibale and Agostino had an intimate, genre-like idiom at their disposal. This, it seems, found expression more often in drawings than in pictures, although a number of genre paintings do exist and many more must have existed, judging from contemporary notices. A picture like the *Butcher's Shop* at Christ Church, Oxford, makes it evident that the Carracci at Bologna had come in contact with, and were deeply impressed by, north-

32. Annibale Carracci: *Man with a Monkey*, before 1595. Florence, Uffizi

ern genre painting in the manner of Pieter Aertsen.[30] Annibale's homely portrait sketch in oil of a smiling young man (Rome, Galleria Borghese) and, above all, the half-length of a *Man with a Monkey* looking for lice in his master's hair (Uffizi) [32] illustrate the trend with an admirable and entertaining candour. This last picture was probably painted two or three years before Caravaggio's *Bacchus* in the Uffizi [11]. Compared with it, Annibale's painting strikes one as 'impressionist' and progressive; it is, moreover, genre pure and simple.

It is clear from contemporary sources – in the first place from Malvasia, the biographer of Bolognese artists – that the two Carracci brothers regarded nothing as too insignificant or too uninteresting to be jotted down on paper on the spur of the moment. They were tireless draughtsmen and their curiosity was unlimited. They had an eye for the life and labours of the common people, for the amusing, queer, odd, and even obscene happenings of daily life, and something of this immediacy of approach will also be noticed in their grand manner. But with these two idioms, the official and the unofficial, at their command, a duality was possible which would have been unthinkable in the age of Raphael. By being able to work simultaneously on two levels, the Carracci reveal a dichotomy which from then on became more and more pronounced in the work of great artists and culminated in the dual activity or aspirations of a Hogarth or a Goya.

It is not at all astonishing that this mentality predestined the Carracci to become the originators of modern caricature: caricature, that is, in the pure sense, as a mocking criticism of other people's shortcomings. It is well attested that Annibale was the inventor of this new form of art.[31] The caricaturist substitutes a primitive, timeless technique for the established conventions of draughtsmanship, and an uninhibited personal interpretation for the objective rendering of reality which was the principal requirement of the Renaissance tradition. The artist who was acclaimed as the restorer of that tradition also forged dangerous weapons to undermine it.

Caravaggio's Followers and the Carracci School in Rome

Annibale Carracci alone had a school in Rome in the accepted sense of the term. Not only were he and the other members of his family good teachers, but his art, particularly his Roman manner, lent itself to being taught. The foundation of the school was, of course, laid in the Bolognese 'academy', and his young pupils and friends who followed him to Rome arrived there well prepared. Caravaggio on the other hand, a bohemian, turbulent and uncontrolled, never tried to train a pupil, nor indeed could he have done so since the subjective qualities of his style, his improvisations, his *ad hoc* technique, his particular mystique of light, and his many inner contradictions were not translatable into easy formulas. Yet, what he had brought into the world of vision was a directness, a power of immediate appeal that had an almost hypnotic fascination for painters, so that even Carracci pupils and followers fell under his spell at certain stages of their development. Moreover, generations of painters inside Italy and even more outside her confines sought inspiration from his work. Nevertheless when one contemplates the life and art of Caravaggio and of Annibale, the pattern of the development in Rome during the first quarter of the seventeenth century seems almost a foregone conclusion.

The Caravaggisti

Few of Caravaggio's followers actually met him in Rome, but most of them were deeply moved by his work while its impact was still fresh and forceful. The list of names is long and contains masters of real distinction. Among the older painters Orazio Gentileschi (1563–1639[1]) stands out. Next to him artists like Antiveduto Gramatica (1571–1626) and Giovanni Baglione (1566–1643) are of only marginal interest. The most important younger artists were Orazio Borgianni (1578 or earlier–1616), Bartolomeo Manfredi (*c.* 1587–1622),[2] Carlo Saraceni (1579[3]–1620), Giovanni Battista Caracciolo (d. 1637), Giovanni Serodine (1600–30), and Artemisia Gentileschi (1593–*c.* 1652), apart from a host of northerners, among whom the Italo-Frenchman Valentin (1594–1632) should here be mentioned.[4]

These names make it at once apparent that Caravaggio's manner was taken up by painters with very different backgrounds, traditions, and training. Few among them were Romans; Gentileschi, for example, came from Pisa, Saraceni from Venice, Manfredi from near Mantua, and Serodine from Ascona. In contrast to the Bolognese followers of the Carracci who shared a common training and believed in similar principles, these artists never formed a homogeneous group. Caravaggio's idiom was a kind of ferment giving their art substance and direction for a time; but with most of them it was like a leaven not fully absorbed and which was to be discarded when they thought fit. In this respect Orazio Gentileschi's career is symptomatic. He was in Rome from 1576 on and came under Caravaggio's influence in the early years of the new century. But a typically Tuscan quality always remained noticeable in his work – so much so that his pictures are on occasions reminiscent of Bronzino and even of Sassoferrato: witness his clear and precise contours, his light and cold blues, yellows, and violets as well as the restraint and simplicity of his compositions. Moreover, his lyrical and idyllic temperament is far removed from Caravaggio's almost barbaric vitality.

The chronology of Orazio's *œuvre* is not without problems, for dated pictures are few and far between. One of his

33. Orazio Gentileschi: *The Annunciation*, probably 1623. Turin, Pinacoteca

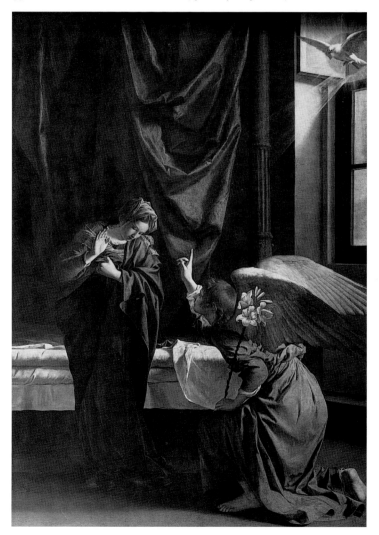

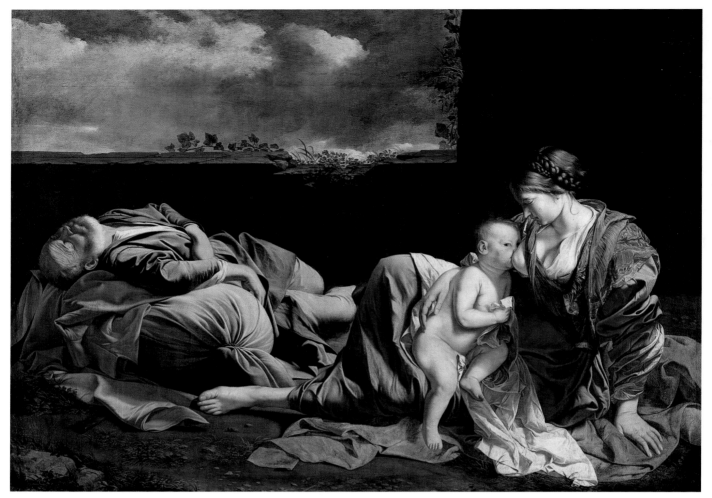

34. Orazio Gentileschi: *Rest on the Flight into Egypt*, *c.* 1626. Paris, Musée du Louvre

chief works, the graceful *Annunciation* in Turin [33], painted for Charles Emanuel I of Savoy, probably in 1623, clearly shows him developing away from Caravaggio, and the pictures painted after he settled in England in 1626 as Charles I's court painter carry this tendency still further. They are extremely light in colour, and the Florentine note supersedes his *Caravaggismo*. By contrast a work like the Dublin *David and Goliath* with its powerful movement, foreshortening, chiaroscuro, and its Caravaggesque types must have been created in Rome at an early period of his career.[5] Examples of Orazio's later manner may be seen in a picture such as the *Rest on the Flight into Egypt* [34] (known in four versions in Birmingham; the J. Paul Getty Museum, Los Angeles, Cal.; Vienna; and the Louvre),[6] datable *c.* 1626, and in his principal work in England, the nine compartmental pictures for the hall of the Queen's House, Greenwich, probably executed after 1635, and now in a mutilated condition in Marlborough House.[7] The difference between the two latter works makes it evident that the longer he was away from Rome the thinner became the Caravaggesque veneer. It is undeniable that in the setting of the London Court, with its progressive tendencies represented by Rubens and Van Dyck, the work of Gentileschi appears almost outdated.[8]

The development of Orazio Gentileschi is characteristic of much of the history of the early *Caravaggisti*. But in the case of an artist such as Giovanni Baglione the emphasis is somewhat different. Baglione, nowadays chiefly known as the biographer of sixteenth- and early seventeenth-century Roman artists, belongs essentially to the late academic phase of Mannerism. An exact contemporary of Caravaggio's, he was that artist's bitter enemy. However, for a brief moment in his career, and even earlier than the rank and file of the *Caravaggisti*, he was overwhelmed by the impact, although never fully understanding the implications, of the great master's work. His *Sacred Love subduing Profane Love* [35] (Berlin), painted after 1600 in competition with Caravaggio's *Earthly Love* for Cardinal Benedetto Giustiniani, is a hybrid creation where a Caravaggesque formula hardly conceals Late Mannerist rhetoric.[9]

The art of Orazio Borgianni, Carlo Saraceni, and Bartolomeo Manfredi represents very different facets of *Caravaggismo*. Borgianni, a Roman who grew up in Sicily and spent several years in Spain, returned permanently to Rome in 1605,[10] where he painted a small number of great and impressive pictures. Their extraordinarily free handling and their warm and glowing colours are exceptional for an artist born in Rome. Some are reminiscent of the Bassani, in

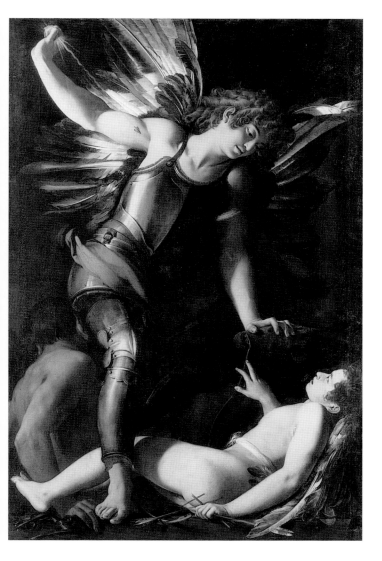

others there is a strong Tintorettesque note, others again, like the *Nativity of the Virgin* of *c.* 1613 (Savona, Santuario della Misericordia), seem to anticipate the Venetian work of Domenico Fetti. His best pictures, among which the *Virgin in Glory handing the Child to St Francis* of 1608 (Sezze Romano, Town Hall), the *St Charles Borromeo* of 1611–12 (S. Carlo alle Quattro Fontane) [36], and *St Charles attending the Plague-stricken* (*c.* 1613, formerly S. Adriano, now Chiesa della Casa Generalizia dei Padri Mercedari, Rome) may be mentioned, excel by a deep and mystical devotion which in its compassionate appeal differs from that of Caravaggio. What in fact Borgianni owed to Caravaggio was perhaps the strengthening of inherent realistic and chiaroscuro tendencies. Nevertheless before his pictures one feels compelled to believe that this highly talented artist, who, incidentally, was another personal enemy of Caravaggio's, would have developed as he did even without the great master's example before his eyes.

The art of Carlo Saraceni was to a large extent determined by his contact with the German Elsheimer, to whose close circle he belonged soon after his arrival in Rome, perhaps as early as 1598. Their pictures are sometimes so intimately related that the dividing line between them is not easily seen.[11] Elsheimer expressed his immensely poetical microcosmic view of the world in miniature format. Saraceni, although accepting the miniature style (and also

35. Giovanni Baglione: *Sacred Love subduing Profane Love*, after 1600. Berlin, Staatliche Museen, Gemäldegalerie

36. Orazio Borgianni: *St Charles Borromeo*, 1611–12. Rome, S. Carlo alle Quattro Fontane

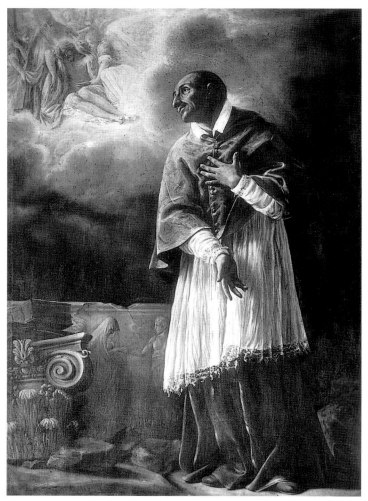

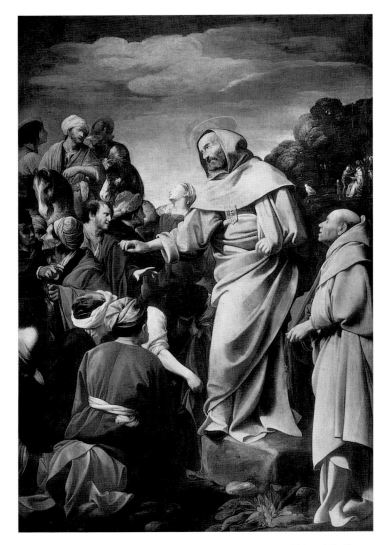

37. Carlo Saraceni: *St Raymond preaching*, *c.* 1614. Rome, Chiesa della Casa Generalizia dei Padri Mercedari

Caravaggio's dramatic Roman manner; nor did he ever fully absorb the latter's *tenebroso*. It remains true that even before these monumental pictures one does not easily forget that his real talent lay in the *petite manière*.[14] In 1620 Saraceni returned to Venice, where he died the same year.

Manfredi's known work falls approximately into the period 1610–20. He was one of the few close imitators of Caravaggio and interpreted the master in a rather rough style which later generations came to regard as characteristic of Caravaggio himself; for it was Manfredi possibly more than anyone else who transformed Caravaggio's manner into proper genre, emphasizing the coarse aspects of the latter's art to the neglect of his other qualities. Guard-room and tavern scenes as well as religious subjects suffer this metamorphosis. Valentin's choice of subjects is similar to that of Manfredi, and indeed the two artists have often been confused. The son of an Italian, coming from France (Boulogne), Valentin settled in Rome in about 1612. Most of his known work seems to date from after 1620. His pictures

38. Giovanni Serodine: *Portrait of his Father*, 1628. Lugano, Museo Civico

the copper panel technique), toned down this Northern magic and invested his pictures with an almost Giorgionesque quality which revealed his Venetian upbringing. In his early Roman period there is, of course, an unbridgeable gulf between him and Caravaggio, as a comparison between the latter's *Rest on the Flight into Egypt* with former's similar work of 1606 in Frascati[12] shows: Saraceni translated Caravaggio's tense and mysterious scene into a homely narrative enacted before a warm 'Elsheimer' landscape. One would, therefore, not expect to find much of Caravaggio's spirit during Saraceni's Caravaggesque period which begins in the second decade, after Elsheimer's death. Yet in these pictures the format as well as his vision grows. One can follow this process of monumentalization from the *St Raymond preaching* (*c.* 1614, formerly S. Adriano, now Chiesa della Casa Generalizia dei Mercedari)[13] [37] to the *St Charles Borromeo and the Cross of the Holy Nail* (*c.* 1615, S. Lorenzo in Lucina) and the *Miracle of St Benno* and *Martyrdom of St Lambertinus* (*c.* 1617–18, both S. Maria dell'Anima). Saraceni, however, can never compete with

are not only infinitely more disciplined than Manfredi's, but also exhibit an extensive scale of differentiated emotions and passages of real drama. Valentin carried on Caravaggio's manner in Rome longer than almost any other *Caravaggista*.[15]

Like Valentin, Serodine really belongs to a younger generation, but both died so young that they should be included among the first generation of Caravaggio followers. Yet when Serodine arrived in Rome in about 1615, Caravaggio was little more than a legend. By far the greatest colourist of the whole group, Serodine can be followed in his rapid development from the Caravaggesque *Calling of the Sons of Zebedee* at Ascona (*c.* 1622), which combines reminiscences of Caravaggio's *Madonna di Loreto* and of Borgianni's palette, to his masterpiece, the immensely touching *Almsgiving of St Lawrence* of the mid 1620s (Rome, Galleria Nazionale); thence to the freer *St Peter and St Paul* (Rome, Galleria Nazionale) and to the Edinburgh *Tribute Money*. The last-named picture, with its light background and its painterly handling recalling Bernardo Strozzi, prepares the way for the extraordinary *tour de force* of the *Portrait of his Father*,[16] painted in 1628 (Lugano, Museo Civico) [38], which is reminiscent of the mature works of Fetti and Lys. Still later is the *St Peter in Prison* (Rancate, Züst Collection) where he used Honthorst's candle-light but not his technique. The impasto calls to mind Rembrandt's advanced work, and the 'impressionist' freedom of the individual brush-stroke leads further away from Caravaggio than the work of any other of his followers in Rome. The rapidity of Serodine's development is equalled only by that of Caravaggio. The fact that it removed him from Caravaggio towards rich chromatic values ties him to the aspirations of a new age.

By about 1620 most of the *Caravaggisti* were either dead or had left Rome for good. Those who returned home quickly adjusted their styles to their native surroundings; some of them hardly reveal in their late work that they had ever had any contact with Caravaggio.[17] Not one of them had really understood the wholeness of his conception. They divested his realism of its irrational quality and his *tenebroso* of its mystique. They not only devitalized his manner, but as a rule they selected from his art only those elements which were congenial to their taste and ability. Some of them, like Gentileschi and to a certain extent Saraceni, were strongly attracted by Caravaggio's early Roman phase; others, like Manfredi and Valentin, who saw chiefly the plebeian side of his art, blended the genre subjects of his early Roman phase with the *tenebroso* of his later style. Soon after 1620 Caravaggism in Rome had lost its appeal. It remained successful only in the popular genre in cabinet format, the introduction of which was largely due to the Haarlem artist Pieter van Laer, who was in Rome from 1625 to 1639. His so-called *Bambocciate*[18] [39] survived as an undercurrent with a long history of their own.

In spite of the comparatively brief life of *Caravaggismo* in Rome and in spite of the toning down of the master's example, the diffusion of his style continued, either directly or indirectly, and by a variety of routes. Apart from Naples, where his work had a more lasting and invigorating effect than anywhere else in Italy, its penetration to Bologna and

39. Pieter van Laer(?): *The Brandy-Vendor*, after 1625. Rome, Galleria Nazionale

Siena, Genoa and Venice, and throughout Europe, is one of the most astonishing phenomena in the history of art. The names of Terbrugghen, Crabeth and Honthorst, Baburen, Pynas and Lastman, Jan Janssens, Gerard Seghers, Rombouts, and Vouet, most of them working in Rome at some time during the second decade of the century, indicate the extent of his influence; and we know now that neither Rubens, who had very early in his career experienced Caravaggio's direct influence in Rome, nor Rembrandt, Velasquez, and Vermeer, would have developed as they did without the Caravaggio blood-transfusion. But while elements of Caravaggism became a permanent feature of European painting, I must repeat that many of those who were responsible for its dissemination discarded it on their return to their home countries in favour of current styles. As an example, the Frenchman Vouet, after an intense early Caravaggesque phase, submitted entirely to an easy international Baroque style tempered by a classical note.[19] It is all the more remarkable that *Caravaggismo* did not begin to spread to any considerable extent until the third decade of the century, that is, at a moment when in Rome itself it was moribund or even dead.

The Bolognese in Rome and Early Baroque Classicism

I have already indicated that the Carracci school presents a picture vastly different from the *Caravaggisti*. A phalanx of young Bolognese artists, observing Annibale's success, chose to follow him to Rome; nor did events show that their assessment of the situation was incorrect. They had besides much to recommend themselves. First and foremost they were excellent artists. They had undergone a thorough training in the Carracci academy and had acquired a solid classical background even before they reached Rome. They were supported by Annibale's unrivalled authority and could rely on a circle of wealthy and powerful patrons. Moreover, they were all masters of the fresco technique and were, therefore, both able to assist Annibale in his own work and to execute monumental fresco commissions on their own account. In addition, during the short reign of Gregory XV (1621–3), who was himself born in Bologna, they were in undisputed command of the situation.

Guido Reni (1575–1642) and Francesco Albani (1578–1660) appeared in Rome shortly after April 1600, Lanfranco (1582–1647) and Domenichino (1581–1641) came soon after, and the much younger Guercino (1591–1666) arrived in 1621. Annibale used Domenichino for work in the Galleria Farnese,[20] and it was mainly Albani, assisted by the Parmese Lanfranco and Sisto Badalocchio, also from Parma, who carried out from Annibale's designs most of the frescoes in the S. Diego Chapel in S. Giacomo degli Spagnuoli between 1602 and 1607.[21] At the same time Innocenzo Tacconi,[22] another Bolognese of the second rank, executed the frescoes on the vault of the Cerasi Chapel in S. Maria del Popolo, for which Annibale painted the *Assumption of the Virgin*.

In the succeeding years these Bolognese artists firmly established a style in Rome which by and large shows a strengthening of the rationalist and classical tendencies inherent in the Farnese ceiling. With the exception of Domenichino and Lanfranco, however, the time spent in Rome by these artists was neither consecutive nor protracted. Domenichino stayed for a period of almost thirty years, though he returned to Bologna between 1617 and 1621, and Lanfranco, who was once absent from Rome between 1610 and 1612, left for Naples only in 1633–4. On the other hand Reni, after visits to Rome between 1600 and 1604 and again from 1607 to 1611 and from 1612[23] to 1614, made Bologna his permanent home, remaining there except for a few relatively brief intermissions until his death in 1642. Albani did not leave Rome until mid 1617,[24] to return only for short periods of time; and Guercino's years in the Holy City were confined to the reign of Gregory XV, from 1621 to 1623.

From about 1606 onwards these masters were responsible for a series of large and important cycles of frescoes. Their activity in this field is an impressive testimony to their rapidly rising star. A feeling for the situation is best conveyed by listing in chronological sequence the major cycles executed by the whole group during the crucial twelve years 1606–18.

1606–7: Palazzo Mattei di Giove, Rome. Three rooms with ceiling frescoes in the south-west sector of the *piano nobile*, by Albani: *Isaac blessing Jacob, Jacob and Rachel*, and *Jacob's Dream*.[25]

1608: Sala delle Nozze Aldobrandini, Vatican. Reni's *Stories of Samson* (repainted).[26]

1608: Sala delle Dame, Vatican. Reni's *Transfiguration, Ascension of Christ*, and *Pentecost* on the vault of the room.

1608: Oratory of St Andrew, S. Gregorio Magno, Rome. The large frescoes of *St Andrew adoring the Cross* by Reni and the *Scourging of St Andrew* by Domenichino, commissioned by Cardinal Scipione Borghese [40].

1608–9: S. Silvia Chapel, S. Gregorio Magno, Rome. The apse decorated by Reni with *God the Father and Angels*.

1608–10: Abbey of Grottaferrata. Chapel decorated by Domenichino with scenes from the *Legends of St Nilus and St Bartholomew*. The commission was due to Cardinal Odoardo Farnese on Annibale's recommendation.

1609: Palazzo Giustiniani (now Odescalchi), Bassano (di Sutri) Romano. The ceiling of a small room painted by Domenichino with stories of the myth of Diana, in the manner of the Farnese Gallery. The frescoes of the large hall by Albani. On the ceiling of the hall Albani represented the *Fall of Phaeton* and the *Council of the Gods*, the latter placed in tight groups round the edges of the vault – the whole an unsuccessful attempt at illusionistic unification. Along the walls there are eight scenes illustrating the consequences of the *Fall*. The patron was the Marchese Vincenzo Giustiniani.[27]

1609–11: Chapel of the Annunciation, Quirinal Palace. The whole decorated by Reni and his Bolognese assistants, see p. 8.

1610, 1612: Cappella Paolina, S. Maria Maggiore. Reni is responsible mainly for single figures of saints.

1612–14: Choir, S. Maria della Pace. Albani completes the mariological programme begun in the sixteenth century.

1613–14: Casino dell'Aurora, Palazzo Rospigliosi, Rome. The *Aurora* ceiling painted by Reni for Cardinal Scipione Borghese [48].

1613–14: S. Luigi de' Francesi, Rome. Domenichino's scenes from the *Life of St Cecilia* [41].[28]

1615: Palazzo Mattei di Giove, Rome. Lanfranco (*Joseph interpreting Dreams* and *Joseph and Potiphar's Wife*).[29] These frescoes are inspired by Raphael's Logge.

c. 1615 and later: Palazzo Costaguti, Rome. Domenichino: *The Chariot of Apollo* in the centre of the ceiling of the large hall, set in a Tassi *quadratura*.[30] Lanfranco: the ceiling with *Polyphemus and Galatea* (destroyed, replica in the Doria Gallery); the ceiling with *Justice and Peace* probably 1624[31] (*quadratura* by Tassi?); the third ceiling with *Nessus and Deianeira*, previously given to Lanfranco, is now attributed to Sisto Badalocchio.[32] The ceiling with Guercino's *Armida carrying off Rinaldo*, once again in a Tassi *quadratura*, was painted between 1621 and 1623. Mola's and Romanelli's frescoes belong to a later phase.

1616: S. Agostino, Rome. Lanfranco's decoration of the Chapel of St Augustine.[33]

c. 1616: Palazzo Verospi (now Credito Italiano), Corso,

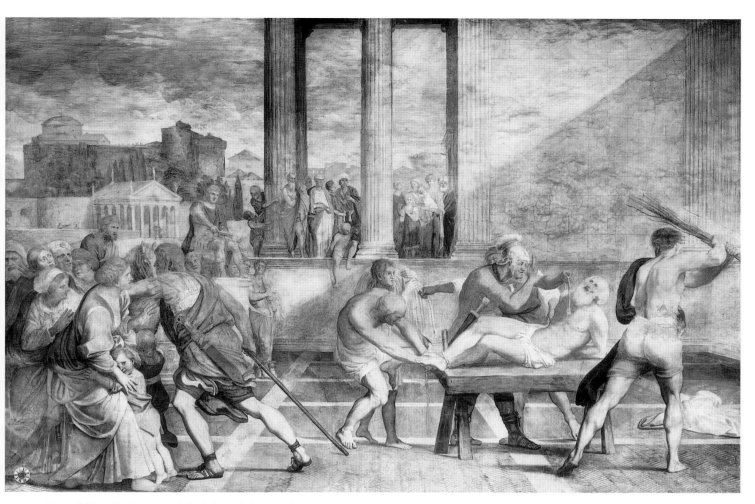

40. Domenichino: *The Scourging of St Andrew*, 1608. Rome, S. Gregorio
Magno, Oratory of St Andrew

Rome. Albani: ceiling of the hall with *Apollo and the Seasons*. The artist's Carraccesque style has become more decidedly Raphaelesque, and reliance on the *Cupid and Psyche* cycle in the Farnesina is evident.[34]

1616–17: Sala de' Corazzieri, Quirinal Palace. For Lanfranco's contribution to the frieze of this large hall, see p. 8.

1616–18: Stanza di Apollo, Villa Belvedere (Aldobrandini), Frascati. Eight frescoes with scenes of the myth of Apollo, painted by Domenichino and pupils at the instance of Monsignor Agucchi for Cardinal Pietro Aldobrandini (now National Gallery, London).[35]

All these frescoes are closely connected by characteristics of style. Not only are most of the ceiling decorations painted as *quadri riportati*, but they are also more severely classical than the Farnese Gallery. Annibale's rich and complex framework, reminiscent of Mannerist decoration, was dropped and, at the most classical moment between 1613 and 1615, the *quadro riportato* appears isolated on the flat centre of the vault. Thus, Guido's *Aurora* was framed with stuccoes, leaving the surrounding area entirely white. The principle was perhaps followed in the Palazzo Mattei and certainly in the *Rape of Deianeira* ceiling in the Palazzo Costaguti, probably the only room which survives undisturbed from the period around 1615. These examples are

evidence that in the second decade of the century the Bolognese artists were inclining towards an extreme form of classicism. It is, of course, Domenichino in whose work this development is most obvious, and it typifies the general trend that his St Cecilia frescoes of 1613–14 are far more rigidly classical than his previous work.

Corresponding to the requirements of decorum, his *Scourging of St Andrew* [40] of 1608 takes place on a Roman piazza; the carefully prepared stage is closed by the wall and columns of a temple placed parallel to the picture plane, and its rigidity contrasts with the somewhat freer arrangement of the ancient city and landscape in the left background. In order to safeguard the foreground scene against visual interference from the crowd assembled under the temple portico, Domenichino introduced an unusual device; disregarding the laws of Renaissance perspective, he made these figures unduly small, much smaller than they ought to be where they stand. The principal actors are divided into two carefully composed groups, the one surrounding the figure of the saint, the other consisting of the astonished and frightened spectators. Firmly constructed though these groups are, there is a certain looseness in the composition and, particularly in the onlookers, a distinct lack of definition. In the St Cecilia frescoes the depth of the stage has shrunk and the scenes are closed [41]. The figures have grown in size and importance; each is clearly individualized and expresses its

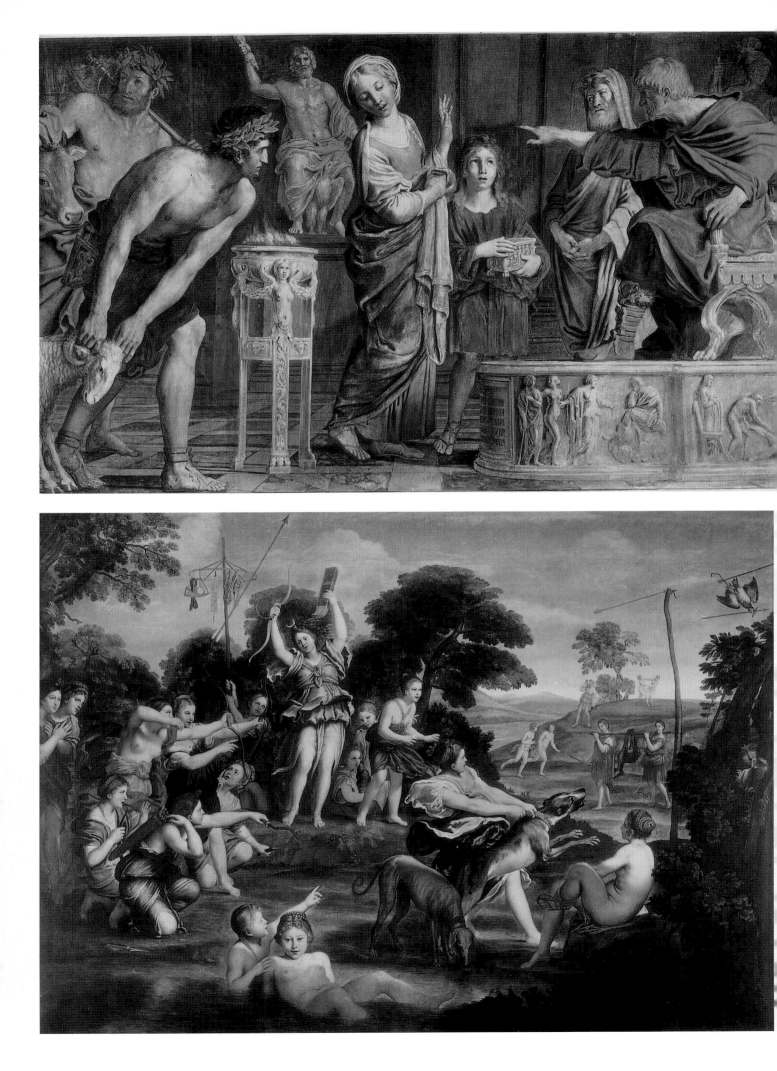

mood by studied gestures. Many figures are directly derived from classical statues, archaeological elements are more conscientiously introduced, and the spirit of Raphael permeates the work to an even greater extent.[36] But at the same time Domenichino has seen all this through the eyes of Annibale.

At this moment Domenichino was probably acknowledged as the leading artist in Rome, and the circle of his friend Agucchi must have regarded the St Cecilia frescoes as the apogee of painting. One would have expected Domenichino to pursue the same course which accorded so well with Agucchi's and his own theoretical position.[37] History, however, is never logical and so, after his performance in S. Luigi de' Francesi, we find Domenichino beginning to turn in a different direction. In his most important commission of the next decade, the choir and pendentives of S. Andrea della Valle (1622, not 1624, –8),[38] this arch-classicist seemed to be tempted by the new Baroque trend. This is clearly visible in the Evangelists on the pendentives, where a strong Correggiesque note is added to the reminiscences of Raphael and Michelangelo. It may be supposed that Domenichino wished to outshine his rival Lanfranco, who to the former's anguish was given the commission for the dome. A development towards the Baroque will also be noticed in the celebrated scenes from the life of St Andrew in the apse of the church (c. 1623–6). While the single incidents are still strictly separated by ornamented ribs, the stage is widened and on it the figures move in greater depth than formerly, some of them in beautiful co-ordination with the rich landscape setting. In addition, borrowings from Lodovico Carracci make their appearance,[39] another indication of Domenichino's drifting away from the orthodox classicism of ten years before.

41 (opposite, above). Domenichino: *St Cecilia before the Judge*, 1613–14. Fresco. Rome, S. Luigi de' Francesi

42 (opposite, below). Domenichino: *Hunt of Diana*, 1617. Rome, Galleria Borghese

43. Francesco Albani: Ceiling fresco. Rome, Palazzo Verospi

In 1631 Domenichino left Rome for Naples,[39a] where he was under contract to execute the pendentives and dome of the Chapel of S. Gennaro in the cathedral. Here he built on the tendencies already apparent in the pendentives of S. Andrea and amplified them to such an extent that these frescoes appear as an almost complete break with his earlier manner. He filled the spherical spaces to their extremities with a mass of turgid, gesticulating figures which at the same time seem to have become petrified. The principal interest of these paintings lies in their counter-reformatory content, which Émile Mâle has recounted; but it cannot be denied that Domenichino's powers, measured by the standard of his most perfect and harmonious achievements, were on the decline.[40] Nor was his attempt to catch up with the spirit of a new age successful. The hostility he met with in the course of executing his work in Naples and which may have contributed to his failure is well known; however, after his dramatic flight north in 1634 he returned once more to Naples, but left the work in the chapel unfinished at his death in 1641.

Domenichino's reputation has always remained high with the adherents of the classical doctrine, and during the eighteenth century he is often classed second only to Raphael. But this reputation was not based only on his work as a fresco-painter. Oil-paintings such as the Vatican *Last Communion of St Jerome* of 1614 or the Borghese *Hunt of Diana*[41] of 1617 [42], done for Cardinal Pietro Aldobrandini but acquired by force by Scipione Borghese, reveal him as a more refined colourist than his frescoes would lead one to expect. These two works, painted during his best period, show the breadth of his range. The *St Jerome*, more carefully organized and more boldly accentuated than his model, Agostino Carracci's masterpiece, has never failed to carry conviction by its sincerity and depth of religious feeling.[42] Coming from Domenichino's frescoes, one may note with surprise the idyllic mood in the *Diana*, but that he was capable of it is attested by a number of pure landscapes which he painted.[43] These, and particularly the later ones, show a relaxing of Annibale's more severe approach. By allying the pastoral and the grand, Domenichino created a landscape style which was to have an important influence on the early work of Claude.

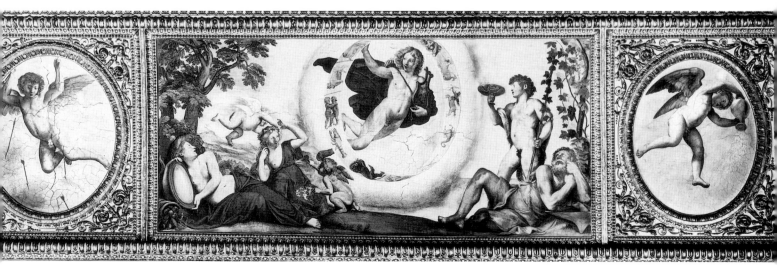

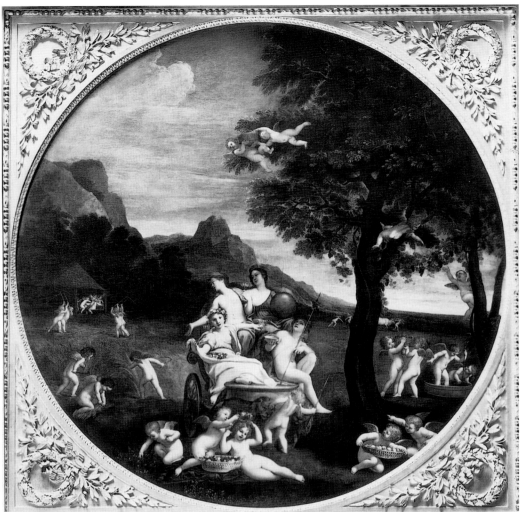

44. Francesco Albani: *Earth*, one of a series of *The Four Elements*, 1626–8. Turin, Pinacoteca

The art of Albani follows a more limited course. Like Domenichino he had started as a pupil in Calvaert's school[44] and later removed to the Carracci. At first vacillating between dependence on Lodovico (e.g. *Repentance of St Peter*, Oratorio S. Colombano, Bologna, 1598) and on Annibale (*Virgin and Saints*, Bologna, Pinacoteca, 1599), his early work already shows a somewhat slight and lyrical quality which later on was to become the keynote of his manner. It is therefore not at all surprising that in Rome he was particularly captivated by Raphael (Palazzo Verospi frescoes) [43] without abandoning, however, his connexion with Lodovico, as one of his ceilings in the Palazzo Mattei shows.[45] Although he worked for Reni in the chapel of the Quirinal Palace, he remained in these years essentially devoted to Domenichino's type of classicism, but lacked the latter's precision and unfailing sense of style. Even before returning to Bologna his special gift led him towards light-hearted and appealing representations of myth and allegory in landscape settings[46] of the sort that is perhaps best exemplified by the *Four Elements* in Turin, painted in 1626–8 [44]. In his later years Albani became involved in theoretical speculations of a strictly classical character. Although he had a relatively strong moment in the early 1630s (*Annunciation*, S. Bartolommeo, Bologna, 1633) [45], during the last period

his large canvases, many of which have little more than a provincial interest, often combine influences from Reni with an empty and boring symmetry of arrangement.

Guido Reni was an infinitely more subtle colourist than Domenichino. In retrospect it would appear that his vision and range far surpassed those of his Bolognese contemporaries. His fame was obscured by the large mass of standardized sentimental pictures coming from his studio during the last ten years of his life, the majority the product of assistants. It is only fairly recently, and particularly through the Reni Exhibition of 1954, that the high qualities of his original work have revealed him once again as one of the greatest figures of Seicento painting.

Guido was less dependent on Annibale than the other Bolognese artists, and from the beginning of his stay in Rome he received commissions of his own. Between 1604 and 1605 he painted the *Crucifixion of St Peter* (Vatican) in Caravaggio's manner. That even Reni, despite having gone through Lodovico's school at Bologna, would for a while be drawn into the powerful orbit of Caravaggio[47] might almost have been foreseen; but although the picture shows an extraordinary understanding of his dramatic realism and lighting – and that at a time before the *Caravaggisti* had come into their own – the basis of Reni's art was classical and his

approach to painting far removed from Caravaggio's. The picture is composed in the form of the traditional classical pyramid and firmly woven into balance by contrappostal attitudes and gestures. Moreover, Reni's essential unconcern for primary requirements is exposed by the irrational behaviour of the executioners: they seem to act automatically without concentration on their task.

Reni's first great fresco, the *St Andrew led to Martyrdom* [46], is in telling contrast to the static quality of Domenichino's fresco on the wall opposite. The figure of the saint, forming part of a procession from left to right which moves in an arch curving towards the front of the picture, is caught in a moment of time as he adores the Cross visible on the far-away hill. There is, however, a lack of dramatic concentration and a diffusion in the composition which, while allowing the eye to rest with pleasure on certain passages of superb painting, distracts from the story itself. How lucidly organized, by contrast, is the Domenichino! And yet one has only to compare the figure of the henchman seen from the back in both frescoes to realize Reni's superior pictorial handling. The classicism of Reni is in fact far freer and more imaginative than that of Domenichino. In addition, Guido was capable of adjusting his style to suit the subject-matter instead of conforming to a rigid pattern. This may be indicated by mentioning some works created during the same important years of his life.

45. Francesco Albani: *Annunciation*, 1633. Bologna, S. Bartolommeo

46. Guido Reni: *St Andrew led to Martyrdom*, 1619. Rome, S. Gregorio Magno, Oratory of St Andrew

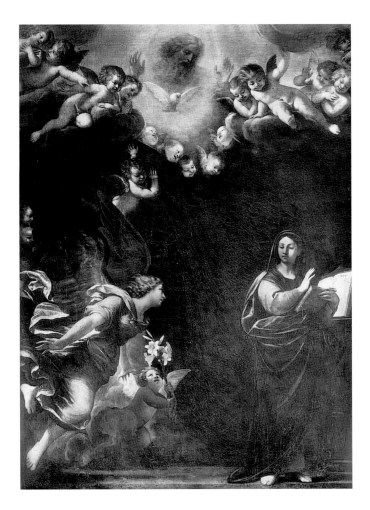

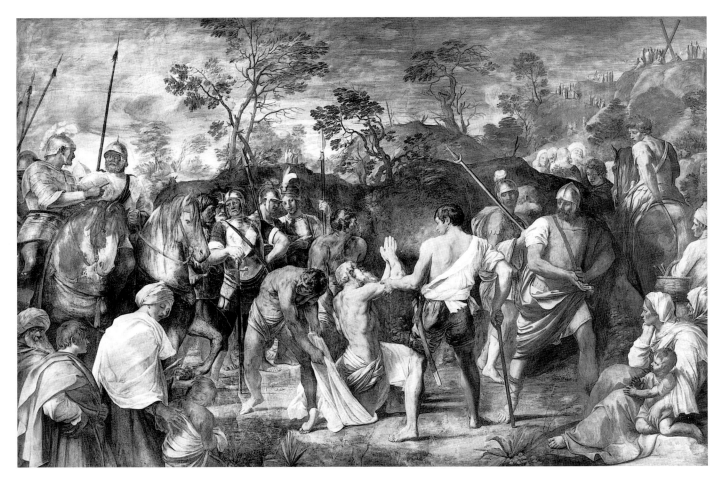

47. Guido Reni: *The Triumph of Samson, c.* 1620. Bologna, Pinacoteca

In the *Music-making Angels* of the S. Silvia Chapel in S. Gregorio Magno, and still more in the denser crowds of angels in the dome of the Quirinal Chapel, Reni has rendered the intangible beauty and golden light which belong to the nature of angels. A few years later he painted the dramatic *Massacre of the Innocents* (Bologna, Pinacoteca).[48] Violence, of which one would have thought the artist incapable, is rampant. But the spirit of Raphael and of the ancient Niobids combine to purge this subtly constructed canvas of any impression of real horror. In the *Samson* (Bologna, Pinacoteca) [47][49] he mitigated the melancholy aftermath of the bloodthirsty scene by the extraordinary figure of the hero, standing alone in the twilit landscape in a pose vaguely reminiscent of Mannerist figures, as if moving to the muffled sound of music, with no weight to his body. Triumph and desolation are simultaneously conveyed by the contrast of the brilliant warm-golden hue of the elegant nude and the cold tones of the corpses huddled on the field. The monumental *Papal Portrait*, probably painted a decade later,[50] now at Corsham Court, is a serious interpretation of character in the Raphael tradition, showing a depth of psychological penetration which is surprising after a picture like the *Massacre*, where the expressions of all the faces are variations on the same theme. Finally, Reni transmutes in the *Aurora* [48][51] a statuesque ideal of bodily perfection and beauty by the alchemy of his glowing and transparent light effects, welding figures adapted from classical and Renaissance art into a graceful and flowing conception.

As early as 1610 it seemed that Reni would emerge as the leading artist in Rome. The road to supreme eminence was open to him, not least because of his favoured position in the household of Cardinal Scipione Borghese, through whose

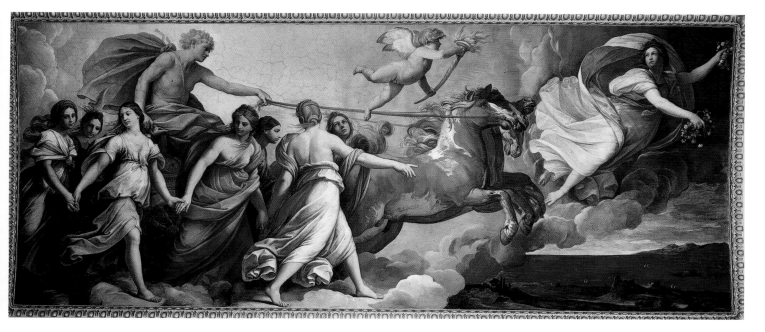

48. Guido Reni: *Aurora*, 1613–14. Fresco. Rome, Palazzo Rospigliosi, Casino dell' Aurora

49. Guido Reni: *The Assumption of the Virgin*, 1616–17. Genoa, S. Ambrogio

good offices he had been given the lion's share of recent papal commissions. But he himself buried these hopes when in 1614 he decided to return to Bologna, leaving Domenichino in command of the situation. The change of domicile had repercussions on his style rather than on his productivity. One masterpiece followed the other in quick succession. Among them are the great *Madonna della Pietà* of 1616 (Bologna, Pinacoteca), which with its peculiar symmetrical and hieratic composition could never have been painted in Rome, and the *Assumption* in S. Ambrogio, Genoa, begun in the same year, in which evident reminiscences of Lodovico and Annibale have been overlaid with a more vivid Venetian looseness and *bravura* [49]. This rich and varied phase of Reni's activity reaches its conclusion with the *Atalanta and Hippomenes* (Prado) of the early 1620s [50]. The eurhythmic composition, the concentration on graceful line, and the peculiar balance between naturalism and classicizing idealization of the figures, all reveal this work as an epitome of Reni's art. He has discarded his warm palette, and the irrational lighting of the picture is worked out in cool colours. The remaining years of his Bolognese activity, during which he developed this new colour scheme together with a thorough readjustment of general principles, belong to another chapter.

Reni's influence, particularly in his later years, was strongest in Bologna, from where it spread. Lanfranco, on the other hand, after having been overshadowed by Domenichino during the first two decades of the century, eventually gained in stature at the expense of his rival, and in the twenties secured his position as the foremost painter in Rome. Born at Parma in 1582, he first worked there, together with Sisto Badalocchio, under Agostino Carracci, and it was after Agostino's death in 1602 that both artists joined Annibale in the Eternal City. From the beginning Lanfranco was the antipode of Domenichino. Their enmity

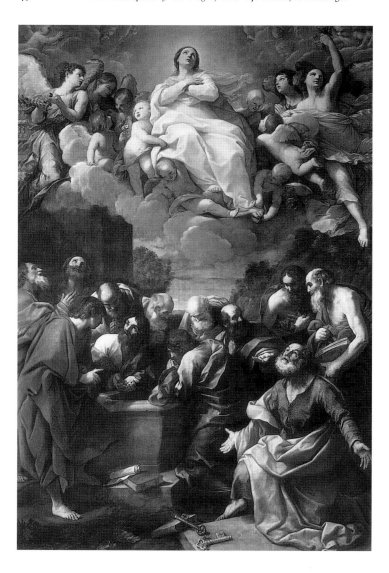

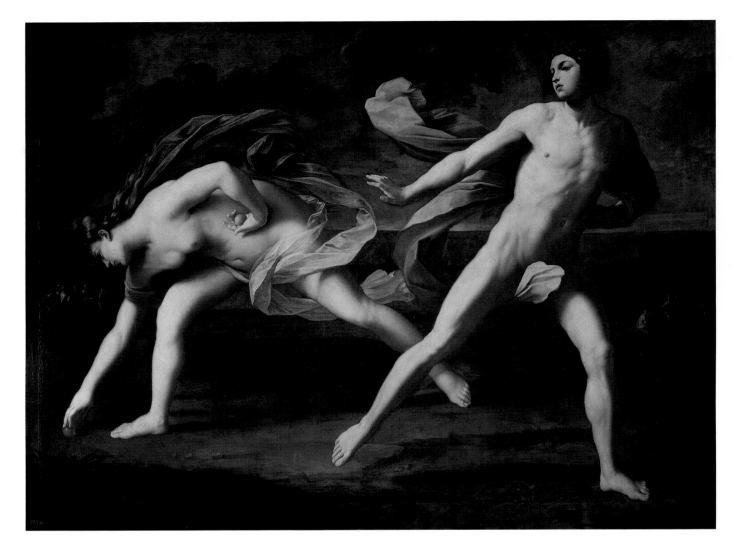

was surely the result of their artistic incompatibility; for Lanfranco, coming from Correggio's town, had adopted a characteristically Parmese palette and always advocated a painterly freedom in contrast to Domenichino's rigid technique. In fact the old antithesis between colour and design, which for a moment Annibale had resolved, was here resurrected once again.

In his early Roman years we find Lanfranco engaged on all the more important cycles of frescoes by the Bolognese group, often, however, in a minor capacity. Beginning perhaps as Annibale's assistant in the Farnese Gallery, he had a share in the frescoes in the S. Diego Chapel, in S. Gregorio Magno, the Quirinal Palace, and even in the Cappella Paolina in S. Maria Maggiore. Of the first cycle painted by Lanfranco on his own in about 1605 in the Camera degli Eremiti of the Palazzo Farnese, three paintings detached from the wall survive in the neighbouring church of S. Maria della Morte.[52] This work shows him already following a comparatively free painterly course, remarkably untouched by the gravity of Annibale's Roman manner. But it was his stay from the end of 1610 to 1612 in his home-town Parma that brought inherent tendencies to sudden maturity. Probably through contact with the late style of Bartolommeo Schedoni[53] he developed towards a monumental and dynamic Baroque manner with strong

chiaroscuro tendencies. It was the renewed experience of the original Correggio and of Correggio seen through Schedoni's Seicento eyes that turned Lanfranco into the champion of the rising High Baroque style. The change may be observed in the Piacenza *St Luke* of 1611 [51]. It appears there that Caravaggio's monumental Roman style helped to usher in Lanfranco's new manner. *St Luke* combines motifs from Caravaggio's two *St Matthews* for the altar of the Contarelli Chapel; a graceful angel in Lodovico's manner is added, and the whole is bathed in Lanfranco's new Parmese tonality. After his return to Rome he gradually discarded the traditional vocabulary, and in a daring composition such as the Vienna *Virgin with St James and St Anthony Abbot* of about 1615–20[54] his new idiom appears fully developed.

Lanfranco's ascendancy over Domenichino began with the frescoes in S. Agostino (1616) and was sealed with the huge ceiling fresco in the Villa Borghese of 1624–5 [52].[55] An enormous illusionist cornice is carried by flamboyant stone-coloured caryatids between which is seen the open sky. This framework, grandiose and at the same time easy, reveals a decorative talent of the highest order. But although there is a Baroque loosening here, the dependence on the Farnese ceiling cannot be overlooked: the *quadratura* yields on the ceiling to the large *quadro riportato* depicting the Gods of Olympus. Compared with the Farnese Gallery, the

simplification and concentration on a few great accents are as striking as the shift of visual import from the *quadro riportato* to the light and airy *quadratura* with the accessory scenes. Traditional *quadratura* of the type practised by Tassi was reserved for architecture only. By making use of the figures as an inherent part of his scheme Lanfranco revealed a more playful and fantastic inventiveness than his predecessors, excellently suited to the villa of the eminent patron who required light-hearted grandeur.

The next important step in Lanfranco's career, the painting of the dome of S. Andrea della Valle, 1625–7,[56] opens up a new phase of Baroque painting [53]. Correggiesque illusionism of the grandest scale was here introduced into Roman church decoration, and it was this that spelt the real end to the predominance of the classicism of the second decade.

A similar step had been taken a few years before by Guercino in the decoration of palaces. One should not forget that this artist belonged to a slightly younger generation; thus already in his earliest known work, carried out in his birthplace, Cento, he reveals a breaking away from the Carraccesque figure conception. Although these frescoes of 1614 in the Casa Provenzale are derived from those by the Carracci in the Palazzo Fava, Bologna, they contrast with

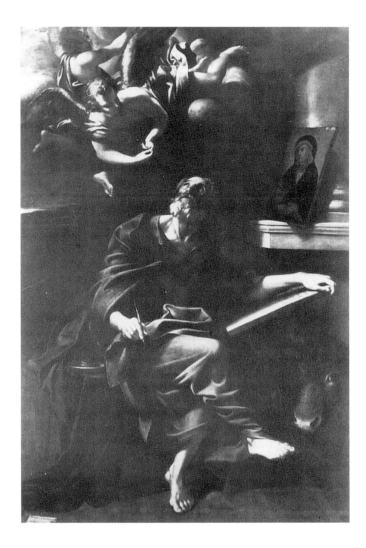

50 (*left*). Giudo Reni: *Atalanta and Hippomenes*, early 1620s. Madrid, Museo del Prado.

51 (*right*). Giovanni Lanfranco: *St Luke*, 1611. Piacenza, Collegio Notarile

52 (*below*). Giovanni Lanfranco: *The Gods of Olympus* (repainted) and *Personifications of Rivers*, 1624–5. Detail of ceiling fresco. Rome, Villa Borghese

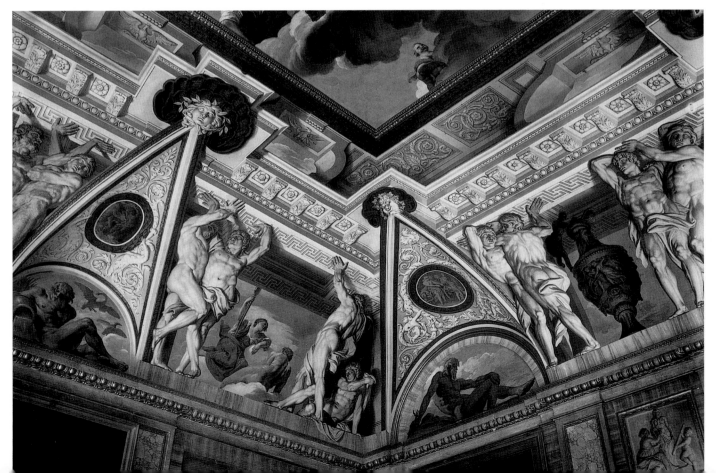

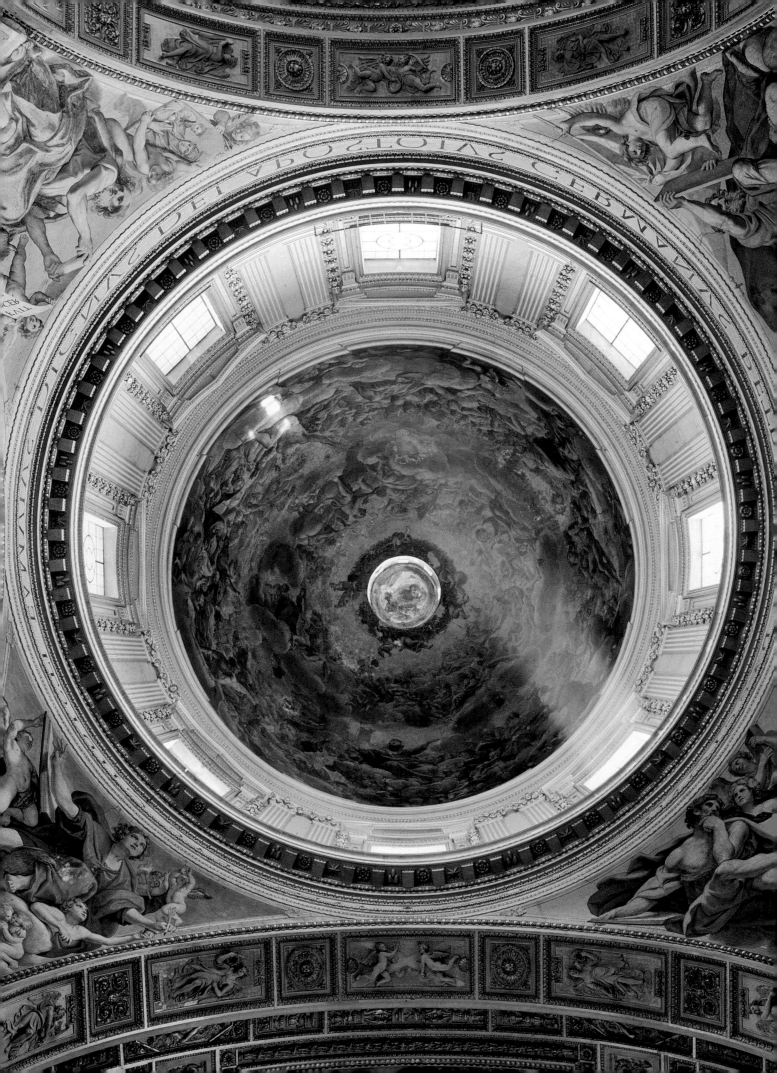

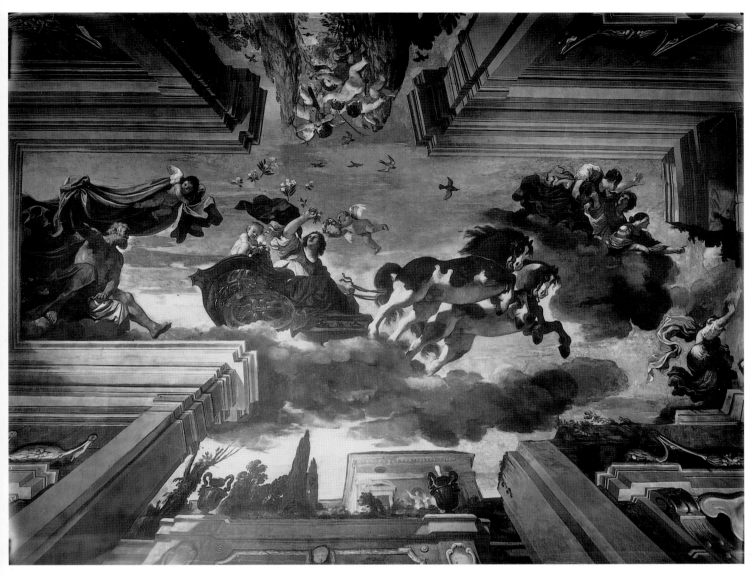

53 (*opposite*). Giovanni Lanfranco: *The Virgin in Glory*, 1625–7. Fresco. Rome, S. Andrea della Valle, dome

54 (*above*). Guercino: *Aurora*, 1621–3. Fresco. Rome, Casino Ludovisi

their model in their flickering effect of light which goes a long way to dissolve cubic form. These atmospheric qualities, which to a certain extent Guercino shared with Lanfranco, were developed more fully during the next ten years. Between 1616 and his visit to Rome in 1621 Guercino painted a series of powerful altarpieces which entitle him to rank among the first artists of his time. His *Virgin with Saints* of 1616 (Brussels Museum), the *Martyrdom of St Peter* of 1618 (Modena), the *Prodigal Son* of 1618–19 (Vienna), and the Louvre *St Francis and St Benedict*, the *Elijah fed by Ravens* (London, Mahon Collection), and particularly the *St William receiving the Habit* (Bologna, Pinacoteca), all of 1620, show a progression towards Baroque movement, the merging of figures with their surroundings, form-dissolving light effects, and glowing and warm colours. In addition, *contrapposto* attitudes become increasingly forceful, and there is an intensity of expression which is often carried far beyond the capacity of Lodovico, for whose early style Guercino felt the greatest admiration.[57]

When Guercino appeared in Rome in 1621, it seemed a foregone conclusion that his pictorial, rather violently Baroque manner would create a deep impression and hasten a change which the prevailing classical taste would be incapable of resisting. Between 1621 and 1623 he executed, above all, the frescoes in the Casino Ludovisi for the *Cardinale nipote* of Gregory XV [54]. The boldly foreshortened *Aurora* charging through the sky which opens above Tassi's *quadratura* architecture is the very antithesis of Guido's fresco in the Casino Rospigliosi. At either end the figures of *Day* and *Night*, emotional and personal interpretations with something of the quality of cabinet painting, foster the mood evoked by the coming of light. There is here an extraordinary freedom of handling, almost sketch-like in effect, which forms a deliberate contrast to the hard lines of

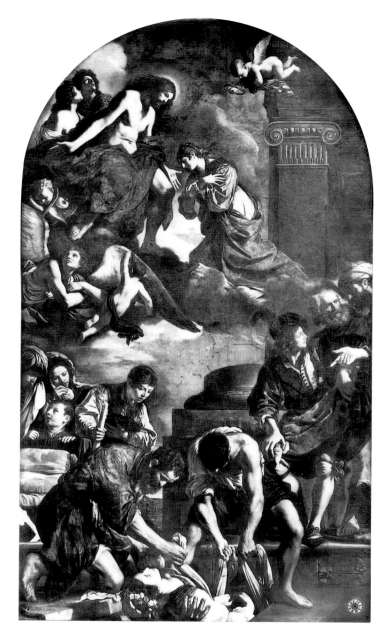

55. Guercino: *The Burial and Reception into Heaven of St Petronilla*, 1622–3. Rome, Capitoline Museum

the architecture and must at the time have appeared as a reversal of the traditional solidity of the fresco technique. This work, however, which might have assured Guercino a permanent place in the front rank of Roman painters, had for the artist an unexpected consequence. Under the influence of the Roman atmosphere, which was charged with personal and theoretical complexities, his confidence began to ebb. Already in the great *Burial and Reception into Heaven of St Petronilla* of 1622–3 (Rome, Capitoline Museum) [55] there is a faint beginning of an abandonment of Baroque tendencies. The figures are less vigorous and more distinctly defined, the rich palette is toned down, and the composition itself is more classically balanced than in the pre-Roman works.[58] It is a curious historical paradox that Guercino who, it is not too much to say, sowed the seeds in Rome of the great High Baroque decorations, should at this precise moment have begun to turn towards a more easily appreciated classicism. But in the very picture where this is first manifest, the idea of lowering the body of the saint into the open sepulchre in which the beholder seems to stand has a directness of appeal unthinkable without the experience of Caravaggio.[59] Thus a painterly Baroque style, an echo of Caravaggio, and a foretaste of Baroque-Classicism combine at this crucial phase of Guercino's career. The aftermath, in the painter's home-town, Cento, must be mentioned later on and in a different context.

Painting Outside Rome

The Italian city-states and provincial centres looked back to an old tradition of local schools of painting. These schools lived on into the seventeenth century, preserving some of their native characteristics. In contrast to the previous two centuries, however, their importance was slight compared with Rome's dominating position. It is true they produced painters of considerable distinction, but it was only in Rome that these masters could rise to the level of metropolitan artists. It seems a safe guess that the Bolognese who followed Annibale Carracci to Rome would have remained provincial if they had stayed at home.

Before discussing the contributions of the local schools, the leading trends may once again (see p. 4) be surveyed. About 1600, Italian painters could draw inspiration from, and fall back upon, three principal manners. First, the different facets of Venetian and North Italian colourism: the warm, glowing and light palette of Veronese, the loaded brush-stroke of the late Titian, Tintoretto's dramatic flickering chiaroscuro, and Correggio's *sfumato*. Venetian 'impressionist' technique was surely the most important factor in bringing about the new Baroque painting. Its influence is invariably a sign of progressive tendencies, and it is hardly necessary to point out that European painting remained permanently indebted to Venice, down to the French Impressionists. Secondly, there was the anti-painterly style of the Florentine Late Mannerists, a style of easy routine, sapped of vitality, which remained nevertheless in vogue far into the seventeenth century. But this style contained no promise for the future. Florence, which for more than a hundred years had produced or educated the most progressive painters in Europe, became a stagnant backwater. Wherever Florentines or Florentine-influenced artists worked at the beginning of the seventeenth century, it spelled a hindrance to a free development of painting.[1] Thirdly, Barocci (1528 or later –1612),[2] whose place is in a history of sixteenth-century painting, has to be mentioned. All that can be said of him here is that he always adhered to the ideal of North Italian colour and fused an emotionalized interpretation of Correggio with Mannerist figures and Mannerist compositions. Whenever artists at the turn of the century tried to exchange rational Late Mannerist design for irrational Baroque colour, Barocci's imposing work was one of the chief sources to which they turned. Among his direct followers in the Marches the names of Andrea Lilli (1555–1610),[3] Alessandro Vitale (1580–1660), and Antonio Viviani (1560–1620) may be noted. His influence spread to the Emilian masters, to Rome, Florence, Milan, and above all to Siena, where Ventura Salimbeni (*c.* 1567–1630) and Francesco Vanni (1563–1610)[4] adopted his manner at certain phases of their careers.

As the century advanced beyond the first decade three more trends became prominent, the impact of which was to be felt sooner or later throughout Italy and across her frontiers, namely the classicism of Annibale Carracci's school, Caravaggism, and Rubens's northern Baroque, the last resulting mainly from the wedding of Flemish realism and Venetian colourism. This marriage, accomplished by a great genius, was extraordinarily fertile and had a lasting influence above all in northern Italy.

At the end of the sixteenth and the beginning of the seventeenth centuries provincial painters could not yet have recourse to the new trends which were then in the making. But provincial centres were in a state of ferment. Everywhere in Italy artists were seeking a new approach to painting. This situation is not only cognate to Barocci's Urbino, Cerano's and Procaccini's Milan, Bernardo Strozzi's Genoa, Bonone's Ferrara, and Schedoni's Modena, but even to Cigoli's Florence, and may be characterized as an attempt to break away from Mannerist conventions. On all sides are seen a new emotional vigour and a liberation from formulas of composition and colour.[5] Since the majority of these artists belonged to the Carracci generation, much of their work was painted before 1600. They were, of course, reared in the Late Mannerist tradition, and from this, despite their protest against it, they never entirely emancipated themselves. It was only in Bologna, due mainly to the pioneering of the Carracci 'academy', that at the beginning of the Seicento a coherent school arose which hardly shows traces of a transitional style. As regards the other provincial towns, it is by and large more appropriate to talk of a transitional manner brought about by the efforts of individual and often isolated masters, some of whose names have just been mentioned. The special position in the Venice of Lys and Fetti will be discussed at the end of this chapter, while the lonely figure of Caracciolo may more conveniently be added to the names of the later Neapolitan painters (see II: p.160).

BOLOGNA AND NEIGHBOURING CITIES

The foremost names of Bolognese artists who did not follow Annibale to Rome are Alessandro Tiarini (1577–1668), Giovanni Andrea Donducci, called Mastelletta (1575–1655), Leonello Spada (1576–1622), and, in addition, Giacomo Cavedoni from Sassuolo (1577–1660).[6] They all begin by adopting different aspects of the Carracci teaching, on occasion coloured by Caravaggio's influence. It is, however, in the second decade of the seventeenth century that these artists emerge as the authors of a series of powerful and vigorous masterpieces. Nevertheless their production is essentially provincial. Neither academic in the sense of the prevalent Domenichino type of classicism nor fettered to

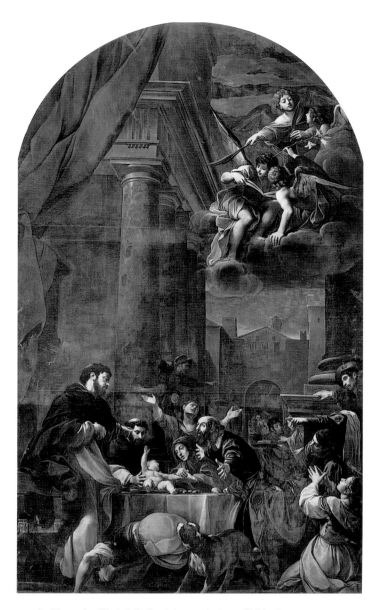

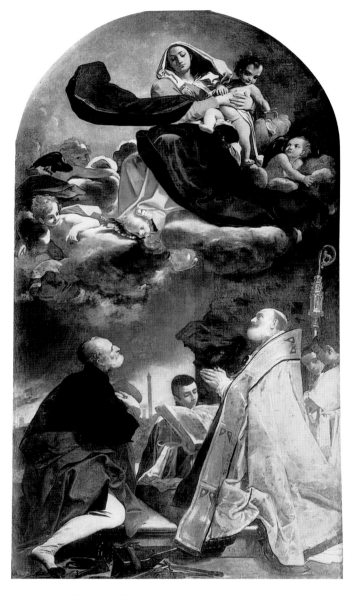

56. Alessandro Tiarini: *St Dominic resuscitating a Child*, 1614–15. Bologna, S. Domenico

57. Giacomo Cavedoni: *The Virgin and Child with SS. Alò and Petronius*, 1614. Bologna, Pinacoteca

Caravaggismo, their work is to a certain extent an antithesis to contemporary art in Rome. The culmination of this typically Bolognese manner occurs about fifteen years after Annibale's departure to Rome, when the powers of Lodovico, both as painter and as head of the Academy, were on the wane. In the ten years between 1610 and 1620, above all, the artists of the Carracci school fulfilled the promise of their training; but on the return of Guido Reni to Bologna, they relinquished one by one their individuality to this much superior painter.

If Mastelletta was the most original of this group of artists, the most highly talented were undoubtedly Cavedoni and Tiarini. After a brief Florentine phase in his early youth[7] the latter returned to Bologna, where he soon developed a characteristic style of his own. His masterpiece, *St Dominic resuscitating a Child*, a many-figured picture of huge dimensions, painted in 1614–15[8] for S. Domenico, Bologna, is dramatically lit and composed [56]. Since he was hardly

impeded by theoretical considerations, little is to be found here of the classicism practised at this moment by his compatriots in Rome. While the solidity of his figures and their studied gestures reveal his education in the Carracci school, his 'painterly' approach to his subject proves him a close follower of Lodovico, on whom he also relies for certain figures and the unco-ordinated back-drop of the antique temple and column. During the next years he intensified this manner in compositions with sombre and somewhat coarse figures of impressive gravity. Characteristic examples are the *Pietà* (Bologna, Pinacoteca) of 1617, and *St Martin resuscitating the Widow's Son* in S. Stefano, Bologna, of about the same period. According to Malvasia's report he was deeply impressed by Caravaggio, and a version of the latter's *Incredulity of St Thomas*, at the time in Bologna, was gleefully copied by him. In the twenties Tiarini uses a lighter range of colours; his style becomes more rhetorical and less intense, and simultaneously an interest in Veronese and

58. Leonello Spada: *The Way to Calvary*, *c*.1610–11 or 1613. Parma, Gallery

59. Pietro Faccini: *The Mystic Marriage of St Catherine*, *c*.1600. Bologna, Molinari Pradelli collection

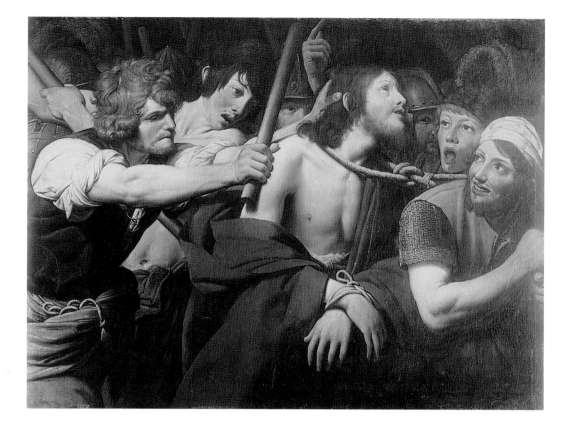

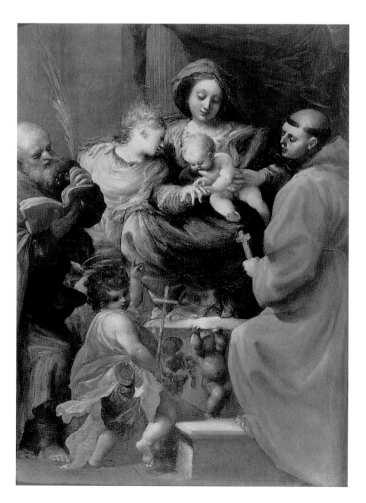

Pordenone is noticeable. His latest work, under the influence of Domenichino and above all Reni, hardly bears testimony to his promising beginnings.

Cavedoni lacks the dramatic power of Tiarini's early style, but he displays in the second decade a sense for a quietly expressive mood which he renders with a looser and more painterly technique. If his reliance on Lodovico Carracci is the dominant feature of his work, a Correggiesque note probably reaches him through Schedoni, with whom he has certain affinities – as can be seen in the frescoes of 1612–14 in S. Paolo, Bologna. In his masterpiece, the *Virgin and Child in Glory with SS. Alò and Petronius* of 1614 (Bologna, Pinacoteca) [57], his glowing palette shows him directly dependent on sixteenth-century Venetian painting. This is surely one of the most commanding pictures produced at Bologna during the period. Cavedoni never again achieved such full-blooded mastery.

It seems difficult to discard Malvasia's circumstantial report that Spada accompanied Caravaggio to Malta.[9] His early manner is close to Calvaert's Mannerism (*Abraham and Melchisedek*, Bologna, *c*. 1605). In 1607 he was still in his home-town, as is proved by the fresco of *The Miracle of the Loaves and Fishes* in the Ospedale degli Esposti. There is no trace here of Caravaggio's influence, and it is Lodovico, as in Spada's later pictures, who is uppermost in the artist's mind. Only in the course of the second decade do we find him subordinating himself to Caravaggio, and although nowadays this would appear slightly less conspicuous than his Bolognese nickname of *scimmia del Caravaggio* ('Caravaggio's ape') might lead one to suppose, the epithet was doubtless acquired by virtue of his liberal use of black and his realistic

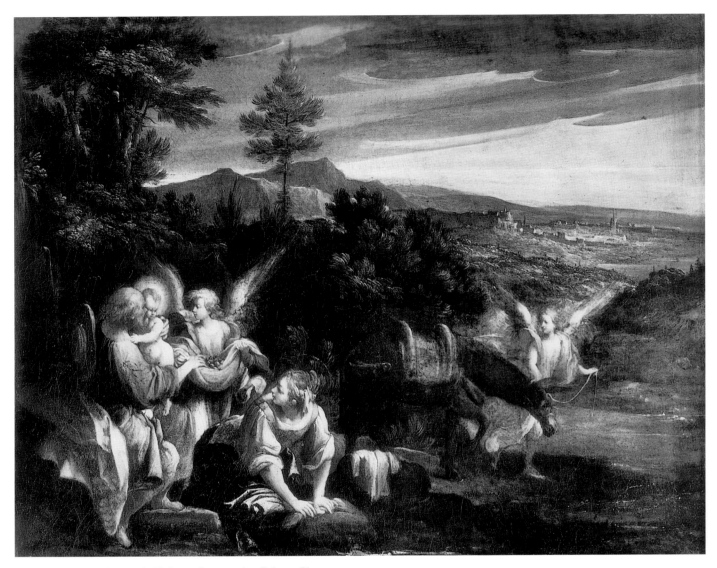

60. Mastelletta: *The Rest on the Flight into Egypt, c.* 1620. Bologna, Pinacoteca

and detailed rendering of close-up figures in genre scenes (*Musical Party*, Maisons Laffitte) or in more blood-thirsty contexts (the *Cain and Abel* in Naples or the *Way to Calvary* in Parma) [58]. His use of Caravaggio's art, however, is always moderated by a substantial acknowledgement of the instruction of the Carracci academy. But he seems to have regarded Caravaggism as unsuited to monumental tasks, for there is no trace of it in *The Burning of Heretical Books* of 1616 in S. Domenico, Bologna, where the tightly packed and sharply lit figures before a columned architecture fall in with the style commonly practised at Bologna during these years. In his late period Spada worked mainly in Reggio and Parma for Ranuccio Farnese, and his *Marriage of St Catherine* (Parma) of 1621 shows that under the influence of Correggio his style becomes more mellow and that his Caravaggism was no more than a passing phase.

Together with Mastelletta, Pietro Faccini must be mentioned. Both these unorthodox artists are totally unexpected in the Bolognese setting. Faccini, a painter of rare talents who had been brought up in the Mannerist tradition, died in 1602 at the early age of forty. In the 1590s he followed the Carracci lead, but in his very last years there was a radical change towards an extraordinarily free and delicate manner, to the formation of which Niccolò dell' Abate, Correggio, and Barocci seem to have contributed [59]. His *Virgin and Saints* in Bologna is evidence of the new manner which is fully developed in the self-portrait (Florence, Uffizi), possibly dating from the year of his death. This curious disintegration of Mannerist and Carraccesque formulas gives to his last works an almost eighteenth-century flavour. Mastelletta painted on the largest scale in a *maniera furbesca* (Malvasia), and the two huge scenes in S. Domenico, Bologna, reveal that in 1613–15 he was not bound by any doctrinal ties. His chief interest for the modern observer lies in his small and delicate landscapes in which the influence of Scarsellino as well as Niccolò dell' Abate may be discovered.[10] They are in a dark key, and the insubstantial, brightly-lit figures emerging from their shadowy surroundings contribute to give to these pictures an ethereal effect [60]. The most imaginative and poetical artist of his generation in Bologna remained, as might be expected, an isolated figure, and even today his work is almost unknown.[11]

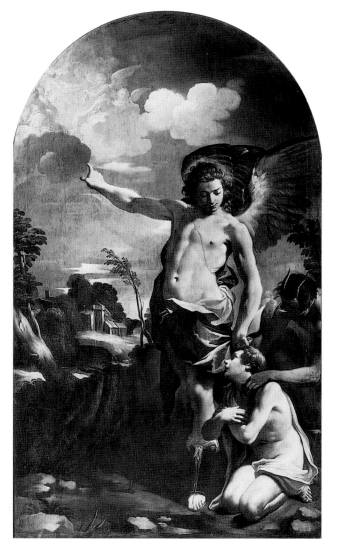

61. Carlo Bonone: *The Guardian Angel, c.* 1610. Ferrara, Pinacoteca

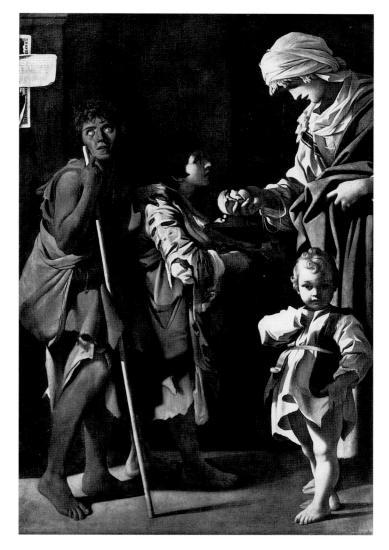

62. Bartolommeo Schedoni: *Christian Charity*, 1611. Naples, Museo Nazionale

At the same period Ferrara can claim two artists of distinction, Scarsellino[12] (1551–1620) and Carlo Bonone (1569–1632). The former belongs essentially to the late sixteenth century, but in his small landscapes with their sacred or profane themes he combines the spirited technique of Venetian painting and the colour of Jacopo Bassano with the tradition of Dosso Dossi. He thus becomes an important link with early seventeenth-century landscape painters, and his influence on an Emilian master like Mastelletta is probably greater than is at present realized. In Carlo Bonone Ferrara possessed an early Seicento painter who in his best period after 1610 shows a close affinity to Schedoni. Though not discarding the local tradition stemming from Dossi, nor neglecting what he had learned from Veronese, he fully absorbed the new tendencies coming from Lodovico Carracci [61]. In his fresco in the apse of S. Maria in Vado, depicting the *Glorification of the Name of God* (1617–20), he based himself upon Correggio without, however, going so far towards Baroque unification as Lanfranco did in Rome. Parallel to events in the neighbouring Bologna, his decline begins during the twenties. In his two dated works in the

Modena Gallery, *The Miracle of the Well* (1624–6) and the *Holy Family with Saints* (1626), he displays a provincial eclecticism by following in the one case Guercino and in the other Veronese. His last picture, *The Marriage at Cana* (Ferrara) of 1632, shows him not surprisingly returning to a typically Ferrarese Late Mannerism.

Bartolommeo Schedoni (1578–1615)[13] is in his latest phase certainly an artist of greater calibre. He was born in Modena and worked mostly at Parma, where he died. His frescoes in the town-hall at Modena of 1606–7 are still predominantly Mannerist in their dependence on Niccolò dell'Abate, although his style is already more flowing. But beginning in about 1610 there is an almost complete break with this early manner. Pictures of considerable originality such as the *Christian Charity* of 1611 in Naples [62], the *Three Maries at the Sepulchre* of 1614, and the *Deposition* of the same period, both in Parma, and the unfinished *St Sebastian attended by the Holy Women* (Naples) prove that it is Correggio who has provided the main inspiration for this new style. It is marked both by an intensity and peculiar aloofness of expression and by an emotional use of areas of

bright yellows and blues which have an almost metallic surface quality. His colour scheme, however, is far removed from that of the Mannerists, for he limits his scale to a few tones of striking brilliance. The treatment of themes with low-class types as in pictures like the *Charity* probably resulted from the experience of Caravaggio or his followers. It is a pointer in the same direction that Schedoni often placed his figures before a neutral background. Yet how different from Caravaggio is the result! In Schedoni's case there is a strange contrast between the dark ground and the figures which shine like precious jewels.[14]

It appears from this survey that the Emilian masters owed more to Lodovico than to any other single personality, but it is equally evident that the style of the outsize canvases by artists like Tiarini, Spada, and Mastelletta, with the many narrative incidents, the massive figures, and the studied academic poses, did not join the broad stream of the further development. Only of Schedoni, the master less obviously connected with the Carracci tradition, can it be said that he had a lasting influence, through the impression he made on the youthful Lanfranco.

FLORENCE AND SIENA

It has already been indicated that the role of Florence in the history of Seicento painting is disappointingly but not unexpectedly limited. Not a single artist of really great stature was produced there at this period. To a greater or lesser extent Florentines remained tied to their tradition of draughtsmanship, and their attempts to adjust themselves to the use of North Italian colour were more often than not halfhearted and inconsistent. Furthermore, neither the emotionalism of Barocci nor the drama and impetuosity of Lanfranco and the young Guercino were suitable to Tuscan doctrine and temperament. Bernardino Poccetti's (1548–1612) sober and measured narrations (Chiostro di S. Marco, 1602) remained the accepted style, and artists like Domenico Cresti, called Passignano (1558/60–1638), were faithful to this manner far into the seventeenth century. Passignano did, however, make concessions to Venetian colour, and his pictures tend to show a richer and warmer palette than those of his contemporaries. Similarly, Santi di Tito (1536–1603) softened his style towards the end of his career, but his paintings, though often simple and appealing, lacked vigour and tension and were never destined to transmit new life. This style was continued anachronistically by Tito's faithful pupil Agostino Ciampelli (c. 1568–1630, not c. 1575–1642).[15] It is likely that the Veronese Jacopo Ligozzi (1547–1626),[16] who spent most of his life in Florence, was instrumental in imposing northern chromatic precepts upon the artists in the city of his choice.

A painter of considerable charm, who deserves special mention, is Jacopo Chimenti da Empoli (1551/4–1640). He began in Poccetti's studio with a marked bias towards Andrea del Sarto and Pontormo, but the manner which he developed in the second and third decades of the new century is a peculiar compound of the older Florentine Mannerism and a rich, precise, and sophisticated colour scheme in which yellow predominates. Venturi was reminded before a picture such as the *Susanna* [63] of 1600

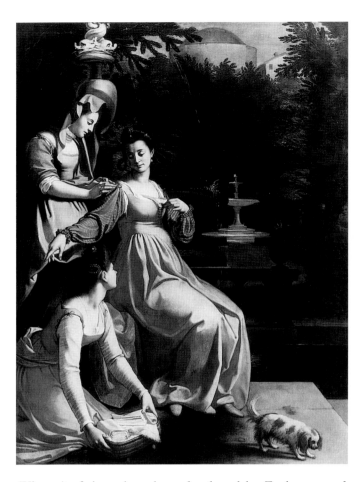

(Vienna) of the palette later developed by Zurbaran, and similar colouristic qualities may also be found in his rare and attractive still lifes,[17] the arrangement of which is dependent on the northern tradition.

By far the most eminent Florentine artist of this generation, however, is Ludovico Cardi, called Il Cigoli (1559–1613). An architect of repute and a close friend of Galilei,[18] he went further on the road to a true Baroque style than any of his Florentine contemporaries. In the beginning he accepted the Mannerism of his teacher, Alessandro Allori. At a comparatively early date he changed under the influence of Barocci (Baldinucci). In his *Martyrdom of St Stephen* [64] of 1597 (Florence, Accademia) Veronese's influence is clearly noticeable, while one of his most advanced works, the *Last Supper* of 1591 (Empoli, Collegiata), reveals him as colouristically, but not formally, dependent on Tintoretto. The clarity, directness, and simplicity of interpretation of the event show him almost on a level with the works of the Carracci at the same moment. In some of his later works, like the *Ecce Homo* (Palazzo Pitti), a typically Seicento immediacy of appeal will be found; in others, like his famous *Ecstasy of St Francis* [65], he gives vent to the new emotionalism. Nevertheless, he hardly ever fully succeeded in casting off his Florentine heritage. He went to Rome in 1604, returning to Florence only for brief intervals. His largest Roman work, the frescoes in the dome of the Cappella Paolina in S. Maria Maggiore (1610–13), are, in spite of spatial unification, less progressive than they may at first appear. In his last frescoes (1611–12), those of *Cupid and Psyche* from the Loggetta Rospigliosi (now Museo di

63. (*left*). Jacopo Chimenti da Empoli, *Susanna*, 1600. Vienna, Kunsthistorisches Museum

64. (*below*). Cigoli: *Martyrdom of St Stephen*, 1597. Florence, Accademia

65. (*right*). Cigoli: *The Ecstasy of St Francis*, 1596. Florence, S. Marco, Museum

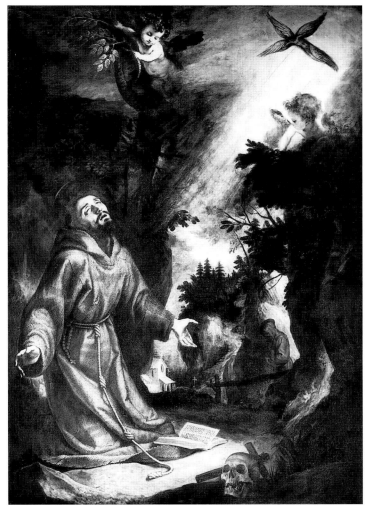

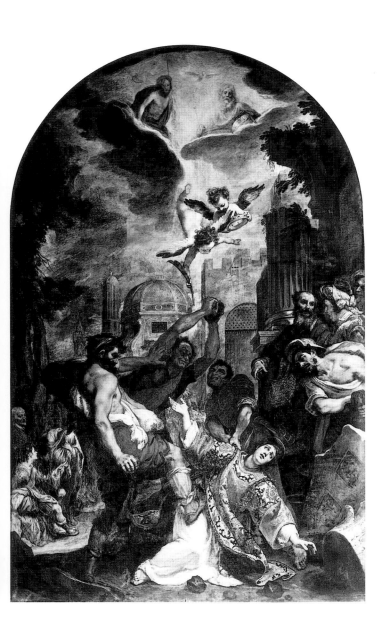

Roma), he accepted the Carraccesque idiom to such an extent that they were once attributed to Lanfranco as well as to Annibale himself.

Even the best of Cigoli's followers, Cristofano Allori (1577–1621) and the Fleming Giovanni Biliverti (1576–1644), adhere to a transitional style.[19] More important than these masters is their exact contemporary Matteo Rosselli (1578–1650), a pupil of Passignano. He owed his position, however, not to his intrinsic qualities as a painter but to the fact that he was the head of a school which was attended by practically all the younger Florentine artists.[20]

Siena at this period had at least one painter worth recording apart from the Barocci followers Ventura Salimbeni and Francesco Vanni, who have been mentioned. Rutilio Manetti (1571–1639), Vanni's pupil, was also not unaffected by Barocci's manner. But only with his conversion to Caravaggism in his *Death of the Blessed Antonio Patrizi* of 1616 (S. Agostino, Monticiano)* does he emerge as an artist of distinction [66]. In the following years his vigorous genre scenes are reminiscent of Manfredi and Valentin or even the northern *Caravaggisti*. From the beginning of the thirties these is a falling off in quality, for example in the *St Eligius*

* Alessandro Bagnoli has argued convincingly for a later date for this painting, and consequently Manetti's absorption of the Caravaggesque manner.

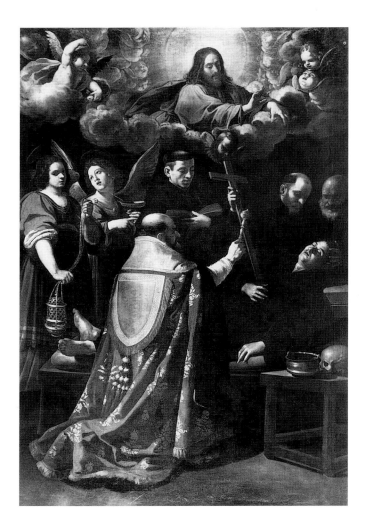

called Cerano (*c.* 1575–1632), and Pier Francesco Mazzuc-chelli, called Morazzone (1573–1626),[23] and a study of their work gives the measure of Milanese 'history painting' at this period: influences from Venice (Veronese, Pordenone) and from Florentine, Emilian (Tibaldi), and northern Mannerism (e.g. Spranger) have been superimposed upon a local foundation devolving from Gaudenzio Ferrari. To a lesser degree than Genoa, Milan at this historical moment was the focus of crosscurrents from south, east, and north. But this Milanese art is marked by an extraordinary inten-sity which has deep roots in the spirit of popular devotion epitomized in the pilgrimage churches of the *Sacri Monti* of Lombardy. [See also II: 182, 183.]

Cerano, born at Novara, was the most comprehensive tal-ent of the Milanese group. Architect, sculptor, writer, and engraver apart from his principal calling as painter, he became in 1621 the first Director of Federico Borromeo's newly founded Academy. In fact his relation to the Borromeo family dates back to about 1590, and he remained in close contact with them to the end of his life: no wonder, therefore, that he had the lion's share in the St Charles Borromeo cycle. Despite his long stay in Rome (1586–95), he shows, characteristically, in his early work a strong

66. Rutilio Manetti: *The Death of the Blessed Antonio Patrizi*, 1616. Monticiano, S. Agostino

67. Cerano: *The Virgin of the Rosary*, *c.* 1615. Milan, Brera

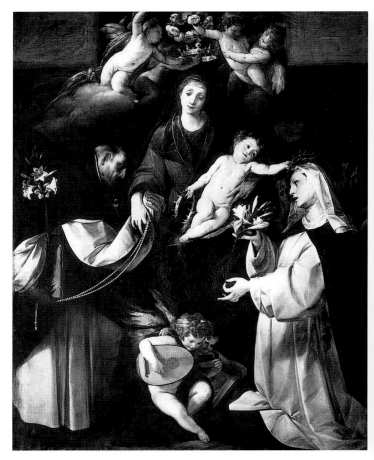

of 1631 at Siena; in his latest production, to a great extent executed with the help of pupils, the energy displayed dur-ing the previous fifteen years is exhausted.[21]

The popular Florentine narrative style of the Poccetti–Passignano type, which was adopted by Manetti early in his career, was a success not only in Rome but also in the North, particularly in Liguria and Lombardy. However, the use to which it was put was not everywhere the same. While in Genoa it was imported directly, without variation, in Milan it was blended with new tendencies in an effort to produce a distinctly 'native' manner.

MILAN

Seicento painting in Milan developed under the shadow of the great counter-reformer St Charles Borromeo (d. 1584), who was discussed in the first chapter. His spirit of devotion was kept alive by his nephew Archbishop Federico Borromeo. It was he who in 1602 commissioned a cycle of paintings to honour St Charles's memory. These large can-vases depicting scenes from his life were increased in 1610, the year of St Charles's canonization, to over forty to include portrayals of his miracles (the whole cycle in Milan Cathedral). Many of these pictures were due to the three foremost Milanese painters of the early Seicento, Giulio Cesare Procaccini (1574–1625),[22] Giovanni Battista Crespi,

68. Morazzone: *Ecce Homo* Chapel, 1609–13. Frescoes. Varallo, Sacro Monte

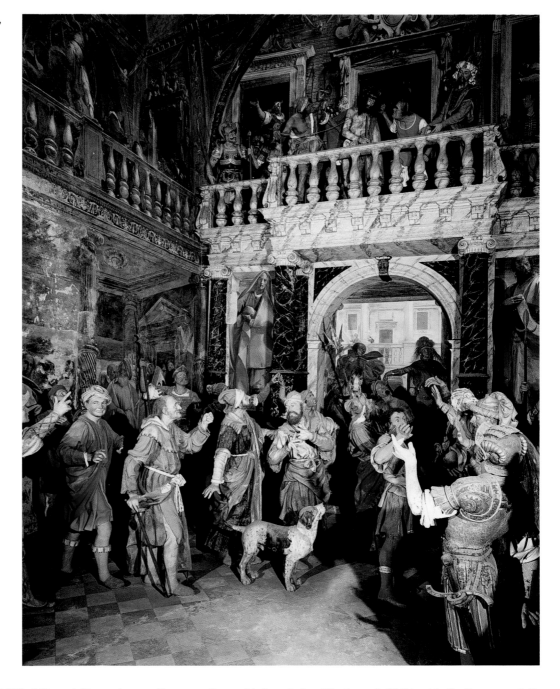

attachment to Gaudenzio,[24] Tibaldi, and Barocci as well as to Flemish and even older Tuscan Mannerists (*Archangel Michael*, Milan, Museo di Castello).[25] But he soon worked out a Mannerist formula of his own (*Franciscan Saints*, 1600, Berlin, destroyed) which is as far removed from the formalism of international Mannerism around 1600 as from the palpability of the rising Baroque. An often agonizing tension and an almost morbid mysticism inform many of his canvases, and the silver-grey light and clear scale of tones for which he is famed lend support to the spiritual quality of his work. Although he never superseded his mystic Mannerism, as may be seen in one of his greatest works, the *Baptism of St Augustine* of 1618 in S. Marco, Milan, and although no straight development of his style can possibly be construed, he yet produced during the second decade compositions of such impressive simplicity as the *Madonna del Rosario* in the

Brera [67] and the *Virgin and Child with St Bruno and St Charles* in the Certosa, Pavia, both of about 1615, in which he humanized the religious experience by falling back on the older Milanese tradition. Few pictures are known of Cerano's latest period. In 1629 he was appointed head of the statuary works of Milan Cathedral, and from this time date the impressively compact monochrome *modelli* for the sculpture over the doors of the façade (Museo dell'Opera, Cathedral) which were translated into flaccid marble reliefs by Andrea Biffi, G. P. Lasagni, and Gaspare Vismara.[26]

Like Cerano, Morazzone had been early in his life in Rome (*c.* 1592–8), and some of this work in the Eternal City can still be seen *in situ* (frescoes in S. Silvestro in Capite). But Morazzone's style was even more radically formed than Cerano's on Gaudenzio Ferrari. Back home, he made his debut as a fresco painter in the Cappella del Rosario in S.

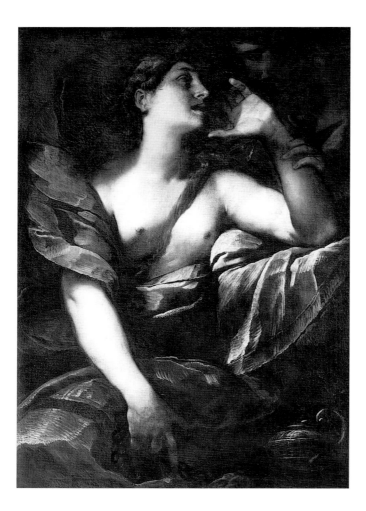

famous 'three-master-picture', the *Martyrdom of SS. Rufina and Seconda* in the Brera of about 1620.[29]

The S. Rufina painted by Giulio Cesare Procaccini in the lower right half of this work carries the signature of a precious manner and a bigoted piety very different from those of his collaborators. The more gifted brother of the elder Camillo (*c.* 1560–1629), Giulio Cesare had moved with his family from Bologna to Milan in about 1590; but if any traces of his Bolognese upbringing are revealed in his work, they point to the older Bolognese Mannerists rather than to an influence from the side of the Carracci. In Milan he began as a sculptor with the reliefs for the façade of SS. Nazaro e Celso (1597–1601),[30] and a statuesque quality is evident in his paintings during the first two decades. Apart from his contacts with Morazzone and Cerano, the important stages of his career are indicated by his renewed interest in sculpture after 1610, by his stay in Modena between 1613 and 1616, where he painted the *Circumcision* (Galleria

69. Giulio Cesare Procaccini: *St Mary Magdalen, c.* 1616. Milan, Brera

70. Antonio d'Enrico, il Tanzio: *David, c.* 1620, Varallo, Pinacoteca

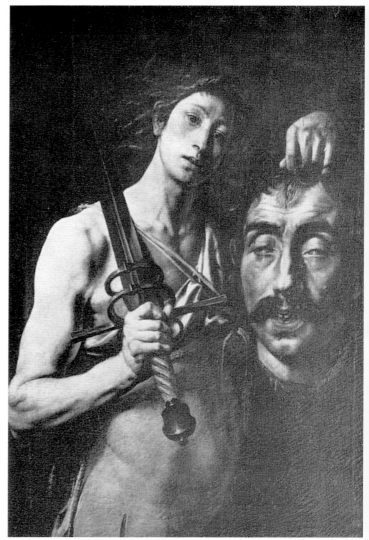

Vittore at Varese (1599 and 1615–17). Large frescoes followed at Rho (*c.* 1602–4) and in the 'Ascent to Calvary' Chapel of the Sacro Monte, Varallo (1605). In the frescoes of the 'Flagellation' Chapel of the Sacro Monte near Varese (1608–9) and the 'Ecce Homo' Chapel at Varallo (1609–13) [68] Morazzone's characteristic style is fully developed. In 1614 he finished the frescoes of the 'Condemnation to Death' Chapel at Varallo, and between 1616 and 1620 he executed those of the 'Porziuncola' Chapel of the Sacro Monte at Orta.[27] It is at once evident that Morazzone, like his contemporary Antonio d'Enrico, called Tanzio da Varallo (1574/80–1635), was thoroughly steeped in the tradition of these collective enterprises, in which the spirit of the medieval miracle plays was revived and to the decoration of which a whole army of artists and artisans contributed between the sixteenth and eighteenth centuries.[28] Morazzone's reputation as a fresco painter, solidly founded on his achievements in the Sanctuaries, opened other great opportunities for him. In 1620 he painted a chapel in S. Gaudenzio at Novara and in 1625, shortly before his death, he began the decoration of the dome of Piacenza Cathedral, the greater part of which was carried out by Guercino. Morazzone as a master of the grand decorative fresco went further than his Milanese contemporaries in promoting the type of popular realism that was part and parcel of the art of the Sanctuaries. But that the intentions of Morazzone, Cerano, and Procaccini lay not far apart is proved by the

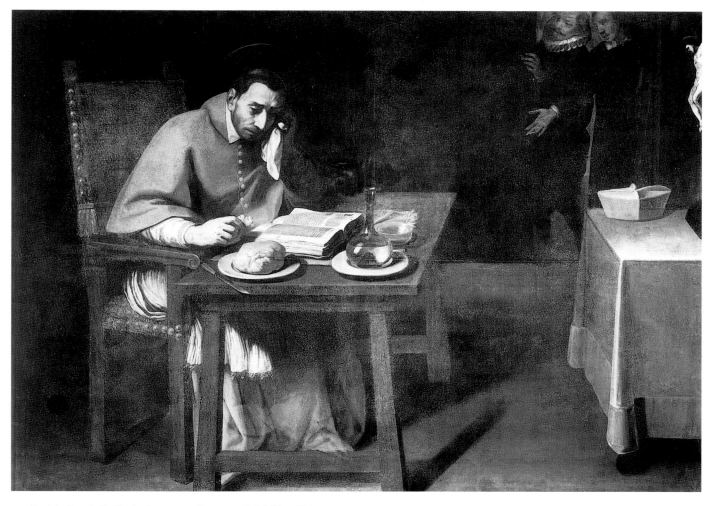

71. Daniele Crespi: *St Charles Borromeo at Supper*, c. 1628. Milan, Chiesa
della Passione

Estense), and his sojourn at Genoa in 1618. After Modena
he was at the mercy of Correggio and his Parmese followers,
above all Parmigianino, as his *Marriage of St Catherine*
(Brera) and the *Mary Magdalen* (Brera) [69] prove. Genoa
brought him in contact with Rubens, and the repercussions
on his style will easily be detected in such works as the
Deposition of the Fassati Collection, Milan, and the *Judith
and Holofernes* of the Museo del Castello.

A word must be said about Tanzio, the most tempera-
mental, tense, and violent of this group of Milanese artists.
It is now fairly certain that he was in Rome some time
between 1610 and 1615, and the impact of *Caravaggismo* is
immediately felt in the *Circumcision* at Fara San Martino
(parish church) and the *Virgin with Saints* in the Collegiata
at Pescocostanzo (Abruzzi), works which appear deliber-
ately archaizing and deliberately crude.[31] The important
frescoes at Varallo as well as those in the Chiesa della Pace,
Milan,[32] show him returning to the local traditions, to
Cerano and the Venetians; nevertheless, *Caravaggismo*
seems to have kept a hold on him, as later pictures attest,
among them the obsessed-looking *David* with the enormous
polished sword and the almost obscene head of Goliath
(Varallo, Pinacoteca) [70] and the most extraordinary *Battle
of Sennacherib* (1627–9, S. Gaudenzio, Novara; bozzetto in

the Museo Civico), where an uncompromising realism is
transmuted into a ghostlike drama with frightfully distorted
figures which seem petrified into permanence.[33]

To the names of these artists should be added that of the
younger Daniele Crespi (*c.* 1598–1630), a prodigious worker
who derived mainly from Cerano and Procaccini, but whose
first recorded work shows him assisting Guglielmo Caccia,
called Il Moncalvo (*c.* 1565–1625),[34] in the frescoes of the
dome of S. Vittore at Milan. In his best works Daniele com-
bined severe realism and parsimonious handling of pictorial
means with a sincerity of expression fully in sympathy with
the religious climate at Milan. His famous *St Charles
Borromeo at Supper* (Chiesa della Passione, Milan, *c.* 1628)
[71] comes nearer to the spirit of the austere devotion of the
saint than almost any other painting of the period and is,
moreover, expressed without recourse to the customary reli-
gious and compositional props from which the three princi-
pal promoters of the early Milanese Seicento were never
entirely able to detach themselves. The question has been
raised if Daniele was indebted to Zurbaran's contemporary
work. Whether or not the answer is in the affirmative, he
certainly was impressed by Rubens and Van Dyck, as is
revealed in his principal work, the cycle of frescoes in the
Certosa at Garegnano, Milan (1629). A similar cycle painted

in the Certosa of Pavia in the year of his death may be regarded as an anti-climax. Daniele's career was prematurely interrupted by the plague of 1630. This event, immortalized by Manzoni, spelled to all intents and purposes the end of the first and greatest phase of Milanese Seicento painting.

GENOA

While the most important period of Milanese painting was over by about 1630, a local Seicento school began in Genoa somewhat later but flourished for a hundred years. During the seventeenth century the old maritime republic had an immensely rich ruling class who made their money for the most part by world-wide banking manipulations; and the international character of their enterprises is also reflected in the artistic field. It is true that at the end of the previous century Genoa had possessed in Luca Cambiaso (1527–85) a great native artist. Capable of working on the largest scale, his influence remained a vital force far into the Seicento, and among his followers must be numbered Lazzaro Tavarone (1556–1641), Battista Castello (1547–1637), and his brother Bernardo (1557–1629). But it was not these much sought-after, tame Mannerists who brought about the flowering of seventeenth-century Genoese art. Genoa grew to importance as a meeting place of artists from many different quarters. There was a Tuscan group to which the Sienese Pietro Sorri (1556–1622), Francesco Vanni, and Ventura Salimbeni belonged. Aurelio Lomi (1556–1622) from Pisa was in Genoa between 1597 and 1604, and Giovanni Battista Paggi (1554–1627), a Genoese who had worked in Florence with Cigoli, brought back the latter's manner to his hometown.

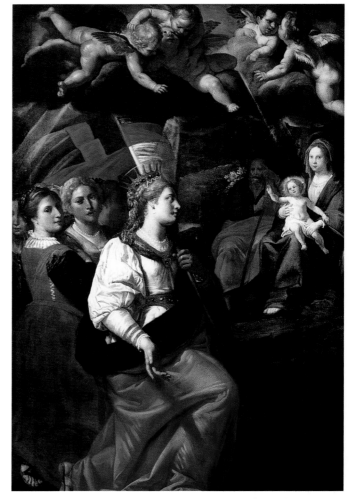

73. Domenico Fiasella: *St Ursula and her Virgins*, 1624. Genoa, SS. Quirico e Giulitta

72. Giovanni Andrea Ansaldo: *The Head of St John the Baptist brought to Herodias*, c. 1630. Genoa, Palazzo Bianco

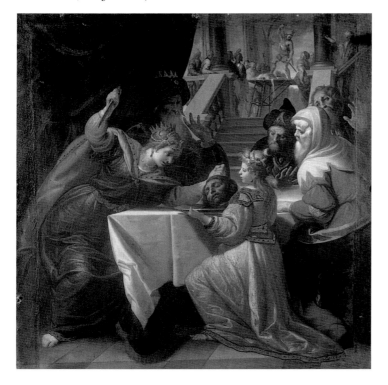

In accordance with their training and tradition these artists represent on the whole a rather reactionary element. More vital was the contact with the progressive Milanese school, and the impact of Giulio Cesare Procaccini, working in Genoa in 1618, was certainly great. Of equal and even greater importance for the future of Genoese painting were the Flemings. They had long regarded Genoa as a suitable place to try their fortunes, and works by artists such as Pieter Aertsen were already collected there in the late sixteenth century. Snyders was probably in Genoa in 1608, and later Cornelius de Wael (1592–1667) became an honorary citizen and leader of the Flemish colony.[35] Their genre and animal pictures form an important link with the greater figure of G. Benedetto Castiglione, and in this context Jan Roos (Italianized: Giovanni Rosa) should at least be mentioned. But the names of all these Flemings are dwarfed by that of Rubens, whose stay in the city in 1607 (*Circumcision*, S. Ambrogio) and dispatch, in 1602, of the *Miracle of St Ignatius* (S. Ambrogio) were as decisive as Van Dyck's sojourns in 1621–2 and 1626–7. Caravaggio, in Genoa for a short while in 1605, left, it seems, no deep impression at that moment. Caravaggism gained a foothold, however, through

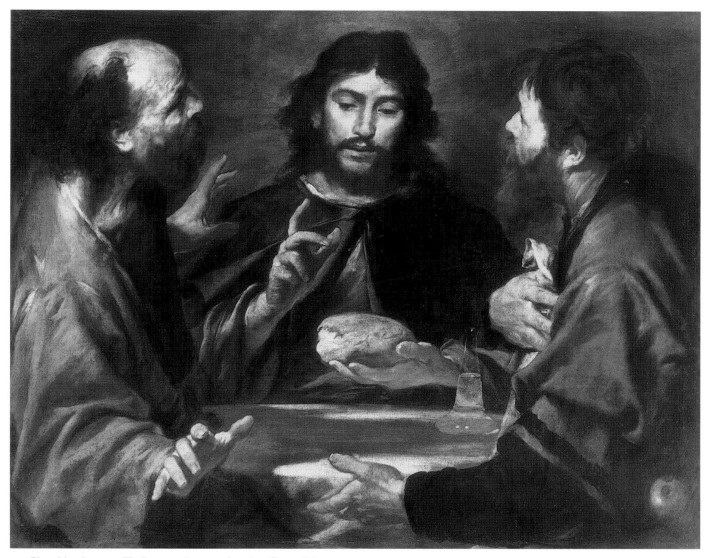

74. Gioacchino Assereto: *The Supper at Emmaus*, after 1630. Genoa, Private Collection

Orazio Gentileschi and Vouet, who were in Genoa at the beginning of the twenties. Finally it should not be forgotten that the Genoese appreciated the art of Barocci and of the Bolognese. The former's *Crucifixion* for the cathedral was painted in 1595; and pictures by Domenichino, Albani, Reni,[36] and others reached Genoa at an early moment. The impression Velasquez made in Genoa at the time of his visit in 1629 seems worth investigating. It can, therefore, be seen that in the first decades of the seventeenth century Genoa was in active contact with all the major artistic trends, Italian and foreign.

The development of the early seventeenth-century native Genoese painters Bernardo Strozzi (1581–1644), Andrea Ansaldo (1584–1638) [72], Domenico Fiasella, called Il Sarzana (1589–1669) [73], Luciano Borzone (1590–1645), and Gioacchino Assereto (1600–49) runs to a certain extent parallel. They begin traditionally enough: Fiasella and Strozzi deriving from Lomi, Paggi, and Sorri; Ansaldo from the mediocre Orazio Cambiaso, Luca's son; and Assereto from Ansaldo. Towards the twenties these artists show the influence of the Milanese school, and only Fiasella, who had

worked in Rome from 1607 to 1617, is really swayed by the *Caravaggisti*.[37] In the course of the third decade they all attempt to cast away the last vestiges of Mannerism and turn towards a freer, naturalistic manner, largely under the influence of Rubens and Van Dyck. It should, however, be said that, lacking monographic treatment, neither Borzone nor Ansaldo and Fiasella are clearly defined personalities; it would seem that the prolific Fiasella, who lived longest and was much in fashion with the Genoese aristocracy, must be regarded as the least interesting and original of this group of artists. By contrast Assereto, through Longhi's basic study, has become for us an artistic personality with clear contours.[38] In his work after 1630, for example in the Genoa *Martyrdom of St Bartholomew* or the Genoa *Supper at Emmaus* [74], he achieved a unification of composition and a complete freedom of handling which places him almost on a level with Strozzi in his Venetian period.

The genius of this generation, surpassing all his contemporaries, was Bernardo Strozzi. His early style, from his 'Tuscan' beginnings to his vacillations between Veronese, Caravaggio, and the Flemings, is not yet sufficiently clear

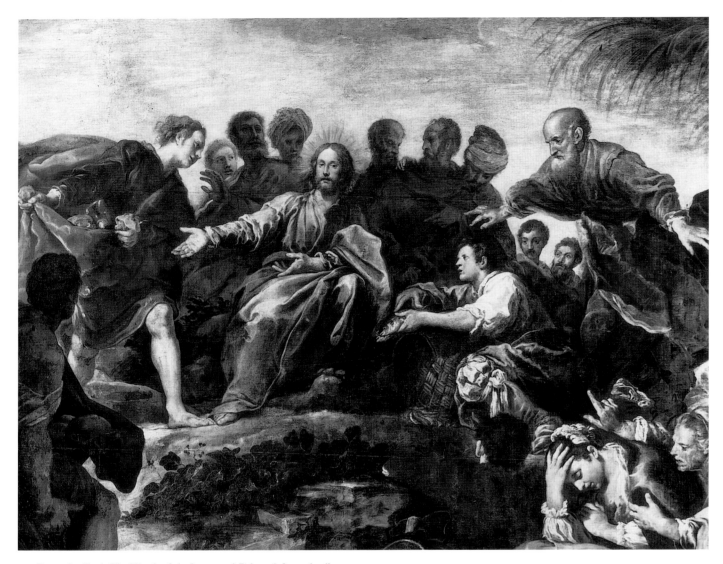

75. Domenico Fetti: *The Miracle of the Loaves and Fishes*, 1618–19, detail.
Fresco. Mantua, Palazzo Ducale

[II: 200].[39] In 1598 he became a Capuchin monk, but in 1610 he was allowed to leave the monastery. Between 1614 and 1621 he acted as an engineer in his home-town and from 1623 to 1625 he painted the frescoes in the Palazzo Carpanetto at San Pier d'Arena. Imprisoned by his Order, he went after his release in 1630 to Venice, where he lived until his death in 1644. Discussion of his work may be postponed, since his great Venetian period belongs to a later chapter.

VENICE

In the smaller centres of northern Italy a Late Mannerist style prevailed practically throughout the first half of the seventeenth century. This was primarily due to the influential position of Venice, where the leading roles were played by three eclectic artists, namely Jacopo Negretti, called Palma Giovane (1544–1628), Domenico Tintoretto (1560–1635), and Alessandro Varotari, called Padovanino (1588–1648). Domenico Tintoretto continued his father's manner with a strong dash of Bassani influence; Padovanino

in his better pictures tried not unsuccessfully to recapture something of the spirit of Titian's early period; Palma Giovane, basing himself on a mixture of the late Titian and Tintoretto, was the most fertile and sought-after but at the same time the most monotonous of the three.[40] Strangely enough, these masters had little understanding for the potentialities of the loaded brush-stroke. As a rule their canvases are colouristically dull, lacking entirely the exciting surface qualities of the great sixteenth-century painters.[41] Deeply under the influence of these facile artists, their contemporaries in the *Terra Ferma*, in Verona, Bergamo, and Brescia, bear witness to the popularity of what had by then become a moribund style. It was, in fact, the degeneration of the great Venetian tradition in Venice itself, together with the rise of Rome as the centre of progressive art, that determined the pattern of seventeenth-century painting for the whole of Italy.

In 1630 probably few Venetians realized that they had had two young artists in their midst who had aroused painting from its 'eclectic slumber'. They were neither Venetian by birth, nor were they ever entrusted with important commis-

sions in the city in which they had settled. Giovanni Lys came to Italy in about 1620, and by 1621 was in Venice. In the same year Domenico Fetti had his first taste of Venice. Both artists excelled in cabinet pictures and both died young. They each developed a manner in which the spirited brush-stroke was of over-riding importance, and by this means they re-invigorated Venetian colour and became the exponents of the most advanced tendencies. They are the real heirs to the Venetian colouristic tradition; with their rich, warm, and light palette and their laden brush-work they are as far removed from the *tenebroso* of Caravaggio as from the classicism of the Bolognese. Lys was born in Oldenburg in North Germany in about 1597, and Fetti in Rome in 1589. Fetti died at the age of thirty-four in 1623; Lys was even younger when he was carried off by the Venetian plague of 1629–30.* Their *œuvres* are therefore limited, and their influence, although considerable – particularly on Strozzi – should not be overestimated.

Fetti's first master was Cigoli, after the latter came to Rome in 1604; but although their association remained close until 1613, little evidence of Cigoli's transitional style can be discovered in Fetti's work. In fact in Rome Fetti must have felt the influence, if not of Caravaggio himself, at any rate of those followers such as Borgianni and Saraceni who were more in sympathy with Venetian colour. Not much is known about Fetti's Roman period, but it would have been in this circle that he developed his taste for the popular genre. At the same time he must have been deeply impressed by the art of Rubens, whose transparent red and blue flesh tones he adopted. When in 1613 he went to Mantua as Court Painter to Duke Ferdinando, he again found himself under the shadow of Rubens, but while working there, he became increasingly dependent on Venetian art, particularly that of Titian and Tintoretto. Fetti was not a master capable of working on a large scale, and to a certain extent the official paintings he had to execute in the ducal service must have been antipathetic to him. Apart from the fresco of the *Trinity* in the apse of the cathedral, now attributed to Ippolito Andreasi (1548–1608),[42] the most massive of these commissions was the *Miracle of the Loaves and Fishes* (Mantua, Palazzo Ducale) where the intricate composition with its manifold large figures falls below the high standard shown in many passages of painting [75]. Fetti's early work is rather dark, but slowly his palette lightened, while he intensified the surface pattern by working with complementary local colours.[43] It was only after his removal to Venice in 1622[44] and during the brief remainder of his life that he was able to devote himself entirely to small easel pictures [76]. These little works, many of them illustrating parables set in homely surroundings, must have attracted the same public as the *Bambocciate* in Rome, and the numerous repetitions of the same subjects from the artist's own hand attest their popularity.[45] It was in these pictures with their loose and pasty surfaces punctuated by rapid strokes of the brush, giving an effect of vibrating light, that Fetti imparted a recog-

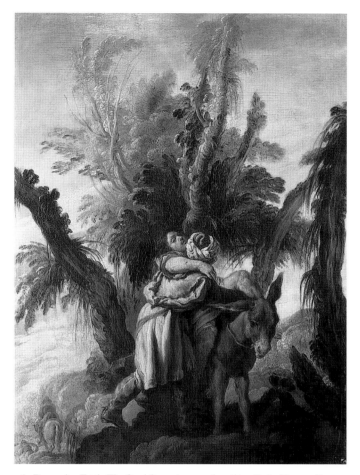

76. Domenico Fetti: *The Good Samaritan, c.* 1622. New York, Metropolitan Museum of Art

nizably seventeenth-century character to the pictorial tradition of Venice. A decisively new stage in the history of art is reached at this point.

Although Fetti himself went a long way towards discarding the established conventions of picture-making, it was Lys who took a step beyond Fetti: his work opens up a vista on the future of European painting. Lys had started his career in about 1615 in Antwerp and Haarlem, where he came into contact with the circles of local painters, in particular Hals and Jordaens. In Venice he formed a friendship with Fetti and, after the latter's death, with the Frenchman Nicolas Regnier (*c.* 1590–1667), a follower of Caravaggio in Rome who moved to Venice in 1627. Only one of Lys's pictures is dated, namely the *Christ on the Mount of Olives* (Zürich, private collection), and the date has been read both as 1628 and 1629. For the rest it would appear that the longer he stayed away from Holland the more he dissociated himself from his Northern upbringing. Not only did he exclude from his repertory the rather rustic northern types, but he also tended towards an ever-increasing turbulence and freedom of handling. His development during his few Venetian years must have been astonishingly rapid. Such a picture as the *Fall of Phaeton* in the Denis Mahon Collection, London,[46] with its velvety texture and an intensity which may be compared with Rubens, must date from about 1625, since despite its softness it is still comparatively

* Lys died on 5 December 1631 (E. Antoniazzi, 'Addenda: La data di morte di Johann Liss', *Arte veneta*, XXIX, 1976, p. 306).

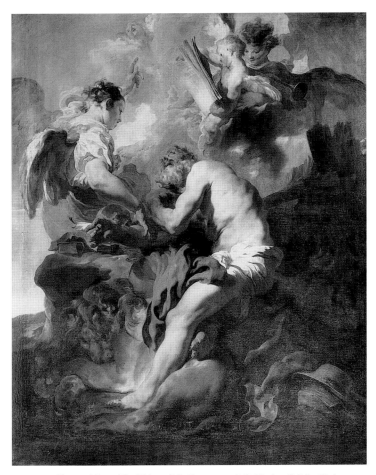

77. Giovanni Lys: *The Vision of St Jerome, c.* 1628. Venice, S. Nicolò da Tolentino

firm in its structure. On the other hand later pictures like the *Ecstasy of St Paul* (Berlin) or the *Vision of St Jerome* (Venice, S. Nicolò da Tolentino) [77] show a looseness and freedom and a painterly disintegration of form which call to mind even the works of the Guardi [III: 138].[47]

CONCLUSION

The reader may well ask what the over-all picture is that emerges from this rapid survey. Almost all the artists mentioned in this and the previous chapters were born between 1560 and 1590. Most of them began their training with a Late Mannerist and retained throughout their lives Mannerist traces to a greater or lesser degree. Only the youngest, born after 1590, who were here included because,

like Lys and Fetti, they died at an early age, grew up in a post-Mannerist atmosphere or were capable of discarding the Mannerist heritage entirely. The majority matured after 1600 and painted their principal works after 1610. What creates a common bond between all these provincial masters in a spirit of deep and sincere devotion. Viewed in this light, a Tiarini, a Schedoni, a Cerano, and a Cigoli belong more closely together than is generally realized. On this level it counts very little whether the one clings longer or more persistently to Mannerist conventions than the other, for they are all equally divorced by a deep rift from the facile international Mannerism of the late Cinquecento, and they all return in one way or another to the great Renaissance masters and the first generation of Mannerists in their search for guidance to a truly emotional art. It would, therefore, be as wrong to underestimate the revolutionary character of their style and to regard it simply, as is often done, as a specific type of Late Mannerism as it would be to stress too much its continuity into the Baroque of the mid century. The beginnings of the style date back to Lodovico Carracci of the early nineties and to Cigoli of the same period. It finds its most intense expression in Caravaggio's work around 1600; by and large it is the idiom of *Caravaggisti* like Orazio Gentileschi, Saraceni, and Borgianni, and of the Emilian and Milanese masters, mainly during the second decade; and, as has been shown again and again in these pages, it slowly comes to an end in the course of the third decade.

It is important to notice that this art is strongest, or even arises, in the provinces at a moment when the temper began to change in Rome. This is revealed not only in the Farnese Gallery but also in Annibale's religious work after 1600, where studied severity replaces emotional tension. In the provinces the enormous intensity of this style, the compound of gravity, solemnity, mental excitation, and effervescence could not be maintained for long. To explore further the possibilities which were open to artists roughly from the beginning of Urban VIII's reign onwards will be the task of the Second Part. But meanwhile the reader may compare the change of religious temper from an early, 'Mannerist', to a late, 'Baroque', Strozzi [II: 201, 203], a telling experience which may be repeated a hundred times with artists of the generation with which we were here concerned.

If it is at all possible to associate any one style or manner with the spirit of the great reformers, one would not hesitate to single out this art between about 1590 and 1625/30, and whether or not this will be agreed to, one thing is certain, that the period under review carries its terms of 'Late Mannerism' or 'Transitional Style' or 'Early Baroque' only *faute de mieux*.

Architecture and Sculpture

ARCHITECTURE

Rome: Carlo Maderno (1556–1629)

In the first chapter the broad pattern was sketched of the architectural position in Rome during the early years of the seventeenth century. The revolutionary character of Maderno's work has already been indicated. It was he who broke with the prevailing severe taste and replaced the refined classicism of an Ottavio Mascherino and a Flaminio Ponzio by a forceful, manly, and vigorous style, which once again, after several generations, had considerable sculptural and chiaroscuro qualities. Like so many masons and architects, Maderno came from the North; he was born in 1556 at Capolago on the Lake of Lugano, went to Rome before Sixtus V's pontificate, and together with his four brothers acquired Roman citizenship in 1588.[1] He began work in a subordinate capacity under his uncle, Domenico Fontana. After the latter's departure for Naples he was on his own, and before 1600 he had made a name for himself. But his early period and, in particular, his relationship to Francesco da Volterra remains to be clarified.[2]

The year 1603 must be regarded as a turning point in Maderno's career [78]; he was appointed 'Architect to St Peter's' and finished the façade of S. Susanna [79].[3] To the *cognoscenti* this façade must have been as much of a revelation as Annibale Carracci's Farnese Gallery or Caravaggio's religious imagery. In fact, with this single work, Maderno's most outstanding performance, architecture drew abreast of the revolutionary events in painting. In contrast to so many Mannerist buildings, the principle governing this structure is easy to follow: it is based on an almost mathematically lucid progressive concentration of bays, orders, and decoration towards the centre. The triple projection of the wall is co-ordinated with the number of bays, which are firmly framed by orders; the width of the bays increases towards the centre and the wall surface is gradually eliminated in a process reversing the thickening of the wall – from the Manneristically framed cartouches to the niches with figures and the entrance door which fills the entire central bay. The upper tier under the simple triangular pediment is conceived as a lighter realization of the lower tier, with pilasters corresponding to the half- and three-quarter-columns below. In this façade North Italian and indigenous Roman traditions are perfectly blended.[4] Maderno imparted a clearly directed, dynamic movement to the structure horizontally as well as vertically, in spite of the fact that it is built up of individual units. Neither in his façade of St Peter's nor in that of S. Andrea della Valle – in its present form mainly the work of Carlo Rainaldi (II: p. 104) – did Maderno achieve an equal degree of intense dynamic life or of logical integration. Nor did he find much scope to develop his individuality in the interiors of S. Maria della Vittoria and S. Andrea della Valle. But the dome of the latter church – the largest in Rome after that of St Peter's – shows Maderno's genius at its best. Obviously derived from Michelangelo's dome, it is of majestic simplicity. Compared with the dome of St Peter's Maderno raised the height of the drum at the expense of the vault and increased the area that was to be reserved for the windows, and these changes foreshadow the later Baroque development.

Long periods of his working life were spent in the service of St Peter's, where he was faced with the unenviable task of having to interfere with Michelangelo's intentions. The

78. Carlo Maderno: Frascati, Villa Aldobrandini, 1603

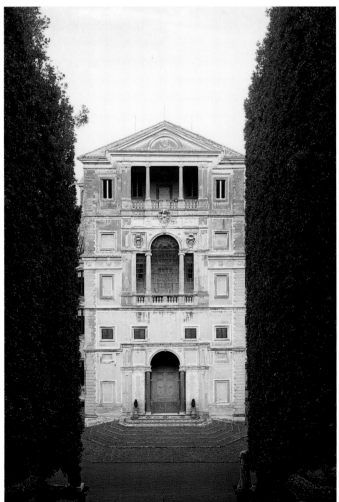

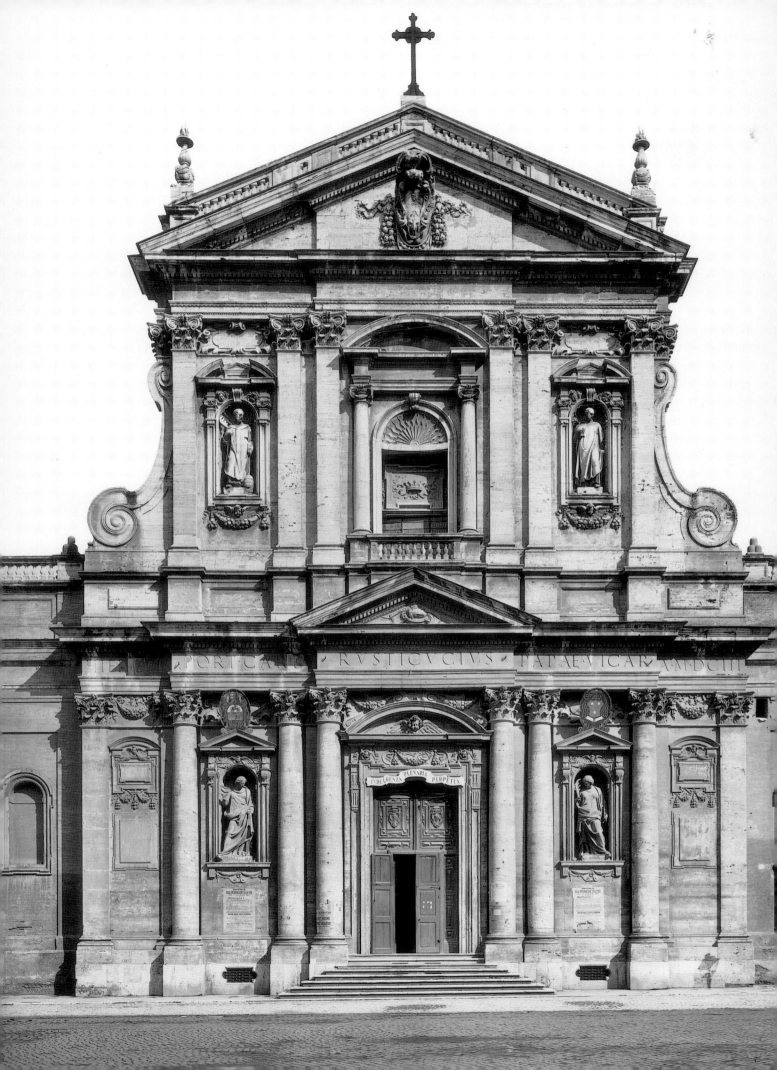

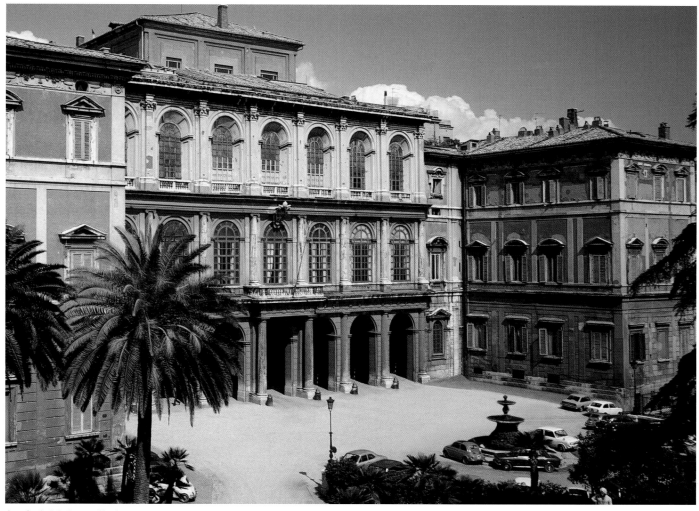

80. Carlo Maderno, Gianlorenzo Bernini and Francesco Borromini: Rome, Palazzo Barberini, 1628–33. Centre of façade

design of the nave, which presented immense difficulties,[5] proves that he planned with circumspection and tact, desirous to clash as little as was possible under the circumstances with the legacy of the great master. But, of course, the nave marred for ever the view of the dome from the square, with consequences which had a sequel down to our own days (II: p. 35–7). For the design of the façade [I:1; II: 46; III: 12] he was tied more fully than is generally realized by Michelangelo's system of the choir and transepts (which he had to continue along the exterior of the nave) and, moreover, by the ritual requirement of the large Benediction Loggia above the portico. The proportions of the original design are impaired as a result of the papal decision of 1612, after the actual façade was finished, to add towers, of which only the substructures – the last bay at each end – were built [II: 43]. These appear now to form part of the façade. Looked at without these bays, the often criticized relation of width to height in the façade is entirely satisfactory. Maderno's failure to erect the towers was to have repercussions which will be reported in a later chapter[6] (II: p. 33).

79. Carlo Maderno: Rome, S. Susanna, 1597–1603

As a designer of palaces Maderno is best represented by the Palazzo Mattei, begun in 1598 and finished in 1616.[7] The noble, austere brick façade shows him in the grip of the strong local tradition. In the courtyard he made subtle use of ancient busts, statues, and reliefs, and the connexion with such Mannerist fronts as those of the villas Medici and Borghese is evident. But the four-flight staircase decorated with refined stuccoes is an innovation in Rome.

It remains to scrutinize more thoroughly the major problem of Maderno's career, his part in the designing of the Palazzo Barberini [80, 81]. The history of the palace is to a certain extent still obscure, in spite of much literary evidence, memoranda and drawings, and a large amount of documents which allow the construction to be followed very closely indeed.[8] The unassailable data are quickly reported. In 1625 Cardinal Francesco Barberini bought from Alessandro Sforza Santafiora, Duke of Segni, the palace at the 'Quattro Fontane'. A year later Cardinal Francesco presented the palace to his brother Taddeo. Pope Urban VIII commissioned Maderno to redesign the existing palace and to enlarge it. The first payment for the new foundations dates from October 1628. Maderno died on 30 January 1629, and the Pope appointed Bernini his successor. To all intents and purposes the palace was completed in 1633, but

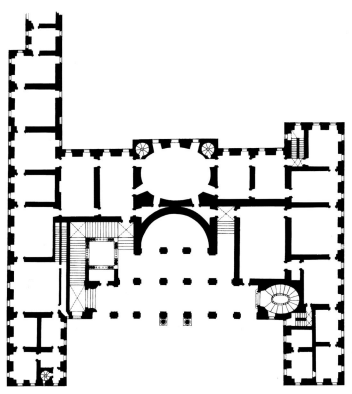

81. Rome, Palazzo Barberini, 1628–33. Plan adapted from a drawing by N. Tessin showing the palace before rebuilding of *c.* 1670

minor work dragged on until 1638. It is clear from these data that Bernini (who was assisted by Borromini) was responsible for almost the entire work of execution.

Maderno's design survives in a drawing at the Uffizi which shows a long front of fifteen bays, fashioned after the model of the Palazzo Farnese, and an inscription explains that the design was to serve for all four sides of the palace. In fact, with some not unimportant alterations, it was used for the present north and east wings.[9] At this stage, in other words, Maderno made a scheme that by and large corresponded to the traditional Roman palace, consisting of a block with four equal sides and an arcaded courtyard. But there is no certainty that this was Maderno's last project. In the present palace, the plan of which may be likened to an H [80], the traditional courtyard is abandoned and replaced by a deep forecourt. The main façade consists of seven bays of arcades in three storeys, linked to the entirely different system of the projecting wings by a transitional, slightly receding bay at each side [81]. Who was responsible for the change from the traditional block form to the new plan?

At first sight, it would appear that nothing like this had been built before in Rome and, moreover, *qua* palace, the structure remained isolated in the Roman setting – it had no succession. Psychologically it is intelligible that one prefers to associate the change of plan with the young genius who took over from Maderno rather than with the aged master. Yet neither the external nor the internal evidence goes to support this. In fact, there is the irrevocable document in Vienna (Albertina) of an unfinished elevation of half the façade (drawn for Maderno by Borromini) which, apart

from minor differences, corresponds with the execution. If one regards the palace, as one should, as a monumentalized 'villa suburbana', the plan loses a good deal of its revolutionary character, and to attribute it to Maderno will then no longer surprise us.

The old Sforza palace which Maderno had to incorporate into his design rose on elevated ground high above the ruins of an ancient temple.[10] The palace overlooked the Piazza Barberini but could never form one of its sides. Nor was it possible to align the west front of the new palace with the Strada Felice (the present Via Sistina). In other words, whatever the new design, it could not be organically related to the nearest thoroughfares. A block-shaped palace with arcaded courtyard cannot, however, be dissociated from an intimate relationship with the street front. It was, therefore, almost a foregone conclusion that the block-shape would have to be abandoned and replaced by the type which became traditional for the 'villa suburbana' from Peruzzi's Farnesina on and which only recently Vasanzio had used for the Villa Borghese [8]. In addition the arcaded centre between containing bays and projecting wings was familiar from such buildings as Mascherino's *cortile* of the Quirinal Palace and the garden front of the Villa Mondragone[11] [9]. There is, therefore, no valid reason why Maderno should not be credited with the final design of the Palazzo Barberini: all its elements were ready at hand, and it is the magnificent scale rather than the design as such that gives it its grand Baroque character and places it in a class of its own. It is even questionable whether Bernini, given a free hand, would have been satisfied with designing three arcaded tiers of almost equal value.

On the other hand, it is certain that adjustments of Maderno's design outside as well as inside were made after Bernini had taken over. The celebrated windows of the third tier, set in surrounds with feigned perspective, are, however, Maderno's. The device, used by Maderno on at least one other occasion,[12] made it possible to reduce the area of the window-openings; this was necessary for reasons of internal arrangement. One may assume that even the enrichment of the orders – engaged columns in the second tier, pilasters coupled with two halfpilasters in the third tier – occurred while Maderno was still alive. Another external feature is worth mentioning. The ground floor and *piano nobile* of the long wings are articulated by framing bands, a device constantly employed by Late Mannerist architects and also by Maderno.[13] Although in a rather untraditional manner, Borromini often returned to it. It is therefore not at all unlikely that it was Borromini's idea to articulate the bare walls of Maderno's design in this way. To what extent the internal organization deviates from Maderno is difficult to determine.[14] As far as the details are concerned we are on fairly firm ground, and Bernini's as well as Borromini's contribution to the design of doors will be discussed later (II: p. 40). But the large staircase with the four flights ascending along the square open well, traditionally ascribed to Bernini, may well be Maderno's. It is as new as the deep portico, the enormous hall of the *piano nobile* lying at right angles to the front, and the inter-connected oval hall at its back. One is tempted to believe that Bernini assisted by Borromini had here a freer hand than on the exterior, but at present these

82. Fabio Mangone: Milan, Collegio Elvetico (Archivio di Stato), first courtyard, begun 1608

problems are still in abeyance and may never be satisfactorily solved.

By the time Maderno died, he had directed Roman architecture into entirely new channels. He had authoritatively rejected the facile academic Mannerism which had belonged to his first impressions in Rome, and although not a revolutionary like Borromini, he left behind, largely guided by Michelangelo, monumental work of such solidity, seriousness, and substance that it was equally respected by the great antipodes Bernini and Borromini.[15]

Architecture outside Rome

In the North of Italy the architectural history of the second half of the sixteenth century is dominated by a number of great masters. The names of Palladio, Scamozzi, Sanmicheli, Galeazzo Alessi, Luca Cambiaso, Pellegrino Tibaldi, and Ascanio Vittozzi come at once to mind. By contrast, the first quarter of the seventeenth century cannot boast of names of the same rank, with the one exception of F.M. Ricchino. On the whole, what has been said about Rome also applies to the rest of Italy: the reaction against the more extravagant application of Mannerist principles, which had generally set in towards the end of the sixteenth century, led to a hardening of style, so that we are often faced in the early years of the new century with a severe form of classicism, which, however, was perfectly in keeping with the exigencies of the counter-reformatory church. On the other hand, the North Italian architects of this period also transformed their rich local tradition more imaginatively than the Romans. The work of Binago, Magenta, and Ricchino is infinitely more interesting than most of what Rome had to offer, and it was to a large extent they who prepared the stylistic position of the High Baroque.

In Venice Vincenzo Scamozzi (1552–1616) remained the leading master after the turn of the century. It is immediately apparent that his dry Late Mannerism is the Venetian counterpart to the style of Domenico Fontana and the elder Martino Longhi in Rome. Just as his great theoretical work, the *Idea dell'Architettura Universale* of 1615, with its hieratic structure and its codification of classical rules, concluded an old era rather than opened a new one, so his architecture was the strongest barrier against a turn towards Baroque principles in all the territories belonging to Venice. One should compare Sansovino's Palazzo Corner (1532) with Scamozzi's Palazzo Contarini dagli Scrigni of 1609[16] in order to realize fully that the latter's academic and linear classicism is, as far as plastic volume and chiaroscuro are concerned, a deliberate stepping back to a pre-Sansovinesque position. Moreover, in many respects

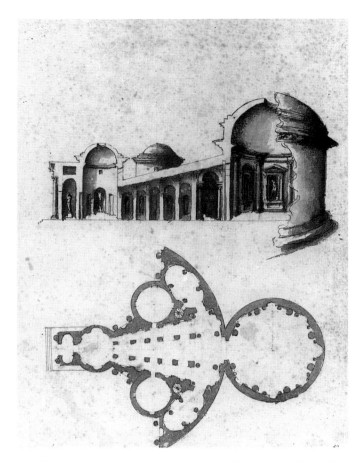

83. Giovanni Battista Montano: Reconstruction of an ancient tomb. London, Sir John Soane's Museum

84. Lorenzo Binago: Milan, S. Alessandro, begun 1601. Plan

newly founded Accademia Ambrosiana. Throughout the seventeenth century the cathedral still remained the focus of Milanese artistic life, and every artist and architect tried there to climb the ladder to distinction. Mangone achieved this goal; in 1617 he succeeded Bisnati as Architect to the Cathedral and remained in charge until his death in 1629. Assisted by Ricchino, the portals were executed by him during this period (with Cerano in charge of the rich decoration, p. 67), but his severe design of the whole façade remained on paper. Mangone's earlier activity was connected with the (much rebuilt) Ambrosiana (1611), which Lelio Buzzi had begun. The façade of the original entrance is as characteristic of his rigorous classicism as is the large courtyard of the Collegio Elvetico (now Archivio di Stato) [82] with its long rows of Doric and Ionic columns in two tiers under straight entablatures, begun in 1608.[20] His façade of S. Maria Podone (begun 1626) with a columned portico set into a larger temple motif points to a knowledge of Palladio's church façades, which he transformed and submitted to an even sterner classical discipline. Thus Milanese architects revert via Palladio to ancient architecture in search of symbols which would be *en rapport* with the prevailing harsh spirit of reform in the city [83].[21]

A different note was introduced into Milanese architecture by Lorenzo Binago (called Biffi, 1554–1629),[22] a Barnabite monk, who built S. Alessandro, one of Milan's most important churches (begun 1601, still unfinished in

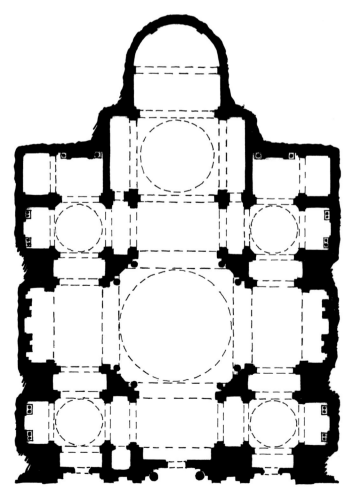

Scamozzi's architecture must be regarded as a revision of his teacher Palladio by way of reverting to Serlio's conceptions. Their calculated intellectualism makes Scamozzi's buildings precursors of eighteenth-century Neo-classicism. His special brand of frigid classicism, a traditional note of Venetian art, was not lost upon his countrymen and left its mark for a long time to come.[17] But in the next generation the rising genius of Baldassare Longhena superseded the brittle, linear style of his master and reasserted the more vital, exuberant, imaginative, and painterly facet of the Venetian tradition.

Even where Scamozzi's influence did not penetrate in the *terra ferma*, architects turned in the same direction. Thus Domenico Curtoni, Sanmicheli's nephew and pupil, began in 1609 the impressive Palazzo della Gran Guardia at Verona, where he applied most rigidly the precepts of his teacher, ridding them of any Mannerist recollections.[18]

Milan, in particular, became at the turn of the century the stronghold of an uncompromising classicism. It was probably St Charles Borromeo's austere spirit rather than his counter-reformatory guide to architects, the only book of its kind,[19] that provided the keynote for the masters in his and his nephew's service. The Milanese Fabio Mangone (1587–1629), a pupil of Alessandro Bisnati, was the man after Cardinal Federico's heart. As a sign of his appreciation he appointed him in 1620 Professor of Architecture to the

1661). Mangone's architecture is strictly Milanese, setting the seal, as it were, on Pellegrino Tibaldi's academic Mannerism. Binago, by contrast, created a work that has its place in an all-Italian context. Like a number of other great churches of this period, the design of S. Alessandro is dependent on the Bramante-Michelangelo scheme for St Peter's.[23] In order to be able to assess the peculiarities of Binago's work, some of the major buildings of this group may be reviewed. In chronological sequence they are: the Gesù Nuovo at Naples (Giuseppe Valeriano, S.J., 1584); S. Ambrogio at Genoa (also G. Valeriano, 1587);[24] S. Alessandro at Milan; S. Maria della Sanità, Naples (Fra Nuvolo, 1602); the Duomo Nuovo at Brescia (G.B. Lantana, 1604); and S. Carlo ai Catinari in Rome (Rosato Rosati, 1612). All these buildings are interrelated; all of them have a square or rectangular outside shape and only one façade (instead of four); and all of them link the centralized plan of St Peter's with an emphasis on the longitudinal axis: the Gesù Nuovo by adding a pair of satellite spaces to the west and east ends, S. Ambrogio by adding a smaller satellite unit to the west and extending the east end; the Duomo Nuovo at Brescia and S. Carlo ai Catinari by prolonging the choir, the latter, moreover, by using oval-shaped spaces along the main axis, S. Maria della Sanità by enriching the design by a pair of satellite units to each of the four arms; S. Alessandro, finally, by adding a smaller centralized group with saucer dome to the east [84]. S. Alessandro, therefore, is in a way the most interesting of this series of large churches. It contains another important feature: the arches of the crossing rest on free-standing columns. Binago himself recommended that these be used with discretion. The motif was immediately taken up by Lantana in the Duomo Nuovo at Brescia and had a considerable following in Italy and abroad, down to Jules Hardouin Mansart's dome of the Invalides in Paris.

The joining of two centralized designs in one plan had a long pedigree. In a sense, the problem was already inherent in Brunelleschi's Old Sacristy of S. Lorenzo; but it was only in the North Italian circle of Bramante that the fully developed type emerged in the form of a coordination of two entirely homogeneous centralized domed spaces of different size,[25] an arrangement, incidentally, which had the support of classical authority.[26] Binago's S. Alessandro represents an important step towards a merging of two previously separate units: now the far arm of the large Greek-cross unit also belongs to the smaller domed space. In addition, the spacious vaulting between the two centralized groups makes their separation impossible. Thus the unification of two centralized groups results in a longitudinal design of richly varied character.

It is at once evident that this form of spatial integration was a step forward into new territory, full of fascinating possibilities. For a number of reasons one may regard the whole group of churches here mentioned as Late Mannerist, not least because of the peculiar vacillation between centralization and axial direction. It is precisely in this respect that Binago's innovation must be regarded as revolutionary, for he decisively subordinated centralized contraction to axial expansion. The future lay in this direction. On the other hand, the derivations from the centralized plan of St Peter's

found little following during the seventeenth century, and it was only in the eighteenth century that they saw a limited revival,[27] probably because of their Late Mannerist qualities.

The next step beyond S. Alessandro was taken by Francesco Maria Ricchino (1584–1658), through whom Milanese architecture entered a new phase. It was he, a contemporary of Mangone, who threw the classicist conventions of the reigning taste overboard and did for Milan what Carlo Maderno did for Rome. Although almost a generation

85. Francesco Maria Ricchino: Milan, S. Giuseppe, begun 1607. Section and plan

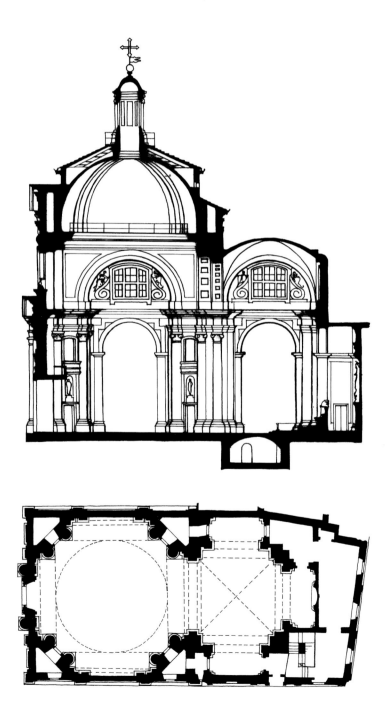

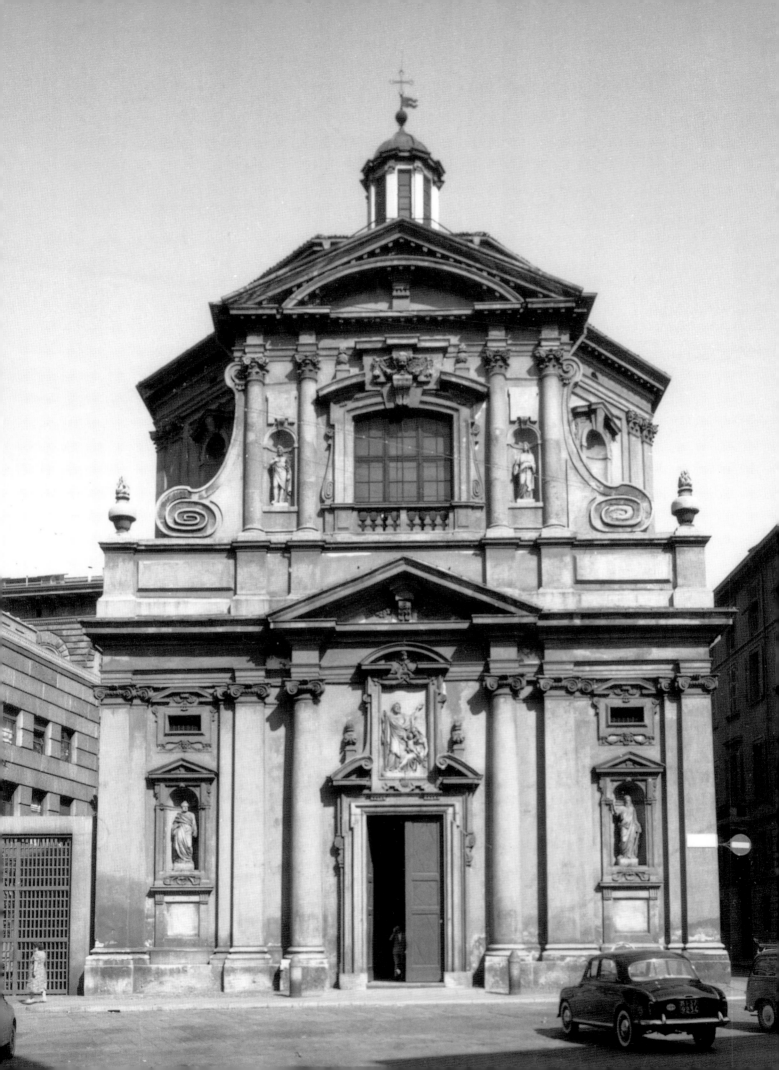

younger than Maderno, his principal works, like Maderno's, fall into the first three decades of the century. Ricchino's work has never been properly studied, but it would seem that, when one day the balance sheet can be drawn up, the prize for being the most imaginative and most richly endowed Italian architect of the early seventeenth century will go to Ricchino rather than Maderno. Beginning work under Binago, he was sent by his patron, Cardinal Federico Borromeo, to Rome to finish his education. After his return in 1603 he submitted his first design for the façade of the cathedral. In 1605 he was *capomastro*, a subordinate officer under Aurelio Trezzi, who was Architect to the Cathedral in 1598 and 1604–5. Much later, between 1631 and 1638, Ricchino himself held this highest office to which a Milanese architect could aspire.

In 1607 he designed his first independent building, the church of S. Giuseppe, which was at once a masterpiece of the first rank.[28] The plan [85] consists of an extremely simple combination of two Greek-cross units. The large congregational space is a Greek cross with dwarfed arms and bevelled pillars which open into *coretti* above niches and are framed with three-quarter columns; four high arches carry the ring above which the dome rises. The small square sanctuary has low chapels instead of the cross arms. Not only does the same composite order unify the two spaces, but also the high arch between them seems to belong to the congregational room as well as to the sanctuary. Binago's lesson of S. Alessandro was not lost. Ricchino employed here a similar method of welding together the two centralized spaces, which disclose their ultimate derivation from Bramante even after their thorough transformation. This type of plan, the seventeenth-century version of a long native tradition, contained infinite possibilities, and it is impossible to indicate here its tremendous success. Suffice it to say that the new fusion of simple centralized units with all its consequences of spatial enrichment and scenic effects was constantly repeated and, mainly in Northern Italy, revised and further developed; but Ricchino had essentially solved the problem.

S. Giuseppe was finished in 1616; the façade, however, was not completed until 1629–30, although it was probably designed at a much earlier date[29] [86]. It represents a new departure in two respects: Ricchino attempted to give the façade a unity hitherto unknown and at the same time to coordinate it with the entire structure of the church. As regards the latter point, the problem had never been squarely faced. By and large the Italian church façade was an external embellishment, designed for the view from the street and rather independent of the structure lying behind it. Ricchino determined the height of the lower tier by the height of the square body of the church and that of the upper tier by the octagonal superstructure; at the same time, he carried the order of the façade over into the rest of the structure, as far as it is visible from the street. Despite this significant integration of the 'show-front' with the whole building, Ricchino could not achieve a proper dynamic rela-

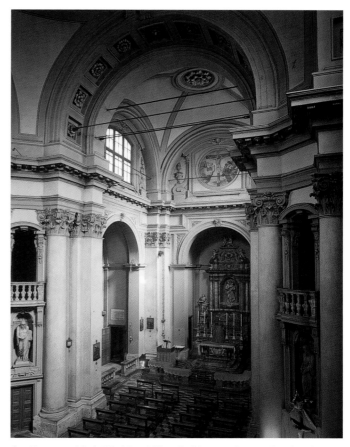

87. Francesco Maria Ricchino: Milan, S. Giuseppe, begun 1607. interior

tionship between inside and outside, a problem that was solved only by the architects of the High Baroque [87]. As to the first point, the façade of S. Giuseppe has no real precursors in Milan or anywhere in the North. On the other hand, Ricchino was impressed by the façade of S. Susanna, but he replaced Maderno's stepwise arrangement of enclosed bays by one in which the vertical links take prominence, in such a way that the whole front can and should be seen as composed of two high aedicules, one set into the other. The result is very different from Maderno's: for instead of 'reading', as it were, the accretion of motifs in the façade in a temporal process, his new 'aedicule front' offers an instantaneous impression of unity in both dimensions. It was the aedicule façade that was to become the most popular type of church façade during the Baroque age.[30]

Fate has dealt roughly with most of Ricchino's buildings. He was, above all, a builder of churches, and most of them have been destroyed;[31] many are only known through his designs;[32] some have been modernized or rebuilt, while others were carried out by pupils (S. Maria alla Porta, executed by Francesco Castelli and Giuseppe Quadrio). In addition, there was his interesting occasional work[33] which needs, like the rest, further investigation. In his later centralized buildings he preferred the oval and, as far as can be judged at present, he went through the whole gamut of possible designs. Of the buildings that remain standing, five may cursorily be mentioned: the large courtyard of the Ospedale Maggiore (1625–49), impressive in size, but created in collaboration

86. Francesco Maria Ricchino: Milan, S. Giuseppe, begun 1607. façade

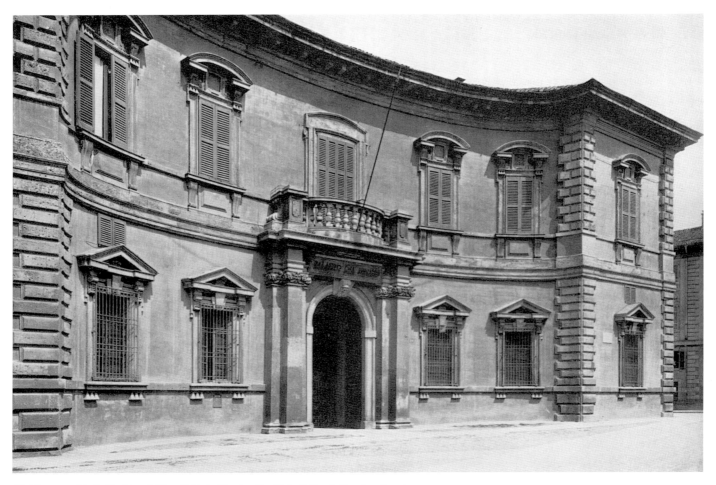

88. Francesco Maria Ricchino: Milan, Collegio Elvetico (Archivio di Stato). Façade, after 1641

with G.B. Pessina, Fabio Mangone, and the painter G.B. Crespi, and therefore less characteristic of him than the grand aedicule façade of the monumental entrance to the Hospital; the palaces Annoni (1631) and Durini (designed 1648), which look back by way of Meda's Palazzo Visconti (1598) to Bassi's Palazzo Spinola;[34] the Palazzo di Brera (1651–86), built as a Jesuit College, with the finest Milanese courtyard which, having arches on double columns in two tiers, marks, after the severe phase, a return to Alessi's Palazzo Marino;[35] and finally, the façade of the Collegio Elvetico, designed in 1627, a work of great vigour which has, moreover, the distinction of being an early, perhaps the earliest, concave palazzo façade of the Baroque [88]. With Ricchino's death we have already over-stepped the chronological limits of this chapter. Nobody of his stature remained in Milan to carry on the work he had so promisingly accomplished.

Mention has been made of the Sanctuary at Varese near Milan which Cardinal Federico Borromeo had very much at heart. The architectural work began in 1604 and was carried out through most of the century.[36] As one would expect, the fifteen chapels designed by Giuseppe Bernasconi from Varese correspond to the severe classicism practised in Milan at the beginning of the seventeenth century. To the modern visitor there is a peculiar contrast between the classicizing chastity of the architecture and the popular realism

of the *tableaux vivants* inside the chapels. If anywhere, the lesson can here be learned that these are two complementary facets of counter-reformatory art.

In the Duomo Nuovo Brescia has an early Seicento work of imposing dimensions (p. 81). But just as so often in medieval times, the execution of the project went beyond the resources of a small city. After the competition of 1595 the design by Lantana (1581–1627) was finally chosen in 1603. The next year saw the laying of the foundation stone, but as late as 1727 only the choir was roofed. Until 1745 there was a renewed period of activity due to the initiative of Cardinal Antonio Maria Querini. The Michelangelesque dome, however, was erected after 1821 by Luigi Cagnola, who introduced changes in the original design.[37]

To the names of the two able Barnabite architects Rosato Rosati and Lorenzo Binago, working at the beginning of the Seicento, that of Giovanni Magenta (1565–1635)[38] must be added. He was the strongest talent at Bologna during the first quarter of the century. A man of great intellectual power, engineer, mathematician, and theoretician, he even became in 1612 General of his Order. In 1605 he designed on a vast scale the cathedral of S. Pietro at Bologna, accomplishing the difficult union with Domenico Tibaldi's choir (1575), which he left untouched. The design differs from St Peter's and the great Roman congregational churches in the alternating high and low arches leading into the aisles. With

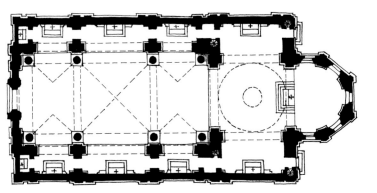

89. Giovanni Magenta: Bologna, S. Salvatore, 1605–23. Plan

its brilliant light and the eighteenth-century *coretti*, added by Alfonso Torreggiani (1765), the church looks much later than it is. The execution lay in the hands of Floriano Ambrosini and Nicolò Donati. While they changed to a certain extent Magenta's project,[39] the latter is fully responsible for the large church of S. Salvatore, designed in 1605 and erected by T. Martelli between 1613 and 1623 [89]. Inspired by the large halls of Roman thermae, Magenta here monumentalized the North Italian tradition of using free-standing columns in the nave.[40] By virtue of this motif, the nave appears isolated from the domed area. In addition, the large central chapels with arches rising to the whole height of the vaulting of the nave look like a transverse axis and strengthen the impression that the nave is centred upon itself. In fact, on entering the church one may well believe oneself to be in a Greek-cross unit (without dome), to which is added a second, domed unit. Whether one may or may not want to find in Magenta's ambiguous design a Late Mannerist element, it is certain that he imaginatively transmuted North Italian conceptions. Early Baroque in its massiveness, S. Salvatore was destined to exercise an important influence on the planning of longitudinal churches. Magenta's church of S. Paolo, begun in 1606, shows that he was even capable of enlivening the traditional Gesù type, to which Roman architects of this period did not really find an alternative. By

90. Bartolomeo Bianco: Genoa, University, planned 1630. Courtyard

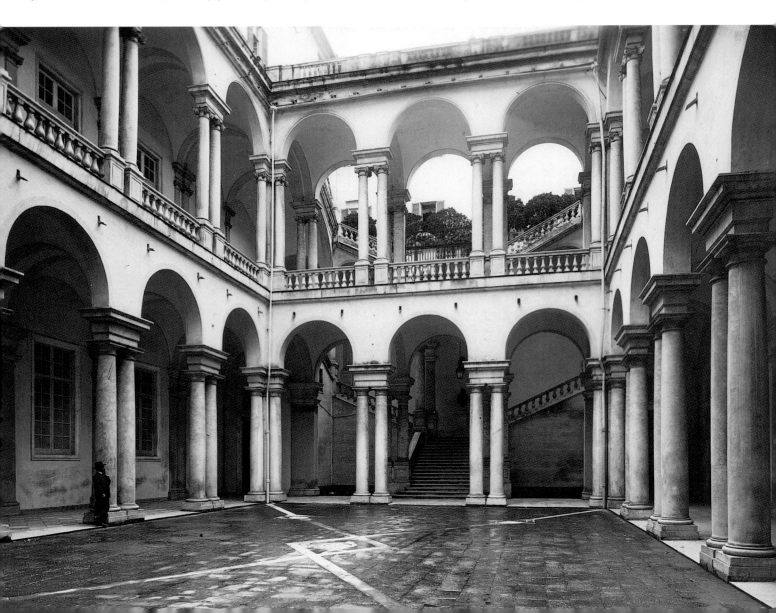

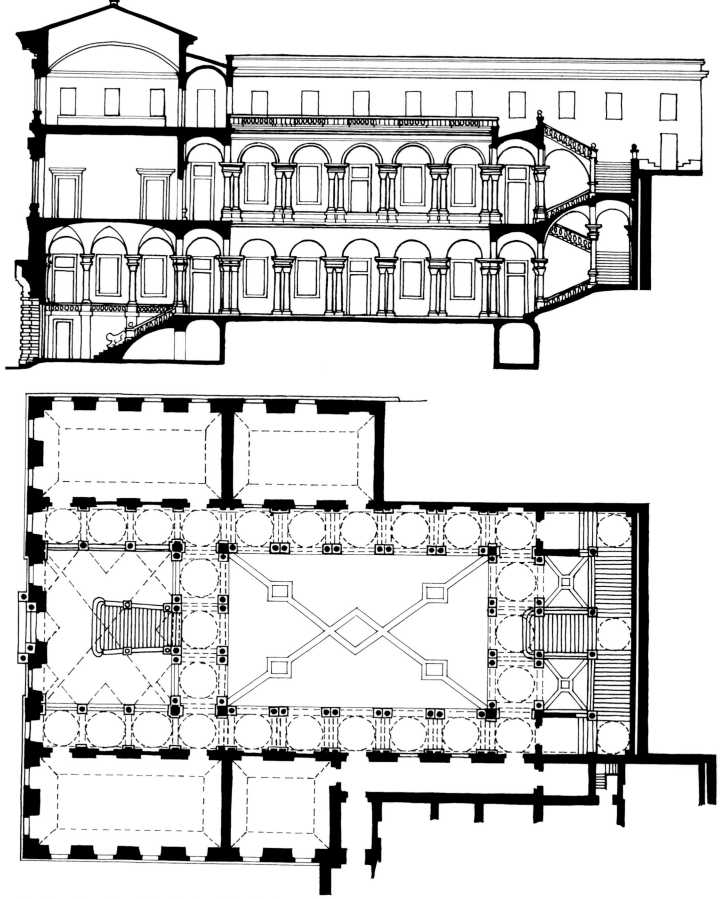

91. Bartolomeo Bianco: Genoa, University, planned 1630. Section and plan

making space for confessionals with *coretti* above them between the high arches leading into the chapels, he created, more effectively than in the cathedral, a lively rhythm along the nave, reminiscent of Borromini's later handling of the same problem in S. Giovanni in Laterano.

Parma, flourishing under her Farnese princes, had in Giovan Battista Aleotti (1546–1636) and his pupil Giovan Battista Magnani (1571–1653)[41] Early Baroque architects. The former, assisted by Magnani, built the impressively simple hexagon of S. Maria del Quartiere (1604–19),[42] the exterior of which is an early example of the pagoda-like build-up of geometrical shapes taken up and developed later by Guarino Guarini (III: Chapter 3, Note 12). Aleotti was for twenty-two years in the service of Alfonso d'Este at Ferrara, where he erected, among others, the imposing façade of the University (1610), together with Alessandro Balbi, the architect of the Madonna della Ghiara at Reggio Emilia (1597–1619), a building dependent on the plan of St Peter's though less distinguished than the series of buildings mentioned above. In Ferrara Aleotti also made his debut as an architect of theatres,[43] an activity that was crowned by his Teatro Farnese, built at Parma between 1618 and 1628. The Farnese theatre, exceeding in size and magnificence any other before it, superbly blends Palladio's and Scamozzi's archaeological experiments with the progressive tendencies evolved in Florence.[44] The wide-open, rectangular proscenium-arch together with the revolutionary U-shaped form of the auditorium contained the seeds of the spectacular development of the seventeenth-century theatre. Heavily damaged during the last war, it has now been largely rebuilt.

Genoa's great period of architectural development is the second half of the sixteenth century. It was Galeazzo Alessi who created the Genoese palazzo type along the Strada Nuova (now Via Garibaldi), begun by him in 1551.[45] But to his contemporary Rocco Lurago must be given pride of place for having recognized the architectural potentialities which the steeply rising ground of Genoa offered. His Palazzo Doria Tursi in Via Garibaldi (begun 1568) shows for the first time the long vista from the vestibule through the *cortile* to the staircase ascending at the far end. Bartolomeo Bianco (before 1590–1657), Genoa's greatest Baroque architect,[46] followed the lead of the Palazzo Doria Tursi. His most accomplished structure is the present University, built as a Jesuit College (planned 1630)[47] along the Via Balbi (the street which he began in 1606 and opened in 1618); it presents an ensemble of incomparable splendour [90, 91]. For the first time he unified architecturally the vestibule and courtyard, in spite of their different levels; in the *cortile* he introduced two tiers of lofty arcades resting on twin columns;[48] and at the far end he carried the staircase, dividing twice, to the whole height of the building. Fully aware of the coherence of the whole design, the eye of the beholder is easily led from level to level, four in all. The exterior contrasts with the earlier Genoese palazzo tradition by the relative simplicity of the design without, however, breaking away from the use of idiomatic Genoese motifs.[49]

Compared with the University, Bianco's Palazzi Durazzo-Pallavicini (Via Balbi 1, begun 1619) and Balbi-Senarega (Via Balbi 4, after 1620) are almost an anticlimax. While the latter was finished by Pier Antonio Corradi (1613–83), the former was considerably altered in the course of the eighteenth century by Andrea Tagliafichi (1729–1811), who built the grand staircase. Apart from the balconies and the cornices resting on large brackets, both palaces are entirely bare of decoration. This is usually mentioned as characteristic of Bianco's austere manner. It is, however, much more likely that these fronts were to be painted with illusionist architectural detail (such as window surrounds, niches, etc.) and figures in keeping with a late sixteenth-century Genoese fashion.[50]

In contrast to the north of Italy, the contribution of Tuscan architects to the rise of Baroque architecture is rather limited. One is inclined to think that Buontalenti's ample and rich decorative manner might have formed a starting point for the emergence of a proper Seicento style. Yet Ammanati's precise Late Mannerism and, perhaps to a larger extent, Dosio's austere classicism corresponded more fully to the latent aspirations of the Florentines. It is hardly an overstatement to say that towards 1600 an academic classicizing reaction against Buontalenti set in. Nevertheless, Buontalenti's decorative vocabulary was never entirely forgotten; one finds it here, there, and everywhere till the late eighteenth century, and even architects outside Florence were inspired by it.

Thus the Florence of the early seventeenth century developed her own brand of a classicizing Mannerism, and this was by and large in keeping with the all-Italian position. But Florence never had a Maderno or a Ricchino, a Bianco or Longhena; she remained to all intents and purposes anti-Baroque and hardly ever broke wholly with the tenets of the early seventeenth-century style. The names of the main practitioners at the beginning of the seventeenth century are Giovanni de' Medici (d. 1621),[51] Cosimo I's natural son, who supervised the large architectural undertakings during Ferdinand I's reign (1587–1609); Lodovico Cigoli (1559–1613), the painter (pp. 64–5) and architect,[52] Maderno's unsuccessful competitor for St Peter's, the builder of the choir of S. Felicità, of a number of palaces, and according to Baldinucci also of the austere though unconventional courtyard of Buontalenti's Palazzo Nonfinito; and Giulio Parigi (1571–1635) and his son Alfonso (1600–c. 1656),[53] famous as theatrical designers of the Medici court, who imparted a scenographic quality to the *Isolotto* and the theatre in the Boboli gardens. Giulio exerted a distinct influence on his pupil Callot and also on Agostino Tassi, whose scenic paintings reveal his early training.[54] Finally, Matteo Nigetti (1560–1649),[55] Buontalenti's pupil, must be added, whose stature as an architect has long been overestimated. His contribution to the Cappella dei Principi is less original than has been believed, nor has he any share in the final design of S. Gaetano, for which Gherardo Silvani alone is responsible (II: p. 118).[56] His manner may best be judged from his façade of the Chiesa di Ognissanti (1635–7). Here, after forty years, he revived with certain adjustments[57] the academic Mannerism of Giovanni de' Medici's façade of S. Stefano dei Cavalieri at Pisa (1593). In order to assess the sluggish path of the Florentine development, one may compare the Ognissanti façade with that of Ascanio Vittozzi's Chiesa del Corpus Domini at Turin, where it can be seen

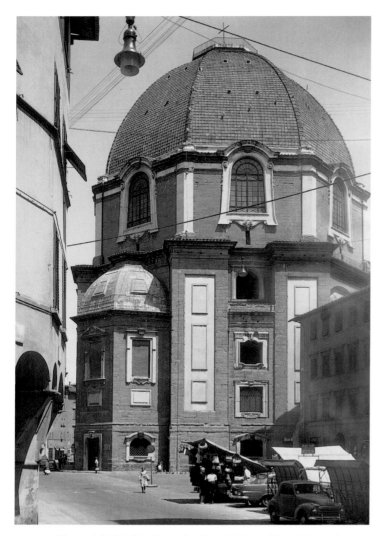

92. Giovanni de' Medici, Alessandro Pieroni, Matteo Nigetti, Bernardo Buontalenti: Florence, S. Lorenzo, Cappella dei Principi, begun 1603

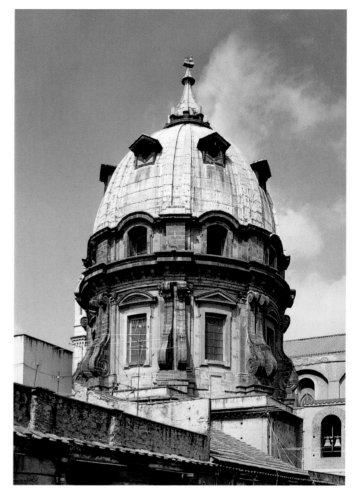

93. Francesco Grimaldi: Naples, Cathedral, Cappella del Tesoro, 1608–after 1613

how by 1607 the theme of S. Stefano was handled in a vigorously sculptural Early Baroque manner.

During the first half of the seventeenth century the erection of the huge octagonal funeral chapel (Cappella dei Principi) absorbed the interest and exhausted the treasury of the Medici court. Lavishly incrusted with coloured marbles and precious stones, the chapel, lying on the main axis of S. Lorenzo, was to offer a glittering viewpoint from the entrance of the church. Since the wall between the church and the chapel remained standing, this scenic effect, essentially Baroque and wholly in keeping with the Medicean love of pageantry and the stage, was never obtained. As early as 1561 Cosimo I had planned a funeral chapel, but it was only Grand Duke Ferdinand I who brought the idea to fruition. After a competition among the most distinguished Florentine artists, Giovanni de' Medici together with his collaborator, Alessandro Pieroni, and Matteo Nigetti prepared the model which was revised by Buontalenti (1603–4). The latter was in charge of the building until his death in 1608, when Nigetti continued as clerk of works for the next forty years.[58] If in spite of such activity the chapel remained

a torso for a long time to come, it yet epitomizes Medici ambition of the early seventeenth century. In the interior the flat decorative quality takes precedence over the structural organization, and by Roman standards of the time the exterior [92] must have been judged as a shapeless pile. Rather sober and dry in detail, the large drum and dome do not seem to tally with their substructure. Windows of different sizes and in different planes are squeezed in between the massive and ill-articulated 'buttresses'. There is, in fact, no end to the obvious incongruities which manifest a stubborn adherence to the outmoded principles of Mannerism.

Naples saw in the last two decades of the sixteenth century a considerable intensification of architectural activity, due to the enthusiasm of two viceroys. Lacking native talents, architects had to be called from abroad. Giovan Antonio Dosio (d. 1609) and Domenico Fontana (d. 1607) settled there for good. The former left Florence in 1589;[59] the latter, running into difficulties after Sixtus V's death, made Naples his home in 1592, where as 'Royal Engineer' he found tasks on the largest scale, among them the construction of the Royal Palace (1600–2). Thus Florentine and

Roman classicism were assimilated in the southern kingdom. A new phase of Neapolitan architecture is linked to the name of Fra Francesco Grimaldi (1543–1613), a Theatine monk who came from Calabria.[60] His first important building, S. Paolo Maggiore (1581/3–1603), erected over the ancient temple of Castor and Pollux, proves him an architect of uncommon ability. In spite of certain provincialisms, the design of S. Paolo has breadth and a sonorous quality that may well be called Early Baroque. The wide nave with alternating high and low arches, opening respectively into domed and vaulted parts of the (later) aisles, is reminiscent of Magenta's work in Bologna and more imaginative than Roman church designs of the period. In 1585 Grimaldi was called to Rome, where he had a share in the erection of S. Andrea della Valle. He must have had the reputation of being the leading Theatine architect. Among his post-Roman buildings, S. Maria della Sapienza (begun 1614, with façade by Fanzago) returns, more sophisticated, to the rhythmic articulation of S. Paolo, while S. Maria degli Angeli (1600–10), the Cappella del Tesoro [93], which adjoins the cathedral and is itself the size of a church (1608–after 1613), and SS. Apostoli (planned *c.* 1610, executed 1626–32) are all thoroughly Roman in character and succeed by their scale and the vigorous quality of the design.

Next to Grimaldi, Giovan Giacomo di Conforto (d. 1631) and the Dominican Fra Nuvolo (Giuseppe Donzelli) should be mentioned. Conforto began under Dosio, was after the latter's death architect of S. Martino until 1623, and built, apart from the campanile of the Chiesa del Carmine (1622, finished by Fra Nuvolo, 1631), three Latin-cross churches (S. Severo al Pendino, S. Agostino degli Scalzi, 1603–10, and S. Teresa, 1602–12). A more fascinating figure is Fra Nuvolo. He began his career with S. Maria di Constantinopoli (late sixteenth century), where he faced the dome with majolica, thus inaugurating the characteristic Neapolitan type of colourful decoration. His S. Maria della Sanità (1602–13) has been mentioned (p. 81); his S. Sebastiano, with a very high dome, and S. Carlo all'Arena (1631), both elliptical, are uncommonly interesting and progressive.

These brief hints indicate that by the end of the first quarter of the seventeenth century Naples had a flourishing school of architects. By that time the great master of the next generation, Cosimo Fanzago, was already working. But it was then that Rome asserted her ascendancy, and Naples as well as the cities of the North, which had contributed so much to the rise of the new style, were relegated once again to the role of provincial centres.

SCULPTURE
Rome

We have seen in the first chapter that sculpture in Rome had reached a low-water mark during the period under review. By and large the work executed in the Chapel of Paul V in S. Maria Maggiore during the second decade of the seventeenth century was still tied to the Late Mannerist standards set in Sixtus V's Chapel, and none of the sculptors of the Carracci generation – Cristoforo Stati,[61] Silla da Viggiù, Ambrogio Bonvicino, Paolo Sanquirico, Nicolò Cordier, Ippolito Buzio – showed a way out of the impasse in which sculpture found itself landed. Among this group there was hardly an indication that the tired and facile formalistic routine would so soon be broken by the rise of a young genius, Bernini, who was then already beginning to produce his juvenilia. It cannot be denied that the older masters also created solid work. In particular, some of Buzio's, Cordier's, and Valsoldo's statues and busts have undeniably high qualities, but that does not impair the assessment of the general position. In a varying degree, they all translated the models

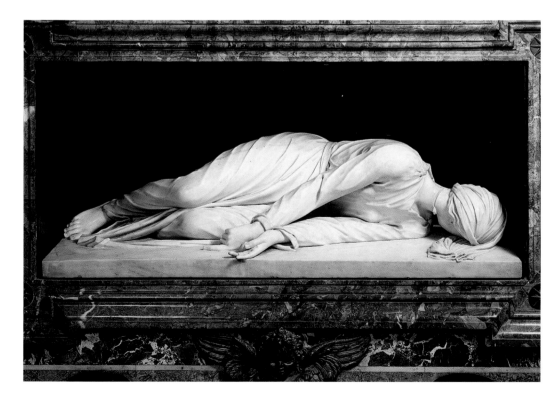

94. Stefano Maderno: *St Cecilia*, 1600. Rome, S. Cecilia

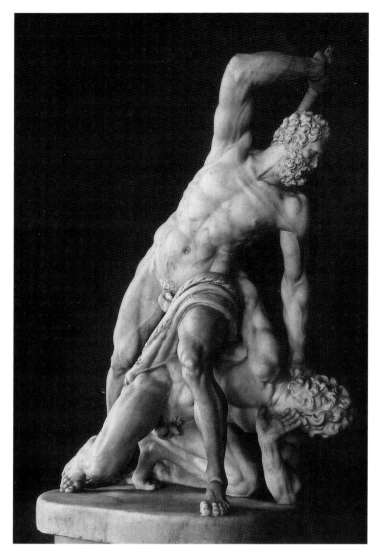

95. Stefano Maderno: *Hercules and Cacus, c.* 1610. Dresden, Albertinum

Cecilia, 1600) which depicts according to a persistent legend the body of the youthful saint exactly in the position in which it was found in 1599 [94].[63] The sentimental flavour of this story apart, which helped to secure for Maderno his lofty place in the history of sculpture, the statue is imbued with a truly moving simplicity, and many later statues of recumbent martyr saints followed this model. His later monumental work in marble for Roman churches is not particularly distinguished;[64] but in his small terracotta models, bronzes, and (rare) marbles (Cà d'Oro, Venice; Palermo; Dresden; London; Oxford; etc.),[65] which derive from famous antiques, he combines a carefully studied classicism with solid realistic observations [95]. This was the artistic climate in which Bernini's early work was to rise.

As the father of the great Gianlorenzo, Pietro Bernini (1562–1629) commands special interest.[66] His career unfolds in three stages: the early years in Florence and Rome, the twenty-odd years in Naples (1584–1605/6), and the last decades in Rome, mainly in the service of Paul V. The Neapolitan setting held no surprise for a Florence-trained sculptor, and during the full years of his sojourn he adjusted himself without reservation to the pietistic climate of the southern metropolis, notable in the work of Naccherino, with whom he also collaborated. In Rome he changed to a more boisterous manner, no doubt through contact with Mariani and Mochi, and produced work in which he combined the new Early Baroque *brio* with a painterly approach which is not strange to find in the pupil of Antonio Tempesta (*Assumption of the Virgin*, Baptistery, S. Maria Maggiore, 1607–10; *Coronation of Clement VIII*, Cappella Paolina, S. Maria Maggiore, 1612–13). But the bodies of his figures lack structure and seem boneless, and the texture of his Roman work is soft and flaccid [96]. All this is still typically Late Mannerist, and indeed between his slovenly treatment of the marble and the firm and precise chiselling found in the early work of his son there is an almost unbridgeable gulf. Nor is the dash to be observed in his Roman work purposeful and clearly defined. He prefers to represent unstable attitudes which baffle the beholder: his *St John* in S. Andrea della Valle is rendered in a state between sitting, getting up and hurrying away.

Camillo Mariani b. 1556 work was of greater consequence in revitalizing Roman sculpture.[67] He was born in Vicenza and had in the studio of the Rubini the inestimable advantage of going through the discipline of Alessandro Vittoria's school. Shortly after his arrival in Rome he executed his masterpieces, the eight simple and noble monumental stucco figures of saints in S. Bernardo alle Terme (1600), in which the Venetian nuance is obvious for anyone to see [97]; but it is strengthened by a new urgency and a fine psychological penetration which make these works stand out a mile from the average contemporary production and ally them to the intensity of the transitional style in painting in which we found crystallized the true spirit of the great reformers.

Mariani was also the strongest single factor in shaping the style of Francesco Mochi (1580–1654).[68] Born at Montevarchi near Florence, Mochi had his early training with the Late Mannerist painter Santi di Tito before studying under Mariani in Rome. His first independent work of importance, the large marble figures of the *Annunciation* at

they followed into a tame and frigid style. This is true for Buzio's Sansovinesque St James of *c.* 1615 (S. Giacomo degli Incurabili) as well as for Cordier's Luisa Deti Aldobrandini (*c.* 1605, Aldobrandini Chapel, S. Maria sopra Minerva), which goes back to Guglielmo della Porta,[62] and for Valsoldo's St Jerome (*c.* 1612, S. Maria Maggiore), so clearly dependent on Alessandro Vittoria. If one adds the tradition of the style of Flemish relief one has accounted, it would seem, for the primary sources of inspiration of these sculptors.

Four other artists, also engaged on the Chapel of Paul V, have not yet been discussed, namely Stefano Maderno, Pietro Bernini, Camillo Mariani, and, above all, Francesco Mochi, though it is they who had a considerable share in the revitalization of Roman sculpture after 1600. Stefano Maderno from Bissone in Lombardy (1576–1636) appeared in Rome at the end of the sixteenth century. He soon made a name for himself with the marble statue of St Cecilia (in S.

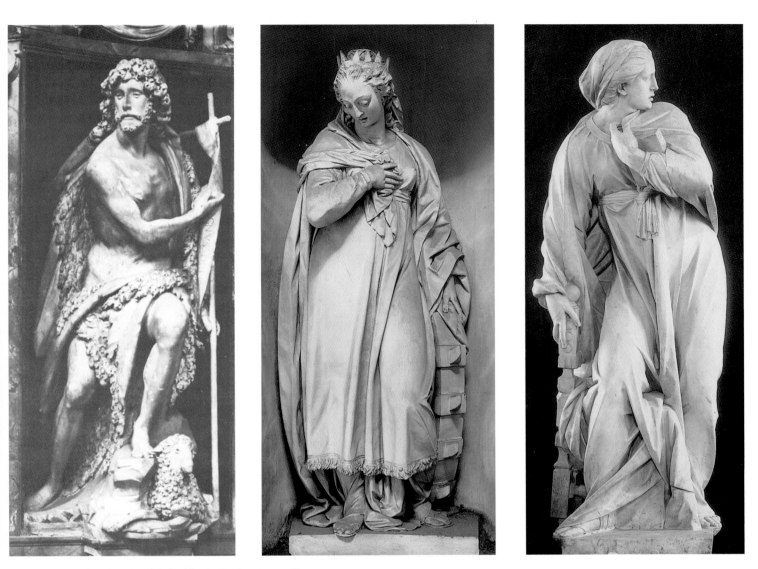

96 (*above, left*). Pietro Bernini: *St John the Baptist*, 1614–15. Rome, S. Andrea della Valle

97 (*above, centre*). Camillo Mariani: *St Catherine of Alexandria*, 1600. Rome, S. Bernardo alle Terme

98 (*above, right*). Francesco Mochi: *The Virgin of the Annunciation*, 1603–8. Orvieto, Museo dell'Opera

Orvieto (1603–8), show in a fascinating mixture the components of his style: linear Tuscan and realistic North Italian Mannerism. Mochi knew how to blend these elements into a manner of immense vitality; the *Annunciation* is like a fanfare raising sculpture from its slumber [98]. It is clearly more than a coincidence that on Roman soil the new invigorating impetus appears in the three arts almost simultaneously: Mochi's *Annunciation* is informed by a bold spirit, freshness, and energy similar to Caravaggio's Roman grand manner (1597–1606), Annibale's Farnese ceiling (1597–1604), and Maderno's S. Susanna (1597–1603). From 1612 to 1629 Mochi stayed with brief interruptions at Piacenza in the service of Ranuccio Farnese and created there the first dynamic equestrian statues of the Baroque, breaking decisively with the tradition of Giovanni Bologna's

school. The first of the two monuments, that of Ranuccio Farnese (1612–20), is to a certain extent still linked to the past, while the later, Alessandro Farnese's (1620–5), breaks entirely new ground [99]. Imbued with a magnificent sweep, the old problem of unifying rider and horse is here solved in an unprecedented way. Never before, moreover, had the figure of the rider held its own so emphatically against the bulk of the horse's body.

After his return to Rome he executed his most spectacular work, the giant marble statue of *St Veronica* (St Peter's, 1629–40), which seems to rush out of its niche driven by uncontrollable agony. In this work Mochi already reveals a peculiar nervous vehemence and strain. A stranger in the changed Roman climate, outclassed by Bernini's genius and disappointed, he protested in vain against the prevalent tide of taste. Frustrated, he renounced everything he had stood for and returned to a severe form of Mannerism. His later statues, such as the *Christ* [100] and *St John* from the Ponte Molle (1634–*c.* 1650),* the *Taddaeus* at Orvieto (1641–4), and the *St Peter and St Paul* of the Porta del Popolo

* Mochi's *Baptism* was carved for S. Giovanni dei Fiorentini, but rejected; it was placed on the Ponte Molle only in the nineteenth century.

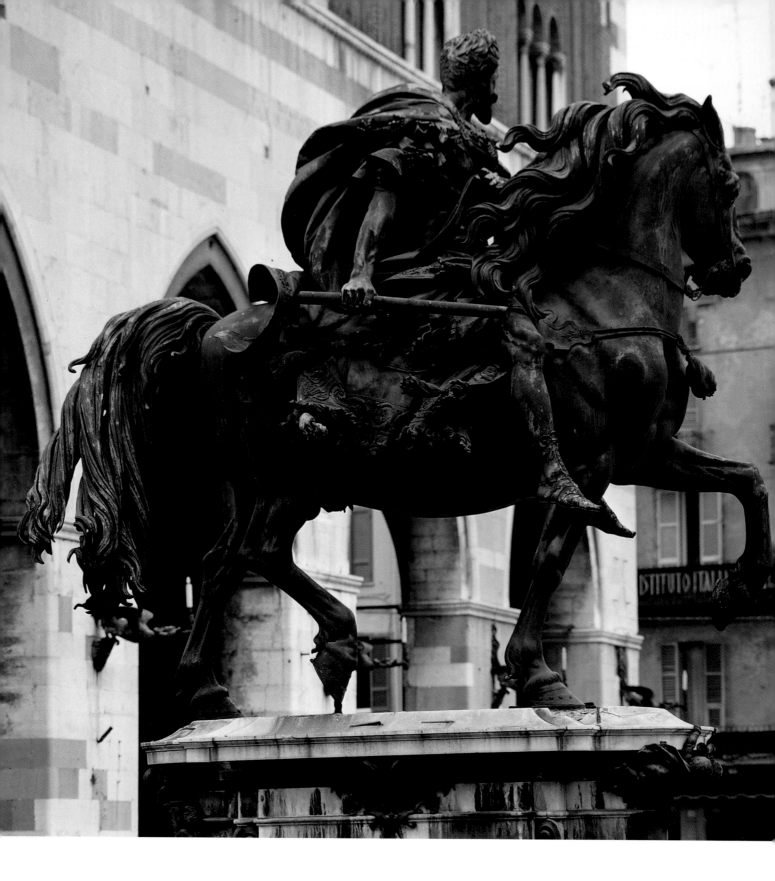

99. Francesco Mochi: *Alessandro Farnese*, 1620–5. Bronze. Piacenza, Piazza
Cavalli

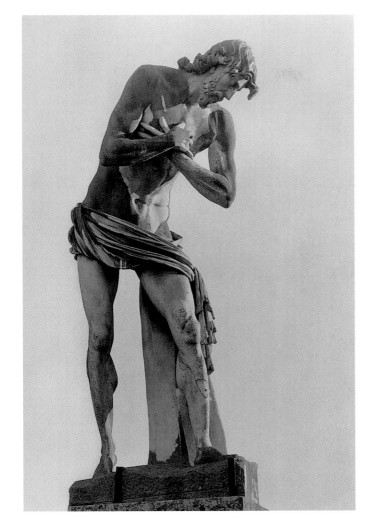

100. Francesco Mochi: *Christ*, from *The Baptism*, after 1634. Rome, Museo di Roma

(1638–52), are not only an unexpected anachronism, but are also very unequal in quality. Always alone among his contemporaries, first the sole voice of uninhibited progress, then the sole prophet of bleak despair, he was utterly out of tune with his time. His Baroque works antedate those of the young Bernini, whose superiority he refused to acknowledge – and it was this that broke him.[69]

Sculpture outside Rome

Florentine sculptors of the first half of the seventeenth century faithfully nursed the heritage of the great Giovan Bologna. Pietro Francavilla (*c.* 1553–1615) and Giovanni Caccini (1556–1612), characteristic exponents of this often very engaging *ultima maniera*, belong essentially to the late Cinquecento. The same applies to Antonio Susini (d. 1624), Bologna's collaborator, who went on selling bronzes from his master's forms, a business which his nephew Francesco Susini continued until his death in 1646.[70] The latter's 'Fountain of the Artichokes', erected between 1639 and 1641 on the terrace above the courtyard of the Palazzo Pitti, is in the draughtsman-like precision of the architectural

structure closely linked to similar sixteenth-century fountains, while decorative elements such as the four shell-shaped basins derive from Buontalenti's Mannerism. Similarly, Domenico Pieratti's and Cosimo Salvestrini's Cupids on the fountains placed along the periphery of the large basin of the *Isolotto* in the Boboli, designed by the Parigi between 1618 and 1620, have the precious poses of Late Mannerist figures. Even Pietro Tacca (1577–1640),[71] certainly the greatest artist of this group and the most eminent successor to Giovanni Bologna, is not an exception to the rule. First, from 1598 onwards he was a conscientious assistant to the master; later he finished a number of works left in various stages of execution at the latter's death.[72] Deeply steeped in Giovanni Bologna's manner, he began work on his own. His most celebrated figures are the four bronze slaves at the base of Bandini's monument to Ferdinand I de' Medici at Livorno (1615–24).[73] Such figures of subdued captives, of classical derivation, played an important part in the symbolic Renaissance representations of triumphs,[74] and we know them in Florentine sculpture from Bertoldo's battle-relief and Michelangelo's tomb of Julius II down to Giovanni Bologna's (destroyed) equestrian monument of Henry IV of France. Here too, as in the case of Tacca's work, the four chained captives at the corners of the base were a polite metaphor rather than a conceit laden with deep symbolism. Two of these captives, for which Francavilla was responsible, have survived; by comparison Tacca's figures show a fresh realism[75] and a broadness of design which seem, indeed, to inaugurate a new era. But one should not be misled. These captives not only recall the attitudes imposed on models in life drawing classes, but their complicated movement, the ornamental rhythm and linear quality of their silhouettes are still deeply indebted to the Mannerist tradition, and even older Florentine Mannerists such as the engraver Caraglio come to mind. Later works by Tacca confirm this view. The famous fountains in the Piazza Annunziata at Florence, originally made for Livorno in 1627, with their thin crossing jets of water, the over-emphasis on detail (which presupposes inspection from a near standpoint and not, as so often in the Baroque, from far away), the virtuosity of execution, and the decorative elegance of monstrous formations are as close to the spirit of Late Mannerism as the over-simplified gilt bronze statues of Ferdinand I and Cosimo II de' Medici in the Cappella dei Principi in S. Lorenzo (1627–34).[76] Even his last great work, the Philip IV of Spain on the rearing horse in Madrid (1634–40) [101],[77] is basically akin to Giovanni Bologna's equestrian monuments with the customary trotting horse. The idea of representing the horse in a transitory position on its hindlegs – from then on *de rigueur* for monuments of sovereigns – was forced upon Tacca by Duke Olivares, who had a Spanish painting sent to Florence to serve as model.[78] But Tacca's equestrian statue remains reserved and immobile and is composed for the silhouette. It lacks the Baroque momentum of Francesco Mochi's Alessandro Farnese and Bernini's Constantine.

In Giovanni Bologna's wake, Florentine Mannerist sculpture of the *fin-de-siècle* had, even more than Florentine painting of the period, an international success from the Low Countries to Sicily. Also Neapolitan sculpture at the

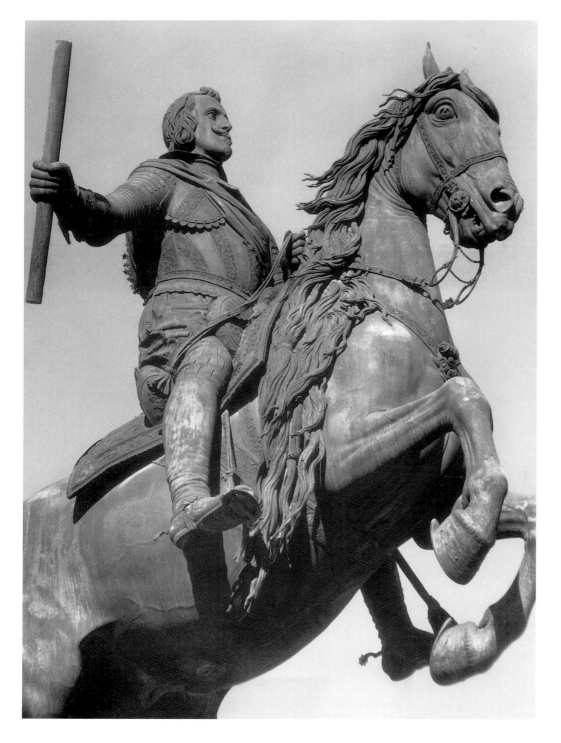

101. Pietro Tacca: *Philip IV*, 1634–40. Madrid, Plaza de Oriente

turn of the century was essentially Florentine Mannerist in character. Two artists, above all, were responsible for this trend: Pietro Bernini, whom we found leaving Naples for Rome in 1605/6, and Michelangelo Naccherino, a pupil of Giovanni Bologna, who was the strongest power in Naples for almost fifty years, from his arrival in 1573 till his death in 1622. He never abandoned his intimate ties with Florentine Mannerism, but owed more to the older generation of Bandinelli, Vincenzo Danti, Vincenzo de' Rossi, and even to Donatello than to his teacher, whom he accused of irreligiosity.[79] In the pietistic climate of the Spanish dominion his figures are often imbued with a wholly un-Florentine

religious mood and a mystic sensibility, eloquent testimonies of the spirit of the Counter-Reformation. Characteristic examples are his tombs of Fabrizio Pignatelli in S. Maria dei Pellegrini (1590–1609) [102], Vincenzo Carafa in SS. Severino e Sosio (1611), and Annibale Cesareo in S. Maria della Pazienza (1613). In all these tombs the deceased is represented standing or kneeling, one hand pressed against the chest in devotional fervour.[80] Naccherino anticipated here a type of sepulchral monument that was to become of vital importance in the different atmosphere of Rome during the 1630s and 1640s.

The contribution of Lombardy to the history of the

Baroque consists to a considerable extent in the constant stream of stonemasons, sculptors, and architects to Rome, where they settled. In Milan itself seventeenth- as well as eighteenth-century sculpture is disappointing. The reasons are difficult to assess. They may lie in the permanent drain on talents, in the petrifying influence of the Ambrosian Academy, or in the bureaucracy which had developed in the works of the cathedral. For generations the great sculptural tasks were connected with the cathedral, and it was only there and, to a more limited degree, in the Certosa of Pavia that sculptors could find rewarding employment. Thus the academic Late Mannerist tradition of Pellegrino Tibaldi and the younger Brambilla was continued by the latter's pupil Andrea Biffi (d. 1631) and others, and by Biffi's pupils Gaspare Vismara (d. 1651) and Gian Pietro Lasagni (d. 1658), the leading masters, who perpetuated the stylistic position of about 1600 until after the middle of the seventeenth century. Even an artist like Dionigi Bussola (1612–87), whose dates correspond almost exactly with those of the romanized Lombard Ercole Ferrata (II: p. 122), did not radically change the position[81] in spite of his training in Rome before 1645. It seems hardly possible to talk of a Milanese High Baroque school, and we may therefore anticipate later events by mentioning Giovan Battista De Maestri, called Volpino, who executed about a dozen statues for the cathedral between 1650 and 1680. During the seventeenth and eighteenth centuries more than 150 sculptors worked in the cathedral studio. Art historians have scarcely begun to sift this material, and one may well ask whether such an undertaking would not be love's labour lost.

Like Bologna and Venice, Genoa hardly had an autonomous school of sculptors during the first half of the seventeenth century. Production was partly under the influence of Lombard academic Mannerism, partly derived from Michelangelo's pupil Montorsoli. The far-reaching impact of Florentine sculpture at this moment may be judged from the fact that Francesco Camilliani's and Naccherino's fountain in the Piazza Pretoria at Palermo, Naccherino's and Pietro Bernini's Fontana Medina at Naples, and Taddeo Carloni's (1543–1613) weak Neptune fountain of the Palazzo Doria at Genoa – all depend on Montorsoli's Orion fountain at Messina.[82]

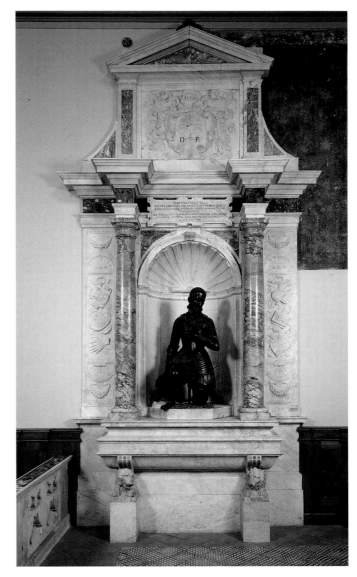

102. Michelangelo Naccherino: Tomb of Fabrizio Pignatelli, 1590–1606. Naples, Santa Maria dei Pelligrini

List of the Principal Abbreviations Used in the Notes

Archivi	*Archivi d'Italia*
Art Bull.	*The Art Bulletin*
Baglione	G. Baglione, *Le Vite de' pittori, scultori, architetti . . .* Rome, 1642
Bellori	G. P. Bellori, *Le Vite de' pittori, scultori ed architetti moderni.* Rome, 1672
Boll. d'Arte	*Bollettino d'Arte*
Boll. Soc. Piemontese	*Bollettino della Società Piemontese di architettura e delle belle arti*
Bottari	G. Bottari, *Raccolta di lettere.* Milan, 1822
Brauer-Wittkower	H. Brauer and R. Wittkower, *Die Zeichnungen des Gianlorenzo Bernini.* Berlin, 1931
Burl. Mag.	*The Burlington Magazine*
Donati, *Art. Tic.*	U. Donati, *Artisti ticinesi a Roma.* Bellinzona, 1942
G.d.B.A.	*Gazette des Beaux-Arts*
Golzio, *Documenti*	V. Golzio, *Documenti artistici sul seicento nell'archivio Chigi.* Rome, 1939
Haskell, *Patrons*	F. Haskell, *Patrons and Painters: A Study in the Relations between Italian Art and Society in the Age of the Baroque.* London, 1963
Jahrb. Preuss. Kunstslg.	*Jahrbuch der Preussischen Kunstsammlungen*
J.S.A.H.	*Journal of the Society of Architectural Historians*
J.W.C.I.	*Journal of the Warburg and Courtauld Institutes*
Lankheit	K. Lankheit, *Florentinische Barockplastik.* Munich, 1962
Mâle	É. Mâle, *L'art religieux de la fin du XVIe siècle . . .* Paris, 1951
Malvasia	C. C. Malvasia, *Felsina pittrice.* Bologna, 1678
Passeri-Hess	G. B. Passeri, *Vite de' pittori, scultori ed architetti.* Ed. J. Hess. Vienna, 1934
Pastor	L. von Pastor, *Geschichte der Päpste.* Freiburg im Breisgau, 1901 ff.
Pollak, *Kunsttätigkeit*	O. Pollak, *Die Kunsttätigkeit unter Urban VIII.* Vienna, 1927, 1931
Quaderni	*Quaderni dell'Istituto di storia dell'architettura* (Rome)
Rep. f. Kunstw.	*Repertorium für Kunstwissenschaft*
Riv. del R. Ist.	*Rivista del R. Istituto di archeologia e storiadell'arte*
Röm. Jahrb. f. Kunstg.	*Römisches Jahrbuch für Kunstgeschichte*
Titi	F. Titi, *Descrizione delle pitture, sculture e architetture . . . in Roma.* Rome, 1763
Venturi	A. Venturi, *Storia dell'arte italiana.* Milan, 1933 ff.
Voss	H. Voss, *Die Malerei des Barock in Rom.* Berlin, 1924
Waterhouse	E. Waterhouse, *Baroque Painting in Rome.* London, 1937
Wiener Jahrb.	*Wiener Jahrbuch für Kunstgeschichte*
Wittkower, *Bernini*	R. Wittkower, *Gian Lorenzo Bernini.* London, 1955
Zeitschr. f. b. Kunst	*Zeitschrift für bildende Kunst*
Zeitschr. f. Kunstg.	*Zeitschrift für Kunstgeschichte*

Notes

FOREWORD

1. See *Journal of Aesthetics and Art Criticism*, v (1946), 77–128, with articles by R. Wellek, W. Stechow, R. Daniells, W. Fleming; J. H. Mueller, *ibid.*, XII (1954), 421; and *ibid.*, XIV (1955), 143–74, with articles by C. J. Friedrich, M. F. Bukofzer, H. Hatzfeld, J. R. Martin, W. Stechow. Also G. Briganti, *Paragone*, I (1950), no. I and II (1951), no. 13; *idem*, *Pietro da Cortona*, Florence, 1962, 15 ff.; Wittkower in *Accademia dei Lincei*, CCLIX (1962), 319. See also Bibliography (II,A).

CHAPTER I

1. Giovanni Andrea Gilio, *Due Dialogi*, Camerino, 1564 (ed. P. Barocchi, *Trattati d'arte del Cinquecento*, Bari, 1961, II, 40).
2. This belongs, of course, to the oldest tenets of the Church. The proscription reaffirms promulgations of the Nicean Council. On the origin and character of the decree, see H. Jedin in *Tübinger Theologische Quartalschrift*, CXVI (1935).
3. A full critical review of the extensive literature in C. Galassi Paluzzi, *Storia segreta dello stile dei Gesuiti*, Rome, 1951. See also F. Zeri, *Pittura e Controriforma: L'arte senza tempo di Scipio da Gaeta*, Turin, 1957, and E. Battisti, 'Riforma e Controriforma', in *Enciclopedia universale dell'arte*, XI, 366–90.
4. For the history of the word and its meaning see M. Treves in *Marsyas*, I (1941).
5. L. Ponnelle and L. Bordet, *St Philip Neri and the Roman Society of his Times*, London, 1932, 576.
6. Apart from the famous case of Padre Pozzo, the architects G. Tristano, G. De Rosis, Orazio Grassi, and Giacomo Briano, the painters Michele Gisberti and Rutilio Clementi, and the sculptor and engraver G. B. Fiammeri may be mentioned. During the years 1634–5 no less than fourteen Jesuit artists were working in the Gesù at Palermo. In addition, decorative wood-carving was largely in the hands of Jesuit artists, such as Bartolomeo Tronchi, Francesco Brunelli, the Taurino brothers, and Daniele Ferrari. A rich material, mainly from Jesuit archives, was published by Pietro Pirri, S.I., in *Archivum Historicum Societatis Iesu*, XXI (1952).
7. These connexions were first discussed in the valuable but almost-forgotten book by W. Weibel, *Jesuitismus und Barockskulptur*, Strasbourg, 1909.
8. See p. 26.
9. See Galassi Paluzzi (above, Note 3) and G. Rovella, S.I., in *Civiltà Cattolica*, 103, iii (1952), 53, 165. See also *Baroque Art and the Jesuit Contribution*, ed. I. Jaffé and R. Wittkower (Bibliography, II, A).
10. On Ponzio see L. Crema in *Atti del IV Congresso Nazionale di storia dell'arte*, Milan, 1939, and H. Hibbard, *The Architecture of the Palazzo Borghese*, Rome, 1962, 97, up to date the fullest biographical treatment. Born at Viggiù near the Lake of Lugano, his career in Rome seems to have started in May 1585 as architect of the Villa d'Este (D. R. Coffin, *The Villa d'Este at Tivoli*, Princeton, 1960, 101). In 1591–2 he worked as 'misuratore' in S. Andrea della Valle.
11. It should, however, be noticed that during the early nineties the Cavaliere's rich and elegant classicism with its deliberate references to Raphael and Michelangelo (to be studied in the Loggia Orsini of the 'house of Sixtus V', Via di Parione, 1589; in the vault of the Contarelli Chapel, S. Luigi de' Francesi, 1591/2; and in the Cappella Olgiati, S. Prassede, 1592–5) held promise for the future which his further development did not realize. See I. Faldi, *Boll. d'Arte*, XXXVIII (1953), 45 ff.
12. F. Haskell, in his review of Zeri's *Pittura e Controriforma* (*Burl. Mag.*, C (1958), 396 ff.), emphasized that the poverty of the Jesuits dictated the choice of their artists.
13. Mâle, III.
14. For Brill's earlier work in the Vatican, see H. Hahn in *Miscellanea Bibliothecae Hertzianae*, Munich, 1961, 308.
15. See the interesting remarks by H. Röttgen, 'Repräsentationsstil und Historienbild in der römischen Malerei um 1600', in *Beiträge für Hans Gerhard Evers*, Darmstadt, 1968, 71–82, who interprets, e.g., Roncalli's 'grand manner' as an autonomous Roman development.
16. The decoration of the pendentives began in 1598 from designs by Cesare Nebbia and Cristoforo Roncalli. For further details, also of the large altarpieces, see H. Siebenhüner, in *Festschrift für Hans Sedlmayr*, Munich, 1962, 292, 295, 300. For the programme of the dome mosaics, see H. Sedlmayr, *Epochen und Werke*, Vienna-Munich, 1960, II, 13.

17. E. Durini, 'Ambrogio Bonvicino . . .', *Arte Lombarda*, III, 2 (1958), is disappointing.
18. Fullest discussion of this building by H. Egger in *Mededeelingen van het Nederlandsch historisch Instituut te Rome*, IX (1929).
19. The documents of payments made to the sculptors working in the chapel between 1608 and 1615 were published by C. Dorati, *Commentari*, XVIII (1967), 231–60.
20. Passignano also painted the frescoes in the large new sacristy of the basilica. For the programme of the paintings of the Cappella Paolina, see Mâle. For the payments made to the painters working in the chapel, see A. M. Corbo, in *Palatino*, XI (1967), 301 ff.
21. According to Belloriʾ, ed. 1672, 369, he changed an angel into the Virgin.
22. Further to the complicated history of the Quirinal Palace: J. Wasserman in *Art Bull.*, XLV (1963), 205 ff., with full documentation; also G. Briganti, *Il Palazzo del Quirinale*, Rome, 1962, 1–29.
23. J. Hess, *Agostino Tassi*, Munich, 1935, believed that the frieze was executed in two campaigns, 1611–12 and 1616–17. His conclusions have been rejected by recent research; see Chiarini in *Boll. d'Arte*, XLV (1960), 367, and the full discussion by G. Briganti (Note 22), 34. In addition, E. Schleier in *Burl. Mag.*, CIV (1962), 255, and W. Vitzthum, *ibid.*, CVI (1964), 215.
24. W. Vitzthum, *Burl. Mag.*, CVII (1965), 468 ff. Spadarino (see Chapter 4, Note 17) also received (relatively small) payments. R. Longhi, *Paragone*, X (1959), no. 117, 29, claims on stylistic grounds that the Veronese artists Bassetti, Ottino, and Turchi had minor shares, a view accepted by Briganti.
25. A good deal of ink has been spilled over this problem, since Longhi opened the discussion (*Vita Artistica*, I (1926), 123); see Notes 23 and 24 for further bibliographical guidance.
26. For other paintings in the palace by Tassi, Orazio Gentileschi, and Antonio Carracci, see Briganti, *op. cit.*, 41 *passim*.
27. Documents 26 September 1609–16 February 1612; see Briganti, *op. cit.*, 30.
28. See pp. 10, 51 ff.
29. On Scipione Borghese's collection, see J. A. F. Orbaan, *Documenti sul barocco*, Rome, 1920, and F. Noack in *Rep. f. Kunstw.*, L (1929).
30. According to Hibbard, *Palazzo Borghese* (above, Note 10), 69, Vasanzio may be responsible for the second tier of the façade.
31. The complex building history of the palace has been disentangled by H. Hibbard (above, Note 10). He showed convincingly that the palace was begun by Vignola, 1560–5.
32. Hoogewerff's articles in *Palladio*, VI (1942), and in *Archivio della R. deputazione romana di storia patria*, LXVI (1943), clarify the mystery surrounding this architect, who was born at Utrecht about 1550 and died in Rome in 1621.
33. See Guglielmi in *Boll. d'Arte*, XXXIX (1954), 318: payment of 15 February 1614.
34. This casino has been destroyed; on Cigoli's frescoes, see p. 64. The report about the Pallavicini complex of decorations by F. Zeri in *Connoisseur* (1955), 185, has been superseded by H. Hibbard, *Journal of the Society of Architectural Historians*, XXIII (1964), 163.
 Tassi and Gentileschi, friends who had become enemies in 1612, worked once again together in 1613 in the Villa Lante at Bagnaia (near Rome). They were joined there by the Cavaliere d'Arpino; see L. Salerno in *Connoisseur*, CXLVI (1960), 157.
35. See M. Sacripanti, *La Villa Borghese*, Rome, 1933, with new documents and full bibliography.
36. The loggia [9] has incorrectly been attributed to Ponzio by Venturi, *Storia dell'Arte*, XI, ii, 905, figure 837, and others, but the new building period only started after November 1613, when the villa was purchased by Scipione Borghese. At that time Ponzio was dead.
37. For the Acqua Paola and urban planning under Paul V, see C. H. Heilmann, *Burl. Mag.*, CXII (1970), 656 ff. For the dates, see Hibbard, *op. cit.*, 101 (documents). The engineering problems of this and the smaller 'Fontana di Ponte Sisto' were in the hands of Domenico Fontana's brother, Giovanni (1540–1614). The latter fountain consists of one triumphal arch, designed by Vasanzio in 1612–13; it stood at the end of Via Giulia and was moved to the other side of the Tiber in 1897. On Giovanni Fontana, the most distinguished water engineer of the period, see Donati, *Artisti ticinesi*, Bellinzona, 1942.
 For these and other fountains, see also D'Onofrio, *Le fontane di Roma*, Rome, 1957, 147, 149, and *passim*.
38. For the collection, see C. P. Landon, *Galerie Giustiniani*, Paris, 1812. The collection has been reconstructed in some articles by L. Salerno in *Burl.*

Mag., CII (1960), 21, 93, 135. Many of the Marchese's pictures formed the nucleus of the Berlin Museum. For the Palazzo Giustiniani in Rome, see I. Toesca in *Boll. d'Arte*, XLII (1957), 296, and *Burl. Mag.*, CII (1960), 166.

For Giustiniani and other Roman patrons see also Haskell, *Patrons.*

The decoration of Vincenzo Giustiniani's palace at Bassano di Sutri north of Rome gives an excellent idea of the catholicity of this patron's taste. During the first decade of the seventeenth century worked here side by side the Florentine Antonio Tempesta, the Genoese Bernardo Castello, the Bolognese Domenichino and Albani, and, in addition, the strange Mannerist eccentric Paolo Guidotti (*c.* 1569–1629). The palace and its decoration has been the subject of illuminating articles by P. Portoghesi, M. V. Brugnoli, and I. Faldi in *Boll. d'Arte*, XLII (1957), 222–95.

39. E. Rodocanachi, *Aventures d'un grand seigneur italien*, Paris [n.d.], and A. Banti, *Europa Milleseicentosei – diario di viaggio di Bernardo Bizoni*, Milan, 1942. On Roncalli see also P. Pouncy in *Burl. Mag.*, XCIV (1952), 356.

40. W. Friedlaender, *Caravaggio Studies*, Princeton, 1955.

41. Fullest information about Agucchi and his circle in D. Mahon, *Studies in Seicento Art and Theory*, London, 1947.

42. Only a fragment of the treatise survives, incorporated into the preface of Simon Guillain's etchings after Annibale Carracci's drawings of Bolognese artisans (1646); see Mahon, *op. cit.*

43. R. Lee, *Art Bull.*, XXXIII (1951), 205.

44. W. Friedlaender, *op. cit.*, and D. Mahon, *Art Bull.*, XXXV (1953), 227.

45. Agucchi, for instance, praises Caravaggio as a colourist, although he regards his realism as vulgar. Albani looks down with utter contempt at the whole trend inaugurated by Caravaggio.

46. For the full history of construction on the basis of new documents, see J. Hess in *Scritti di storia dell'arte in onore di Mario Salmi*, 1963, III, 215. After Longhi's death (1591) Giovan Battista Guerra (1554–1627) took over. In 1605 (date of inscription) Rughesi's façade was not quite finished. All available material for Matteo di Città di Castello in Hess's Appendix I.

47. The complicated early history of the church has been clarified by H. Hibbard in *Art Bull.*, XLIII (1961), 289 (fully documented). The Theatine Francesco Grimaldi had a hand in the design, which – as Hibbard shows – must be regarded as an important step beyond the Gesù towards a typically Seicento articulated and unified conception.

48. For this and other restorations in Early Christian taste, see G. Incisa della Rocchetta, 'Cesare Baronio restauratore di luoghi sacri', in *Cesare Baronio. Scritti vari*, 1963, 323 ff., and E. Hubala, 'Roma sotterranea barocca . . .', in *Das Münster*, XVIII (1965), 157 ff. For SS. Nereo and Achilleo also R. Krautheimer, in *Essays in the History of Art presented to R. Wittkower*, London, 1967, 174 ff.

49. It is interesting in this connexion that between 1570 and 1693 twenty-five Jesuit martyrs alone were beatified or canonized, twenty of them before 1630.

50. É. Mâle, in his classic work on the art after the Council of Trent, differentiates correctly between (i) traditional subjects which live on without considerable changes, (ii) the recasting of old subjects, and (iii) the large body of entirely new themes. – See also E. Kirschbaum in *Gregorianum*, XXVI, 100 ff. and L. Réau, *Iconographie de l'art chrétien*, Paris, 1955, I, 457.

51. Ponnelle and Bordet, *op. cit.* (Note 5), 413.

52. Among the Flemish artists in Rome shortly before and after 1600 were, apart from Rubens and Paul Brill, Willem van Nieulandt and his nephew of the same name, Sebastian Vranx, Jan Bruegel, and Josse de Momper. See L. van Puyvelde, *La peinture flamande à Rome*, Brussels, 1950.

53. For this and the following see M. Vaes in *Mélanges Hulin de Loo*, Brussels, 1931, 309 ff.

54. Anton Mayer, *Das Leben und die Werke der Brüder Matthaeus und Paul Bril*, Leipzig, 1910; Rodolf Baer, *Paul Bril. Studien zur Entwicklungsgeschichte der Landschaftsmalerei um 1600*, Munich, 1930; G. T. Faggin, in *Paragone*, XVI, no. 185 (1965), 21 ff., with a catalogue of Paul Brill's easel paintings and a list of dated paintings between 1587 and 1626. See also above, Note 14.

55. Tassi's role as an intermediary between the northern and Italian genre has been emphasized in recent studies; see II: Chapter 8, Note 20.

56. This has been pointed out by E. Gombrich in his illuminating paper 'Renaissance artistic Theory and the Development of Landscape Painting', *G.d.B.A.*, XCV (1954).

57. It is only in recent years that some progress has been made in reconstructing the careers of the two most important figures, Pietro Paolo Bonzi ('Il Gobbo dei Carracci') and Tommaso Salini. As regards the former (1576–1636), whose earliest still life in the manner of Pieter Aertsen dates from *c.* 1606 (private coll., Madrid), see E. Battisti in *Commentari*, V (1954), 290 ff. and J. Hess, *ibid.*, 303 ff. (frescoes in the Palazzo Mattei, see below, II: Chapter 4, Note 52). For Salini, see Salerno in *Commentari*, III (1952) and V (1954), 254, and Testori in *Paragone*, V (1954), no. 51. Salini, who died, according to Baglione, aged fifty in 1625, painted flower and fruit pieces before a dark background, with the objects close to the picture plane ('invenzioni molto capricciose e bizarre',

Baglione). See also R. Longhi, *Paragone*, I (1950), no. 1, who started the recent discussions. In this context belong also the still lifes by Fede Galizia (1578–1630); see S. Bottari, *Arte Antica e Moderna*, VI, no. 24 (1963), 309, and *idem*, *Fede Galizia*, Trent, 1965.

See also the older papers by Marangoni, *Riv. d'Arte*, X (1917), and Hoogewerff, *Dedalo*, IV (1923–4). Charles Sterling's *La nature morte de l'antiquité à nos jours*, Paris, 1952, contains many suggestive ideas.

58. This may be the place to refer to Ottavio Leoni (Rome, 1578–1630), whose activity in Rome in the first quarter of the seventeenth century was entirely devoted to portraiture, especially to portrait drawings in black and red chalk, to portrait engravings, and, to a lesser extent, portrait paintings. His well-known sober renderings of sitters have preserved for us a veritable pantheon of Roman artists, of professional persons and clerics. H.-W. Kruft, who published Leoni's album in the Biblioteca Marucelliana, Florence, containing 27 portrait drawings of artists (in *Storia dell'arte*, no. 4 (1969), 447 ff.), also suggested a link between Leoni's interpretation of portraiture and the aesthetic views of the Academy of St Luke, of which Leoni was Principe in 1614.

CHAPTER 2

1. For a re-appraisal of both Caravaggio's and Annibale's art, prepared in many studies of the last thirty years, the reader may turn now to the books by D. Mahon, *Studies in Seicento Art and Theory*, London, 1947; W. Friedlaender, *Caravaggio Studies*, Princeton, 1955; R. Wittkower, *The Drawings of the Carracci*, London, 1952; and D. Posner, *Annibale Carracci*, London, 1971.

2. On Peterzano, see C. Baroni, *L'Arte*, N.S. XI (1940), 173 ff., with further references, and M. Calvesi, *Boll. d'Arte*, XXXIX (1954).

3. He was 'about twenty', according to Giulio Mancini, Caravaggio's earliest biographer.

4. All the documents are now available in English translation in Professor Friedlaender's book. See also S. Samek Ludovici, *Vita di Caravaggio. Dalle testimonianze del suo tempo*, Milan, 1956; annotated texts of all the sources and documents.

5. On Gramatica, see R. Longhi, *Proporzioni*, I (1943), 54, and A. Marino, in *L'Arte*, nos. 3–4 (1968), 47 ff.

6. During this period he painted the *Sick Bacchus* and the *Boy with the Fruit Basket*, both in the Borghese Gallery and originally in the possession of the Cavaliere d'Arpino.

7. Among the pictures in the Cardinal's collection were *The Musical Party* (Metropolitan Museum, New York), the *Fortune Teller* (Louvre version?), the *Card Sharpers* (Kimbell Art Museum, Fort Worth), the *Lute Player* (Leningrad), and the *Medusa* (Uffizi). The pictures of the early Roman period are difficult to arrange in a precise sequence, and their chronology will remain, to a certain extent, the subject of controversy. Perhaps the most thorough attempt at establishing a chronology was undertaken by D. Mahon, *Burl. Mag.*, XCIV (1952), 19. Interesting revisions were proposed by E. Arslan, *Arte Antica e Moderna*, II (1959), 191; see also B. Joffroy, *Le Dossier Caravage*, Paris, 1959, especially 300 ff., 331.

8. From 1599 onwards all the important pictures are datable within a fairly narrow margin. 1599–1600: the lateral paintings in the Contarelli Chapel, S. Luigi de' Francesi. There were, however, not three, but four paintings in all, since Caravaggio's first altarpiece of *St Matthew and the Angel* was rejected and bought by the Marchese Vincenzo Giustiniani. (With the rest of the Giustiniani collection it went to the Kaiser Friedrich Museum, Berlin, and was destroyed in 1945.) The second *St Matthew*, substituted for the rejected version, is *in situ*; both versions were painted between February and September 1602 (H. Röttgen, *Zeitschr. f. Kunstg.* (1965), 54 ff.). The earlier lateral panels, the *Calling of St Matthew* and the *Martyrdom of St Matthew*, particularly the *Martyrdom*, contain many revealing *pentimenti* (L. Venturi and G. Urbani, *Studi radiografici sul Caravaggio*, Rome, 1953; for the recent restoration of all the paintings of the chapel, see the detailed reports in *Boll. dell'Istituto Centrale del Restauro*, 1966). 1600–1: *Crucifixion of St Peter* and *Conversion of St Paul*, Cerasi Chapel, S. Maria del Popolo. 1602–4: *Deposition of Christ*, painted for St Philip Neri's church, the Chiesa Nuova, now Vatican Gallery. 1604–5: *Madonna di Loreto*, S. Agostino, Rome. 1605–6: the *Death of the Virgin*, for S. Maria della Scala, now Louvre, Paris; the *Madonna of the Rosary*, painted for Modena, now Vienna Gallery (finished, according to Friedlaender's plausible suggestion, by another hand). 1606: *Madonna dei Palafrenieri*, painted for St Peter's, now Borghese Gallery (for the date see L. Spezzaferro, 'La Pala dei Palafrenieri', *Acc. Naz. dei Lincei* (1974), no. 205, 125–37). 1607: *The Seven Acts of Mercy*, Chiesa del Monte della Misericordia, Naples; *Flagellation of Christ*, S. Domenico Maggiore, Naples. 1608: *Portrait of Alof de Wignacourt*, Louvre, Paris (doubted by Longhi); *Beheading of St John the Baptist*, Cathedral, La Valletta, Malta; *Burial of St Lucy*, S. Lucia, Syracuse. 1609: *Adoration of the Shepherds* and *Raising of Lazarus*, Museo Regionale, Messina. 1609: *Adoration with St Francis and St Lawrence*, Oratorio di S. Lorenzo,

Palermo. Apart from the Wignacourt portrait, this list contains only the large altarpieces.

9. Though hardly ever discussed, it is still an open question whether pictures like the *Boy with the Fruit Basket*, the *Musical Party*, or the *Boy bitten by a Lizard* (Longhi Coll.) were painted with a moralizing or allegorizing intent.

10. In his 'Life' of Caravaggio, Baglione remarks generally that the young artist was in the habit of painting self-portraits in a mirror, specifying a 'Bacchus' guise. Other early pictures such as the *Boy bitten by a Lizard* and the head of *Medusa* may confidently be regarded as self-portraits.

11. The relation of the Bacchus to 'the sensuous idealism of certain Hadrianic representations' (W. Friedlaender, *op. cit.*, 85) should not, however, be overlooked.

12. For the process of revaluing the ancient gods after the Renaissance see the admirable account in F. Saxl's *Antike Götter in der Spätrenaissance*, Leipzig, 1927.

13. A similar though burlesque, reorientation may be observed in Nicolò Frangipani's *Bacchus and Buffoon*, which was painted in Venice at about the same moment (Venice, Querini Stampalia Gallery; Venturi, IX, 7, figure 55).

14. Still lifes of extraordinary perfection are the rule in Caravaggio's early work, see, e.g., the Borghese *Boy with the Fruit Basket*, the Leningrad *Lute Player*, and, of a slightly later date, the National Gallery *Supper at Emmaus*. It comes as no surprise, therefore, to find amongst the earliest works a self-contained still life, the *Basket of Fruit* (Milan, Ambrosiana). It has been pointed out, however, that this picture may be the fragment of a larger composition, a hypothesis borne out by the repainted buff background. See H. Swarzenski, *Boston Museum Bulletin*, LII (1954), whose attribution of the Boston still life to Caravaggio can hardly be accepted, in spite of his pertinent discussion of the whole problem of early still lifes.

15. According to a stimulating hypothesis by D. Heikamp, *Paragone*, XVII, no. 199 (1966), 62 ff., the shield of Medusa has to be regarded as a tournament weapon rather than as a painting.

16. Two of the early religious pictures share the same quality: the *Repentant Magdalen* (Rome, Galleria Doria-Pamphili) and the *St Catherine* (Madrid, Thyssen Coll.). Their interest is largely focused on still life and embroidered dresses. For the iconography of the *Magdalen*, see I. Toesca, *J.W.C.I.*, XXIV (1961), 114.

17. The date of this painting is still controversial. Dates as far apart as 1594 and 1602 have been suggested. My previous assumption '*c.* 1597' seems too early; the picture can hardly have been painted before 1600. See M. Levey, *National Gallery Catalogues. The Seventeenth and Eighteenth Century Italian Schools*, London, 1971, 49–53.
 * It is now documented to 1601.

18. The reader may be reminded of Mantegna's *Dead Christ* in the Brera. For the whole problem of extreme foreshortening, see Kurt Rathe, *Die Ausdrucksfunktion extrem verkürzter Figuren*, London, 1938.

19. For the iconography of the *Deposition*, see G. Wright, 'Caravaggio's *Entombment* considered *in situ*', *Art Bull.*, LX (1978), 35–42.

20. Most of Caravaggio's late pictures, painted in great haste, are in poor condition. In recent years some have been carefully cleaned and restored, among them the two pictures mentioned in the text. On this occasion the extremely high quality of the *Lazarus* was revealed, whose authenticity had sometimes been doubted.

21. The Borghese *David with the Head of Goliath* (*c.* 1605), for instance, follows a representational type which was already current in the fifteenth century and ultimately derives from illuminations in manuscripts of Perseus with the head of Medusa. For the rest, the reader must be referred to W. Friedlaender's thorough iconographical studies.

22. Bellori, in his biography of Caravaggio, mentions that he painted this picture twice and X-ray studies have proved correct (see above, Note 8).

23. The line of the neck of the Virgin in the Doria *Repose on the Flight* recurs in a number of pictures, e.g. the *Penitent Magdalen* and the *Madonna di Loreto*.

24. See Chapter 3, pp. 36–7.

25. The break, of course, is not radical but was foreshadowed in early pictures.

26. Two versions are extant, one in the Doria Gallery, the other in the Capitoline Museum, Rome. D. Mahon (*Burl. Mag.*, XCV (1953), 213) tried to show that the latter picture, for long regarded as a copy, is the one mentioned by Bellori as being in the collection of Cardinal Pio. See also D. Mahon and D. Sutton, *Artists in Seventeenth-Century Rome*, Loan Exhibition, Wildenstein, London, 1955, no. 17, with a full discussion of the intricacies of the subject matter. Further, see E. Battisti in *Commentari*, VI (1955), 181 ff., whose researches in the Pio archives seem to militate against Mahon's identification. But L. Salerno, *G. Mancini. Considerazioni sulla pittura*, Rome, 1957, II, note 891, gives convincing reasons for linking the Pio and Capitoline versions.
 * It is now generally accepted that the Doria version is a copy; see in particular *Identificazione di un Caravaggio: Nuove tecnologie per un rilettura del 'San Giovanni Battista'*, ed. G. Correale, Venice, 1990.

27. The better of the two existing versions seems to be that in the Wadsworth Athenaeum, Hartford, Connecticut, see *Mostra del Caravaggio, Catalogo*, 1951, no. 17.

28. Dr Friedlaender in his recent book does not quite agree with this interpretation of the sources. I cannot do more here than state his case, without being able to argue the matter out. Cf. L. Spezzaferro, *op. cit.* (Note 8).

29. For a detailed discussion of the relationship between Caravaggio's art and the reform movement the reader must be referred to W. Friedlaender's *Caravaggio Studies*, 121 ff.

CHAPTER 3

1. Translation in E. G. Holt, *Literary Sources of Art History*, Princeton, 1947, 329 ff.

2. See the survey in D. Mahon's *Studies in Seicento Art and Theory*, London, 1947, 212 ff.

3. Their collaboration is particularly puzzling in the cycle of frescoes of the Palazzo Fava (*c.* 1583–4) with scenes from Virgil's *Aeneid* as well as in that of the Palazzo Magnani-Salem (1588 ff.) which illustrates the early history of Rome after Livy (see J. M. Brown, *Burl. Mag.*, CIX (1967), 710 ff., and opposing Brown, A. W. A. Boschloo, *ibid*, CX (1968), 220 f.). It is easier to differentiate between the three masters in the frescoes of the Palazzo Sampieri-Talon (*c.* 1593–4). See Bodmer, *Lodovico Carracci*, Burg, 1939, 118 ff., with further references.
 The paper by S. Ostrow in *Arte Antica e Moderna*, III, no. 9 (1960), 68, is concerned with the iconography of the Palazzo Fava cycle.

4. The character and history of the Carracci Academy are discussed by H. Bodmer in the periodical *Bologna*, XIII (1935), 61 ff. Bodmer dates the foundation of the Accademia degli Incamminati in 1582. G. C. Cavalli, the compiler of the *Regesto* published in the Catalogue of the *Mostra dei Carracci*, Bologna, 1956, 76, believes the date to be 1585. See also J. H. Beck and M. Fanti, 'La sede dell' Accademia dei Carracci', *Strenna storica bolognese*, XVII (1967), 53 ff. For all dates of the *vite* of the Carracci the *Regesto* should be consulted.

5. For Agostino's development as an engraver see H. Bodmer, *Die Graphischen Künste*, IV (1939) and V (1940). Agostino's importance is nowadays generally underrated. With his systematic studies of parts of the body, of eyes, ears, arms, and feet (engraved after his death and for 150 years frequently republished), he became the ancestor of academic teaching; see R. Wittkower, *The Drawings of the Carracci at Windsor Castle*, London, 1952. The Vienna pictures, published by O. Kurz, *J.W.C.I.*, XIV (1951), reveal Agostino as a sophisticated and entertaining master of mythological allegory.

6. Tietze believed that this picture was mainly executed by Lucio Massari. There is no reason to accept this view. The picture is signed and dated and original drawings by Annibale are extant.
 * The general consensus has moved in favour of Massari, on the designs of Annibale; in so far as Annibale oversaw its production, this does not invalidate Wittkower's comments (see D. Posner, 1971, II, 31, cat. 72).

7. See, e.g., E. K. Waterhouse, *Baroque Painting in Rome*, London, 1937, 7, where the term is used in spite of certain reservations.

8. The history and fallacies of the term 'eclectic' have been discussed by D. Mahon, *op. cit.* See also R. W. Lee in *Art Bull.*, XXXIII (1951), 204 ff., Mahon, *ibid.*, XXXIV (1952), 226 ff., the apt remarks by B. Berenson in his *Caravaggio*, London, 1953, 78 ff., and Wittkower in *Aspects of the Eighteenth Century*, ed. E. Wasserman, The Johns Hopkins Press, 1965.

9. Even in Lodovico's most Baroque pictures there is a Mannerist undercurrent. Figures often lack a firm stance and – particularly in later works – gestures may be as ill-defined as they are *outré* and eccentric. Such figures as the donors who appear in the Cento altarpiece like intruders from outside are a well-known Mannerist formula (see, e.g., Passarotti's *Presentation in the Temple*, S. Maria della Purificazione, Bologna).

10. According to the *Mostra dei Carracci* (*op. cit.*, 128), the *Martyrdom of St Angelus* should be dated *c.* 1598–9.

11. Examples: *The Calling of St Matthew* of *c.* 1605 (Bologna, Pinacoteca), the *Assumption of the Virgin*, *c.* 1605–8 (Modena, Galleria Estense), *St Charles adoring the Child*, *c.* 1615 (Forlì, Pinacoteca), and the *Paradise* of *c.* 1616 (Bologna, S. Paolo) with its immensely elongated boneless figures.

12. The iconography of the only canvas, *Hercules at the Crossroads*, now in the Naples Museum, was exhaustively discussed by E. Panofsky, *Hercules am Scheidewege*, Leipzig, Berlin, 1930. J. R. Martin, *Art Bull.*, XXXVIII (1956), 91, who threw new light on the iconography of the whole cycle, showed that the programme was conceived by Fulvio Orsini.

13. J. R. Martin, *The Farnese Gallery*, Princeton, 1965, 51 ff., with further literature on the complicated question of chronology; see also the pertinent observations by D. Posner, in *Art Bull.*, XLVIII (1966), 111 ff.

14. Martin, *op. cit.*, 52 ff.

15. *Ibid.*, 144f.

16. For the symbolical interpretation the reader had to be referred until recently to Bellori, to Tietze's basic article, and to Panofsky in *Oud Holland*, L (1933). These earlier attempts have been superseded by the full discussion in J. R. Martin's *Farnese Gallery*. Nevertheless, today we are as far apart as ever regarding the ultimate meaning of this festive decoration. While Martin stresses the neo-Platonic overtones, C. Dempsey, in a remarkable paper (see Bibliography), submits that a punning, satirical, mock-heroic spirit informs the classical scenes of the ceiling.

17. Preserved in drawings; see Tietze's article; Wittkower, *Carracci Drawings* (*op. cit.*); D. Mahon, *Mostra dei Carracci, Disegni*, Bologna, 1956, 108.

18. See Karoline Lanckoronska's article in *Wiener Jahrb.*, IX (1935). For the history and development of ceiling decoration see F. Wurtemberger, 'Die Manieristische Deckenmalerei in Mittelitalien', *Röm. Jahrb. f. Kunstg.*, IV (1940), and A. F. Blunt, 'Illusionist Decorations in Central Italian Painting of the Renaissance', *Journal of the R. Society of Arts*, CVII (1959), 313. For the early history of *quadratura* painting, see the illuminating paper by J. Schulz, *Burl. Mag.*, CIII (1961), 90.

19. For the brothers Alberti in Rome, see A. C. Abromson, *Art Bull.*, LV (1973), 531–47.

20. From Alberti's *De Pittura* on it was regarded as an unassailable dogma that 'history painting' (in the widest sense) stood at the top of the hierarchical scale of artistic activity.

21. Later, Domenichino contributed most to the completion of the gallery (see J. R. Martin, *Boll. d'Arte*, XLIV (1959), 41; *Farnese Gallery*, 62ff.), while the contributions of Lanfranco and Badalocchio are more problematical. D. Mahon has attempted to distribute a number of subsidiary scenes among these three hands; see 'Notes sur l'achèvement de la Galerie Farnèse et les dernières années d'Annibal Carrache', in R. Bacou, *Dessins des Carraches*, Louvre Exhibition, 1961, 57. See also below, Chapter 4, Note 20.

22. J. R. Martin wanted to identify this famous scene as 'Glaucus and Scylla' and C. Dempsey (in *Zeitschr. f. Kunstg.*, XXIX (1966), 67ff.) as 'Thetis borne to her Wedding'.

23. J. Anderson, in *Art Bull.*, LII (1970), 41ff., demonstrated convincingly that Agostino's cycle, dependent on classical epithalamic poetry, was painted as part of the celebrations for the arrival of the bride of Ranuccio I, Margherita Aldobrandini. The programme was probably devised by the Bolognese humanist Claudio Achillini.

24. Agostino's funeral in Bologna was a memorable occasion, during which Lucio Faberio, a member of the literary Academy of the Gelati, delivered the funeral oration. This speech, important for the creation of the 'eclectic legend', has been thoroughly analysed by D. Mahon in *Studies in Seicento Art*, 135ff., and in *J.W.C.I.*, XVI (1953), 306.

25. For work executed during the period of Annibale's illness, mainly by studio hands, see D. Posner in *Arte Antica e Moderna*, III, no. 12 (1960), 397; and below, Chapter 4, Notes 20, 21.

26. A comparison of pictures like the early Roman *Coronation of the Virgin* (London, D. Mahon Coll.) with works dating from after 1600, like the Naples *Pietà* or the Bridgewater *Danaë* (destroyed), fully illustrates this development.

27. See D. Mahon, *Studies, op. cit.*, 204.

28. This is particularly impressive in the Louvre *Virgin with St Luke* of 1592.

29. The best of six lunettes, painted, according to Bellori, for the chapel of the Palazzo Aldobrandini, and executed with the help of pupils. H. Hibbard (*Burl. Mag.*, CVI (1964), 183) has found documentary proof according to which Albani together with other collaborators worked on these lunettes in 1605 and again in 1613. For the whole problem and a new attempt to distribute the execution among Annibale, Albani, Lanfranco, and Badalocchio, see Cavalli in *L'Ideale classico del Seicento in Italia e la pittura del paesaggio*, Catalogue, Bologna, 1962, 61, with further literature. E. Borea in *Paragone*, XIV (1963), no. 167, 22, gives Domenichino a share in the lunettes.

30. A more thorough investigation of this problem would probably reveal that their activity in this sphere belongs to a trend current in Bologna in the circle of such artists as Calvaert (who came from Antwerp), Passarotti, Prospero Fontana, and others. The *Butcher's Shop*, published by me (*Carracci Drawings, op. cit.*) as Agostino, was attributed to Annibale at the Carracci Exhibition. J. R. Martin has shown (*Art Bull.*, XLV (1963), 265) that this work, far from being a 'naive' genre painting, combines figures from Michelangelo's *Sacrifice of Noah* on the Sistine Ceiling and Raphael's fresco of the same subject in the Vatican Logge.

31. Few caricatures by Annibale have so far been traced; see Wittkower, *Carracci Drawings*, 18. I cannot fully agree with some of the attributions made by W. Boeck in *Münchner Jahrbuch der bildenden Kunst*, V (1954), 154ff. As for the problem of early caricatures, see Brauer-Wittkower, *Die Zeichnungen des Gianlorenzo Bernini*, Berlin, 1931; W. R. Juynboll, *Het komische genre in de italiaansche schilderkunst*, Leiden, 1934; E. Kris, *Psychoanalytic Explorations in Art*, London, 1953 (III, ch. 7, with E. Gombrich); also M. Gregori, 'Nuovi accerta-

menti in Toscana sulla pittura "caricata" e giocosa', *Arte Antica e Moderna*, nos. 13–16 (1961), 400ff., and W. Boeck, *Inkunabeln der Bildniskarikatur bei Bologneser Zeichnern des 17. Jahrhunderts*, Stuttgart, 1968.

CHAPTER 4

1. Orazio Gentileschi died on 7 February 1639. Documentary evidence found by A. M. Crinò (*Burl. Mag.*, CIII (1961), 145) settles the old dispute.

2. B. Nicolson (see Bibliography) has assembled the little we know about Manfredi.

3. V. Martinelli, 'Le date della nascita e dell' arrivo a Roma di Carlo Saraceni', *Studi Romani*, VII (1959), 679.

4. Valentin's Christian name is unknown. It is not Moïse, as is usually maintained, which is simply a misunderstood version of 'Monsù'. Caracciolo and Artemisia Gentileschi will be discussed with the Neapolitan school. For the Dutch, Flemish, and French *Caravaggisti* the reader must be referred to other volumes of the Pelican History of Art. For the literature on the artists mentioned in this chapter, see also Bibliography.

5. See R. Longhi, *Proporzioni*, I (1943), 21f. Before the Caravaggesque phase, which includes such works as the *Crowning with Thorns* (Varese, Lizza-Bassi Coll.), Longhi has reconstructed an earlier Elsheimer-like period. In this he placed, no doubt correctly, the small Berlin *David* and *St Christopher*, previously attributed to Elsheimer. Pictures such as the *St Cecilia and the Angel* (Dr Bloch Coll.) and the *Virgin and Child* (Florence, Contini-Bonacossi Coll.), with their strong Florentine qualities, may belong to a pre-Elsheimer period. One wonders whether the impressive *SS. Cecilia, Valerianus, and Tiburtius* in the Brera, one of Orazio's masterpieces, usually dated during his stay in the Marches (before 1617–21?), may not be a few years earlier and nearer the time when the impact of Caravaggio was most in evidence.

For Orazio's work in the Marches, see Mezzetti, *L'Arte*, N.S. I (1930), 541ff., and Emiliani, *Paragone*, IX (1958), no. 103, 38 (partly out of date); also H. Voss in *Acropoli*, I (1960–1), 99 (for the frescoes in the Cappella del Crocefisso, Fabriano Cathedral, datable between 1613 and 1617); for his stay in Paris (*c.* 1623–5), see C. Sterling, *Burl. Mag.*, C (1958), 112; for his arrival in England (document of 1626), *Burl. Mag.*, C (1958), 253. See also A. M. Crinò, *ibid.*, CII (1960), 264 (documents); Crinò and B. Nicolson, *ibid.*, CIII (1961), 144; E. Schleier, *ibid.*, CIV (1962), 432; Crinò, *ibid.*, CIX (1967), 533.

6. The pictures are mentioned here in the sequence in which they were painted according to H. Voss (*The Connoisseur*, CXLIV (1959), 163).

For Gentileschi's *Lot and his Daughters*, also dating from the early 1620s and existing in several autograph versions, see R. W. Bissell, in *Bulletin. The National Gallery of Canada*, Ottawa, XIV (1969), 16ff.

7. See J. Hess in *English Miscellany* (1952), no. 3.

8. But Van Dyck's influence makes its appearance e.g. in the Prado *Finding of Moses*, painted in London and listed in 1636 in the inventory of Philip IV's paintings; see J. Costello, *J.W.C.I.*, XIII (1950), 252. As shown by E. Harris, *Burl. Mag.*, CIX (1967), 86, the picture was taken to Madrid in the summer of 1633.

9. Baglione's career has been reconstructed by Carla Guglielmi, *Boll. d'Arte*, XXXIX (1954). It appears that the artist vacillated between progressive trends without absorbing them fully. After his Caravaggesque phase (see V. Martinelli, *Arte antica e moderna*, II, 5 (1959), 82), he turned 'Bolognese' (second decade, *Rinaldo and Armida*, Rospigliosi); in the third decade he followed Guercino's Baroque (*St Sebastian*, S. Maria dell'Orto, 1624). From *c.* 1630 on the quality of his work rapidly declines.

For Baglione's career, see also I. Faldi in *Diz. Biografico degli Italiani*, V, 1963, 187. For the involved story of his painting of *Divine Love*, see Martinelli, *loc. cit.*, and L. Salerno, *Burl. Mag.*, CII (1960), 103; also R. Longhi, *Paragone*, XIV (1963), no. 163, 25.

10. See S. Bottari, *Commentari*, VI (1955), 108, who published Borgianni's first picture, the *St Gregory* (Catania, Palazzo Cerami), signed and dated 1593. Consequently Borgianni was probably born earlier than was hitherto believed.

H. E. Wethey has successfully reconstructed Borgianni's early career (*Burl. Mag.*, CVI (1964), 148ff.); *c.* 1595–8, Rome; *c.* 1598–1602, first Spanish trip; 1603, Rome; 1604–5, second Spanish trip. See I. Toesca's letter (378), Wethey's response (381), and Toesca's rejoinder (*ibid.*, CIV (1965), 33f.).

11. For Saraceni see the unprinted New York University thesis by Eve Borsook, 1953, with an excellent catalogue of the artist's œuvre. See also Martinelli's paper (Note 3, above), and F. Arcangeli, *Paragone*, XVII, no. 199 (1966), 46ff. Finally, the satisfactory monograph by Cavina, 1968 (see Bibliography), which contains most critical material. Some of my dating below differs slightly from that given by Cavina.

For Elsheimer's relations with Saraceni and other Italian painters, see the excellent catalogue of the Elsheimer Exhibition in the Städelsches Kunstinstitut, Frankfurt, 1966–7 (written by Jutta Held).

12. Replicas in Bologna, Vienna, Hanover, Lille, etc. testify to the popularity of the picture.

13. The picture was carefully cleaned in 1968, see *Attività della Soprintendenza alle Gallerie del Lazio*, Rome (1969), 27.

14. See the famous nine mythological scenes in landscape settings (on copper) in the museum at Naples. Very close to Saraceni is the small group of impressive pictures by an anonymous artist, possibly of French origin and now assembled under the pseudonym 'Pensionante del Saraceni' (Longhi, *Proporzioni*, I (1943), 23). Saraceni's French contacts are well known. During the last year of his life he was assisted by Jean Le Clerc from Nancy (*c.* 1590–*c.* 1633). After his return to Venice Saraceni was commissioned with the large *Doge Enrico Dandolo preaching the Crusade in St Mark's* for the Sala di Gran Consiglio in the Palazzo Ducale, but it would seem that Le Clerc was wholly responsible for the work and that he carried it out between 1620 and 1622.

According to R. Pallucchini (*Arte Veneta*, XVII (1963), 178) Le Clerc also executed the *Annunciation* in the Parish Church at Santa Giustina (Feltre), with Saraceni's signature and the date '1621' (anachronistically – for the artist had died in 1620).

For Le Clerc in Italy, see N. Ivanoff in *Critica d'Arte*, IX (1962), 62, and for his post-Italian career, F. G. Pariset in *La Revue des Arts*, VIII (1958), 67.

15. For Valentin, see R. Longhi, *ibid.*, 59 (with *œuvre* catalogue) and M. Hoog, *ibid.*, X (1960), 267.

16. An ethereally painted halo seems to surround the head, but the inscription proves that Serodine's father is represented.

For a revision of Longhi's chronology of Serodine's work, see B. Nicolson, *Terbrugghen*, London, 1958, II (note). W. Schoenenberger's *Giovanni Serodine, pittore di Ascona*, Basel, 1957, was written in 1954 as a dissertation without a knowledge of Longhi's work or of Serodine's correct birth-date (1600). Although not published until 1957, the author left his text (including patent errors) unchanged, but added some new facts in a preamble, among them documentary evidence of the artist's death on 21 December 1630. P. Askew, 'A Melancholy Astronomer by G. S.', *Art Bull.*, XLVII (1965), 121, enlarged Serodine's small *œuvre* by a picture in Dresden and added important iconographical considerations.

17. Among other painters who came under Caravaggio's influence mainly during the second decade may be mentioned the Veronese Pasquale Ottino (1570–1630), Marcantonio Bassetti (1586–1630), and Alessandro Turchi, called L'Orbetto (1578–1648), all three Felice Brusasorci's pupils before going to Rome (R. Longhi in *Proporzioni*, I (1943), 52); the Roman Angelo Caroselli (1585–1652) and Bartolomeo Cavarozzi from Viterbo (*c.* 1590–1625) who were both influenced by Orazio Gentileschi; Giovan Antonio Galli ('Spadarino'), a painter of real distinction (d. after 1650); Nicolò Musso, who died in his hometown, Casale Monferrato, *c.* 1620 after a stay of several years in Rome; Alonso Rodriguez (1578–1648) from Messina, in Rome in 1606, who followed Caravaggio in the second decade (A. Moir, *Art Bull.*, XLIX (1962), 205); finally Nicolas Regnier (Niccolò Renieri) from Maubeuge (*c.* 1590–1667), who appeared in Rome *c.* 1615 and settled in Venice about ten years later, where he stayed to the end of his days. About his early Caravaggesque phase see Voss, *Zeitschr. f. b. Kunst*, LVIII (1924). Characteristic works of all these painters were to be seen during the 1951 Caravaggio Exhibition; see the *Catalogo*, in addition to H. Voss, *Die Malerei des Barock in Rom*, Berlin, 1924, and Longhi, *Proporzioni*, I (1943).

Other 'part-time' *Caravaggisti* will be discussed in their proper place.

18. Pieter van Laer's appearance and character earned him the name of *Bamboccio*, which can be translated as childish, simple. By referring to his work as *Bambocciata*, meaning a trifle, the pun is evident. The term remains today to designate the whole genre. On Van Laer see Hoogewerff, *Oud Holland*, L (1932) and LI (1933) and G. Briganti, *Proporzioni*, III (1950) and *idem*, *I Bamboccianti*, *Catalogo*, 1950. The Würzburg dissertation by A. Janeck on Pieter van Laer (1968, see Bibliography) supersedes the earlier literature. Janeck does not accept the painting of illustration 39 as autograph. It is here reproduced as a characteristic piece of the genre rather than as a characteristic Van Laer.

19. See A. Blunt, *Art and Architecture in France 1500–1700* (Pelican History of Art), Harmondsworth, 1953 (paperback edition, based on 2nd hardback edition, Harmondsworth, 1973; references in the present volume are to the first, hardback, edition); W. R. Crelly, *The Painting of Simon Vouet*, New Haven and London, 1962 (see also the review by D. Posner, *Art Bull.*, XLV (1963), 286). For Vouet's Italian period, see now J. Thuilliers, 'Simon Vouet en Italie. Essai de catalogue critique', *Saggi e memorie di storia dell' arte*, IV (1965), 27 ff.

20. See J. Pope-Hennessy, *Drawings of Domenichino at Windsor Castle*, London, 1948, 14, and M. V. Brugnoli in *Boll. d'Arte*, XLII (1957), 274; in addition to the literature given in Chapter 3, Note 21.

21. D. Posner in *Arte Antica e Moderna*, III, no. 12 (1960), 397, has dealt fully with this work and the distribution of hands. Execution did not start until 1604. The frescoes, now in rather bad condition, are in the Museum at Barcelona and in the Prado, Madrid.

22. Little is known about Tacconi apart from his having been a pupil of Annibale and active in Rome between *c.* 1607 and 1625.

23. In April 1612 Reni was in Naples; see F. Bologna in *Paragone*, XI (1960), no. 129, 54.

24. Bottari–Ticozzi, *Raccolta di lettere . . .*, Milan, 1822, I, 287.

25. The old puzzle of the attribution and dating of these scenes was finally resolved by the publication of the documents by G. Panofsky-Soergel, in *Röm. Jahrb. f. Kunstg.*, XI (1967–8), 132 ff. The first frescoes of the new palace were executed by pupils of Cristoforo Roncalli (1600–1). Later, in 1607–8, other late Mannerists, Gaspare Celio and Francesco Nappi, painted ceilings in the palace.

26. For the chronology of this entry and the following Reni entries, see H. Hibbard, in *Burl. Mag.*, CVII (1965), 502, and CVIII (1966), 90.

27. The documents were published by M. V. Brugnoli, in *Boll. d'Arte*, XIII (1957), 266 ff.

28. The correct dating is owed to E. Borea, *Boll. d'Arte*, XLVI (1961), 237.

29. Contract of 4 December 1614 published by Golzio, *Archivi*, IX (1942), 46 ff.

30. J. Hess, *Agostino Tassi*, Munich, 1935, 21 f., believed that Domenichino's *Chariot of Apollo* was painted *c.* 1610 as an isolated *quadro riportato* and that some time later (*c.* 1621) the ceiling was converted by Tassi into an open sky with a *quadratura* surround. Pope-Hennessy (*Domenichino Drawings*, 92 f.), on the basis of original drawings, refuted this view, which also seems contradicted by the iconographic evidence (Saxl in *Philosophy and History*, Essays dedicated to Ernst Cassirer, Oxford, 1936, 213 ff.). Hess reaffirmed his old view in *Commentari*, V (1954), 314, but dated *The Chariot of Apollo* in 1615.

31. L. Salerno, *Commentari*, IX (1958), 45.

32. *Ibid.*, 45 for the attribution, and *passim* for the reconstruction of Badalocchio's *œuvre*. See also *Maestri della pittura del Seicento emiliano* (1959 Exhibition), 232, with further literature for Badalocchio. The artist returned to Parma after Annibale's death. Back in Rome after 1613, he settled Parma in 1617. His later work, after his Annibalesque Roman period, has a strong Parma flavour. See also D. Mahon, in *Bull. Wadsworth Atheneum* (1958), no. I, 1–4; E. Schleier, in *Burl. Mag.*, CIV (1962), 246 ff.; *L'ideale classico del Seicento in Italia*, Catal., Bologna, 1962, 63, 68.

33. I. Toesca, *Boll. d'Arte*, XLIV (1959), 337, and *Burl. Mag.*, CIV (1962), 392, for the correct date of these frescoes.

34. The dating of these frescoes varies widely. Boschetto's date 1607–8 (*Proporzioni*, II (1948), 143) seems as unacceptable as that of Posse (Thieme-Becker), 1625. Tietze dates after 1609; Bodmer (*Pantheon*, XVIII (1936)), *c.* 1609–14. According to Albani himself (Malvasia, II, 125) the work was executed after Bassano di Sutri, i.e. after 1609. For reasons of style a date nearer to the middle of the second decade seems likely (see also Brugnoli (Note 20), 274). This dating has now been confirmed by L. Salerno, in *Via del Corso*, Rome (Cassa del Risparmio), 1961, 177. But his discovery of a small scene representing an event of 1617 opens a new problem, because Albani left Rome in 1616.

35. These frescoes were usually dated much earlier, in accordance with the stylistic (but as we now know, misleading) evidence; see the admirable paper by L. Salerno in *Burl. Mag.*, CV (1963), 194, who (like others before him) advocated the years 1605–6. Only E. Borea in *Paragone*, XI (1960), no. 123, 12, and XIV (1963), no. 167, 28, favoured a date after 1611. The issue has been settled once and for all by C. D'Onofrio, *La Villa Aldobrandini di Frascati*, Rome, 1963, 126, who published the payments to Domenichino between November 1616 and June 1618. The whole question has been fully reviewed by M. Levey, *National Gallery Catalogues, The Seventeenth and Eighteenth Century Italian Schools*, London, 1971, 96–106.

36. It characterizes the whole classical trend that, after Annibale's death, Raphael's influence grew rapidly.

37. See above, p. 14.

38. See H. Hibbard in *Miscellanea Bibliothecae Hertzianae*, Munich, 1961, 357 (documents); also E. Borea, *Domenichino*, Milan, 1965, 126, 184.

39. In the *Calling of St Andrew and St Peter* the figure of Christ is adapted from the Christ in Lodovico's *Calling of St Matthew* (Bologna, Pinacoteca) and the oarsman from a similar figure in the *Preaching of St John* (ibid.).

39a. He left behind the unfinished Cappella della Strada Cupa, a chapel in S. Maria in Trastevere, to which R. E. Spear has dedicated a fully documented article in *Burl. Mag.*, CXI (1969), 12 ff., 220 ff.

40. For a different view, see Pope-Hennessy, *op. cit.*, 25, who should also be consulted for the sequence of the execution of these frescoes.

41. The traditional title of the picture is incorrect. It illustrates *Aeneid*, V, 485–512, as K. Badt has shown in an illuminating paper in *Münchner Jahrbuch d. bild. Kunst*, XIII (1962), 216.

42. It should, however, be recalled that Domenichino's arch-enemy, Lanfranco, had the picture engraved at his own expense in order to make Domenichino's 'plagiarism' as widely known as possible.

43. For Domenichino's landscapes, see M. Imdahl in *Festschrift Martin Wackernagel*, Münster, 1958, 153; E. Borea, *Paragone*, XI (1960), no. 123, 8; *L'Ideale classico del Seicento* (Bologna Exhib. Cat., 1962); M. Fagiolo dell'Arco, *Domenichino ovvero Classicismo del Primo-Seicento*, Rome, 1963, 104 (list of Domenichino's landscapes in chronological sequence).

44. Denis Calvaert (1540–1619), a northern Mannerist who had made his home at Bologna. For Albani, see the hitherto unpublished dissertation by E.

Van Schaack (Columbia University, 1969) with many new documents and *œuvre* catalogue.

45. In the *Jacob's Dream* the influence of Lodovico is very strong. Albani must have known the picture of the same subject, now in the Pinacoteca, Bologna. This connexion with Lodovico is interesting in view of the fact that after his arrival in Rome Albani was Annibale's collaborator in the Herrera Chapel and the Aldobrandini landscapes (see p. 46 and Chapter 3, Note 29). For Albani's relation to Annibale Carracci, see also M. Mahoney, *Burl. Mag.*, CIV (1962), 386.

46. The first example of this manner is the four *Venus* and *Diana* roundels in the Galleria Borghese which were commissioned by Cardinal Scipione Borghese in 1622.

47. Payments found by H. Hibbard allow the *Crucifixion* to be dated later than had hitherto been assumed. The Louvre *David* is another example of Reni's *Caravaggismo*. The most impressive fusion of influences from Caravaggio and Lodovico may perhaps be found in the *Colloquy between the Apostles Peter and Paul* in the Brera of *c.* 1605.

48. This painting is usually dated about 1611, but D. J. S. Pepper, *Guido Reni's Activity in Rome and Bologna, 1595–1614* (Columbia University Dissertation (unpublished), 1969, 219) argued persuasively that the picture dates from as late as 1615–16.

49. See last Note; the *Samson* should probably be dated about 1620.

50. The identification of the pope is peculiarly difficult. D. Mahon (*Burl. Mag.*, XCIII (1951), 81) replaced the old name Paul V by that of Clement VIII. This would date the portrait *c.* 1602, which seems hard to accept. The sitter is almost certainly the Bolognese Gregory XV and the date therefore *c.* 1621.

51. The old title *Aurora* is not quite correct. The fresco shows Apollo in his chariot surrounded by the dancing figures of the Horae and Aurora hovering on clouds before him and strewing flowers on the dark Earth below.

52. Lanfranco's problematical early career has been investigated by L. Salerno, *Burl. Mag.*, XCIV (1952), 188, and *Commentari*, IX (1958), 44, 216. See also *Maestri della pittura del Seicento emiliano* (Exhib. Cat., Bologna, 1959), 214, and for Lanfranco's drawings J. Bean-W. Vitzthum, *Boll. d'Arte*, XLVI (1961), 106, R. Enggass, *Burl. Mag.*, CVI (1964), 286. For Lanfranco's ascendancy over Domenichino, above all D. Posner, in *Essays in Honor of Walter Friedlaender*, New York, 1965, 135–46.

53. First implied by Voss, then discussed by N. Pevsner, the relationship to Schedoni was further investigated by Mahon (*Burl. Mag.*, XCIII (1951), 81) and Salerno, in the papers mentioned in Note 52.

54. This dating was suggested by Mahon in the catalogue of the 1955 Wildenstein Exhibition in London (*Artists in Seventeenth Century Rome*, 60).

55. Extensively repainted; see Waterhouse, 75. These frescoes, always dated too early, were painted between August 1624 and March 1625; see H. Hibbard, in *Miscellanea Bibliothecae Hertzianae*, Munich, 1961, 355.

56. See Hibbard, *op. cit.*, 358.

It is worth summarizing Lanfranco's career as a fresco painter in the second and third decade. 1616–17: frescoes in S. Agostino and the Quirinal Palace. 1619–20: decoration of the Benediction Loggia over the portico of St Peter's, a commission of the greatest importance which attests to Lanfranco's reputation at this time but which, though extensively prepared, was not executed. (Reconstruction of Lanfranco's project by E. Schleier, in *Revue de l'Art*, no. 7 (1970), figure 49.) 1621–3: decoration of the Cappella del Sacramento, S. Paolo fuori le Mura (ruined); fully discussed by B. L. La Penta, *Boll. d'Arte*, XLVIII (1963), 54. 1624–5: Villa Borghese. 1625–7: S. Andrea della Valle. After 1627: the newly found frescoes of the Villa Muti at Frascati; see E. Schleier, *Paragone*, XV (1964), no. 171, 59.

For the dating of Lanfranco's easel paintings, particularly of the first and second decade, see E. Schleier, *ibid.*, no. 177, 3.

At the time of the dome frescoes of S. Andrea della Valle the Frenchman François Perrier worked for Lanfranco. This artist was a success in Rome and after his first stay there in 1625–9 returned for a longer period (1635–45), during which he executed the frescoes of the gallery of the Palazzo Gaetani-Ruspoli (now Almagià) on the Corso; see E. Schleier, *Paragone*, XIX (1968), no. 217, 42 ff.

57. It has been shown by D. Mahon (*Burl. Mag.*, LXX (1937)) that the young Guercino was influenced by Scarsellino in Ferrara, where Guercino must have been in about 1616. Venetian influences, transmitted to him through Scarsellino, were reinforced by a visit to Venice in 1618. See also D. Mahon in the Catalogue of the Guercino Exhibition of 1968, especially pp. 20 ff.

58. This slow change in Guercino's manner has been fully discussed by D. Mahon in *Studies in Seicento Art and Theory*.

59. It has been rightly pointed out that Guercino's chiaroscuro, North Italian in character, was developed without any appreciable influence from Caravaggio's form-preserving *tenebroso*. It is also likely that the plebeian types which appear in Guercino's early work reached him at one remove from Caravaggio.

CHAPTER 5

1. This is, of course, a judgement *post festum*, looking back from the Baroque position. Around 1600 Florentine painters were vigorously active and their all-European influence on the formation of the 'international' Mannerism can hardly be over-estimated; see F. Antal, 'Zum Problem des Niederländischen Manierismus', *Kritische Berichte*, I–II (1927–9).

2. For Barocci's dates, see H. Olsen, *Federico Barocci*, Copenhagen, 1962, 20.

3. A. Emiliani, 'Andrea Lilli', *Arte Antica e Moderna*, I (1958), 65; G. Scavizzi, 'Note sull'attività romana del Lilio e del Salimbeni', *Boll. d'Arte*, XLIV (1959), 33.

4. P. A. Riedl, 'Zu Francesco Vanni und Ventura Salimbeni', *Mitt. d. Kunsthist. Inst. in Florenz*, IX (1959–60), 60 and 221 (Salimbeni's work, full bibliography).

5. W. Friedlaender, *Mannerism and Anti-Mannerism in Italian Painting*, New York, 1957.

6. When this book first appeared (1958) our knowledge of these artists had hardly increased since N. Pevsner's *Die Barockmalerei in den romanischen Ländern*, published in 1928. But in connexion with the Bologna Exhibition of 1959 Bolognese Seicento painting has been intensely studied. The Catalogue (*Maestri della pittura del Seicento emiliano*) is therefore indispensable for this section. See also Bibliography under Artists.

7. A. Graziani, *Critica d'Arte*, IV (1939), 93, pointed out that Tiarini was influenced by Bartolomeo Cesi, his first teacher in Bologna (see Note 11).

8. For documented dates of all the works in the Cappella di S. Domenico, see V. Alce, *Arte Antica e Moderna*, I (1958), 394.

A. Ghidiglia Quintavalle, *Paragone*, XVII (1966), no. 197, 37 ff., discusses Tiarini's documented work at Parma, where he worked from 1626 onwards.

9. J. Hess's hypothesis that Spada was in Rome between 1596 and 1601/2 is unconvincing (*Commentari*, V (1954), 281).

10. Mastelletta's *Triumph*, published by R. Kultzen, *Burl. Mag.*, C (1958), 352, is an early picture, painted under the influence of Polidoro da Caravaggio.

11. Four minor artists belong in this context: Francesco Brizio (1574–1623) and Lorenzo Garbieri (1580–1654), the former mainly Agostino Carracci's pupil, the latter a close follower of Lodovico; Lucio Massari (1569–1633), Albani's friend, who oscillates between painterly tendencies pointing back to Parmigianino and a stiffly wooden classicism (C. Volpe, *Paragone*, VI (1955), no. 71, 3); and Francesco Gessi (1588–1649), who began as a Lodovico follower and later capitulated to Reni. For Massari, Garbieri, and Brizio see also F. Arcangeli, *Arte Antica e Moderna*, I (1958), 236, 354. The fresco decoration of the Oratorio di S. Colombano in Bologna, where also Albani, Reni, Domenichino, and Galanino painted, is the main topic of this paper, which contains a major contribution to the Bolognese position around 1600. See also above, p. 33.

Although not connected with this group of artists, the name of Bartolomeo Cesi (1556–1629) should at least be mentioned. A Mannerist, outside the Carracci circle, yet in his masterpiece, the *Virgin in Glory with Saints* of 1595 (Bologna, S. Giacomo Maggiore), he reached a stylistic position not far from Lodovico. His later work shows progressive petrifaction. His career has been fully reconstructed by Graziani in the article quoted in Note 7.

12. M. A. Novelli, *Lo Scarsellino*, Bologna, 1955, with full bibliography.

13. For Schedoni's correct place and date of birth, see *Maestri della pittura del seicento emiliano*, Bologna, 1959, 204. For Schedoni's procedure, see R. Kultzen, 'Variationen über das Thema der heiligen Familie bei B.S.', *Münchner Jb. d. bild. Kunst*, XXI (1970), 167 ff.

14. Giulio Cesare Amidano, who began under the influence of Correggio and Parmigianino, in his later work fell under the spell of Schedoni.

15. In this context should be mentioned Fabrizio Boschi (*c.* 1570–1642), who hardly ever betrays that most of his working life belonged to the seventeenth century.

16. M. Bacci, 'Jacopo Ligozzi e la sua posizione nella pittura fiorentina', *Proporzioni*, IV (1963), 46–84. Full monographic treatment.

17. S. Bottari, in *Arte Antica e Moderna*, III (1960), 75.

18. See E. Panofsky's fascinating paper *Galilei as a Critic of the Arts*, The Hague, 1954.

For a fully annotated edition of Cigoli's letters to Galilei, see 'Macchie di sole e pittura; carteggio L. Cigoli-G. Galilei, 1609–1613', ed. A. Matteoli, in *Boll. della Accademia degli Euteléti della città di San Miniato*, XXII, N.S., no. 32 (San Miniato, 1959).

The fullest information on Cigoli in the Catalogue of the 1959 Exhibition (ed. M. Bucci, etc., San Miniato); see also M. Pittaluga, *Burl. Mag.*, CI (1959), 444.

For interesting material on Sigismondo Coccapani, Cigoli's collaborator, see F. Sricchia, in *Proporzioni*, IV (1963), 249.

19. G. Ewald, in *Pantheon*, XXIII (1965), 302 ff., discussed, among other Florentines, mainly Allori and Biliverti, and published a Life of Biliverti written by the latter's pupil, Francesco Bianchi.

20. For the development of Florentine painting in the first half of the seventeenth century, see F. Sricchia (Note 18); see also the frescoes in seven rooms of the Casino Mediceo, Via Cavour 63 (1621–3), illustrating Medici exploits, to which a great number of artists contributed; A. R. Masetti, *Critica d'Arte*, IX (1962), 1–27, 77–109.

21. For a new attempt at defining Manetti's stylistic development, see C. dal Bravo, in *Pantheon*, XXIV (1966), 43–51.

Francesco Rustici (d. 1626) from Pisa, who had a great reputation in his time, is still an undefined personality. According to C. Brandi (*R. Manetti*) he followed the Bolognese and in particular Reni's manner. An equally problematical figure is the Pisan Riminaldi (1586–1631); as the Exhibition *Caravaggio e caravaggeschi nelle gallerie di Firenze*, 1970, showed, he was an artist of considerable dramatic power. The much younger Pietro Paolini (Lucca 1603–81), Caroselli's pupil in Rome, much of whose work is reminiscent of R. Manetti, has recently received some attention; see A. Marabottini Marabotti, in *Scritti di storia dell'arte in onore di Mario Salmi*, Rome, 1963, III, 307; A. Ottani in *Arte Antica e Moderna*, no, 21 (1963), 19.

22. Procaccini's birth date is taken from an unpublished document discovered by H. Bodmer.

23. For details regarding the two cycles, see E. Arslan, *Le Pitture nel duomo di Milano*, Milan, 1960, 47, 63. Cerano painted no less than ten canvases and Procaccini six. M. Rosci, *Mostra del Cerano*, Catalogue, Novara, 1964, 66, 71, claims that Cerano was the inventive genius of the entire first series (nineteen bozzetti by him in the Villa Borromeo d'Adda at Senago). Morazzone's contribution is also problematical; although his name does not appear in the documents, two paintings of the first series have always been attributed to him; further to this question M. Gregori, *Il Morazzone*, Catalogue, Milan, 1962, 7, 31.

24. The strong Gaudenzio note in the early Cerano has been emphasized by G. Testori in *Paragone*, VI (1955), no. 67.

25. See *Mostra del manierismo piemontese . . . 1955*; *Mostra del Cerano*, 46 (no. 24).

26. The results of N. Pevsner's pioneering article on Cerano, published in 1925, have been revised by G. A. Dell'Acqua in *L'Arte*, N.S. XIII (1942) and XIV (1943). Rosci's Catalogue of the Cerano Exhibition summarizes the entire research (full bibliography).

For Cerano's pupil Melchiorre Gherardini (1607–75), who is often mixed up with his master, see S. Modena, *Arte Lombarda*, IV (1959), 109, and F. R. Pesenti, in *Pantheon*, XXVI (1968), 284 ff.

27. For his frescoes in the Cappella di S. Rocco in S. Bartolomeo, Borgomanero (c. 1615–17), see M. Rosci, *Boll. d'Arte*, XLIV (1959), 451; M. Gregori's Morazzone Catalogue, 60.

28. For the Sacri Monti see, in addition to the Bibliography, Wittkower, in *L'Œil* (1959).

29. After G. Nicodemi's uncritical monograph of 1927, work on Morazzone was carried a step further by C. Baroni, (*L'arte*, XLIV, 1941 and *Emporium*, 1944), E. Zuppinger (*Commentari*, II, 1951), and M. Rosci (*Boll. d'arte*, XLIV, 1959). The comprehensive Morazzone Exhibition of 1962 has clarified many problems. M. Gregori's excellent Catalogue supersedes all previous research. See also M. C. Gatti Perer in *Arte Lombarda*, VII (1962), 153, and M. Valsecchi, in *Paragone*, XXI (1970), no. 243, 12 ff.

30. For documents about the early works see S. Vigezzi in *Riv. d'Arte*, XV (1933), 483 ff. This and F. Wittgens' article, *ibid.*, 35 ff., correct some of the results of N. Pevsner's basic paper on G. C. Procaccini (*ibid.*, X (1929)).

31. See F. Bologna, *Paragone*, IV (1953), no. 45.

32. See W. Arslan in *Phoebus*, II (1948). After these articles and the Caravaggio Exhibition of 1951 and the Turin Exhibition of Piedmontese and Lombard Mannerists of 1955, Tanzio began to emerge as an artist of considerable calibre. The Tanzio Exhibition of 1959 (Bibliography) brought most of his known work together; see G. Testori's Catalogue and M. Rosci, *Burl. Mag.*, CII (1960), 31.

In a 1967 paper M. Calvesi (see Bibliography) made it likely that Tanzio was in Naples about 1610 and returned home via Apulia and possibly Venice.

33. For Tanzio's collaboration with his brother, the sculptor Giovanni d'Enrico, see A. M. Brizio, in *Pinacoteca di Varallo Sesia*, Varallo, 1960, 19.

34. Moncalvo, who worked mainly in Milan, Pavia, Turin, Novara, and in small towns of Piedmont, is a typical *Neo-Cinquecentista* who, in spite of his extensive *œuvre*, may safely be omitted from this survey. Fullest discussion: V. Moccagatta in *Arte Lombarda*, VIII (1963), 185–243. See also A. Griseri, *Paragone*, XV (1964), no. 173, 17.

35. M. Vaes in *Bulletin de l'institut historique belge de Rome*, IV (1925).

36. Reni's *Assumption* [49] of 1616–17 was commissioned by Cardinal Durazzo.

37. R. Longhi in *Proporzioni*, I (1943), 53.

38. In addition to Longhi's article in *Dedalo*, VII (1926–7), see Delogu in *Pinacotheca*, I (1929), and Longhi, *ibid.*; Marcenaro, *Emporium*, CV (1947); Grassi, *Paragone*, III (1952), no. 31; G. V. Castelnovi, *Emporium*, CXX (1954), 17.

39 After the studies by Grosso in *Emporium*, LVII (1923), and by Lazareff, in

Münchner Jahrbuch der bildenden Kunst, N.S. VI (1929), little work has been done on the early Strozzi; but see H. MacAndrew, *Burl. Mag.*, CXIII (1971), 4 ff.

40. For these and other artists active in Venice in the first quarter of the seventeenth century – Scarsellino, Leandro Bassano, Sante Peranda, Matteo Ponzone, and Pietro Damiani – see the Catalogue of the Seicento Exhibition in Venice, 1959. For Palma Giovane see also V. Moschini, *Arte Veneta*, XII (1958), 97, and G. Gamulin, *Arte Antica e Moderna*, IV (1961), 259, who suggests a revaluation of Palma's late period. For Palma as draughtsman, see H. Schwarz, *Master Drawings*, III (1965), 158, and D. Rosand, *ibid.*, VIII (1970). – For Padovanino, see R. Pallucchini, *Arte Veneta*, XVI (1962), 121.

Pallucchini (*ibid.*, 126) counts Saraceni, N. Regnier, J. Heintz, and Vouet among the renovators of Venetian art next to or even before Fetti, Lys, and Strozzi. This view of the great connoisseur of Venetian painting cannot be accepted: for, first, the Venetian period of those four artists is either contemporary with or later than that of Fetti and Lys; and, secondly, none of them took up and developed further the specific Venetian colouristic tradition.

41. The best statement regarding the Venetian situation at the turn of the sixteenth to the seventeenth century is D. Rosand's paper 'The Crisis of the Venetian Renaissance Tradition', *L' Arte*, nos. 11–12 (1970), 5 ff.

42. See P. Askew, in *Art Bull.*, L (1968), 1–10.

43. See J. Wilde, *Jahrbuch der kunsthistorischen Sammlungen, Wien*, N.F. X (1936).

44. P. Michelini, 'Domenico Fetti a Venezia', *Arte Veneta*, IX (1955), 123. Here also the correct date of Fetti's death: 1623 (document).

45. The unprinted University of London Ph.D. thesis by Pamela Askew (1954) contains a full and reliable *catalogue raisonné* of Fetti's works. Partly published in a new form as 'The Parable Paintings of D.F.', *Art Bull.*, XLIII (1961).

46. V. Bloch, *Burl. Mag.*, XCII (1950), 278.

47. One of the few Venetians of this period who learned his lesson from Van Dyck was Tiberio Tinelli (1586–1638), but his portraits – his main claim to fame – are archaizing compared with his model. See A. Moschetti, *Burl. Mag.*, LXXII (1938), 64, and R. Pallucchini, *Arte Veneta*, XVI (1962), 126.

Of the three Veronese painters, Bassetti, Turchi, and Ottino, referred to above (Chapter 4, Note 17), the most Venetian is certainly Bassetti. He spent some time in Venice before going to Rome. On occasions he was capable of impressive creations (portrait, Museo Civico, Verona), which attest to his links with Fetti.

CHAPTER 6

1. The basic monograph on Maderno by N. Caflisch (Munich, 1934) is not always reliable. U. Donati's monograph (1957) has many good illustrations.

2. W. Lotz (*Röm. Jahrb. f. Kunstg.*, VII (1955), 65) gives Maderno a larger share in the façade of S. Giacomo degli Incurabili than was hitherto believed on the strength of Baglione (ed. 1733, 196). But Francesco da Volterra, the architect of the church, designed the façade after 1592 and Maderno seems to have finished it after Volterra's death in 1594/5 (see H. Hibbard, in *Burl. Mag.* (December 1967), 713).

3. At the same moment Maderno also worked at Cardinal Pietro Aldobrandini's Villa di Belvedere at Frascati; see K. Schwager, *Röm. Jahrb. f. Kunstg.*, IX–X (1961–2), 291.

4. The emphasis on the columns derives from the North, while the conception of the enclosed bays is typically Roman. For the façade of S. Susanna, see also below, pp. 83, III: 8.

5. A minor though considerable problem consisted in that Domenico Fontana had placed the obelisk a few degrees out of the axis of Michelangelo's St Peter's, which was not noticeable as long as the old basilica was standing. My own conclusion had been that Maderno corrected this mistake by slightly shifting the axis of his nave. A new and probably correct interpretation is given by C. Thoenes in *Zeitschr. f. Kunstg.*, XXVI (1963), 128.

Maderno's project was selected in 1607 after a competition in which the following other architects also took part: Flaminio Ponzio, Domenico and Giovanni Fontana, Girolamo Rainaldi, Niccolò Braconio, Ottavio Torrigiani, Giovan Antonio Dosio, and Lodovico Cigoli. The latter's designs (Uffizi) are particularly interesting.

6. Work on the towers stopped at Paul V's death in 1621.

7. E. Paribeni, *Il Palazzo Mattei in Roma*, Rome, 1932, has been superseded by G. Panofsky-Soergel, in *Röm. Jahrb. f. Kunstg.*, XI (1967–8), 111 ff. The new palace replacing an older one was carried out in three stages: 1598–1601, southeast sector; 1604–13, south-west part with the loggia of the cortile and the staircase; 1613–16, northern extension.

8. See, above all, O. Pollak, *Kunsttätigkeit*, I, Vienna, 1928, 251 ff.; further Hempel, *Borromini*, Vienna, 1924; Caflisch, *Carlo Maderno*; Brauer-Wittkower, *Zeichnungen des G. L. Bernini*, Berlin, 1931. Fullest discussion of all available evidence in a paper by A. Blunt, *J.W.C.I.*, XXI (1958), 256, to which the reader must be referred. I have left my original text unchanged since my results largely

coincide with Blunt's.

9. H. Thelen informed Blunt (note to p. 260) that the Uffizi drawing was originally made for a different patron and a different site. Blunt reasonably suggests that it was submitted as an example of the type of palace which Maderno proposed to build.

10. For the prehistory of the Palazzo Barberini, see Cardinal Ehrle, *Roma al tempo di Urbano VIII. La pianta di Roma Maggi-Maupin-Losi del 1625*, Rome, 1915.

Some of the rooms still have the Sforza coat of arms.

11. For the complicated history of the Villa Mondragone see C. Franck, *Die Barockvillen in Frascati*, Munich-Berlin, 1956, 51.

12. See the arched opening at the foot of the staircase of the Palazzo Mattei. The Albertina drawing mentioned in the text also shows the same type of window. In the framework of the tomb of the Countess Matilda in St Peter's Bernini returned to this type of Madernesque design. The same motif in Maderno's loggia of the Palazzo Borghese facing the Tiber is an eighteenth-century addition, see H. Hibbard, *Palazzo Borghese*, 1962, 66 f.

13. He used the motif in the courtyard of the Palazzo Mattei. Borromini's influence on the external details is ascertained by his window design [II: 48]; see II: p. 39.

14. Blunt attributes to Bernini the enlargement of the *salone* and this, according to the author, led to complications in the design of the palace.

15. Among the other practitioners in Rome at this period the amateur architect Rosato Rosati (*c.* 1560–1622) should be mentioned. Born near Macerata (Marches), he was appointed Rector to a small Barnabite College in Rome before 1590. In 1612 he designed S. Carlo ai Catinari with a dome of unorthodox design within the Roman setting (dome finished 1620; apse finished 1646; most of the interior decoration between 1627 and 1649; façade by Soria, 1636–8). Further for this important church, see p. 81; Vincenzo Fasolo, *La cupola di S. Carlo ai Catinari*, Istituto di Studi Romani, 1947.

16. Among the characteristics of this important palace are the elongated proportions of the windows, reminiscent of Gothic shapes, the almost complete abandonment of decoration, the emphasis on the empty wall of the wide middle day, and the incongruous Serlio motif topping the centre.

For Scamozzi see F. Barbieri's monograph, 1952.

17. R. Pallucchini, 'Vincenzo Scamozzi e l'architettura veneta', *L'Arte*, XXXIX (1936), 3 ff.

18. For Curtoni, see P. Gazzola in *Bollettino del Centro Internaz. di Studi di Architettura*, IV (1962), 156.

19. Anthony Blunt, *Artistic Theory in Italy*, Oxford, 1940, 127. On Milanese architecture of this period see, above all, H. Hoffmann in *Wiener Jahrb.*, IX (1934), 91 ff.; C. Baroni, *Documenti per la storia dell' architettura a Milano*, Florence, 1940; idem, *L'architettura da Bramante al Ricchino*, Milan, 1941; P. Mezzanotte and G. C. Bascapé, *Milano nell'arte e storia*, Milan, 1948; P. Mezzanotte in *Storia di Milano*, X, Milan, 1957, part IV; M. L. Gatti Perer, in *Il mito del classicismo nel Seicento*, Florence, 1964, 101.

20. The second court, also usually ascribed to Mangone, was built later in the century by Girolamo Quadrio.

21. The Milanese Giovan Battista Montano (1534–1621) undertook the task of charting an enormous number of ancient buildings in several publications which appeared posthumously between 1624 and 1636. The influence exercised by these books has not yet been sufficiently studied. G. Zander's industrious paper in *Quaderni*, no. 30 (1958), 1, is mainly concerned with the problem of Montano's reliability.

22. Premoli, 'Appunti su L. Binago', *Archivio storico lombardo*, XLIII (1916), 842; G. Mezzanotte, 'Gli architetti Lorenzo Binago e Giovanni Ambrogio Mazenta', *L'Arte*, LX (1961), 231–70, with much new material.

23. The façade too takes up the theme, introduced by Bramante, of two towers which form the effective group with a dome between them. Binago's façade, not finished until the eighteenth century (together with the encasing of the dome), is an important link between Alessi's S. Maria di Carignano at Genoa and Borromini's S. Agnese in Rome. Further information on S. Alessandro in C. Baroni, *Documenti per la storia dell' architettura a Milano*, Milan, 1940, I, 3–34 (documents); see also Mezzanotte (above, Note 22), 253.

24. C. Bricarelli in *Civiltà Cattolica*, LXXXIII, iii (1932), 251; F. Zeri in *Paragone*, VI (1955), no. 61, 35; idem, *Pittura e Controriforma*, Turin, 1957, 60; M. Enrichetti, 'L'architetto Giuseppe Valeriano (1542–1596) . . .' *Archivio stor. per le prov. napoletane*, XXXIX (1960), 325.

25. Examples: S. Maria di Canepanova, Pavia (begun 1492?) or S. Magno at Legnano, 1504–18.

26. See, e.g., Fra Giocondo's drawing in the Uffizi (3932), illustrated in G. T. Rivoira, *Roman Architecture*, Oxford, 1925, figure 209. Also plans and sections in G. B. Montano's *Scielta di varj tempietti antichi*, Rome, 1624.

27. See, e.g., Francesco Gallo's Duomo S. Donato at Mondovì (1743–63) and C. Corbellini's S. Geremia in Venice (1753–60).

28. E. Cattaneo, *Il San Giuseppe del Richini*, Milan, 1957, 36. The church was opened in 1616. Cardinal Federico Borromeo celebrated the first Mass.

When he entered the building, he exclaimed: 'Ha del Romano.'

29. Original ground-plans in the Bianconi Collection (Biblioteca Trivulziana), probably dating from 1607, prove that the façade was designed with the church; but an (undated) elevation of the façade by Ricchino shows a 'pre-aedicule' stage; see E. Cattaneo, *op. cit.*, 86 and figures 27, 28, 37.

30. It must be pointed out, however, that the façade of S. Giuseppe contains a residue of Mannerist ambiguity: only the verticals of the columns flanking the door in the lower and the window in the upper tier are carried through with consistency. The outer columns of the upper tier find no proper response in the lower tier: they rise not over columns but over pilasters; here the vertical movement is also interrupted by the unbroken horizontal of the entablature over the outer bays of the lower tier.

In addition, a chronological problem arises since Girolamo Rainaldi used the type in S. Lucia at Bologna in 1623. But, as we have mentioned, Ricchino's design is probably older and, in any case, he also planned the 'aedicule façade' of the Ospedale Maggiore in the mid twenties, see below, p. 83.

31. The following no longer exist: S. Ulderico, S. Eusebio, S. Lazaro in Pietra santa, all built before 1619; S. Pietro in Campo Lodigiano and S. Vito al Carrobbio, both 1621; S. Vittore al Teatro, S. Giorgio al Palazzo, S. Bartolomeo, 1624; S. Pietro con la Rete and S. Salvatore, 1625; S. Maria del Lentasio, 1640; S. Giovanni alle Case Rotte, 1645; the Chiesa del Seminario di S. Maria della Canonica (*c.* 1651); and S. Marta, S. Agostino, S. Giovanni alle Quattro Faccie. Best survey of Ricchino's work in L. Grassi, *Province del Barocco e del Rococò*, Milan, 1966, 289 ff.

32. E.g. S. Maria della Vittoria, S. Maria Maddalena, S. Giacomo alle Vergini Spagnoli. See also M. L. Gengaro, 'Dal Pellegrini al ricchino', *Boll. d'Arte*, XXX (1936), 202.

33. P. Mezzanotte, 'Apparati architettonici del Richino per nozze auguste', *Rassegna d'Arte*, XV (1915), 224.

34. See Hoffmann, *op. cit.*, 83. For the date of the Palazzo Durini, see P. Mezzanotte, *Raccolta Bianconi*, Milan, 1942, 93 (extremely rare).

35. C. Baroni has made it probable, however, that Martino Bassi's designs of 1591 for the courtyard were still used in 1651. Most of the Brera was executed after Ricchino's death by his son Gian Domenico, Giuseppe Quadrio, and Rossone. The famous staircase, usually ascribed to Ricchino, belongs to the second half of the century.

36. See the richly illustrated work by C. Del Frate, *S. Maria del Monte sopra Varese*, Varese, 1933. For the chapel architecture by G. Bernasconi, see S. Colombo, *Profilo della architettura religiosa del Seicento. Varese . . .*, Milan, 1970.

37. Antonio Morassi, *Catalogo delle cose d'arte . . . Brescia*, 1939, 144, with full bibliography.

38. A. Foratti, 'L'architetto Giov. Ambr. Magenta', in *Studi dedicati a P. C. Falletti*, Bologna, 1915. G. Mezzanotte, *L'Arte*, LX (1961), 244. The dates of Magenta's buildings given in the text are based on this author's research.

39. G. Cantagalli in *Comune di Bologna* (1934), 48, and Mezzanotte, *op. cit.* (last Note).

40. For early repercussions of the columned North Italian nave in Rome, see Ottavio Mascherino's S. Salvatore in Lauro (1591–1600). The columns in Paolo Maggi's SS. Trinità dei Pellegrini (1614) belong to G. B. Contini's eighteenth-century restoration (see G. Matthiae in *Arti Figurative*, II (1946), 57, note 7).

41. Magnani rebuilt between 1622 and 1624 Bernardino Zaccagni's S. Alessandro. He was also the architect of the Palazzo del Municipio (1627), which was destroyed during the last war.

42. According to D. de Bernardi Ferrero, *I disegni d'architettura civile et ecclesiastica di G. Guarini . . .*, Turin, 1966, 63, a drawing for the church in the State Archive at Parma carries only Magnani's name and not that of Aleotti.

43. Theatre of the Accademia degli Intrepidi (1606), destroyed by fire in 1679. For Aleotti's Ferrarese activity, see the well documented paper by D. R. Coffin, *Journal of the Soc. of Architectural Historians*, XXI (1962), 116.

44. L. Magagnato, *Teatri italiani del Cinquecento*, Venice, 1954, 80.

45. The history of the Strada Nuova has now been published in an exemplary cooperative work directed by L. Vagnetti, *Genova, Strada Nuova*, Genoa, 1967: next to exhaustive sections on social, urban, and other aspects, a complete documentation of each palace along the street.

46. The history of Genoese Baroque architecture remains to be written. In spite of valuable work, mainly by Mario Labò and Orlando Grosso, a large number of Genoese palaces are still anonymous, nor does a solid historical basis exist for the major structures of the Sei- and Settecento. But a start has been made with L. Profumo Müller's monograph of B. Bianco (see Bibliography) and with the fine study by G. Colmuto on a specific type of Genoese longitudinal churches with paired columns along the nave (1970, see Bibliography). Bianco's date of birth is often given as 1604 (O. Grosso), which is not possible in view of his activity during the second decade.

47. According to M. Labò, 'Il palazzo dell' Università di Genova', *Atti della R. Università di Genova*, XXV (n.d.), Bianco planned the palace in 1630 and made his final project in 1634, when construction was begun. See also L.

Profumo Müller, *B. Bianco . . .* , 1968; see Bibliography.

48. Similar to the courtyard of the Palazzo Borghese in Rome (p. 34). Airy arcades resting on single or even double columns are familiar from late sixteenth-century ecclesiastical architecture at Genoa, see SS. Annunziata, S. Siro, and S. Maria della Vigna.

49. The embossed columns of the entrance have a Mannerist pedigree, and the ground-floor window surrounds are crowned by lions' heads biting the voussoirs, following the example of the Palazzo Rosso (by Rocco Lurago?).

50. See, e.g., Palazzo Pallavicini on Piazza Fontane Marose (1565) and the Palazzi Lomellini and Serra on Piazza de' Bianchi.

51. Vera Daddi Giovannozzi, in *Mitteilungen des kunsthistorischen Instituts in Florenz*, v (1937–40), 58.

52. V. Fasolo, 'Un pittore architetto: Il Cigoli', *Quaderni* (1953), nos. 1, 2; L. Berti in the Catalogue of the *Mostra del Cigoli*, 1959, 165.

53. L. Berti in *Palladio*, I (1951), 161; R. Linnenkamp, 'Giulio Parigi architetto', *Riv. d'Arte*, VIII (1958), 51, with list of Giulio's works and new documents.

54. J. Hess, *Agostino Tassi*, Munich, 1935.

55. L. Berti in *Riv. d'Arte*, XXVI (1950), 157; and XXVII (1951–3), 93.

56. I follow Berti's careful assessment of the documentary material.

57. See Giovannozzi, *op. cit.*, 60.

58. For the history of the chapel see W. and E. Paatz, *Die Kirchen von Florenz*, Frankfurt, 1955, II, 469, 541, etc., and Berti, *loc. cit.* (Note 55).

59. L. Wachler in *Röm. Jahrb. f. Kunstg.*, IV (1940), 194.

60. For Neapolitan Baroque architecture see Chierici's articles in *Palladio*, I (1937), and R. Pane's book (Naples, 1939), which contains the only coherent history of the subject.

For Francesco Grimaldi, see H. Hibbard, *Art Bull.*, XLIII (1961), 301, whom I follow for the dates of Grimaldi's buildings.

61. For Stati's (1556–1619) stylistic position, see V. Martinelli in *Riv. d'Arte*, XXXII (1959), 233.

62. Cordier also enjoyed a reputation as restorer of antique statuary; see S. Pressouyre, in *G.d.B.A.*, LXXI (1968), 147 ff. For the sculpture in the Aldobrandini Chapel see *idem*, *Bulletin de la Société Nationale des Antiquaires de France* (1971).

63. N. v. Holst in *Zeitschr. für Kunstg.*, IV (1935), 35, has deflated this legend. J. Pope-Hennessy, *Italian High Renaissance and Baroque Sculpture*, London, 1963, Catalogue, 137, does not accept Holst's conclusions.

64. Statues and reliefs in the Cappella Aldobrandini, S. Maria sopra Minerva (1598–1605); in S. Giovanni in Laterano (1600); in the Cappella Paolina, S. Maria Maggiore (1608–12); in S. Maria della Pace (1614); and S. Maria di Loreto (1628–9), etc.

65. R. Wittkower, in *Zeitschr. f. b. Kunst*, LXII (1928), 26; I. Robertson in *Burl. Mag.*, LXIX (1936), 176; A. Donati, *Stefano Maderno scultore*, Bellinzona, 1945.

66. Literature about him is fairly large. More recently P. Rotondi in *Capitolium*, XI (1933), 10, 392, and *Riv. del R. Ist.*, V (1935–6), 189, 345, and V. Martinelli in *Commentari*, IV (1953), 133, with further references.

67. See G. Fiocco's basic article in *Le Arti*, III (1940–1), 74.

68. V. Martinelli's articles in *Commentari*, II (1951), 224 and III (1952), 35, list the considerable post-Thieme-Becker literature and also contain an additional list of works.

69. For a different interpretation of Mochi's development the reader has to be referred to a recent paper by I. Lavin, in *Art Bull.*, LII (1970), 132 ff.

70. In some of his bronzes, however, Francesco Susini broke away from the tradition of the Giovanni Bologna studio (e.g. *Rape of Helen*, 1626); see E. Tietze-Conrat in *Kunstg. Jahrb. der k.k. Zentral-Kommission*, II (1917), 95.

71. See the fully documented article by S. Lo Vullo Bianchi in *Riv. d'Arte*, XIII (1931), 131–213. Also E. Lewy, *Pietro Tacca*, Cologne [1928].

72. Above all the bronze equestrian statues of Ferdinand I (Florence, in the Piazza Annunziata), Henry IV of France (1604–11, Paris, destroyed), and Philip III of Spain (1606–13, Madrid).

73. Giovanni Bandini's statue was erected in 1595–9 (H. Keutner, *Münchner Jahrbuch d. bild. Kunst*, VII (1956), 158). Tacca's *Slaves* were executed with the help of Andrea Bolgi, Cosimo Cappelli, Cosimo Cenni, Bartolomeo Cennini, Michele Luccherini, and of Lodovico Salvetti. Soon after, Bolgi left for Rome. Cennini, too, went to Rome, where he made his name as a bronze founder in Bernini's studio. The other pupils were men of little distinction.

74. W. Weisbach, *Trionfi*, Berlin, 1919.

75. It has, however, been correctly pointed out that Hellenistic bronze statuettes of Negro slaves show attitudes extremely close to those of Tacca's slaves; see, e.g., K. A. Neugebauer, *Die Griechischen Bronzen* (Staatl. Museen), Berlin, 1951, plate 36.

76. The statue of Ferdinand I was not finished until 1642 by Pietro Tacca's son, Ferdinando.

77. Finished shortly before Pietro's death and erected by Ferdinando in 1642.

78. It is not certain whether the copy in the Palazzo Pitti after the Velasquez painting in the Prado or the Spanish copy in the Uffizi after Rubens's lost picture of 1628 was dispatched from Madrid for this purpose.

79. For instance, his *Virgin and Child* on the tomb of Porzia Coniglia (Naples, S. Giacomo degli Spagnuoli) derives from Danti's *Virgin and Child* in the Cappella Baroncelli, S. Croce, Florence; and the group of *Adam and Eve*, which he presented to the Grand Duke Cosimo II (1616, now Boboli Gardens), from Bandinelli's group in the Bargello.

80. L. Bruhns in *Röm. Jahrb. f. Kunstg.*, IV (1940), 293. On Naccherino, see A. Maresca di Serracapriola, *Michelangelo Naccherino*, Naples, 1924.

81. His figures in the Chapel of the Crucifixion, Sacro Monte, Varese, show, however, a true sense of Baroque drama and break with the conventions of the older Francesco Silva (1580–1641), who executed most of the groups in the chapels of the Sacro Monte.

82. Among the sculptors who worked at Genoa may be mentioned Filippo Planzoni from Sicily (d. 1636), Domenico Bissoni from Venice (d. 1639) and his son Giovan Battista (d. 1659), and Stefano Costa (d. 1657) and Pietro Andrea Torre (d. 1668). Most of these worked mainly in wood. Artists like the Bissoni have become more clearly defined personalities through the 1939 Exhibition at Genoa (see III: pp. 63–4).

Index

A cumulative index to all three volumes appears at the end of volume III

PHOTOGRAPHIC ACKNOWLEDGEMENTS

Archivi Alinari 2, 3, 4, 5, 6, 7, 8, 9, 10, 11, 13,
14, 15, 19, 23, 24, 28, 30, 33, 37, 40, 41, 42, 43,
44, 45, 46, 49, 52, 54, 55, 57, 59, 60, 62, 64, 65,
67, 69, 71, 75, 77, 79, 82, 90, 92, 98; Institut
Amattler d'Art Hispanic, Barcelona 101;
© Bildarchiv Preussischer Kulturbesitz, Berlin,
1997/Jörg P. Anders 35; Canali Photobank 80,
87, 93, 102; The Conway Library, Courtauld
Institute of Art, London 83; Gabinetto
Fotografico Nazionale 25, 26, 36, 39, 96, 97;
© Photo RMN – R.G. Ojeda/P. Neri 34;
Sächsische Landesbibliothek-Staats- und
Universitätsbibliothek, Dresden, Dezernat
Deutsche Fotothek 20, 21; Scala II–III, 1, 16, 17,
27, 48, 53, 68, 70, 78, 94, 99; A. Villani e Figli
22, 29, 31, 32, 47, 56.